ANIMAL
PAINTING
&
ANATOMY

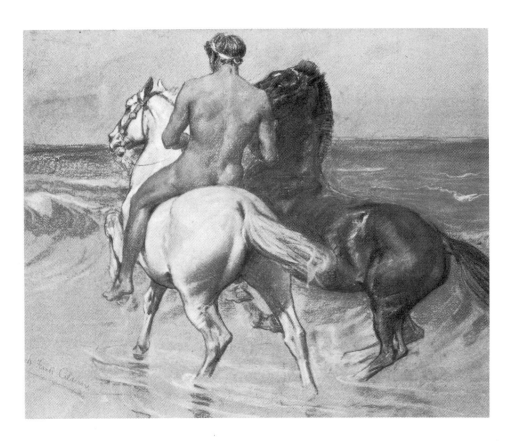

"ON A SEA BEAT COAST"
(Pastel Study)
By kind permission of Mrs. Howard Crook

ANIMAL PAINTING
&
ANATOMY

By

W. FRANK CALDERON

Founder & Principal (1894—1918) of the School of Animal Painting
Sometime Lecturer on Animal Painting
at the Royal Academy

DOVER PUBLICATIONS, INC.
NEW YORK

Published in Canada by General Publishing Company, Ltd., 30 Lesmill Road, Don Mills, Toronto, Ontario.
Published in the United Kingdom by Constable and Company, Ltd., 10 Orange Street, London WC 2.

This Dover edition, first published in 1975, is an unabridged and unaltered republication of the work originally published in 1936. It is reprinted by special arrangement with Seeley, Service and Company, 196 Shaftsbury Avenue, London WC 2, England, publisher of the original edition.

International Standard Book Number: 0-486-22523-2
Library of Congress Catalog Card Number: 72-75583

Manufactured in the United States of America
Dover Publications, Inc.
180 Varick Street
New York, N.Y. 10014

LIST OF CONTENTS

PART I

CHAPTER PAGE

I. DRAWING. THE TRAINING OF THE HAND, THE EYE & THE MEMORY 17

II. DRAWING. FREEDOM 23

III. THE THIRD DIMENSION. PERSPECTIVE & THE RENDERING OF SOLID FORM 26

IV. THE MAKING OF SKETCHES & STUDIES . . . 33

V. DRAWING FROM LIFE 41

VI. ANATOMY IN RELATION TO DRAWING 51

VII. MOVEMENT 57

VIII. THE CONCEPTION OF A PICTURE 62

IX. COMPOSITION. DESIGN, RESTRAINT, SKETCHES FOR COMPOSITION 67

X. COMPOSITION. RHYTHM, BALANCE OF LIGHT & SHADE, RELATIVE SCALE OF ANIMALS & LANDSCAPE, COLOUR, THE VISION " CUT OUT," FOREGROUNDS . 76

XI. PAINTING & COLOUR 87

PART II

I. THE VERTEBRAL SKELETON 95

II. THE BONES OF THE HEAD 118

III. THE MUSCLES OF THE HEAD 144

IV. MUSCLES OF THE VERTEBRAL SKELETON . . . 159

V. FORE LIMB 170

VI. MUSCLES OF THE FORE LIMB 206

VII. MUSCLES ATTACHING THE SHOULDER-BLADE TO THE TRUNK 234

VIII. THE BONES & MUSCLES OF THE HIND LIMB . . 257

IX. MUSCLES OF THE HIND LIMB 285

X A STANDARD HORSE 315

LIST OF PLATES

PART I

PLATE		PAGE
1	Measuring	19
2	The Fundamental Line	21
3	Pigs in a Trough	27
4	Horse Feeding	28
5	Belgian Cart Horse	30
6	Back View of Cow	31
7	Tail Piece	32
8	Cow Looking Back	33
9	Charcoal Drawing	34
10	Cow Licking its Back	35
11	Three Pigs in a Trough	37
12	Belgian Cart Stallion	38
13	Dog on Bench Unattended	41
14	The Watch Dog by Paul Potter	42
15	Dalmatian	44
16	Cow Model	46
17	Sheep Feeding	47
18	Puppy Kept Quiet with Gingerbread	48
19	Starveling Having a Feed	50
20	Anatomical Note	52
21	Cow Drinking	53
22	Gelert Killing the Wolf	55
23	Malta 1926. Notes of Action in Sketch Book	56
24	The Epsom Derby, 1821 by Géricault	59
25	Action—the Horse	59
26	Action—the Horse. Explanatory Diagram	59
27	Two Royal Horses & Anderson, their Groom by George Stubbs	60

7

LIST OF PLATES

PLATE PAGE

28 PONIES GALLOPING (FROM MEMORY) 61

29 NOTE OF ACTION 61

30 NOTE BOOK SKETCH 68

31 THE BEACH, BORDIGHERA 71

32 PRELIMINARY SKETCH ON WHICH "CREST OF THE HILL"
 WAS FOUNDED 72

33 REAPER, BINDER & HORSES 75

34 "BŒUF SE RENDANT AU LABOUR" BY TROYON . . 77

35 "LANDSCAPE WITH CATTLE" BY CUYP . . . 79

36 COMPOSITION BY CUYP 81

PART II

1 VERTEBRAL SKELETON 94

2 DIAGRAMMATIC SECTION OF A TYPICAL VERTEBRA . . 96

3 ,, ,, ,, ,, . . 97

4 MOBILITY OF THE UPPER END OF THE NECK TURNING WITH
 THE HEAD 98

5 ARTICULATION OF RIBS WITH VERTEBRÆ . . . 100

6 SHOWING THE JUNCTION OF THE NECK & THE THORAX . 101

7 ,, ,, ,, ,, ,, ,, ,, ,, . 102

8 ANALYSIS OF SKETCH FROM NATURE . . . 102

9 INCIPIENT HUMP ON DRAUGHT OX 103

10 WHITE ITALIAN OXEN 103

11 RIBS OF AN OX 105

12 VERTEBRAL SKELETON OF A GREYHOUND . . . 105

13 PELVIS OF HORSE (REAR VIEW) 107

14 ,, ,, ,, (SIDE VIEW) 107

15 TO SHOW TILT OF PELVIS OF A HORSE RESTING, WEIGHT
 SUPPORTED ON DIAGONALS 109

16 PENCIL STUDY OF DOG IN VERY POOR CONDITION,
 ILLUSTRATING BONE FORMS 110

LIST OF PLATES

PLATE PAGE

17 PELVIS OF DOG (BACK VIEW) 111

17A ,, ,, ,, (SIDE VIEW) 111

18 OX. BACK VIEW OF PELVIS 112

19 OX. PELVIS & LUMBAR VERTEBRÆ (SIDE VIEW) . . 112

20 SALIENT POINTS OF VERTEBRAL SKELETON AS SEEN IN THE
 LIVING ANIMAL 114

20A SHOWING THE TOP OF THE NECK JOINING THE SKULL
 BELOW THE HORN RIDGE 114

21 PELVIS & LUMBAR VERTEBRÆ OF THE HORSE . . . 116

22 VERTICAL SECTION THROUGH SKULL OF HORSE . . . 118

23 HORSE'S SKULL 119

24 SKULL OF OX IN PROFILE 121

25 ,, ,, ,, ($\frac{3}{4}$ FRONT VIEW) 122

26 ,, ,, ,, ($\frac{3}{4}$ BACK VIEW) 123

27 BULL'S SKULL FORESHORTENED 126

28 COWS' HEADS 127

29 SKULL OF SHEEP 128

30 ,, ,, IRISH WOLFHOUND 129

30 ,, ,, LION 129

31 SKULLS OF LARGE & SMALL DOGS 130

32 SKULL OF MAN 131

33 FRAMEWORK OF NOSTRILS 132

34 ,, ,, NOSTRIL 133

35 NOSTRIL 134

36 DIAGRAMMATIC FIGURE TO SHOW STRUCTURE OF FALSE
 NOSTRIL, FALSE NOSTRIL SLIT OPEN 134

37 HORSE'S HEAD, NOSTRILS OPEN 135

38 ,, ,, NOSTRILS CLOSED 136

39 NASAL CARTILAGES OF DOG COMPARED WITH MAN'S . 137

40 THE MASTOID PROCESS & CREST 138

41 THE BOWL OF THE EAR 139

9

LIST OF PLATES

PLATE PAGE

42 DOMESTIC CAT, SHOWING SET ON OF EAR . . . 140

43 EAR OF DOG, OPENED OUT TO SHOW ITS ACTUAL SHAPE 141

44 DOGS' EARS 142

45 HORSE'S HEAD. BONE FORMATION & MUSCLE ORIGINS
 146—147

46 ,, ,, DEEP MUSCLES 146—147

47 ,, ,, MIDDLE LAYER . . . 146—147

48 ,, ,, FINAL MUSCLES 146—147

49 HEADS OF MAN, DOG & FOXHOUND SHOWING ANATOMICAL
 SIMILARITIES 148

50 EAR MUSCLES OF DOG, FROM BEHIND 149

51 HEAD MUSCLES 150

52 SUPERFICIAL MUSCLES 151

53 HEAD OF DOG, MOUTH OPEN 155

54 HEAD OF FOXHOUND (EAR ROUNDED) . . . 156

55 ,, ,, GREYHOUND 157

56 LARGE OBLIQUE MUSCLE OF THE HEAD . . . 160

57 THE TRACHELO-MASTOID MUSCLE 161

58 TO SHOW ATTACHMENTS OF STERNO-MAXILLARIS . 162

59 MUSCLES OF THE VERTEBRAL SKELETON . . . 164

60 THE SPLENIUS, THE SMALL ANTERIOR SERRATUS, &c. . 168

61 BONES OF FORE LIMB OF HORSE 171

62 ,, ,, ,, ,, ,, LION 171

63 ARM OF MAN 172

64 BONES OF FORE LIMB OF DOG 172

65 ,, ,, ,, ,, ,, OX 173

66 LEFT SCAPULA OF HORSE (OUTER FACE) . . . 174

67 RIGHT ,, ,, ,, (INNER FACE) . . . 174

68 HUMERUS & ADJOINING BONE STRUCTURES OF HORSE . 175

69 LEFT HUMERUS OF HORSE 176

70 HUMERUS & ADJOINING BONES OF HORSE . . . 178

71 POSTERIOR VIEW OF BONES OF LEFT FOREARM OF HORSE 179

LIST OF PLATES

PLATE PAGE

72 EXTERNAL VIEW OF BONES OF LEFT FOREARM OF HORSE 179

73 SKELETON OF LEFT FORELEG OF DOG, FOOT EXTENDED . 181

74 LEFT KNEE OF HORSE 182

75 LEFT KNEE JOINT OF HORSE 183

76 ,, ,, ,, ,, ,, 183

77 CARPAL LIGAMENTS. INSIDE VIEW OF RIGHT KNEE OF
 HORSE 184

78 CARPAL LIGAMENTS. INSIDE VIEW OF RIGHT KNEE OF
 HORSE 184

79 CARPAL LIGAMENTS. OUTSIDE VIEW OF LEFT KNEE OF
 HORSE 185

80 BONES OF A MAN'S LEFT HAND 186

81 ,, ,, LEFT FORELEG OF HORSE FROM SECOND KNEE
 JOINT DOWNWARDS 187

82 BONES OF LEFT FORELEG OF HORSE FROM SECOND KNEE
 JOINT DOWNWARDS 188

83 BONES OF THE LEFT FORELEG OF OX 190

84 ,, ,, ,, ,, FOREFOOT OF HORSE . . . 191

85 LATERAL CARTILAGES OF LEFT FOREFOOT OF HORSE . 191

86 ,, ,, ,, ,, ,, ,, ,, . 191

87 LEFT FOOT OF HORSE 193

88 RIGHT HOOF (FROM ABOVE) 193

89 ,, ,, (FROM BELOW) 193

90 LEFT FOREFOOT 195

91 ,, ,, 195

92 SECTION AT MIDDLE LINE 196

93 LEFT FOREFOOT OF DOG 197

94 ,, ,, ,, ,, 198

95 THIRD DIGIT OF CAT, TIGER, &c. (CLAW WITHDRAWN) . 199

96 ,, ,, ,, ,, &c. (CLAW EXTENDED) . . 199

97 ,, ,, ,, DOG 200

LIST OF PLATES

PLATE PAGE

98 FOREPAW OF DOG. PADS 200

99 DIGIT OF HORSE 201

100 SUSPENSORY LIGAMENT OF LEFT FORELEG OF HORSE . 202

101 „ „ „ HORSE 203

102 „ „ „ OX, LEFT FORELEG . . 204

103 „ „ „ „ „ „ . . 204

104 INSIDE VIEW OF RIGHT FORELEG OF HORSE, FLEXED . 207

105 LEFT FOOT OF HORSE, LIFTED 207

106 PERFORANS MUSCLE 209

107 LEFT FORELEG OF HORSE 209

108 EXTERNAL VIEW OF THE LEFT FORELEG OF THE HORSE
 (SUPERFICIAL MUSCLES) 210

109 FORELEG OF OX 211

110 THE MUSCLES OF THE LEFT FORELEG OF THE LION,
 FRONT VIEW 213

111 SUPERFICIAL MUSCLES OF THE LEFT FORELEG OF THE
 HORSE, BACK VIEW 214

112 LEFT FORE LIMB OF HORSE 215

113 BACK VIEW OF LEFT FORELEG OF DOG . . . 216

114 LEFT FORELEG OF HORSE (SUPERFICIAL MUSCLES) . 218

115 INSIDE VIEW OF DOG'S RIGHT FORELEG . . . 220

116 ORIGINS AND INSERTIONS OF MUSCLES OF LEFT FORELEG
 OF DOG 222

117 LEFT SHOULDER & ARM OF HORSE 224

118 „ „ „ „ „ GREYHOUND . . 224

119 THE MUSCLES & VEINS OF THE RIGHT FORELEG OF THE
 HORSE, INSIDE VIEW 226

120 MUSCLES OF RIGHT SHOULDER & ARM OF HORSE . . 231

121 HORSE. MUSCLES ATTACHING THE SHOULDER-BLADE . 235

122 DEEP MUSCLES OF NECK, SHOULDERS, &C. OF CARNIVORA 236

123 MUSCLES ATTACHING FORE LIMB 237

LIST OF PLATES

PLATE		PAGE
124	SUPERFICIAL & DEEP MUSCLES	238
125	FRONT VIEW OF HORSE	239
126	SUPERFICIAL & DEEP MUSCLES OF HORSE	241
127	DEEP PECTORAL MUSCLES & SUPERFICIAL MUSCLES OF HORSE	242
128	SUPERFICIAL MUSCLES—FRONT VIEW	242
129	COW. MUSCLES OF THE SHOULDER	243
130	FRONT VIEW OF DOG SHOWING PECTORAL MUSCLES CONNECTING LIMB WITH THORAX	244
131	FRONT VIEW OF DOG, SITTING UP TO SHOW DISPOSITION OF SUPERFICIAL MUSCLES OF CHEST, NECK & SHOULDERS	245
132	FOREHAND OF HORSE	246
133	MASTOIDO-HUMERALIS MUSCLE OF HORSE	247
134	GREYHOUND. MUSCLES OF THE NECK & SHOULDER	248
135	SUPERFICIAL MUSCLES OF CARNIVORA	249
136	,, ,, ,, NECK, CHEST & SHOULDER OF DOG	250
137	SKIN MUSCLES	251
138	PLATYSMA MYOIDES	253
139	GREYHOUND. SKIN MUSCLES	254
140	DOG	255
141	SUPERFICIAL MUSCLES OF MAN STOOPING	255
142	MAN. BONES OF THE LEG	258
143	LION. BONES OF THE HIND LIMB	258
144	SKELETON OF LEFT HIND LIMB OF HORSE	259
145	RIGHT FEMUR OF HORSE (FRONT VIEW)	260
146	,, ,, ,, ,, (OUTSIDE VIEW)	260
147	END ON VIEW OF FEMUR FROM BELOW	261
148	RIGHT FEMUR OF HORSE (BACK VIEW)	262
149	,, ,, ,, ,, (INSIDE VIEW)	263
150	HUMAN THIGH BONE	264

LIST OF PLATES

PLATE		PAGE
151	WOLFHOUND'S THIGH BONE	265
152	TIBIA & FIBULA OF HORSE, RIGHT LEG	266
153	„ OF THE RIGHT LEG OF HORSE	267
154	RIGHT TIBIA & FIBULA OF HORSE	267
155	„ „ „ „ „ „	269
156	„ „ OF HORSE, FROM IN FRONT & BELOW	270
157	PATELLA OF HORSE, RIGHT LEG	271
158	„ „ „ „ „	271
159	LIGAMENTS	272
160	INSIDE VIEW OF RIGHT STIFLE, EXTENDED	273
161	FLEXION & EXTENSION	274
162	„ „ „	274
163	TARSUS & METATARSUS OF RIGHT LEG OF HORSE	276
164	„ „ „ „ „ „ „ „	276
165	„ „ „ „ „ „ „ „	277
166	„ „ „ „ „ „ „ „	277
167	LIGAMENTS OF THE HOCK OF HORSE	279
168	„ „ „ „ „ „	279
169	„ „ „ „ „ „	281
170	„ „ „ „ „ „	281
171	RIGHT HIND LIMB OF HORSE	283
172	BONES OF HIND LIMB OF OX	284
173	SKELETON OF LEFT HIND LEG OF HORSE	286
174	MUSCLES ACTING ON FOOT	287
175	HIND QUARTERS OF A HORSE WITH THE FOOT HELD UP	288
176	RIGHT HIND LEG OF OX	289
177	SUPERFICIAL MUSCLES OF HIND LEG OF DOG	290
178	SKETCH FROM NATURE ANALYSED	291
179	BONES OF RIGHT HIND LEG OF HORSE	292
180	DEEP MUSCLES OF RIGHT HIND LEG OF HORSE, FROM BEHIND	293

LIST OF PLATES

PLATE PAGE

181 MUSCLES ACTING ON THE TARSUS & METATARSUS OF THE
 LEFT HIND LEG OF HORSE 295

182 STRUCTURE OF FLEXOR METATARSI OF RIGHT LEG OF
 HORSE 296

183 SUPERFICIAL MUSCLES OF RIGHT HIND LEG OF HORSE . 297

184 SKELETON OF CROUP & THIGH OF HORSE . . . 299

185 DEEP MUSCLES OF THIGH OF HORSE 299

186 HIND QUARTERS OF HORSE 301

187 SUPERFICIAL MUSCLES OF THE HIND QUARTERS OF HORSE 302

188 GLUTEAL & THIGH MUSCLES OF MAN 303

189 DEEP MUSCLES 304

190 SUPERFICIAL MUSCLES 304

191 SUPERFICIAL MUSCLES OF HIND LIMB OF DOG . . . 305

192 HIND LIMB OF LION 306

193 DEEP & SUPERFICIAL MUSCLES OF THE HIND LIMB . . 308

194 INSIDE VIEW OF LEFT HIND LEG OF HORSE . . . 310

195 OX 311

196 DOG 312

197 MUSCLES OF THE HIND LIMB 313

198 A STANDARD HORSE 316

199 VARIATIONS FROM STANDARD 318

200 ALIGNMENT OF BACK TENDON 319

201 NOT CONFORMING TO STANDARD 320

202 A COMMON FAULT IN DRAWING 321

203 POINTS WORTH COMPARING WHEN DRAWING THE BACK
 VIEW 322

204 HORSE. SHOULDERS SEEN FROM THE FRONT . . . 323

205 DIAGRAM TO SHOW COLLAR PLACE 324

206 COLLAR POSITION WITH NECK TURNED 325

207 THE LIMIT OF THE NECK 326

208 TO SHOW HOW HARNESS MAY HELP TO EXPLAIN FORM 327

15

CHAPTER I

DRAWING

The Training of the Hand, the Eye & the Memory

WHAT is meant by drawing? So few people seem to understand what drawing is, or the important part it plays in every branch of art, that perhaps a few words to explain what it implies to artists in general may not be amiss.

Many people are under the impression that it only refers to the elementary part of an artist's education, and is exclusively concerned with pencil or chalk. They do not realize that it is the very essence of all pictorial art, and that without it painting would be meaningless.

Drawing simply means the delineation of form and has nothing to do with the materials employed. It embraces practically the whole of the painter's art, except in so far as it has nothing to do with abstract colour. The placing of every touch on the canvas is an act of drawing.

No matter what medium is employed, whether it be pen, pencil, pastel, or paint, whenever form of any kind is represented, drawing is the chief agent. Everything we see, everything we paint, has some shape, some boundary, some form; and it is the faculty of drawing alone that enables the artist to depict it.

Good draughtsmanship demands a sure eye, a steady hand, and a good visual memory.

The eye must be taught to see correctly and the memory to retain the image whilst the hand draws it. When this satisfactory condition is reached the student will be in a fair way to becoming an expert draughtsman, but in order to reach it he must be prepared to go through the mill as he would have to do in any other profession. He must learn his A.B.C., he must practise his pothooks and hangers, his straight lines and curves and all other exercises that may be needful to produce ocular and manual efficiency.

When he has reached the stage when he can copy at sight any simple object that is set before him as readily and as accurately as he would write a dictated sentence, he may be said to have completed the first part of his education.

The art student's course of study should be arranged progressively, and, at first, the training of the eye is the all-important thing, for until he can see correctly it is obvious he cannot draw correctly. More bad draughtsmanship results from neglected visual training than from any want of facility in handling the pencil.

Before beginning the actual drawing lessons, the master should ascertain that the student's horizontal and vertical vision is normal; that is to say, that he can tell when a line is exactly level and when another is perfectly upright. Correct observation in these respects is indispensable to accurate draughtsmanship.

The direction of every line in a picture, as well as the relative positions of everything it contains, depends upon it. The whole time an artist is at work he is comparing the different parts of his subject with one another and settles their exact relationship by means of imaginary horizontal and vertical lines. He finds one point is immediately over or under another, or a little to one side or the other of his imaginary perpendicular. Another point is on a level with something else, and so on, so that it will be seen that if his visual judgment of these directions is faulty, all his inferences will be wrong. A very good plan for teaching beginners to judge horizontals and perpendiculars is for the instructor to place a mark on the blackboard and for the student to try and put another one level with or perpendicular to it, and to test the results with a plumb line and spirit level.

If these exercises can be made competitive and treated rather as a game than a lesson, they will be found both instructive and entertaining. Quite an amusing way of training the eye—and incidentally one that enables the teacher to discover prevailing visual defects—is to have some clean white cards, uniform in size and shape, upon one of which he marks a spot at random, and after passing it round the class, asks each student to put a spot in the corresponding place on his own card.

The amount of error in each case may be ascertained by placing his own over each competitor's card and piercing the spot with a pin which will leave a punctured mark on the one below.

It will be found that some of the pupils habitually place their spots too high, others too low, or to a particular side—tendencies that in the early stages may be easily rectified, but which if allowed to pass unnoticed are difficult to correct later.

In the same way let them practise putting two or three spots in a horizontal or vertical line, or they might be given sloping lines to copy, in fact anything that is capable of proof by ocular demonstration.

By degrees, the exercises might be made more complex, and if the interval between the seeing and recording is gradually increased it becomes a very useful method of training the memory as well as the sight.

Endless variations might be invented for the simultaneous training of both faculties, and so long as the results can be proved and clearly demonstrated, they cannot fail to be beneficial, and the more entertaining this part of the education can be made the better.

The great Leonardo da Vinci himself, in one of his note-books,[1] suggests that artists might well indulge in some such " profitable recreations

[1] Translated by McCurdy (Duckworth & Co., 1906).

and diversions " for the purpose of " training the eye to acquire accuracy of judgment," which, as he tells us, is " the primary essential of painting."

Another useful exercise is for the student to stand facing the centre of a doorway, and to practise bringing up a card at arm's length until the top and one side of the card coincide with the top and side of the frame of the door. If care is taken to make both edges fit at the same time, it not only teaches the student to judge horizontal and vertical lines but it compels him to hold the card vertically while doing so, a matter of vital importance whenever any tests are being made with it. When once the student has learned to hold his card upright he will find it a very useful implement, not only for estimating horizontals and perpendiculars, but also for judging curves and contours.

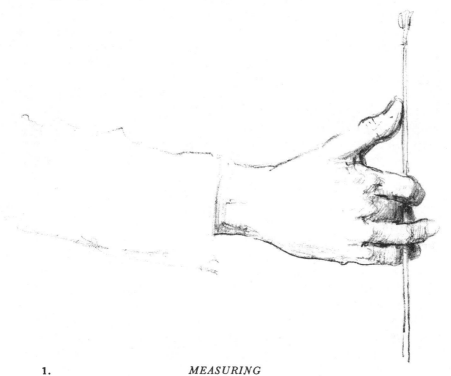

1. *MEASURING*

In order to keep the brush upright when measuring, pass it through the fingers in the manner shown above, and slide the thumb up and down. All measuring should be done at the full extent of the arm.

When actually at work, an artist generally finds it more convenient to use his pencil or brush for making rough measurements of his model. Whatever he uses, all his measurements must be made at the same distance from his eye.

This distance must never vary, and the pencil must never be tilted either towards or away from him.

Failure to realize these conditions is the reason why students so often get different results at different times, and why their measurements can seldom be depended upon.

To ensure good results, therefore, all measurements should be made with the arm outstretched to its full extent, and the pencil held as if its whole length rested against an upright sheet of glass interposed between him and his subject.

The length of the straightened arm does not vary, whereas, if bent, it is impossible to regulate the distance between hand and eye.

It should be the aim of every young animal painter eventually to do without measuring and to trust to his eye entirely. This, however, demands very severe training and years of practice, and in the meantime it is well he should know the proper way in which to verify his drawings.

Animals move about too much to permit of elaborate measurements and comparisons being made. Yet opportunities do occur of comparing proportions of which advantage should be taken; but not as a guide for what has yet to be done. It is a great mistake to mark out measurements beforehand as it hampers the drawing and prevents freedom of execution. Better a few slight errors and a confident flowing line, than absolute exactitude and a hesitating, timid one.

Having learned to some extent to judge the horizontal and perpendicular directions at sight, and having acquired some facility in using the card or brush in the way described, the student should now be taught to judge sloping lines.

In every drawing we make, it is of paramount importance to be able to hit off the exact directions of the principal lines, for if one of these is ever so little misjudged, the whole of the drawing may be affected.

If a few straight lines be drawn at different angles, and the student is asked to copy them, the results can be easily compared by drawing a true horizontal or perpendicular line and measuring the angles where the sloping lines meet them with a protractor, a carpenter's bevel, or even with an ordinary penknife, half open.

When the student can, with some degree of certainty, judge the length and direction of any straight line, and at the same time place it approximately where it should be on his paper, he has accomplished something of which to be proud.

The power of placing a simple line exactly where and how intended is then the first thing to accomplish, as it is practically the last, for it may be said to cover the whole art of drawing.

Let us take an example *(Plate 2)*, giving the primary lines indicating a horse in profile. A—B is the first line drawn; if this slopes in the wrong direction the attitude is wrong; if it is made too long, the head will be too large; if too much to the left or right, too high or too low, it is wrongly placed on the paper, so it will be seen that the whole

attitude and size of the horse, as well as its position on the canvas, is entirely dependent upon this initial line being correct.

The directions of other leading lines must be considered as carefully. The line A—C represents the top of the neck. If, in copying the angle B.A.C. we make it too obtuse, the neck becomes more horizontal and too wide at the collar place. To correct this we must raise the whole horse, bringing it higher up on the canvas; in addition, in order to preserve the proper length of the neck, we have to shift the body farther back (shaded portion). So it will be seen that, simply from misjudging the direction of the line A—C, the whole of the rest of the drawing must be reconsidered.

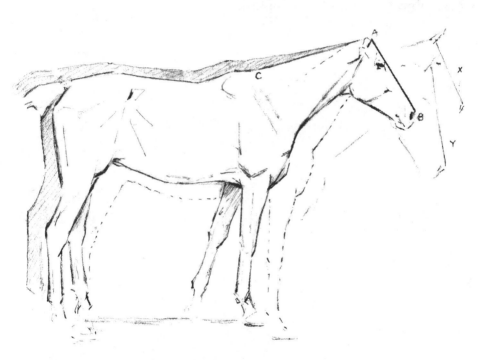

2. *THE FUNDAMENTAL LINE (shown by A—B)*

The shaded portion indicates where the horse would come if the angle BAC were too oblique. Dotted lines indicate the position if too acute. XY—indications of heads in which the line AB is wrongly placed and wrongly proportioned. In the preliminary stages straight lines should be used wherever possible. They can be sweetened afterwards.

Similarly, if we make the angle too acute, the line A—C becomes more perpendicular, and gives the appearance of the head being more elevated, and the whole animal has then to be brought down and forward (dotted lines). So whatever we do incorrectly leads us into endless complications, and so it goes on throughout the whole drawing.

Carelessness in the early stages is inexcusable. Fundamental errors cannot be remedied afterwards. As soon as a mistake is discovered it should be corrected. One generally knows when a drawing begins to go wrong, and when the different parts won't fit, and the thing is to find out where the fault lies at once. Students are often inclined to think it does not very much matter. " What if my horse does come higher or lower than I intended? I can cut a bit off the top or bottom of my picture." This is all very well if we are only making a study and have plenty of canvas to spare all round. In the case, however, of a picture containing other animals and figures, which has all been previously considered and arranged, and which depends for its pattern on the exact placing of each feature, it would be fatal, as everything would have to be altered and the whole subject practically redesigned.

CHAPTER II

Freedom

FOR general utility there is nothing better than charcoal as a medium for
drawing. Charcoal is what every artist uses when first sketching in the
general outline of his subject on his canvas. Many also use it in prefer-
ence to pencil when beginning a water-colour drawing, as well as for the
initial stages of chalk or even pencil work itself. Any medium may be
used over it, and from the fact that it can so easily be dusted off, it is
more expeditious to handle than anything else.

By itself, it may be used as a black and white medium, and finished
work, rich in tone and of exquisite quality may be done with it, as well
as line drawings of a charmingly sensitive character. In fact, in skilled
hands it has practically no limitations and may be used for almost any
kind of drawing.

Many people, both students and masters, are inclined to fight shy of it
because they say it is so messy and that it so constantly breaks. This
undoubtedly is the case in inexperienced hands, but as these disad-
vantages have to be overcome sooner or later, the sooner the student is
taught how to handle it the better.

A light hand is as essential to the artist as it is to the horseman, and
dirty, heavy drawing generally results from having bad hands. The
reason that charcoal breaks so frequently is that the student puts too
much weight upon it. The very first thing he has to learn is to draw
without using his hand to support him. The arm should be so trained as
to sustain the whole weight of the hand, so that the latter is absolutely
free to move and direct the pencil whithersoever the eye intends it to go,
and not an ounce of dead weight should be allowed to interfere with the
free action of the pencil in the delicate work it has to perform.

The aim of most art students is presumably to learn to paint or design
on a reasonable scale, and not to confine themselves exclusively to trivial
work of note-paper size, and if this be so, no time should be lost in teach-
ing them the proper method.

For the very reason that charcoal is so brittle, it is one of the best means
of training the hand, and might well be employed even for that purpose
alone.

When drawing with a pencil on a small scale, one naturally rests the
hand on the paper, as in writing; the arm is flexed, and having nothing

to support, does not tire. There is, however, no freedom of movement; the sphere of action is very limited and it is a practical impossibility to draw a sure line exceeding a few inches in length without rubbing the hand on the paper. For larger work, or as a preparation for using the brush, this method is obviously unsuitable, and some other should be employed.

Students should, from the first, practise drawing at an easel, with their paper upright before them; they should sit or stand (the latter for preference) well away from their work, so that they can see the whole of it without moving. With the head erect and arm outstretched they should work on as large a scale as possible, always bearing in mind that at first their drawing should be no larger than the eye can conveniently encompass at arm's length.

In this attitude, holding the pencil as if using it to point out something, with thumb on top, arm and wrist extended, the whole directing movement should be done from the shoulder joint. This method, as will be readily seen, allows of complete freedom of movement over the whole surface of the drawing; the length of stroke being no longer regulated by the movement of the finger and thumb, but only limited by the length of the arm pivoting from the shoulder.

When drawing in this way the beginner naturally finds that the arm, being unused to it, and unsupported, quickly tires. But practice soon cures this, and as the muscles become inured to the work it becomes the most natural and the easiest way of all, as it is the most serviceable.

By adopting this method, the student acquires a free style of drawing from the beginning, and it is the one that he must always employ when doing work on any considerable scale. It is better to stand than to sit because it encourages the student to step back and review his work from time to time, whereas, if comfortably seated, he might be reluctant to do so. A moderately high stool, on which he can work, half seated, half standing, is permissible and affords a certain amount of support, but on the whole, if he is young, it is better for him to depend on the strength of his own hind legs.

The great thing is to avoid sitting in a cramped, stooping attitude, which is bad in every way—bad for the back and eyes, as well as for the drawing. If seated, the student should still have his paper almost upright and work at arm's length, the only exceptions being when he is drawing on a small scale or in his sketch book, and even then he should always keep his head well away from his work.

The use of the mahl stick should never be permitted under any circumstances, as it defeats the main object in view, which is to make the hand independent of support of any kind. The use of the mahl stick encourages the cramped attitude with its limited field of action. The student is again adopting the writing method, which he should endeavour to get away from.

At arm's length then, with a piece of charcoal or chalk, or a blunt lead pencil, let him practise his exercises. Let him draw straight and curved lines, in every direction, with a sweep of the arm, until he can do them firmly, fluently, and accurately. It is quite a useful practice if the master occasionally draws some simple design or flourish on a blackboard with white chalk, and the student with a moderate sized clean brush tries to efface the chalk line with one steady, continuous stroke of the arm. This is equally beneficial for both eye and hand, and the faults will be apparent from the quantity of the original chalk line which remains untouched.

Another good practice for the training of the hand is for the student to draw a firm clear line over a prepared faint outline, or to make tracings of good outline drawings, always with the arm extended. At first, these may be done slowly and carefully, but as the principal object of these exercises is to train the hand to guide the point of the pencil unhesitatingly, the student should be gradually encouraged to do it freely and quickly. The lines he is to draw being already indicated on the paper, he can see exactly where his pencil ought to go and should soon learn to make it follow any given direction with unerring certainty. For the purpose in view this is better than copying, for until he can be sure that his hand will do exactly what his eye directs, and can with certainty trace an outline over one that is already there, it is unlikely that he will be able to copy one correctly.

Copying from the flat has, too, certain advantages, one of which is that faults can be pointed out and proved by actual comparison with the original, and in a way that is impossible when drawing from the living model.

Many uninformed people are inclined to question the usefulness of copying from the flat, but to those who have had much to do with elementary teaching the advantages are obvious, and indeed where the originals are good, it is far more instructive at first than drawing from the round.

CHAPTER III

Perspective and the rendering of solid form

WHEN looking at a landscape from any point of view, the horizon is always level with the eye of the spectator. If you climb up to the top of a hill, the horizon seems to mount with you. If you descend to the valley it is still level with your eye. When designing a picture, therefore, the placing of the horizon is one of the first things to be considered, and its position entirely depends upon the height from which the subject is supposed to be seen. No matter what the picture represents—whether it be an indoor or outdoor subject—or if the horizon is visible or no, its place in the picture must be settled before anything else is done, because all perspective calculations are based upon it, all *horizontal lines* leading into the picture terminate somewhere on this horizon and all that are parallel go to the same point. Those at a right angle with the picture plane go to the point of sight, i.e. the point immediately opposite the painter's eye.[1] Those at other angles to different vanishing points which are often outside the limits of the picture but always on the horizon.

Another point to be considered is the distance at which the artist should be from his subject when painting. If too near, the objects look distorted, those in the foreground being too large, and others beyond diminishing too rapidly. A close-up photograph of the front view of a horse, for instance, although it may be perfectly correct, will look as long as a Dachshund. Occasionally the artist is obliged to be too near, especially when painting indoors.

Often one goes into some old stable or cowshed and is charmed with the effect and lighting, and the mystery of it all, with the animals and figures, old beams and accidental arrangement, and thinks what a grand subject it would make. But where is one to stand with one's easel? Frequently there is a wall at the end which prevents one's getting back, and one feels that another six feet would give all the room required. The wall cannot be removed, so, rather than give up the subject, you stand against it and make notes of the construction, the placing of the animals and so on, and, when you get home, with the help of your notes, your memory and your perspective, you proceed to make another sketch, in which you imagine yourself to be that extra six feet away. You can then carry on with your picture, returning to the stable as often as you like for more facts and more information. A large canvas you cannot

[1] *For further study of this subject the reader is referred to* PERSPECTIVE *by Rex Vicat Cole. New Art Library.*

26

take with you, but you can make colour notes, diagrams, written notes, and all the manifold aids to memory which will enable you to revisualize the whole subject at home.

You will probably find that there is some time in the day when the stable is empty, and you can arrange to have one of the principal animals tethered further up, in somewhat similar lighting, where there is more room and where you can make a more careful study of it, or even work on the picture itself, revising and simplifying it afterwards from your other sketches. But the knowledge of the elements of perspective will enable you to construct your picture, not only so that it looks right, but so that it would be right if that wall were taken away and you had seen it from further off.

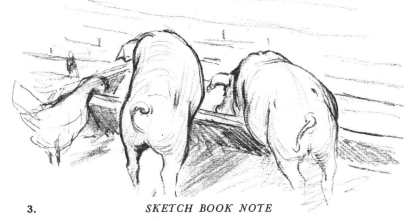

3. *SKETCH BOOK NOTE*

Now the distance at which the artist should stand from his subject is that from which he can comfortably take in the whole of what he wishes to include in his picture without having to turn his head. When painting a landscape it is not a bad plan, having decided upon the subject, to put two long sticks upright in the ground to show you the lateral boundaries of your picture plane, then walk backwards until you see your subject framed as you wish it to be between these uprights, and place your easel there. This should ensure your getting the prominent features in their right places on the canvas.

Elaborate architectural subjects, interiors with ornamental paving or intricate roof construction, and similar problems, require a greater knowledge of linear perspective than is needed by the *plein air* artist, most of whose sketches from nature should be approximately accurate if he is a fairly good draughtsman.

As a matter of fact, when painting direct from nature, even where buildings are introduced, it is seldom that the artist, knowingly, thinks about perspective. If he be a good draughtsman, everything should take its proper place and be perspectively right, without any specialized knowledge.

If his study is " in drawing," the perspective will be correct. It is, however, when making use of the study and in its adaptation to the purposes of his picture that the student will find some knowledge of perspective useful, as it will enable him to make the necessary adjustments if, as is so often the case, the horizon in his picture happens to be at a different height from that in the study, or as in the instance quoted he was standing too close to his model when making it.

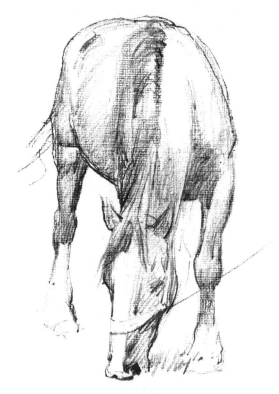

4. *SKETCH BOOK NOTE*

Every picture is an optical illusion, for the artist has to represent on a flat surface his idea of various concrete objects in relief at different distances from one another, together with their accompaniments of colour and atmosphere. He has to suggest depth, space and light. Everything he deals with is seen and depicted in perspective. He has to make believe that he is showing you a scene through a frame—hence the term " perspective " from " *perspicere*," to see through. The illusion does not end with the representation of the principal group which provides his subject; it must be complete from end to end and from top to bottom of his canvas. This, then, is where painting and sculpture differ. Painting is illusory—sculpture, for the most part, actual.

The sculptor's energies are chiefly devoted to the realization of form. His group is independent of background and that additional contrast which, in a picture, is produced by the inclusion of secondary figures and objects, and of colour. His work has to be seen from all sides. Every view presents a different problem, and each point of view has to be dealt with in relation to the others. If he makes a change in one place, he has to see that it does not jeopardize the composition when seen from somewhere else. But the painter considers his work from one fixed spot, and can, therefore, alter it at will, and to suit that point of view alone. So it will be seen that the sculptor has to overcome quite as great difficulties as the painter, but difficulties of another kind. When dealing with figures in the round he is able to correct or test his proportions by actual measurement from the model. This the painter can only do to a very limited extent. For instance, if representing an animal in exact profile, he can roughly test its measurements horizontally and perpendicularly, but this is all. A foreshortened view he can only measure very approximately, owing to the fact that it is in perspective. He has to give the appearance of his proportions being correct. He can never make them so, or they would be wrong pictorially and perspectively.

The sculptor has no concern with either linear or aerial perspective, nor with atmospheric conditions or colour variations of any kind. The principal figure or group in a picture should have the appearance of being solid, rounded and modelled—in fact of being real, but all the things beyond and around it (although only the setting, so to speak, of the main group) ought to be reproduced as faithfully, and in their proper tone relation. The whole must be treated as one composition, of which every part has its relativeness, each its important bearing on the other, with some special duty to perform in completing the illusion.

In life nothing is exactly the same for two minutes together; the model tires. If it is a horse and it rests a leg, the whole balance is upset, and the whole pose immediately changes. If a man, he also tires, and in his endeavour to ease the tired muscles his position and equilibrium change, and although, to the unobservant, it may not seem to make much difference, it is quite sufficient to mislead the beginner and makes absolute and definite comparison with his drawing impossible.

When drawing from still life or casts, or from the " round " as it is called, although they do not move there are still many things to puzzle and distract the novice. The student himself is apt to move so that he gets different points of view at different times.

To prove this he has only to look at a group of small objects on a table, first with one eye and then with the other, when he will see that even with each eye he gets a different view—with the left eye he sees more of the left side, and vice versa with the right eye. Again, if he moves nearer the table he sees more of the tops of things and less as he moves

back, so that perspective has to be considered from the moment he begins to draw from real things.

For the present, our main object is to keep clear of every other department but that with which we are immediately concerned, which is the correct imitation of definite and unchangeable things, which can be actually compared with his drawing.

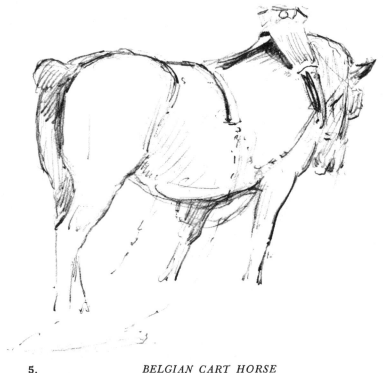

5. *BELGIAN CART HORSE*

Every drawing representing solid, tangible form, is of necessity a translation, not an exact imitation. The mere fact that the artist is representing on a flat surface things in space, in which there are no actual lines for him to copy, means that he must first reduce his subject to a formula that is capable of being transferred to his paper. He must make a mental outline of his picture before he can draw it. He must know why he selects certain edges to translate into lines and ignores others. He must know why he begins a line in a particular place and why he ends it where he does; why he draws a broken line here and a continuous one there.

Shading. As in an outline drawing we at first use straight lines to express the general shapes of things, so, in a shaded drawing we must learn to see our subject as a combination of flat planes before attempting to deal with the modelling of the surface forms.

By drawing in this way we see our subject devoid of all modelling—ugly, archaic, but solid and strong.

By learning to see the way the different planes face, we are able to understand the basic problems of light and shade—each plane is indicated with definite edges, and each one is of an almost flat tone of a

6. *SKETCH BOOK NOTE*

different value from its neighbour, from which it is easily distinguished.

If when representing any concrete body we accustom ourselves to look for the planes and straight lines and leave the rounding off and modelling until later, we are more likely to get virility and solidity into our work than if we think of our subject as consisting of curves and rounded forms from the beginning.

When representing any concrete body, we can understand the light and shade and render it much more accurately if we can first reduce it, in our mind's eye, to a thing of which the surface is made up of flat planes and facets.

If, for instance, we take an apple, it is difficult to reproduce its shape because of the subtle way in which the different tones merge into each

other. If, however, we carefully remove the peel with a sharp knife, we find that without materially altering the shape, we have a surface consisting of innumerable more or less flat planes, each one of which is a separately visible item and differently lit from its neighbours. This enables us to appreciate how the light and shade tones vary, and we see that it depends upon the angle at which each part is placed in relation to the source of light.

Planes. An outline represents visible edges, so lines can be used to express the boundaries of different objects as well as the visible edges of their several parts.

In the case, however, of rounded forms—of which there are so many in nature—where there are no dividing lines between the tones, the artist must himself determine where he can use lines, the variations of light and shade by which nature reveals herself being often too subtle. He must therefore analyse each separate part to understand in which direction each one faces.

If he imagines, after dividing it up, that each separate part has been flattened, he then in his mind, sees these round forms as planes facing in different directions, and this analysis should enable him to realize (rather brutally) its conformation and make it easier for him to render it intelligibly.

Modelling. There is no better way of learning to see planes than by modelling.

In modelling the actual surfaces are copied, and if this is done intelligently, the student cannot fail to realize the directions in which the different parts face. The front of a thing is actually the front, both in his subject and his own model; the back is the back, the top, sides and underneath all actual representations, and not perspective interpretations on a flat surface, as in drawing or painting.

He learns the form in this way and renders it in a tangible manner, and he will find, when reverting to his drawing, that this lesson, having taught him what the *actual* shape is, will enable him to render it with greater precision.

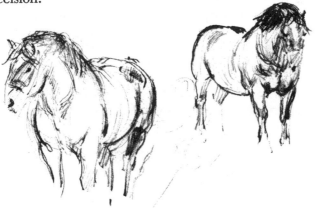

CHAPTER IV

THE MAKING OF SKETCHES & STUDIES

THE ultimate success or failure of a work of art entirely depends upon how it is commenced. The first half hour as a rule decides its fate. As soon as the main features are in their right places and rightly proportioned, the artist may take up his brushes and palette and proceed.

The first few lines settle the pattern, and no matter in what manner or in what medium it may afterwards be carried out, they constitute the basis of the whole structure. If they are inartistically or carelessly indicated the work starts on rotten foundations, which no amount of subsequent care or skilful execution can ever counteract.

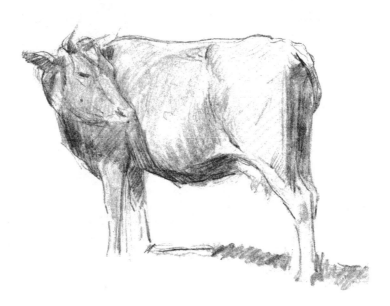

8. *COW LOOKING BACK*

The first thing, then, is to set out on the canvas a simple plan of the subject, which can be reviewed and amended without the feeling that some subtle details (which should not yet be there) will have to be sacrificed. It is the greatest mistake in the world to allow oneself to become so enamoured of a particular part as to feel any compunction in rubbing

9.
CHARCOAL DRAWING
The type of drawing an artist might do before taking up his brushes and beginning to paint.

it out should it be found to be wrong or to interfere with the conception of the design as a whole.

Every work of art must be regarded from a broad point of view and considered as a unit and not as a disjointed collection of items which have to be combined by an after process. In order to retain this broad view, we should make up our minds in the early stages rigorously to exclude all supplementary details and ornamentation, and to preserve the utmost simplicity of treatment until the whole subject is built up and every feature of it is right as regards the other features—rightly placed, right in proportion and rightly conceived.

10. *RAPID NOTE OF ACTION*

The main features should be blocked in squarely and frankly. The simplest kind of drawing is outline drawing, and the simplest line of all is a straight line; let straight lines therefore be used whenever they will serve the purpose. Nature's subtle curves and gradations are very beautiful, and we must try to render them with all their grace and all their beauty, but this must be done at the right time, and we must remember they are only the embellishments of the structure and not the essence of the structure itself. We must first address ourselves to the consideration of the crude form over which the ornaments are to be distributed, after which the work can be completed and elaborated without running the risk of losing sight of the structural essentials.

The kind of drawing every student should try to imitate is that which an experienced artist would consider to be necessary to put on his canvas before commencing to paint. That is to say, a slight simple drawing, containing all the fundamental elements, properly placed, spaced and proportioned, without details or particularities of any kind—nothing but the suggestion of the bare unadorned facts. They should never use two strokes where one will do, and they should avoid the very bad habit, which is so common, of aimlessly going again and again over the same line without having any definite purpose in view. If an important line is wrong it should be corrected at once; if it is right it should be left.

The finest drawings and paintings are always those which are expressed with the least circumlocution. A good work of art always gives the impression that the artist knows what he is doing; that it is a truthful representation of what it professes to be.

The grandest subjects can be indicated with a few simple lines, and from a few simple lines every picture must be built up.

Something in nature suddenly arrests the attention of an artist. It stimulates his artistic sense, and he experiences a thrill which other people may not feel. If he has his sketch-book he scribbles some lines and writes a note or two, and then shuts his book up, but not before he has registered a few facts to act as a reminder to enable him to re-visualize the scene. When he is at leisure he may ruminate over them, and they may possibly be the foundation of a picture.

What are the lines he scribbled in his notebook? On examination they will be found to be those that in his opinion were mainly responsible for the thrill and for the unaccountable effect produced on his mind, which compelled him to try and reveal it to the outside world.

Obviously, then, these are the lines which we must first learn to see and to draw.

In the course of a lifetime the author has filled many hundreds of sketch books with very rough and very indifferent sketches, private notes made when thinking out the designs for pictures, nature notes, records of ideas, and so forth. Most of these, however, have been destroyed as they were far too bad and untidy to show to anyone.

Each sketch had some definite purpose—it was either an attempt to learn something, to work out some scheme of composition, some preliminary trial for an alteration that seemed desirable in part of a picture, or else some quick record of action or grouping. Each book was a record of part of the author's life, and whenever looked at afresh a reminder of some subject or effect seen long ago and long since forgotten.

The different features of our subject are not all defined, but are blended and interwoven in a way that makes it impossible to isolate them. It is not an easy matter to decide where one stops and another begins, or which to include and which to leave out. The best way to settle the question is to ask oneself if it is of prime importance—will it

help in any way to elucidate any great truth? If not, its inclusion can be deferred to a later stage.

In capable hands, with the merest inflection of a line, things can be suggested in a way that renders all further realization unnecessary, and it is the power of putting meaning and expression into every line that denotes the true artist.

" In all things that live there are certain irregularities and deficiencies which are not only signs of life but sources of beauty." No painting or drawing can be scientifically exact in every respect, but it should always give the impression of truth. It is the little accidents and irregularities which give so much charm to a work of art, the broken quality of a line, its vibration, its variety, these are what give vitality to a drawing. It is in the way the pencil is applied to the paper, in the way the artistic temperament of the individual expresses itself, that so much depends.

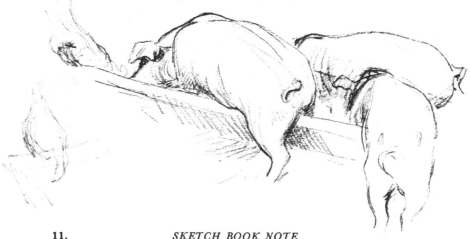

11. *SKETCH BOOK NOTE*

A good line is the essence of a good drawing. A good line is one that has meaning. There can be no meaning without knowledge. *You can't make a line mean anything unless you know what you intend it to mean.*

To be able to express actual form by a few simple lines requires quite as much artistic skill and quite as much knowledge as to make a tone drawing or a painting. In the former case the artist has to give a condensed but lucid impression of his subject—an intelligible suggestion— whereas in the latter he actually imitates the lights and shadows that he sees—he copies what is in front of him and tries to render the different tones and colours as they are.

Line drawing is in itself a very beautiful branch of graphic art, and being less complicated and laborious than shaded drawing, is particularly suitable for making rapid studies, such as an animal painter requires.

By examining some of the simple drawings of the great masters the student will realize what beautiful results may be obtained by these very simple means, and how the slightest drawing may be a great work of art. *These are the drawings to copy.*

The best lesson a student can have is to watch an experienced draughtsman make a simple outline drawing from nature. In that way

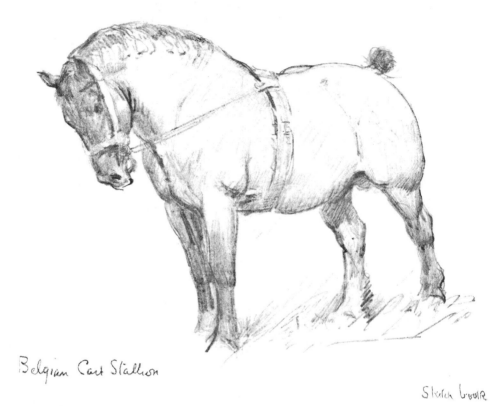

Belgian Cart Stallion

Sketch book

he is able to see how he begins, how he proceeds, and what he looks for. The next best lesson is to copy such a drawing and try and remember how it was done. There can, of course, be no hard and fast rules; each artist has his own method, and each one has some reason for everything he does.

A very careful study in which every part, every value and every colour variation has been carefully understood, examined and accounted for will make a far more lasting impression in the artist's mind, will teach him more and be much more useful to him in the hereafter than the most brilliant slapdash. There is no better method of studying form than by making searching drawings in line. The point of the pencil is

the best investigator. It is easy to do clever drawings if there is knowledge behind, but it is a very superficial cleverness that results from uninformed observation.

Whenever making actual studies from the life, the student should endeavour to produce the most faithful imitation possible. No attempts should be made to idealize them. The artistic feeling should be subjugated to truthful accuracy of representation. These studies should be made with one of two definite objects; either to learn the subject, or else for the purpose of making a record—a working study—which shall be a reliable reference. If the student makes a habit of indulging his artistic fancy and thinks that to make a telling drawing is of more consequence than an exact copy, he will find, when he wishes to make use of it, that he has recorded too much of himself and not enough of his subject, and that the study, brilliant as it may be as a work of art, and pleasing on account of its suggestiveness, will not serve him as a guide to the facts so well as a painstaking and perhaps somewhat overwrought study would.

If the study be made for exhibition purposes with no ulterior motive that is quite another matter. Here the artist is entitled to present it as he likes, to leave out, modify, alter or idealize at will, just as he would be justified in doing if he were painting a picture. But it is seldom that an artist makes a study for this purpose, or admits that he does so.

When one sees an exhibition of studies one likes to feel that they are the sincere attempts of the artist to realize something, and that their purpose was either for his own instruction or else to be used as guides and memoranda when painting his pictures. If we feel at once that they were always intended for exhibition purposes and nothing more they lose half their interest.

Such work usually lacks the sincerity that attaches to utility studies and appeals to the uninitiated and the connoisseur in proportion as it reminds them of the handling of greater masters of bygone days. When, however, we look at the drawings of such masters as Leonardo da Vinci, Raphael, Pisanello and others, we find that the style we admire so much is the result of the painstaking study and careful analysis of whatever they drew, and we feel that they were absorbed entirely in the faithful reproduction of their subject for their own private use, and that when they were engaged upon them they had no thought of their being publicly exhibited.

They are doubly interesting when one is able to see the pictures for which they were used and to understand what care was taken to leave no stone unturned in their search for truth. Their studies were always done as a means to an end and never as the end itself.

Very often in our schools we find students who develop an extraordinary facility for making striking drawings, which, in most cases, is the outcome of a sincere desire to learn and to reproduce faithfully their

models, and it is evidence of exceptional executive skill. Once, however, having acquired that specious accomplishment and having tasted the sweets of success in the shape of the praise of their fellow students and professors, they are only too apt to rest on their oars, and to think more of making clever-looking drawings than of improving their knowledge.

Facile workmanship, because it carries with it greater immediate recognition, takes first place, and the acquisition of knowledge, the second, and that, in my opinion, is why so very few of the best students—the little gods—of our Schools of Art ever make any lasting names for themselves. Almost invariably, those from whom most was expected have turned out failures, and the plodders, who have continued their labours almost unnoticed, have eventually come to the front.

CHAPTER V

DRAWING FROM LIFE

WE are often told that the figure school provides all the training that is necessary for the art student, whatever branch he may eventually determine to follow. Figure painters tell us that it is quite unnecessary for him to have any special training in order to become an animal painter. With this point of view I entirely disagree. In a good figure school, the student will, doubtless, learn how to draw and to paint from a model that keeps reasonably still for a given time, but he will have no idea how to proceed when the model is in active movement.

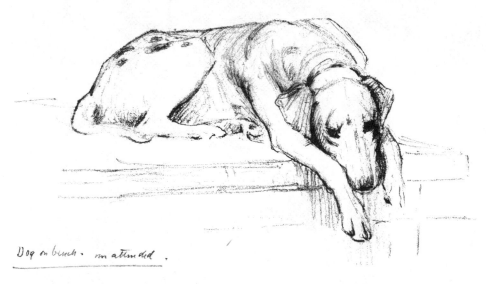

Dog on bench. un attended.

An animal painter has to rely on his memory far more than a figure painter. He never knows how long his model will remain still in one position, but he does know that it will probably be only for a very short while, and then perhaps never again. He can never set to work in the same composed manner as the figure painter, who knows that if his model changes the pose he can tell him so and put him right again. When the human model tires he can rest and again resume the position, so that the artist can carry on from day to day, knowing that whenever his model comes again he will be able to take up the original attitude.

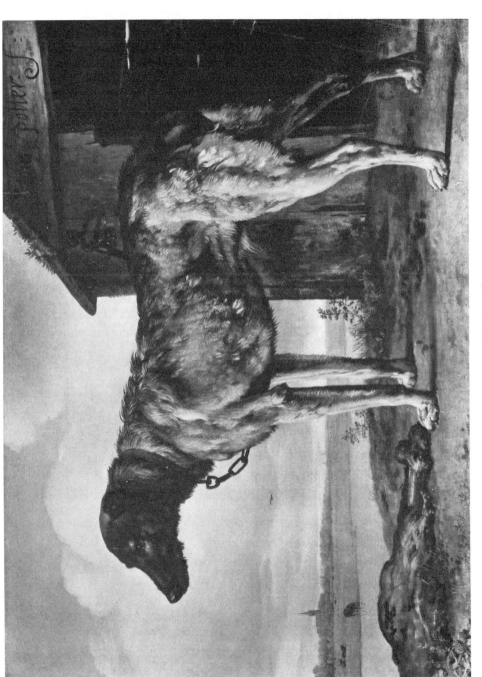

14.　　THE WATCH DOG.　Paul Potter

An excellent study of a dog—well drawn and painted with fine texture.

This can never be the case with an animal. A horse, or a cow, or a dog, may be kept in the same *place* during the sitting, brought there again, but otherwise it must be left free to stand, sit, or lie down as it likes, and it generally takes advantage of this freedom. *An animal can never be posed.*

This should not discourage the young animal painter who must learn to profit by the alterations of position; and instead of trying to do a set drawing of a dull, uninteresting pose in a dull uninteresting way, he should provide himself with a large piece of paper and make a series of studies upon it. Each time his model moves, he should begin a fresh one; he will find that, in the course of the sitting his model will frequently revert to former attitudes.

If these beginnings are all on the same sheet, work can be resumed on any one of them at a moment's notice. In this way the student learns far more about the construction of his subject and produces more lively and interesting work than is the case when he goes on plodding at something with the idea that he is making a finished drawing.

The art of making quick and accurate outline sketches is, for the animal painter, perhaps of more real ultimate use than any other form of drawing. It enables him to hit off a pose, to obtain records of animals and groups of animals in the shortest space of time. From these outline sketches, if they are good, he is not only able to revisualize the original subjects, but if he has a good knowledge of their construction he can supplement their deficiencies. A five minute sketch will often provide the motive for a large and important subject.

Careful deliberation and concentration are necessary if the work is to be expressive, but time should not be wasted on unimportant details. What is wanted is a clear statement of essentials and nothing more.

When first beginning to work from living animals, it is best to obtain as quiet a model as possible and to make drawings from every point of view. A horse is a good model for the beginner. It does not often lie down and, therefore, the number of its positions is limited, and except for the fact that it is always inclined to rest its hind legs alternately and to adjust its fore-legs in conformity, there is very little movement to worry the artist. His principal trouble is caused by the horse changing its direction, and this is very annoying, especially when he is doing a foreshortened view. We may, with the assistance of a capable groom, get a horse to stand fairly still for an hour or two at a time in the same place and under the same conditions of light and shade.

Dogs are more trying, because it is very difficult to prevent them lying down and curling themselves up in a heap. Sometimes one is fortunate enough to get a dog that will stand up fairly well for a time, especially if there is someone who is able to look after it and can keep it interested.

Any smooth-coated dog with a good figure makes a satisfactory model, be it mongrel or thoroughbred. For general practice there is nothing

better than a fox terrier; being white, it is easy to distinguish the form and there is nothing misleading about its shape or proportions. It is best, however, to draw from different types in order to learn how the same features vary in different subjects.

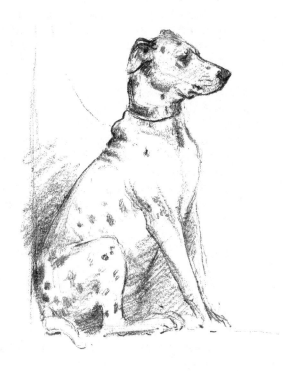

Dalmatian

15.

When representing a particular breed the student must first make himself familiar with its peculiarities, and in order to be able to appreciate these he must have some standard to go by.

As a typical example of shape and proportion, I would choose the Alsatian. It is strong and active as nature intended it to be, and it has not yet acquired any fashionable malformations. And when studying anatomy, there can be no better subject than a greyhound, through whose fine skin the bones and muscles can be identified and whose graceful lines so well express speed and agility.

Making pages of pencil drawings of every conceivable attitude and of every part separately will teach the student more about the construction than anything and will be an immense help to him when trying to under-

stand the anatomy of the large beasts of prey, especially if he can analyse his studies as I hope the later chapters of this book will enable him to do.

For that sort of work, figure school training should, up to a point, suffice, but unless the student is content only to paint animals at rest, he must adopt entirely different methods from those to which he is accustomed when working from a human model.

It is the power to memorize alone which enables the painter to depict animals in action, or fleeting subjects of any kind. When painting a picture where there is any movement, or indeed any life, he must be able to trust his memory. No artist can paint a sky, or any subject where the effect is continually changing unless he has a good visual memory. He can support his memory with notes of shape, of colour, of light and shade, &c., but these notes must of necessity be often very hurried and in many respects very incomplete. His memory, however, will supply their deficiencies and enable him to revisualize his subject afterwards.

Every touch applied to the paper is an effort of memory—that is to say, we look at our subject and then rely on the memory while registering what we have seen. Each memory effort is of short duration, but the memory can be trained gradually to retain impressions for longer and longer periods, until finally it becomes capable of recalling and reproducing quite complex subjects with extraordinary faithfulness, even after a considerable interval of time.

All animal drawing and painting must be memory work, even though a model is there all the time.

By practising memory drawing we learn to realize the essentials and to minimize the smaller details; whereas, when copying from a stationary model, we are more apt to dwell equally on the significant and the insignificant.

The following few hints may be useful to students. They were the means I usually adopted when trying to arrange models for my own students to work from.

As regards horses in the studio, I invariably drew a white line on the floor to indicate the direction in which the animal was to stand. I always had a capable groom at its head, whose instructions were to allow the horse as much liberty as possible, with the one proviso that it was to be kept as nearly as possible on the chalk line. It was to be allowed to rest its legs whenever it liked, and to have a free head.

I used to point out to my pupils that they were to look upon the model as something to refer to and examine, and not to be slavishly copied.

A student making but one study or painting would, as a rule, be expected to make some preliminary notes as to the best pose to choose, and once having decided upon one to adhere to it, no matter what other attitudes the horse itself adopted. Even though the animal might seldom be in exactly the right position, there would always be some part of it that would be approximately right.

When making drawings, and even sometimes when painting, I always recommended them to have two if not three going at once on the same sheet of paper, i.e. one standing at attention, the others with the opposite legs resting. This is especially important when doing foreshortened views, because, from that point of view, when a leg is resting it alters the whole swing of the pose, and there is very little to carry on with when waiting for its resumption.

Every opportunity should be seized for making careful pencil drawings of limbs and parts of limbs—heads, necks, nostrils, ears and eyes, &c., &c., which is the only way of learning what they are like, and it has the advantage of impressing them on the memory as nothing else will do. This method then, aided by such explanations of the construction of each part as I could give, as well as hints on proportion, &c., formed an important feature.

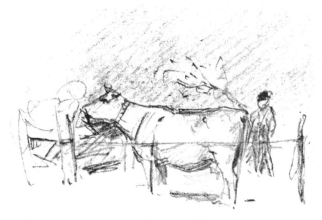

16. *COW MODEL*
A boy with a branch to keep off the flies and plenty of food.

When dealing with cows, I have occasionally had some difficulty in persuading farmers to let me have these animals as models. They generally told me that it would worry them and interfere with their milk production. I have, however, been fortunate enough to be able to overcome their objections in most cases, and at any rate have been allowed a trial.

I generally selected a shady spot and had the cattle fastened to a crate that was full of hay or fresh cut green food. Sometimes I had a small box placed on the ground in front of the crate in which were a few pieces of oilcake as a tit-bit to start upon. This I found always resulted in the animals hurrying up to their places and quietly submitting to be tied up.

A light cord tied to the crate by one end and to a stake in the ground behind the cow, sometimes one on each side, was the means employed

for keeping it in the right direction. The cord was always tied to the stake with a slip knot that could be instantly released if necessary. Finally and most important, I always had a boy with a long leafy branch to keep the flies away, disentangle the animals when they got mixed up with the ropes and so on, with the result that in nearly every case the farmer has told me that his cows had benefited by the treatment and that there had been no shortage of milk.

I adopted this plan for a great number of years on farms all over the country at which I held my outdoor classes, and never had any accidents. Sometimes I dressed the cattle with preparations to keep off the flies, but I always found the boy with the branch best.

17.

I always looked for a crate, but failing that have tied my cattle to trees, gate-posts, fences, waggons, &c. with equally good results.

Again, students do better work when they have two or three studies going on at the same time. After a cow has eaten its fill it invariably lies down and not always on the same side; this necessitates two canvases. On the other hand, a cow does not rest its hind legs as a horse does, so one canvas generally does for the standing pose.

When arranging for students to make studies of sheep, small calves, &c. I found the best plan was to get some sheep wire netting (old and discoloured for choice so as not to catch the eye) and to have a pen made of from ten to fifteen feet in diameter[1] in an orchard or other secluded

[1] A similar pen on a smaller scale answers very well for keeping ducks, geese, &c. within range, and it is an advantage when it can be placed on a mound or slope, so that when standing one does not look down too much on the birds; in fact it is always a good plan to have some old wire netting handy for caging birds, &c. out of doors.

shady place, and to turn three or four animals in with some tempting food to make them feel at home.

Around this pen we could sit or stand and work in comfort. When one of the models moved away another would most likely very soon take its place, if not, a student could always begin a fresh drawing on the same sheet of paper, and so continue until by the end of the sitting he would probably have made a considerable number of reliable studies, each one of which would have taught him something and would serve as a record for future use. Sometimes one would be fortunate enough

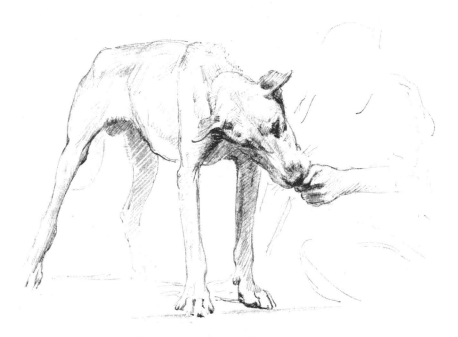

18. *PUPPY KEPT QUIET WITH GINGERBREAD*

to find that a picturesque old apple tree could be enclosed within the pen around which the sheep would group themselves, and so provide a delightful motive for a picture, and one which there was always a reasonable chance of being repeated, and given fair weather, under the same lighting conditions at the same time of day.

For dogs I have found the best plan is to put them on a table and tie them up by a lead that must not, however, be long enough for them to jump off and hang themselves. Then, having decided whereabouts the model is to stand and in which direction, get a friend or someone to sit in front of it at some little distance to engage its attention.

At the School of Animal Painting, which I conducted for many years in London, I had for a considerable time a most excellent lad who had

the knack of managing dogs, and was able to keep their attention for quite long periods.

He generally provided himself with some ginger-nuts or something equally savoury and messy, the bulk of which he kept wrapped up in a piece of paper in his pocket. He would hold one small piece in his hand and just let the dog get a lick at it from time to time. If, after a while, the dog got disgusted with struggling for a taste and threatened to lie down, he would regain its confidence by opening his hand and letting the dog take what was there. Then perhaps he would put his hand in his pocket and rustle the paper, which nearly always had the desired effect, and the dog would stand and watch his pocket for ten minutes or a quarter of an hour at a time. As soon as it became the least bit disinterested he would rustle the paper again, and so on, and at the end of the sitting generally gave the model the lot. This procedure seemed to amuse both the sitter and the boy, and enabled students to make some very good drawings of the standing position.

For this particular job I preferred a dog of the greyhound type as it shows the form, and not being heavy was not always wanting to sit down.

I generally had at the same time two or three other dogs on separate benches against a long wall, to which each was attached by a lead. These would be allowed to lie down or stand as they pleased. A good plan is sometimes to give them a large bone to gnaw; it keeps them awake and generally results in some very interesting attitudes.

With little fluffy dogs it is very difficult to do anything. If you can get them to play with a ball or something, you may get the suggestion of a pose, after which the only thing is to keep them in sight and hope for the best.

With cats, kittens, puppies, rabbits and so forth, the only thing one can do is to put them in some place in a good light, from which they cannot escape. For this purpose I had one or two cages made, with a plate-glass front and a wire lid, and a piece of matting or sawdust on the floor. These could be placed anywhere on rough tables, and one or two students could work in comfort at each. I have used them also for a tame fox, small monkeys, parrots, &c.

I found with cats, a few pennyworth of fish produced good action— in fact, food is what most animals like and the best way to make them like you.

Of course, these suggestions might not all be very popular in some homes, and it must be left to the discretion of the student to decide how much his own particular family will put up with. But they, or some of them, may be found useful to other Schools of Animal Painting, should they ever be started, or in those schools where classes are held on this subject.

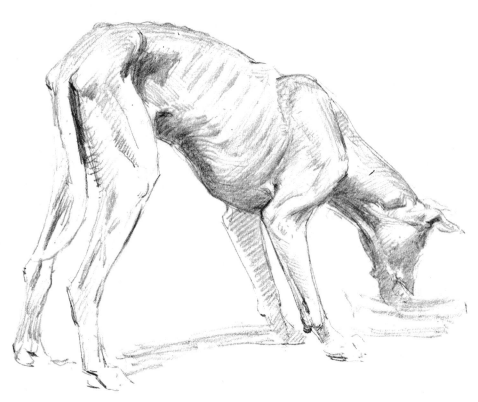

Starveling having a feed. (*Rudolphia*)

CHAPTER VI

ANATOMY IN RELATION TO DRAWING

ANATOMY is the " art of dissecting or artificially separating the different parts of an organized body, to discover their situation, structure and economy." Now, an animal painter's chief difficulty when consulting anatomical books is to know what to ignore and how to set about his investigations without becoming too deeply involved in matters that are irrelevant.

He should avoid diving deeply into scientific veterinary books, which contain much more information than he is likely to require, and which, moreover, deal as a rule with the subject from the surgical point of view, which is not that from which the artist should regard it. He should know sufficient anatomy to enable him to account for the external appearance and general shape and movements of the animal concerned. The shape depends primarily upon the bony structure, and therefore the first thing is to try and understand how the bones are situated in the body and where they come to the surface and are recognizable. It is by the identification of the parts which show on the surface that the artist is enabled to realize the exact positions and directions of the bones themselves.

Variations in the conformation of different animals are not due to different bones and muscles, but to different development of the same bones and muscles, which accommodate themselves to the varying conditions of life and the duties they are called upon to perform in the great struggle for existence. It is therefore no more necessary for the student to make a special study of the anatomy of each species than it would be to make a special study of that of the different breeds of dogs. If he is familiar with the anatomical construction of the horse and the dog it should suffice. His intelligence and powers of observation should enable him to apply it to any other animals he may wish to represent.

The giraffe has a long neck, so that it can reach the leaves of the trees on which it feeds, yet there are precisely the same number of vertebræ in its neck as in that of the guinea-pig or the elephant.

We all know that if one set of muscles is continuously and regularly exercised it increases in bulk and strength. In course of time the bones to which they are attached accommodate themselves to the extra work and they too become changed in shape and size.

On the other hand, if for want of employment muscles cease to func-
tion, they diminish in size and again the bones conform. In some
instances both bone and muscle disappear altogether, although generally
they leave some trace behind, which can be identified as a rudiment of
the original structure.

We have witnessed many changes in the conformation of our domestic
animals, some due to the demands of fashion, but mostly to utilitarian

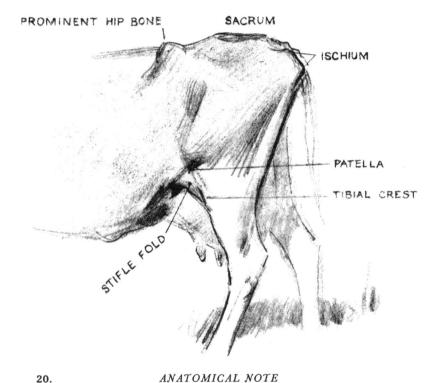

PROMINENT HIP BONE SACRUM

ISCHIUM

PATELLA

TIBIAL CREST

STIFLE FOLD

20. *ANATOMICAL NOTE*

requirements. Horses are bred for draught, for racing, hunting and so
forth; dogs for sport of different kinds, or as ladies' pets; cattle for
milking, for beef, or for both and in some countries to work on the farms;
each of its own kind developing some special features which distinguish
it from the others and fit it for its particular job.

In this way, and by the selection of those animals having the particular
characteristics desired, different breeds have been established.

If then, with man's help, such changes have been effected in a com-
paratively short time, it is not surprising that nature in her own time
should have produced the endless variations which we now see, each one
of which has developed those characteristics which enable it to live and
protect itself in its own sphere. (" Forms now perfectly distinct

descended from a single parent form.") The marvel is that their anatomy has not changed more.

From the foregoing remarks it will be seen that it is not necessary for an artist to make a special study of the anatomy of all the different animals he may wish to paint, but that he should endeavour rather to grasp the main principles upon which all animals are constructed.

Often one may succeed in getting from nature or from memory a good suggestion of action or attitude which, however, it is impossible to

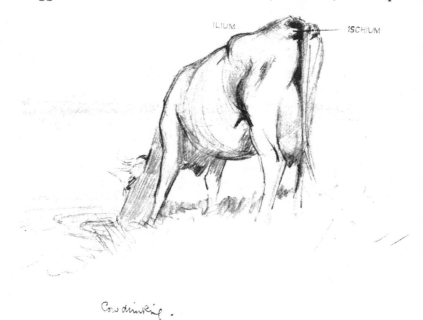

Cow drinking.

verify or correct from the model. Knowledge of anatomy will enable the artist to analyse his study and to prove his facts, and this knowledge will also help him to interpret his studies when engaged in working from them.

It is futile to attempt to draw animals without knowing something of the general principles of their construction. Ignorance in this respect leads to the introduction of excessive detail and consequent muddled technique. The artist should be able to identify at sight those important structures which are common to all animals, and to differentiate between the movable parts and the more stable bone-forms of the trunk. Certain parts of the principal bones are subcutaneous, and therefore can be readily found on the surface, and most of them correspond in different animals.

Personally I do not believe it is either necessary or advantageous for an art student to dissect. He should think of his subject always as living, moving nature, and my own feeling is that the best way to study anatomy

is to examine the living subject, and with sketch-book and pencil try to analyse the visible form. Let the student make clear pencil outline or very slightly shaded drawings, indicating all the conspicuous features that attract his attention. Let him try to realize which are bone and which are muscle, which parts move and which parts are fixed, and then, with the aid of his anatomy book, let him try to understand what are those outstanding features which he has noticed.

From the model we can get colour, surface details and so on, a suggestion here and a suggestion there. In the case of a horse or a dog we may get a limb held in position for a few minutes, or a head kept more or less in the right place. With wild beasts, however, we can only make drawings and colour notes of various parts, which must be done more with a view to our becoming thoroughly familiar with them than with any notion of copying them again directly on to our picture. These studies will serve as reminders when painting the picture, and the more of them and the more thorough and truthful they are the better. The greater the knowledge of anatomical construction and mechanism, the greater will be the use to which these notes and studies can be put.

Let us imagine an artist who wishes to paint a picture of two wild beasts fighting. Obviously he cannot paint such a picture direct from nature. Before he can even make a rough sketch of what he proposes to do, he must be familiar with the chief characteristics of the animals, and the ·sort of attitudes they adopt. Furthermore, he must have enough anatomical knowledge to enable him to indicate the approximate places of the principal structures; he must know where the limbs are attached to the body and the degree of movement that can take place in different parts. In other words, he must have some knowledge of the fundamental construction of his animals and of their actions before he can hope to make his preliminary sketch.

Such a subject as I have suggested is perhaps one of the most difficult that any artist could be asked to undertake. Some there are, however, who like to attack difficult subjects and to overcome the difficulties, others do not. But, granted imagination, patience, perseverance and some knowledge of the fundamental anatomy, the difficulties are not insuperable.

Personally, in such a case, I should take every opportunity of watching dogs and cats at play and make rapid memory notes of their different actions, which I should always analyse anatomically to make sure that they were properly constructed. I should not hesitate even, if opportunities occurred, to take photographs of them and to analyse these; in fact, I should leave no stone unturned that would be likely to assist me to attain my object. I should try and learn all I could before embarking upon my picture, and then having determined my composition, I should make a rough model of the main group in wax or plasticine.

In my opinion, every animal painter should practise modelling as a

Rough Sketch of a picture I painted many years ago of the dog 'Gelert' killing the wolf. Suggested by an Irish Wolf Hound and another large dog at play.

means of learning the actual form. In a model, every region has to be accounted for, no part is hidden by another, and however roughly it may be done, if all the different regions are properly placed and proportioned and the salient features crisply defined, the painter will always have before him something in concrete form to which he can refer and which will be of the greatest assistance to him in rendering the foreshortened parts.

The reader will, by this time, appreciate some of the reasons why a study of anatomy is absolutely indispensable to the would-be animal painter.

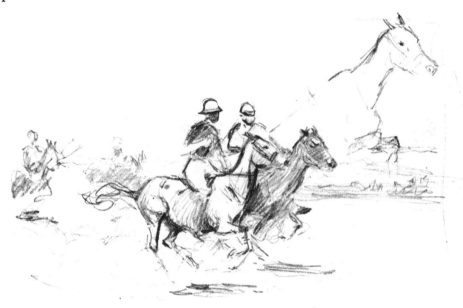

Notes of action — Malta 1926 sketchbook?

23.

CHAPTER VII

MOVEMENT

The Centipede was happy quite
Until one day the Toad—for fun—
Asked her which leg went after which,
Which brought her mind to such a pitch
She lay distracted in a ditch
Considering how to run.

PHOTOGRAPHS of animals in various actions are invaluable as a guide to what actually takes place, for the eye unaided and untaught cannot grasp accurately rapid movements of animals and birds. With the help of the camera the different movements and their sequence can be studied at leisure, but having learned from them what is possible, what impossible, the student should go to nature for his impressions, for no single instantaneous photograph really gives a correct impression of what can be seen with the naked eye. The exposure is far too rapid, and as a matter of fact, only gives a record of a phase reduced to a stationary pose.

As an example of this, let us suppose that an instantaneous photograph is taken of a wheel revolving. The light is good, the lens is good, and if the exposure is very rapid all the spokes will be clearly seen, but it will not give any impression that the wheel is revolving. The better the photograph, the more is this the case. I have in mind some remarkably clear photographs taken by a friend of mine in Egypt. Of these he was extremely proud, and no wonder, for every detail was in focus, and as clear as if they had been taken with a time exposure. Some were of galloping horses in the desert—and of these I distinctly remember how clear the little clouds of sand were, they looked to me like sponges, some sticking to the horses' hoofs, others suspended in midair—but each one a separate, definite, tangible object, which one felt one could take hold of and carry away. There were others of men diving, and in these the disturbed water looked like solid glass. The spray, quite definite and solid looking like isolated globules of water, clearly defined, hanging in the air, and looking as if they could never come down. No accidents, or blemishes, and no movement whatever, it was all so clear. Finally, there was one of a bazaar, with innumerable figures moving about, all in suspended action. People standing on one leg and off their balance yet absolutely petrified. In fact, it was for all the world like a crowd of inanimate people, who had been posed to represent different actions, but the stillness of it all was oppressive.

57

The photographs were too good, the lens was too good, the light was too good, everything was too good, with the result that none of them gave the least idea of movement. All the figures and animals were in positions the eye is not accustomed to see.

Now if one takes up that wonderful book *Muybridge Animals in Motion* and examines the various representations of different animals, one finds very few attitudes that the naked eye is accustomed to see. By studying the different phases in sequence one is able, however, to form a correct idea as to how each movement is performed. The one thing that stands out clearly above all others is that nowhere is there to be found anything to account for the old rocking horse attitude, which has been such a favourite pose adopted by artists in the past to simulate a galloping horse. In our childhood we believed our rocking horse represented a horse galloping, and so strong is the impression received during childhood and such faith do we then have in our early instructors, that a wrong impression received at that time is very difficult to uproot.

In each stride of the gallop a horse makes one unsupported transit with all four legs flexed under the body.

This phase lasts for approximately one quarter the duration of the stride. *The legs are never simultaneously outstretched in front and behind* as in Gericault's well known picture of " The Derby of 1821."

Even that consummate artist and anatomist, " George Stubbs," seems to have paid little attention to the horse's action and makes unaccountable mistakes in his representations of the gallop, canter and walk.

There are, I think, many who nowadays criticize freely, but have never themselves learned to see, and as the rocking horse of the nursery gave them their original idea of the gallop, so in their later years do the *petits chevaux* of the gaming saloons continue the tradition.

The only time I can remember to have seen a living animal in an attitude that suggested an instantaneous photograph was on a sunny afternoon when I was walking near some houses. These threw the roadway entirely into shadow with the exception of one or two narrow shafts of sunlight that came between them. A greyhound I had with me was lagging behind and I called her. As she came galloping towards me, she was almost invisible in the shadows, but as she passed through the shafts of sunlight she was vividly illuminated and the photographic attitudes were clearly revealed. She passed them in a flash and disappeared again into the shadow, but the impression left on my mind was not that of an animal in rapid motion, for she did not appear to move at all, but seemed to be momentarily arrested in one of those attitudes in Professor Muybridge's series of photographs of the galloping greyhound. It was indeed instantaneously registered on my brain in the same way that a photograph is an instantaneous record on a film.

Confusion of Phases. The particular phase of the action was isolated and not confused with any other. *It is the confusion of phases and the*

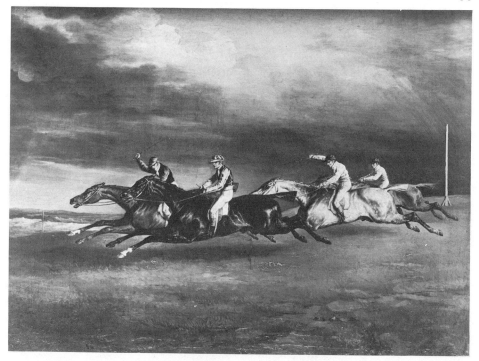

24. *THE EPSOM DERBY, 1821. By Géricault*

A horse's four legs are never outstretched in front and behind simultaneously. There is only one unsupported transit in each stride, during which none of the feet touches the ground. But it is important to note that all four legs are then flexed beneath the body. They are never, in actual fact, in the rocking horse pose familiar to the older artists.

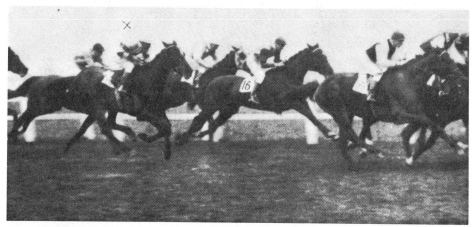

25. *No. 16 has one foot on the ground, i.e. the near hind, but it is very indistinct and confused with the fore legs of the horse beyond, which must not be mistaken for part of the hind leg of No. 16.*

Plate 26 makes the position of 16's near hind quite clear. The horse on the left marked with an X has all four feet off the ground and is in the position noted above.

26.

confusion of the moving limbs with the ground and background which in a picture gives the idea of motion—as soon as we isolate and distinguish those things which the rapid movement prevents us from seeing, we cease to give any idea of movement at all.

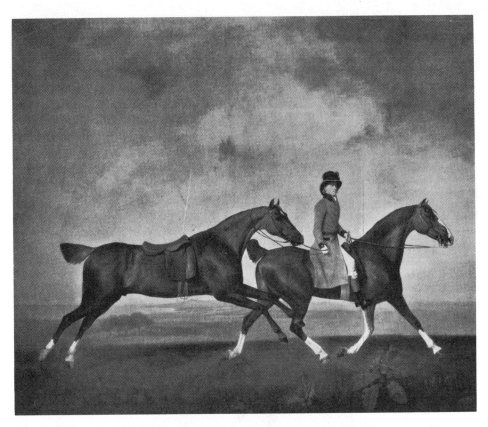

27. *TWO ROYAL HORSES AND ANDERSON, THEIR GROOM*
(40½in. by 50½in.)

From the picture at Windsor painted by George Stubbs in 1793. Reproduced by gracious permission of His Majesty the King.

When we learn that Stubbs studied the action of galloping from dead horses suspended in his studio, we are not surprised at the results. The leading horse is trotting correctly—whether the other is supposed to be galloping or cantering it is wrong. In either of these gaits if the horse is entirely unsupported the legs would be flexed under the body.

We cannot leave a blank where the legs come, but we must be very sure that by over definition we do not draw attention to facts which could not be seen.

In a horse galloping we are conscious of a knee or a hoof, as momentarily it stops and its indication becomes necessary. Great care must then be taken to indicate it in the right place. In the gallop the

limbs move too quickly to be seen, but we can distinguish the shoulders and quarters of a horse, and from these we are able to form an idea

28.
Attempt to represent ponies galloping, from memory, after watching a game of polo.

where approximately the legs belonging to them should be, and the photographic investigations being available there is no valid reason for doing the impossible with regard to action.

29. *NOTE OF ACTION. SKETCH BOOK*

Although the rapid movement may prevent our distinguishing the limbs, we are undoubtedly conscious of some of the sunlit parts as they momentarily come into view.

CHAPTER VIII

THE CONCEPTION OF A PICTURE

" THERE is nothing more fearful," says Goethe, " than Imagination without Taste."

I am often reminded of this when visiting some of the galleries where the very latest fashions in modern art are displayed, and where neither taste nor skill are very much in evidence. Some of the pictures indeed are quite incomprehensible, and one stands before them bewildered and amazed.

Sometimes they are explained in the catalogue, and sometimes, a kind stranger, seeing your perplexity, will come forward and offer to enlighten you as to the artist's meaning, and tell you what the various smudges on the canvas are supposed to represent.

I always feel very grateful for this assistance, but at the same time very much humiliated to think that unaided my eyes are incapable of seeing, or my mind of understanding from the pictures themselves what they are about, and I feel inclined to ask, " Is the motive a suitable one for pictorial expression? " After all, I argue, painting is a universal language by means of which an artist conveys his thoughts and ideas to the whole world, and the man of average intelligence should be able to read what a picture says without the aid of an interpreter. A picture is not like an acrostic—a thing to be solved. To paint the picture and express his ideas is the puzzle which the artist must himself solve, and the answer should be shown on his canvas. The picture should not be the puzzle but the *solution* of the puzzle.

However much some of these problem pictures are open to ridicule, and however badly some of them are done, it behoves us, before condemning them, to try and find out what, if anything, is at the back of the minds of those who produce them. I always say to myself, " There must be some reason for this kind of art although it is not apparent," and I endeavour to find out what it is. Generally, I think, it arises from a very praiseworthy desire for reform, and as a protest against some kind of art that has become wearisome. Or else, it comes from a desire to bring forward new ideas and new theories about painting. Their object, I think, is not so much to produce fine art, as to encourage modern painters to explore new waters, instead of continuing to wallow in the mud of the old familiar channels. If I am right in my surmise, the

motive is distinctly a good one and an entirely warrantable attitude for a pioneer to adopt.

Art, like any other branch of knowledge, requires stimulation; it cannot be allowed to stagnate but must either go forward or backward. Great things have been done in the past, and there is no reason why greater should not be done in the future. In art there are always fresh fields to conquer and countries to explore, and anything that has the power of making people think, does good service to the cause.

For a long time, art in this country had practically stood still, even if it had not actually a backward tendency, and there was an atmosphere of self-satisfaction about it, as if the goal had been reached and there was nothing beyond. Year after year our galleries were crowded with a mass of mediocrity. Many of the pictures were very similar in character and motive—overwrought paintings of the same models and the same studio properties and animated by the same mawkish insipidity and cheap sentimentality were served up again and again, until everyone became satiated with them and was glad to welcome anything which tended to encourage new lines of thought and put some enthusiasm into the minds of those who claimed art for their profession.

Since then, new movements have come to the fore and are tumbling over one another in their eagerness to attract notice. The originators are for the most part sincere in their aims, and although many of them are unpractical idealists, their protests have undoubtedly done a vast amount of good. They have made artists think; have made them also realize that there are perhaps more unexplored regions than they were previously aware of, and even if comparatively few are as yet capable of expressing their ideas intelligibly, others, with more practical skill, are exploiting them.

The communication by means of pictures of any ideas, whether old or new, is entirely dependent on the power of the artist to express them in paint; so that the finest imaginative faculties are (pictorially speaking) utterly wasted unless supported by even greater powers of expression.

Every new movement attracts a great number of imitators. But the unfortunate thing is that the majority of them imitate only the bad qualities of the workmanship and fail to appreciate the underlying motive in the mind of the originator.

My advice to students is to study well each new movement with unbiassed minds; to seek out what is good in it, to learn all they can from it and to exercise their own judgment about it, but, at the same time, they should not neglect the study of the great masters of the past, whose works have stood the test of time, nor forget to profit by the lessons which they also teach.

* * *

In the conception of a work of art a vivid imagination is required. No two people receive exactly the same impression from the same scene, but he who has the keenest sense of beauty and the most imaginative mind will produce the finest picture, always assuming that he has the talent necessary for its successful execution. Many people go about apparently blind to nature's charms. A poetic mind will often be inspired by the most ordinary material and will invest it with a beauty unsuspected by others; some passing atmospheric effect or a sudden gleam of light may have been the means of its revelation, but for which it might have escaped the artist's notice and have remained unrecorded in his mind.

It is this power of receiving impressions and of retaining them that is of such inestimable value and that separates the true artist from the mere copyist; it is the secret of all success and originality of conception, and every artist should cultivate it. Knowledge is the great fertilizer, and a vivid imagination is the result of having a fund of knowledge and ideas stored up in the memory. " The mind is like a trunk; if well packed, it holds almost everything; if ill packed, next to nothing."

The student should, therefore, always be on the look out for the beautiful things in both nature and art. Everything we imagine is derived from things we have seen, and no picture is intelligible to others that does not consist of things which they can recognize. Every opportunity should be seized by the student to fill his mind (and his sketchbook) with every sort of material that may be of use to him. In the presence of nature he should always be on the alert, not merely contenting himself with looking at her, but always studying, analysing, and trying to account for all the charms she reveals to him, for it is only by those means that he can hope to conjure up again clearly the forms and effects which have impressed him.

An animal often appeals to an artist by reason of its colour and the way in which it harmonizes with the rest of the subject—or because of its character—whereas, to the owner and breeder, its beauty more often than not depends on its likeness to some stereotyped or artificially created pattern, just as with dress, the beauty of which seems to depend on fashion.

Is the foxhound more beautiful than the greyhound, or the setter than the Great Dane? Each has its own particular points which make it beautiful of its kind.

For beauty in the abstract, however, there can be no standard, and the artist will often see more beauty in an old carthorse than in a thoroughbred. So much depends on the conditions under which things are seen. Colour and light will produce effects which will make anything look beautiful. It is not so much the things themselves that matter as their environment and their setting.

Before beginning a picture it is not a bad plan for the student to write

a short and rather precise description of what he proposes to do. In a few words he can express what he had in his mind when his subject first occurred to him, which will not only help to stimulate his imagination, but will afterwards prevent him from deviating from his original plan of action.

Such a note, giving particulars of the general scheme, lighting and colour effect, with the weather conditions and any other features of which he has a vivid and definite idea in his mind's eye, should be written before he has begun making any preliminary sketches. This will often prevent his going off at a tangent when new ideas crop up, as they invariably do when one is engaged upon a design; and especially if one starts vaguely making sketches without having any really definite impression of the final form the picture is to assume. Before beginning any composition it is most essential to have a perfectly clear idea of what it is to be, and advantage should be taken of any means that can be employed to register that idea at the earliest possible moment.

Let us suppose in the course of an evening stroll we have come across a group of cattle among some stunted trees by the river bank. The effect of the sinking sun, and the general feeling of peacefulness, has for some reason we cannot explain seized upon our imagination, and gives us a feeling of pleasure we cannot define. We are arrested in our reverie by the little group near the water, and are seized with a desire to make a picture of it. On a blank half sheet of a letter we make a few hurried notes, part diagrammatic, part writing, indicating the places, positions of the more prominent animals, and their relation to the trees and background. We write a few hurried remarks such as *russet ground, greenish tree trunks—foliage indefinite, warm colours—sky reflection cool—trace of sunlight on edges of some of the cattle—sky rosy, purplish towards the horizon, a few soft clouds—horizontal clouds, distance, delicate bluish pearly grey, tinged with rose,* and indeed any remarks which seem apt at the time. A note of the principal masses of dark and light, and so forth. On getting home we pull out the untidy little scrap of paper sketch or scribble as I would prefer to call it, and are able more or less to revisualize it. Probably there has not been sufficient time, or it did not seem of sufficient immediate importance, to notice whether the trees were alders, willows, thorns or what not, but we have a note of their general shape, as seeming to be inseparably connected with our subject, and a record for future use. The animals were not particularly well bred, but their broken and varied colours harmonized so well with their surroundings that it did not seem to matter, nevertheless we proceed to evolve a picture from a scrap of paper, and we lay it in on a canvas, broadly and simply, in the meantime perhaps having revisited the spot for some further information, &c., &c. It would not improve the picture or add a halfpenny to its artistic value were you now to set about changing the cattle, and instead of keeping the rough broken coloured

half-bred animals, which seemed to fit the subject so well, were to intro-
duce a group of symmetrical pedigree beasts. Indeed it would spoil the
whole picture by distracting the attention. The people who would be
delighted with the well-bred beasts would not be those to whom your
first and finest conception would appeal. They would be the people
interested in the cattle alone as cattle, and would judge them as such
and not as part of a pictorial poem. To them the picture would be the
cattle. They would not appreciate the things that go to make up an
harmonious picture, but assuredly such a deviation from the original
impression would only ruin its effect.

Finally, the picture has to be a complete harmony of colours and
tones, bounded by four straight lines, and all this, though done with
pigments on a flat surface, has to convey the impression to the spectator
that he is looking at solid and tangible things and on into space, under
whatever conditions of weather and effect the mind of the artist chooses
to imagine.

The eye has to be led into the picture, right away into the farthest
distance, unconsciously it may be, but naturally carried from one object
to another, and yet the *raison d'être* of the picture must never be over-
looked. The picture must tell its story. The eye must be compelled to
look at the principal features, and this without unduly forcing them, or
treating them as if they were a different proposition from the rest. The
whole must be united, as it would be in nature, or the illusion fails. This,
then, is one of the things which the student should always bear in mind :
that, in order to destroy the real character of the painting—the fact that
it is a flat perpendicular surface—the eye must be conducted inwards.
The length of a picture is limited: its perspective depth is infinite.
This is one reason why it is so difficult to render artistically animals in
profile. A portrait of a horse, for instance, in absolute profile—which is
generally the way in which people want them represented—does not
lend itself to pictorial treatment. The eye naturally follows the direc-
tion in which the animal is standing, which quickly brings it sharply up
against the edge of the frame.

The same objection applies to a processional subject treated in profile.
The ends are cut off and always give the uncomfortable feeling that it
is painted by the yard.

Unless, therefore, the subject is so broken up as to nullify the effect of
its being in profile, it is difficult to connect it naturally with any back-
ground, which therefore generally has the appearance of a second
picture, behind the first one, like the drop scene of a theatre.

CHAPTER IX

COMPOSITION

Design—Restraint—Sketches for Composition

THE art of composition, by which is meant the pictorial arrangement of the material of which the picture is composed, is of the first importance, and as soon as the student has acquired some aptitude in the use of the pencil he should begin trying to put his ideas in pictorial form, but this, being essentially a matter of feeling, cannot be taught by any positive methods.

Acquaintance with great works of art, combined with constant practice, is the surest way of obtaining proficiency. No definite laws of composition can be laid down. In the early stages of a student's career, they would only have the effect of confusing his mind and preventing his work having that freedom of expression which is so desirable.

There are certain conditions pertaining to good design which the student should know about, but these should be gradually imparted in the way of friendly advice or suggestion, rather than as part of a code to be followed implicitly.

Instinct tells us how to plan our pictures, and we pick up ideas and increase our powers in this respect by examining other pictures, by the exchange of criticism, and by friendly argument with our brother artists.

A student should accept criticism willingly from one who has technical knowledge and experience. It is the best lesson he can possibly have, especially if it is given in a friendly spirit and with a view to helping him out of his difficulties. When a picture won't come right, nothing can be of greater help than the candid criticisms of an experienced painter who can appreciate the situation and tries to see the picture from the other man's point of view. If, however, he be one who wants to revisualize and reorganize the whole subject, his criticism has only a discouraging effect, without being at all helpful.

The first consideration in any work of art is the subject, the character of which depends entirely on the personality of the painter.

Having settled what it shall be, he must visualize it in his mind before proceeding to put anything down on paper. Some artists have a more highly developed power of visualization than others, but in no case, I think, does it go beyond a vague suggestion, in which the prominent features and general effect alone are clearly defined. In the mind's eye there is no definition beyond this, and no indication of where the picture

shall begin or where it shall end. It is not seen as a rectangular com-
position, in which the principal group occupies a particular position, but
is simply an impression of certain outstanding features, in perfect
harmony with their surroundings, which fade away as they recede from
the centre of attraction.

It is here then, in the first visualization, that the artist perceives how
much of his subject is of real importance, and what is to form the pre-
dominating feature of his picture, and all his energies must be devoted
to giving effect to this predominance.

30. *NOTE BOOK SKETCH*

It is much the same when working from nature. The artist may find
a subject that attracts him and of which he would like to make a
picture, but he cannot set it down exactly as he sees it. Nature presents
a never ending panorama, consisting of a series of different subjects of
varying artistic interest, but all forming parts of a united whole. When
we try to single out one of these subjects for the purpose of making a
picture and try to disconnect it from its surroundings, it is often difficult
to know exactly where to place the dividing line; how much of this
never ending series is to be included and how much to be left out. We
single out something of outstanding interest, which happens to excite
our emotions in some particular way. Having seized upon this which is
our subject, we place it in what we consider to be the most commanding

position on the canvas, and then proceed to deal with the surroundings, and, as it were, to decorate and furnish the rest of the canvas in sympathy with it. In doing this we cannot always—nor indeed often—just go on painting what is in front of us and introducing the various objects as they happen to come, for we have to consider them in relation to our subject.

The artist's range of vision for the purposes of his picture is limited. If he extends it by reducing the size of his subject matter, so as to include more of the surroundings, his picture becomes trivial and scattered and the interest divided. He must, therefore, adjust the outlying objects to suit the requirements of his subject, and these must be dealt with as belonging to the subject, instead of, as in nature, being merely a stepping-stone to something else.

A decorative painting rather differs from a picture in this respect, that it often forms part of an ornamental scheme in an architectural setting, in which it is desirable to lead the eye from one panel to another.

A picture should arrest the attention of the spectator and keep it; a decorative panel may be intended to lead the eye on to something else.

The artist should, at first, try to register the outstanding character-istics of his principal group and the general idea of his composition. By degrees, and possibly after many futile attempts, he will succeed in pro-ducing a rough sketch containing all the main points of his original scheme in a more or less definite form. If he has not yet evolved a com-pletely satisfactory design, he will, at any rate, have a reminder, which will serve as a jumping-off place for his next effort.

The pattern and colour are the first essentials in design. By nine people out of ten a picture is judged before it is even examined, and unless the first impression strikes the spectator in such a way as to invite further inspection it will often escape notice altogether.

The placing of the subject on the canvas, its colour, tone, balance, rhythm of line and general harmony are the things upon which the artist must rely for making his initial appeal. If these are successfully com-bined, his work is bound to attract the notice of people of taste, who will then take the trouble to examine it. Afterwards it must depend on the excellence of the workmanship to rivet their attention and to continue to excite their interest.

No matter how beautifully individual parts of a picture may be painted or how exciting a story it tells, if the pattern and general effect fail to draw the attention at first sight, there must be something amiss with the composition.

Standing in the middle of a picture gallery, it is curious how one picks out half a dozen canvases or so at the first glance and is impelled to go and inspect them closer. Very often one is disappointed with the execu-tion and passes on, but when one finds that the impression improves with

closer inspection and that the execution is as good as the design, the picture remains in the memory as a masterpiece.

So, before thinking about the drawing and painting, the artist should have a clear idea in his mind of the pattern and general effect he wishes to produce. Nothing else matters at this stage.

Now, in this effort to invite the notice of the public and to create the good impression, the student must be careful not to do anything that will debase his art. To call attention to his picture is not the sole object in painting it, but it must excite admiration by reason of the excellence of the craftsmanship and other fine artistic qualities as well.

The motive for a picture is not the same as for a poster on a hoarding, which may shriek and howl so long as it compels people to look at it. It advertises goods for sale, and if the goods are not of prime quality the advertisement soon disappears from the hoardings and is forgotten. In the same way, if a picture only succeeds in drawing attention to itself and does nothing more (the goods being inferior) its lease of life is short and it, also, is soon forgotten.

Means which may be perfectly legitimate in advertising are to be deprecated in the case of pictures which are intended to live, and of which posterity must be the final judge.

All obvious attempts to attract notice are vulgar and undignified in a picture, as in a person, and the genuine artist will prove himself by the sincerity and moderation of his work. By purposely adopting some peculiarity of manner, some trick of design or execution, which becomes a sort of trade-mark, an artist does himself no good, for, although it may procure him a certain amount of publicity for a time, as the novelty passes away this soon disappears.

Trying to attract attention by choosing clap-trap subjects to arouse controversy is another cheap way of obtaining notoriety and is also to be discouraged.

The young painter should start his career with the determination that he will be known by the excellence of his artistic achievement alone, and that the quality of his work shall be his only advertisement.

In the early stages of settling the composition of his picture, he should think of it only as a monochrome, and aim at producing the best black and white effect that he can. At this stage fine form, the general shape of things, the effective balance and contrast of the masses, the depth of tone, relative values and all those things which can be translated in black and white and which have a direct bearing on the pattern of the picture are what he has to concern himself with; for although, as I have said, good colour is one of the very greatest, if not *the* very greatest attraction in a picture, colour by itself represents nothing, and it is only as the medium with which form is expressed that it has any part to play.

Every part of the picture will eventually be represented in colour. All the time the artist is composing his picture he will be thinking of it

as in colour; but, in this preliminary stage, he will only need to attempt the representation of the value of those colours, their relative depth and lightness, and of this he can best judge when he sees the whole effect in monochrome.

Having made a small monochrome sketch, if the pattern and general effect satisfy him, he should proceed to make a sketch in colour. The general arrangement being already settled, he will be able to give his undivided attention to his colour scheme, and proceed with more direct-ness and sureness than would have been possible if, at the same time, he

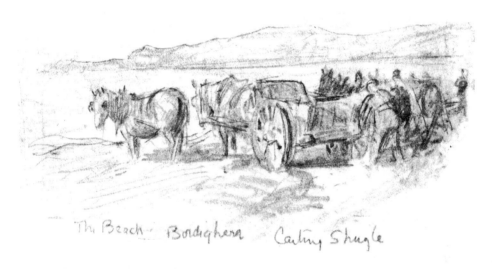

Th Beach — Bordighera Carting Shingle

31.

was thinking of shapes, balance, etc. His monochrome will give him an idea of the depth his colour is to be, and how it is to be disposed, and if he can so combine his colour scheme and the pattern in a small, freely treated sketch, the painting of his picture, however large, should after-wards be comparatively plain sailing; the great thing being to have a definite memorandum of the main features of the composition as a guide before proceeding with the more ambitious scheme.

No trouble should be spared in trying to foresee all difficulties that are likely to crop up, and to know how they are to be dealt with, instead of leaving them to chance when the picture is in progress.

Though all this may seem a somewhat laborious method, it not only saves time in the long run, but permits of the final work being done freely and confidently, and it saves all that muddling about on the picture (the result of uncertainty) which is so detrimental to good paint, and is in-variably the cause of the colours becoming muddy and sticky.

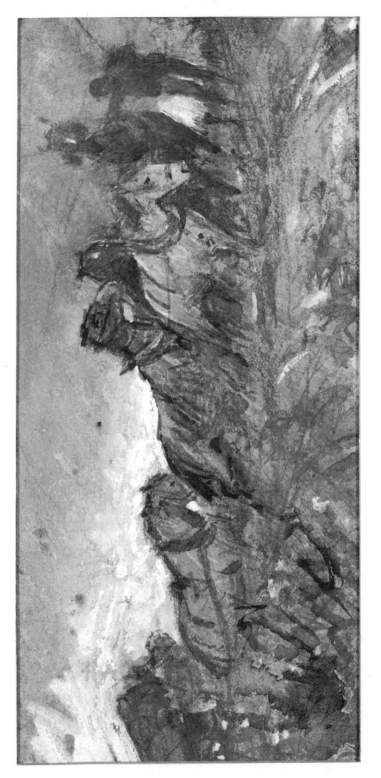

32.

COMPOSITION

Preliminary sketch on which the large picture " The Crest of the Hill " was founded. (Exhibited in the R.A. 1898 & bought by the National Gallery of Queensland.)

A composition sketch should be as broad and simple in effect as it is possible to make it. There should be no attempt at elaboration and no finality about it. The colour should be restrained and harmonious, and, to ensure this, very few pigments should be used. The simpler the palette the greater the harmony will be; and the less realization of details, the more scope is left for the play of the imagination. These sketches are useless to the painter unless they suggest more than they reveal, and, once insignificant details are dragged into the limelight, and ultra-delicate subtleties of colour insisted upon, what was intended for a slight sketch becomes an inferior picture. All the vitality, as a rule, disappears and, with it, its usefulness as a stimulant to the imagination and an incentive to the powers of invention. Constant practice in making composition sketches in colour, *if subjected to frequent expert criticism,* is of very great value, for it not only improves the faculty of designing, but it gives confidence to the student and helps to produce that facility of expression which it is so important he should acquire, and, as the technical powers of drawing and painting improve, so will these sketches become more complete and convincing.

A composition sketch may be very rough and very slight, yet, if it is well composed and has fine colour it can be a very beautiful thing and, from the hands of a master, a great work of art. The fact that it is but a mere suggestion of a thought allows of it being done quickly, with the result that it often has a charm of indistinct expression and indefiniteness which few finished pictures possess. There is often a charm about incomplete sketches and first thoughts of great painters, which is seldom excelled in their completed works. This appears to be principally because so much is left to the imagination, salient features only being insisted upon and secondary facts but lightly hinted at, even if not omitted altogether. A first sketch is often right, in that it just gives the necessary emphasis to those things which are really essential and ignores all else. A large sketch, however, seldom, if ever, has those qualities in the same degree as a small one, the reason being, I think, that in a small sketch the artist does it straight away, probably in a few minutes, and is only trying to make a record for future use. To the intelligent spectator who is able to look at the sketch from the artist's point of view, it will have the charm of anticipation. It allows play to the imagination, which is exactly what every good picture does.

But making sketches is not the one and only aim of the artist, and students must always remember that they are doing theirs for a definite purpose, and as the means to an end. They should never, therefore, allow themselves to be tempted to forsake the substance for the shadow.

A comparatively poor workman may succeed in making an effective sketch. Constant practice will produce a certain facility which, when combined with a good eye for colour, ensures the production of something attractive.

Some artists have a natural sensitive touch, and their personality appears in everything they do, and even though, from want of knowledge, or lack of training, their work may be full of faults and open to technical criticism, yet it always possesses a charm and distinction that appeal to people of taste and discrimination.

Frequently, however, it fails to satisfy the professional expert, who, while able to enjoy to the full the precious, personal qualities, and to appreciate the artistic feeling displayed, feels that there is something more required to make it a really great work of art. The technical defects, which are unnoted by the ordinary cultured connoisseur are very obvious to the professional in his judgment, and detract very considerably from the artistic merit of the work: good material, but untrained.

Very much the same things occurs, I imagine, in music. A man may have a beautiful voice, but, never having learned to produce it, may sing execrably. The beauty of his voice may charm the uninstructed, but to the professional his singing would be anathema. A good voice or musical ear will not go far without education, neither will an artistic nature and a good eye ensure success to the painter if he neglects to educate and improve them.

A slick sketch often looks cleverer than it really is, especially to the uninitiated, and for this reason many young artists run away with the idea that serious study is unnecessary. But it is one thing to make a good sketch on a small scale, and quite another to paint a large picture in the same way.

It often happens, of course, that an artist feels suddenly inspired—perhaps at the sight of a large, clean canvas in his studio that seems to be waiting to have something painted on it. He rushes at this canvas, so to speak, and straightway gets out his colours and revels in the first stages of a great design. All probably goes satisfactorily at first. He thoroughly enjoys himself and possibly produces a fine dashing impression of his group of animals, or whatever was the dominant feature of his conception, and goes to bed full of hope and anxious to get again to work on the morrow.

To-morrow comes. He resumes his work in the same feverish state of excitement. The group of animals is all right, and he proceeds to put in a background. To this, however, he has not given as yet much thought, and everything he suggests seems to interfere with yesterday's group. When at length he has got the canvas covered, he begins to feel his animals look weak and want strengthening, and then, the first excitement having somewhat abated, he begins to get critical of his performance, discovers a leg too short here, a neck too long somewhere else. Faults of construction begin to assert themselves everywhere, and each in turn he endeavours to rectify, with the result that by degrees, as he improves the drawing, the freshness, the virility, the spontaneity disappear, and his enthusiasm fades away.

Much that was there at first and was so promising, has gone and cannot be recovered. It was perhaps good and suggestive, although not quite right.

The fact is, the canvas is too big to be treated as a sketch, quickly done and left at that. How much better it would have been to have made a preliminary sketch on a small scale, when he received the inspiration, and kept it as a guide, with all its faults. It would have also many charms which are inseparable from the work of an artist who feels inspired to do something for the pure love of his art, one who is fascinated by the subject which his imagination has conjured up.

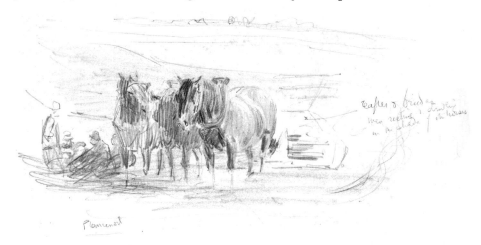

Planuenol

Such a sketch every artist should make as a reminder, whenever the spirit moves him, but it should not occupy much time—an hour or two, or the inside of a day at most; no more time should be spent upon it, or the original conception fades. Remember it is a sketch, and, although by a master craftsman such a sketch may be a great work of art,—and very frequently is,—it is not a picture in the sense in which I am speaking, only a prelude to something else, and in the case of any artist who is less than a genius, the faults would probably outweigh the charms and it would be of no great value except to the artist himself as a means to an end,—the painting of his picture.

Painting a Picture. Many think that the finest picture is the one that looks most like a sketch and, to a certain extent, that may be so. A picture should be done with the same apparent ease and be equally full of suggestion, but to achieve this on any considerable scale requires an amount of knowledge and expert craftsmanship far and away above what is needed for a small sketch. Not only must the artist have great technical skill and a thorough knowledge of every department of his art, but he must be able to apply his knowledge and skill without obtruding it, and this, perhaps, is the most difficult problem he has to face.

CHAPTER X

*Rhythm—Balance of light and shade—Relative scale of Animals and
Landscape—Colour—The vision " cut out "—Foregrounds*

LET us briefly consider some of the conditions attaching to good composition.

In the first place, the story must be told with eloquence. It must be
set forth in a pleasing manner, logically and clearly expressed. It should
never have the appearance of being composed. All obviously composed
pictures look formal and artificial. The greatest artist is the one who
conceals his art and whose work seems to be done without effort.

All the different parts should be blended together and united by means
of rhythmical lines, gradated tones and harmonies of colour, so as to
produce one united whole.

Whatever the subject, there must be some point of supreme importance, in the realization of which everything of a subsidiary nature has
its part to play in arousing and maintaining the spectator's interest.
Through all the various and secondary features the eye must travel until
it finally rests on the principal part of the picture.

A broad, simple painting always rivets the attention of the spectator
and is infinitely more pleasant to live with than one that is overcrowded.
It may be embellished and enriched by contrasts and by the introduction
of variety, but the variety and the detail should always be subordinated
to the unity of the design.

Unity and variety go hand in hand. Not only must all the different
parts of the picture be rhythmically joined but they need variety to
explain them and to make them interesting—variety of colour, variety
of form, variety of light and shade, variety of surface and variety of
treatment. Every object considered by itself is a separate unit, having
its particular duty to perform in the general scheme, and it must be
explained; but no more detail should be employed in the explanation
than is absolutely necessary to make it intelligible. If unduly elaborated
the breadth of the picture is imperilled, and by emphasizing the things
of lesser consequence the artist sacrifices the unity of his picture.

In dealing with each separate part he must always bear in mind its
relation to the rest of his composition and be careful not to give undue
prominence to anything because he finds it interesting to paint.

A picture that is very full of incident and, at the same time, cut up
with strong contrasts of light and shade, will always have a disjointed

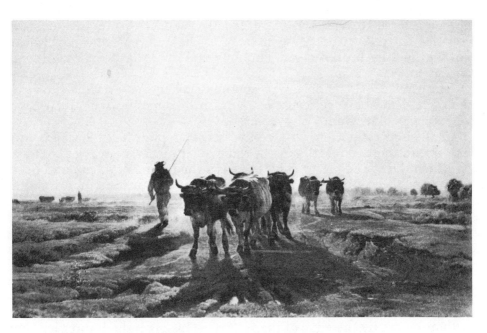

34.　　*" BOEUF SE RENDANT AU LABOUR."*　*Troyon*

A very fine composition, in which everything keeps its proper place without any trivialities to distract the attention.

appearance unless relieved and united by a harmonious colour scheme. If there are strong contrasts of light and shade, a colour harmony will blend the various forms together; whereas, if strong colour contrasts are added, they only tend to increase the general confusion and chaos. On the other hand, if the light and shade effect is broad and subdued the picture will stand considerable contrasts of colour.

In a picture, as in nature, everything requires some complementary opposing force to render it more effective and complete. As unity is complemented by variety, so is dark by light, cool colour by warm, flowing lines by broken ones, simplicity by detail, hardness by softness, and so on.

Every picture is made up of opposites, by means of which force is added and the balance secured. A clash of opposites will add weight where particular emphasis is required.

In the representation of a festive scene, replete with business and movement, there should always be some quiet places, by way of contrast, on which the eye can rest. This increases the feeling of gaiety and helps to balance the picture. Imagine some bacchanalian scene in a wood in which part of the crowd is in bright sunlight, other portions of the picture in shade. The restfulness of the shadow adds to the brilliance of the sunlight and accents the general tumult of the scene, at the same time allowing the spectator to pause and enjoy it. If the whole picture were filled with riotous revelry it would be too disturbing to contemplate.

In the case of a subject the interest of which is spread over the whole canvas, or in which it is desired to suggest an unlimited number of characters, it is advisable that some of the figures or animals should connect with or be cut by the edge of the frame. This gives the impression that there are still more to come and increases the feeling of movement; whereas, if one can see all round the group, the defining of its boundaries limits its size to what is actually shown on the canvas and, at the same time, produces a static effect.

In dealing with a combination of both animals and landscape, the artist has always to consider which is to have the preponderating interest, and not give them such an equality that it is difficult to determine whether it is a landscape or an animal subject. There must never be two subjects on one canvas. A divided interest is always an anomaly.

Constable is an excellent example of a landscape painter, who used animals, &c. to add interest to his pictures without allowing them to overbalance the landscape (*vide* " The jumping horse " and " Flatford Mill ").

Cuyp, on the other hand, was essentially an animal painter, and although the landscape plays an important part in most of his pictures and often occupies a great deal of the canvas, it serves primarily as a setting for the cattle, &c.

Plate 35 is a dignified composition in which the group of cattle occu-

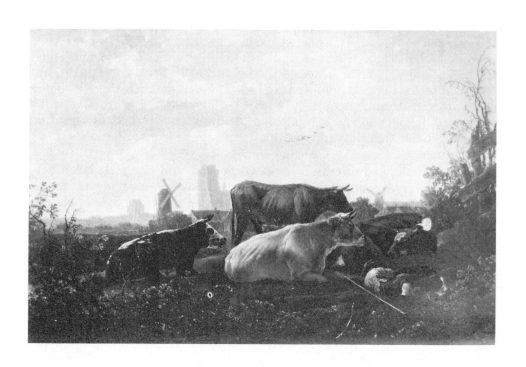

35. *LANDSCAPE WITH CATTLE. Cuyp*

*The artist makes the mistake of connecting the top of the neck with the top of
the horn ridge instead of below it.*

pies a commanding position. In this picture as in others by the same artist, the top of the neck of each cow is made to join the top of the hornridge instead of the base as it should do,—see sketch.

Plate 36 is not as satisfactory. In the first place it contains too many disconnected incidents. Secondly, it seems unbalanced, the interesting group on the right being placed too near the edge of the picture. In addition, the diagonal line of the distant hill divides it into two equal triangles and still further upsets the balance. In fact, it gives the impression of having been painted bit by bit, without much thought being given to the arrangement as a whole. But whatever defects we may think we discover in the composition are fully outweighed by the rich, glowing colour that pervades all this great artist's work and makes it live in the memory.

A badly balanced picture is badly composed, and one feels intuitively that the pieces are in their wrong places. Balance must never be too exact, and can never be effectively secured by the reflection of similar forms on the opposite side of the picture, or by any equal arrangement of its component parts. Variety is needed in the disposition of the material as much as in its representation.

The importance of variety of placing and variety of spacing must always be borne in mind. If striking features are placed at equal intervals, or even if they give the impression that they are placed at equal intervals, the effect is always archaic and unnatural.

In the placing of the subject, care must be taken not to draw attention to the exact centre, the horizontal and perpendicular middle lines, the four corners, or the boundaries of the canvas. Any geometrical or mechanical arrangement is likewise objectionable. Equalities must be avoided.

For the purpose of balancing our picture, therefore, instead of equalities we must use equivalents. For, just as a piece of lead may be balanced in the scales by an equivalent weight of lighter material, which will be of much greater bulk, so, in a picture, some parts will have a stronger effect in drawing the eye towards them, and therefore may be said to have more pictorial weight than others, and it is by the appreciation of their relative values in this respect and in their skilful application that the artist balances his composition.

If the chief point of interest is centred on the canvas it produces a feeling of stillness, as if the pendulum had stopped and all life gone out of the picture. The best arrangement is, perhaps, when the subject seems to be accidentally placed and the balance restored by the sympathetic disposition of the other parts and accessories.

In nature it is the irregularity and variation of everything that is so attractive, and this we should endeavour to imitate in all our art.

Of equal importance with the placing of different objects in the

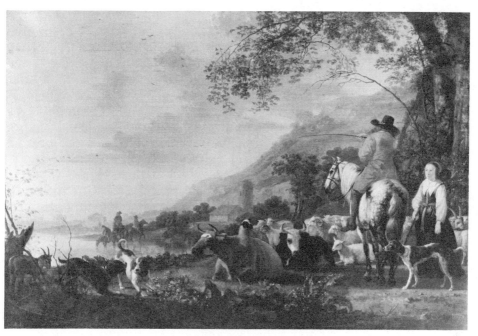

36. *COMPOSITION. Cuyp*

The chief interest is, perhaps, too much to one side of the picture, but whatever defects we may think we discover in the composition are fully outweighed by the rich glowing colour that pervades all this great artist's work and makes it live in the memory.

picture is the consideration of the intervening spaces, which must also be irregularly and decoratively distributed. If the spaces are ugly in shape, or monotonously repeated, they have as much effect in destroying the harmony of the picture as bad disposition of the subject matter itself.

A decorative and accidental arrangement of the spaces adds greatly to the beauty of a design. The pieces of sky that are to be seen through trees are of endless variety, and of all shapes and sizes. They must be employed to help to express the anatomy of the trees, yet, at the same time, must always be considered in relation to the pattern and decorative design of the picture as a whole, and modified or omitted accordingly.

Light spaces which serve as backgrounds to dark and definite forms are, perhaps, the most difficult to deal with because their actual shapes cannot be considered from the decorative point of view alone, but must depend on the character of those forms. In the case of a number of animals on a rise, with a sky background and low horizon, the sky shapes seen amongst the legs, and in other parts of the group, often present very interesting but, at the same time, very perplexing problems, and if considered solely with regard to the drawing of the animals will frequently come very awkwardly, and interfere with the breadth and unity of the picture. Surrounded as they are by dark and definite animal forms, they become very conspicuous, especially if they repeat one another, and the eye is attracted to them, instead of to the main features of the design.

They must then be dispersed and broken up (yet without in any way affecting the proper representation of the animals themselves), so that they draw no more attention than the particular part of the picture requires. Such a problem often presents greater difficulties to the sculptor than to the painter, who can always modify unpleasant shapes by the introduction of other things, such as a bush or a distant tree, or by varying the depth of the sky. In fact, there are endless ways in which the painter can hide what he does not wish to show, without having to reorganize his whole picture; whereas, in sculpture, the group must be so designed that it is right from the first and these awkwardnesses avoided, as also the necessity for their concealment.

In all matters of grouping, whether of figures or animals, the student should first look at his subject from the sculptor's point of view and see that it is well arranged, well spaced and well balanced, irrespective of what advantages he may afterwards derive from other sources.

In composing their pictures, one of the things to which too little attention is given by students is the relation of the subject to the background.

I think, in a great measure, this may be due to the fact that in many of our art schools drawing the figure is looked upon as a study by itself, and sufficient consideration is not given to the things around and behind it.

The drawing of any object against a plain background is always very instructive and, as a means of demonstrating the variety of the contour, cannot be beaten. At the same time, if the student does too much of it, he is apt to overlook the importance of the relationship between his subject and its surroundings and to look upon his background and foreground as of minor consequence. This is a great mistake. The background is as important as the subject itself, and unless they agree with one another the picture never looks natural. The tones of both must be carefully compared, and their relationship in every particular must be true.

The relative sizes of the subject and of things in the background must also be justly expressed. How often one sees a portrait of a horse or a dog with an expanse of landscape beyond that would be suitable for a regiment of cavalry or a battery of artillery, but is far too extensive for anything less imposing. Pictures of game birds, too, among miniature trees and mountains, by comparison with which the birds look as large as ostriches, and standing among miniature grasses that are not even sufficient to conceal their claws.

Nothing makes a picture look so unreal as this want of relativity between subject and surroundings, and, as has been said, it generally arises because the two things are dealt with as separate propositions and not treated as belonging to one scheme; the animals, or whatever the subject consists of, being painted at one time and the background either faked from a sketch in the studio, or else painted out of doors when the model is not there for purposes of comparison.

This is often due to want of knowledge of elementary perspective. I have before me a picture of a horse standing on a flat green pasture, with the horizon cutting its shoulder, but the trees introduced in the distance which appear to be on the same plane are no higher. Now, if the horizon cuts the point of the shoulder of a horse that is standing on a flat plane, it will cut through the same point approximately of every other horse that is standing on that plane. Therefore, it can be used as a standard to measure the height of anything that is on that plane. In this case, the distance from the ground to the shoulder being about three feet, it means that the trees in the distance are only three feet high, whereas, of course, they are intended to be very much more. This, therefore, makes the scale of the horse out of all proportion with the scale of the background.

If, when painting the portrait of a horse, the background is put in at the same time, it will generally look right, not only in scale, but with regard to the relative tone and colour as well, and seldom wants much done to it afterwards, whereas, if painted at some other time, it nearly always looks wrong.

When painting out of doors, a good way of finding out how much of the landscape should be included in the picture is to use a " cut-out "

(i.e. a piece of cardboard about the size of a post-card, with a hole in it, of the same shape and proportions as the canvas) and to look at the subject through this. By bringing it nearer or putting it further away one is able to judge how it looks best, how much background is necessary, what proportion of the picture the main group should occupy, and where its boundaries should come. It is well to carry one or two of these cut-outs, of different shapes, in the pocket-book, so as to be able, at any time, to look at any subject met with. Many artists cut a hole in the cover of their sketch-book which, of course, is then always handy.

It is often necessary when painting a portrait of an animal, to indicate, near by, some familiar object of a definite size; so that, by comparison, the spectator will readily appreciate what is the size of the animal represented. There are many small dogs, for instance, which, in shape and other characteristics resemble some of the larger breeds, and confusion often arises in the spectator's mind if there is nothing to tell him whether he is looking at a picture of a large or a small dog. Whippets and Italian greyhounds may easily be confounded with the true greyhound, although the latter is many times larger; toy bulldogs with true bulldogs, &c. I, myself, have a drawing I made of a very large white boarhound which is frequently mistaken for a drawing of a bull terrier. This does not offend me, for I do not suppose one person in a thousand has ever seen a white boarhound, whereas a white bull terrier is familiar to everybody. As a matter of fact, at the same time as I had this boarhound I also kept a white bull terrier, and whenever they were seen together someone was sure to ask if the bull terrier was not the boarhound's young one. There is no background in my drawing—nothing but the hound itself. Had I introduced the leg of a table or a chair, or indeed anything of a more or less established size, it would have set the scale. Everyone would have known that they were looking at the representation of a large animal, even though they might not have recognized the breed.

Another point, to which I have not yet referred, is that when the main interest of a picture is a long way off, means should be taken to conduct the eye thither, and to show, at the same time, that there is considerable distance between the picture plane and the feature in question. I am rather thinking of those pictures of scenery where one looks across a valley before coming to the subject. One often sees sketches of mountains where the eye looks straight at the distant landscape, and there is nothing to suggest a scale or to indicate the intervening space. Atmosphere alone will not do it; it will only make the picture look weak, unless there is something more strongly defined in the foreground to compare with it. I always like to feel that there is something tangible and solid near by, otherwise it gives me the impression that the artist was suspended in mid-air when painting. If this could be so, and it could have been painted from a captive balloon, some part of

the structure should be included in the picture which would give the necessary contrast, and would convey the idea of space that was needed. A bit of the bank on which the artist stood, or some scrub or tree in the foreground of the picture would be even better, and a perfectly natural solution of the difficulty.

Many amateurs do not realize this, and will make a careful painting of a distant view, without putting any foreground or near object to explain how far away it is.

All things, as they recede from the eye, become more united and indefinite; the different tones and colours become amalgamated and the edges obliterated until, in the farthest distance, a range of hills becomes a flat tone, often indistinguishable from the sky. On the other hand, the light and shade variations and the colours appear more distinct and stronger as they approach the eye.

Delicacy in the treatment of distance will only suggest distance when it can be compared with something nearer that is stronger.

The clearer the atmosphere, the sharper the definition and, consequently, the more difficult it is to suggest distance by means of aerial perspective. In countries where the air is less dense than in our own, distant objects look to us much closer than they really are—all the more necessary, therefore, to find some means of sending them back, and if the difference in values alone won't do it, a contrast of scale will, and the introduction in the foreground of relatively proportioned rocks or trees, or whatever is appropriate, may have the desired effect.

In every picture, I think, some part of the immediate foreground should be solid and take hold of the frame. A solid foreground gives the impression that you can step on to it and walk up to your subject, and consequently it unites the whole composition and attaches it to the frame; whereas, if the subject is " vignetted," by having all the surroundings hazy and vague, the picture looks weak and incomplete.

In the course of the production of every picture, jarring notes and faulty tones are bound to occur, and it is often not until it nears completion that they become evident.

It is when the artist finally starts to pull his picture together that he seeks out these defects and endeavours to bring all the discordant notes into harmonious unity. If the general effect is nearly right—as it should be—this can often be done with slight glazing.

If we look at our picture through a piece of tinted glass we see how this has the effect of uniting the whole composition. It reduces the lights and helps to harmonize the colours. Even a clear glass over a picture, by uniting the surface, has a considerable effect in pulling it together. Time, as we all know, gives mellowness to a picture, which greatly enhances its beauty. But unless the colour is already rich and pure, neither time nor glazing will make it so.

Haydon in one of his lectures tells us that " The splendour of the

Venetian school was produced by laying on every colour in its native purity on white grounds without mixing, never losing the effect of the ground in the dark portion, and bringing the whole into harmonious glory, by glazing with transparent tints, which lowered the gaudiness without losing the power of the original painting."

CHAPTER XI

ALL painting is drawing, although all drawing is not painting, and where the study of the fundamental essentials does not necessitate the employment of paint, it is better for beginners to use materials that are easier to manipulate.

Personally, I have never been in favour of setting any time limit to the preliminary course during which pencil or chalk are to be used, and hold that every student should be allowed to paint as soon as he is likely to derive any benefit from so doing. I am, however, entirely opposed to letting them use paint (or indeed specialize with any other medium) before they have learnt the primary elements on which their art is based, and at any rate never before they have acquired the power of judging the positions and proportions of the main features of what they are copying, and can place them approximately on the paper. Until the pupil can, with a tolerable measure of certainty, put the business end of his brush where it ought to go, it is sheer waste of time and money to let him mess about with paints and canvases.

When the time comes he will soon learn to mix his paints. The thing is to be able to judge the exact colour and to realize when he has got it; and as for using the brush, all that has to be done is to get it full of paint and apply it in the right place on the canvas. The difficulty is to know which *is* the right place and to be able to put it there. Anyone who can put the right colour in the right place is a consummate artist.

The difficulties of painting begin when the paint is applied in the wrong place and in the endeavour to remedy it the paint gets muddy and sticky. Frequent alterations and corrections rob the colours of their luminosity; they lose the freshness and purity which they had when first applied. The paint goes dead, it cracks and does all sorts of unpleasant things unless applied in the right place in the first instance. Frequent corrections and alterations may eventually, to some extent, improve the drawing, but always at the expense of the painting; and the time thus spent is wasted so far as deriving any real benefit from a painting point of view is concerned, as the student is always working under adverse conditions and encountering difficulties which should never have arisen.

Correcting mistakes in paint is a much more serious matter than correcting mistakes in pencil or chalk. If a drawing won't come right,

we can take another piece of paper and do it again and as often as need be; but with canvas, costing many shillings a yard, and paints and brushes in proportion, one hesitates to adopt this plan. Painting on canvas that has been used before is bad for beginners. It takes charcoal very badly, consequently the preliminary drawing gets scamped, so that, from the start, the student finds himself in the very position he should have avoided.

If he wants to learn to paint well, let him, when ready, study under the most favourable conditions. Let the colours be good; let the canvas be good; let the brushes be good; but above all let the drawing be good.

Painting is such a personal matter, that it is difficult, even were it possible, to advise any system that would suit all temperaments.

How to lay the paint on is entirely optional. There are no hard and fast rules. Some paint thick,—some paint thin. Most painters use the brush, some use the palette knife, and I have seen pictures that appeared to have been done with a shovel. Any way is legitimate if it produces the desired result. Each artist has his own method, and even if the student is taught a particular way and made to follow it during his studentship, in after life he invariably deviates from it as his experience or fancy suggests. He tries experiments; he imitates the handling of other painters. In fact, an artist remains a student throughout his life and is always changing his masters and changing his methods.

The pigments he uses are purely matters of taste and opinion, and so long as they are chemically pure, and can be used in combination, it really doesn't matter what they are. He must decide for himself. There is no right or wrong about the manner of painting. A beautiful picture may be done in spite of all laws, but it can never be beautiful if it is ill-drawn.

The most the master can do is to explain his own methods and to give his pupils the benefit of his own experience. He can show them how he himself mixes his colours and lays them on, and to a certain extent he may teach them how to match tints. He can tell them which pigments are permanent and which are not. He can advise them as to the uses of oils and varnishes, how to guard against the paint cracking, and so on, as well as how to keep their brushes and palettes clean. Beyond this, however, there is little he can teach them so far as actual painting is concerned that is not entirely dependent on their powers of drawing. After all, oil painting, water colour painting, tempera, fresco, lithography, etching, &c., are only so many different branches of our art. The materials and pigments employed and the methods of their employment vary, but the foundation and very substance of every one of them is drawing, and the preliminary preparation the same for all. Sureness of hand and eye are the first requirements in every case.

As soon as the student has mastered the elements of drawing and can rely on his hand and eye to direct his tools, he is ready to start painting.

He will find that the technical difficulties which he expected would impede his progress are easily overcome, and having surmounted these constant practice is what he most needs to give him confidence and dexterity. The most difficult problems that he will have to face are not problems of pigment at all, but depend for their solution on his knowledge and understanding of what he is painting,—in the study of collateral subjects and on his own outlook on nature. But, so long as he is hampered by having to fumble about with his paints in his endeavours to interpret what he does not understand, and cannot draw, he is tied by the leg and is only learning how *not* to paint.

Colour. A highly developed sense of colour is the most precious gift any artist can have. In the hands of a true colourist, the pigments seem to blend themselves, and whatever he does produces harmony.

Having an eye for colour is like having an ear for music, and in either case a false note is equally offensive.

Comparatively few artists are born colourists, and most of them improve their sense of colour by imitation,—by copying pictures which are reputed for their colour, and there is no better way, so long as it is not overdone. Imitating the colours of pigments laid on a flat canvas is comparatively easy, and a very different thing from interpreting the colours of nature. In the picture they remain the same, the surface of the original being exactly the same as the surface of the student's canvas; the two can be placed side by side and minutely compared with each other and the colours matched. The student learns what pigments the master used for certain purposes and how he applied them. Patience and diligence should teach him to paint similar subjects in a similar way. But he is imitating only. He is not seeing colour for himself but only through the eyes of the master whose picture he is copying, and unless he copies other masters, who see nature from other points of view, he runs the risk of adopting the conventions and mannerisms of a single individual.

We see many instances of modern painters being founded on some well known master—faint echoes of great men. Some never get away from it and continue repeating the same patterns, the same subjects and the same colour schemes, in the same style, all their lives. If they are clever their pictures look dignified, and because their work is always reminiscent of some great master, it is applauded by the multitude. But it is not original.

The true colourist, however, can afford to be original. He can throw off the shackles of his early days and his early favourites, and see everything with his own eyes. It is, to my mind, a far finer thing to endeavour to paint what you feel yourself, as you feel and see it, however unsuccessfully, than to be content to spend your life in imitating other people's ideas and methods.

If two artists set up their easels side by side and paint the same subject

the results will never be alike. No two people are affected in the same way by what they see, no two see colour alike, and everybody has his own way of applying it. It is this, the personality of the painter, that gives the note of originality, the greatest virtue of a picture, and it is just this that is lacking in the performance of all imitators, who sink their own individuality in their vain attempts to see everything, even colour, through the dead eyes of those who practised in the past.

Still life painting helps to develop a sense of colour, and when painting indoors, the student's work can be placed alongside or under the original subject and the two compared from a distance. In this way, and if the copy is full size, errors of colour and tone can be detected. The two may be compared together in a looking glass, which, by reversing them, enables the student to see his work from another point of view; it is like looking at it with a fresh eye, and the sudden change, after looking at the same thing for a long time, often enables one to detect false notes, which a jaded eye has overlooked.

The looking glass is useful also as an aid to drawing. It often happens that, owing to a slight astigmatism, accentuated by weariness, an artist fails to make his upright lines perpendicular. They look right to him when they are really sloping. The looking glass, by reversing his picture, doubles the amount of the error in the opposite direction, and he notices it at once.

Care should be taken not to overdo the use of it, as its principal recommendation is that it enables one to see one's work with a fresh eye, and if it is continually in use this fresh eye becomes as wearied as the other and the novelty is gone.

Students often ask what colours they should use for painting certain things. Trees, skies, distance, bay horses, chestnut horses, and so forth, to which the answer must always be that as the colour of everything varies with the lighting, no one colour or combination of colours can be recommended for painting the same thing under different conditions, and that much depends on the scheme of colour of the rest of the picture. The colour at mid-day is quite different from the colour in the evening. Quite another combination of colours is required for painting an object in sunlight and on a grey day. The colour of the light parts is quite different from the colour in the shadows and is not merely a lighter shade of the same colour. In fact, out of doors, the colour of every part of every object is continually changing, and depends upon what other colours may be reflected upon it. The blue sky will be reflected on some surfaces, the ground and surroundings on others, and according to the strength of the light and the intensity of the colours so reflected will the original or local colour be modified.

If we were to stretch a piece of the hide of a bay horse on a wall, and a piece of canvas alongside it, we might match the colour exactly, and should get as the result a specimen of what is called the local or actual

colour of the horse. We could make a note of the ingredients and have a prescription made up for bay horse painting. In practice, however, this would be utterly useless.

You can't take pigment and mix it up into different shades, light, half tint and shadow, according to a prescription, and imagine you are going to paint *Colour* with it. The result would be a monochrome, and although a practical way of teaching students to handle paint and blend tones, it is of no value whatever in teaching them to see colour.

Some surfaces receive direct light, some half light, others are in shadow, and the colour varies with every change of light. To appreciate these changes and know how to account for them it is necessary to understand the form of what we are painting so that we can realize in what direction the different planes are facing. We shall expect to find that the sky is reflected on the more horizontal upper surfaces, the ground on the under sides and other things on the more vertical planes, and it is only by investigating these things that we shall understand the effect that direct light and reflections have in modifying and dispelling the actual colour of things, according to their shapes.

As I write, I see from my window some cows which have just come through a gateway. There has been a heavy fall of snow during the night, but the sun is now shining brilliantly and the snow is rapidly thawing.

Some of the cows are grouped against the hedge, which is in shadow, and one, standing a little apart, is silhouetted in the gateway against the snow-covered sloping field beyond. The foreground is a delicate golden colour, except where the snow still hangs in the shadows of the larger tufts of long grass and rushes with which it is covered, where it is of a beautiful tender blue, the clear blue sky being reflected in them. All along in the shadow of the hedgerow is a clear line of blue where the snow has not yet melted—the blue appearing more intense than the smaller shadows in the open field.

The cattle, Red Devons, are lit from beyond; the sun makes the tops of their backs and the hairy edges a brilliant gold colour. The shadow side looks perfectly flat—as if it were done with one brushful of colour— with the exception that the more horizontal surfaces reflect the blue sky which seems to alter the colour without affecting the general tone of the shadow. Under the bellies of those standing against the hedge the reflected light from the sunlit snow looks almost as brilliant as the direct sunlight on their backs. I know it is not so, however, because in the cow that is silhouetted against the snow, and which is quite close to the others and lighted in the same way, the belly looks quite dark. The flat, white background enables me to judge the relative values of the direct and reflected lights, whereas the dark background of the hedge forms such a contrast to both that I cannot appreciate any difference.

The cattle have now moved away, the blue line of snow under the

hedge has nearly disappeared and most of the touches of blue among the grass and rushes have gone too. In fact, the subject and the effect have vanished for ever, but, to a certain extent, I feel that I might be able to revisualize its leading characteristics.

The composition did not particularly impress me, the cattle were not very well grouped, but on another occasion I may see them there again and they may come better. They generally come through in the morning, but the colour effect has never impressed me in the same way.

Beyond is a sloping hillside, broken up with warm coloured hedgerows and trees and a little farmstead where the cows come from. The fields are fast becoming green, but a few minutes ago were of a lovely iridescent pearly sort of colour. Cloud shadows are now passing over them and I see bunches of cumulus cloud coming up. The whole scene is changing, everything melting away. Such is life, and therefore it behoves us to seize our opportunities, make hay while the sun shines, make notes, write memoranda, and try to understand the reasons for the chameleonic changes of everything.

No prescriptions will give such colour, and it is only by trying to account for all the variations that it is possible to revisualize it. The effect has gone, the colour has gone, the trees, the fields and the farmstead still remain, and doubtless the cows will be there to-morrow, just as if nothing had happened. I might still draw the facts, but for the rest should have to depend on my memory and my imagination.

PART TWO

THE

ANATOMY OF ANIMALS

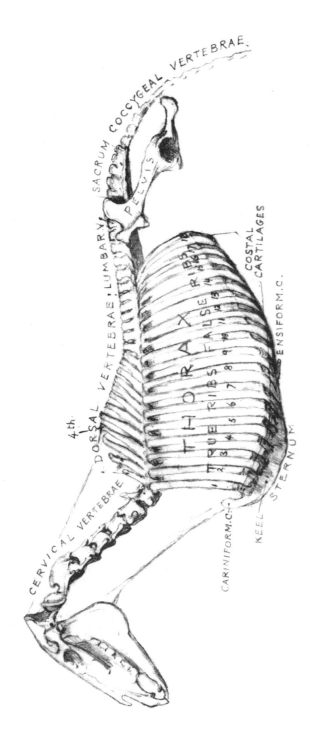

VERTEBRAL SKELETON

1.

PART II

CHAPTER I

THE VERTEBRAL SKELETON

THE Skeleton is by far the most important part of the anatomy from an artist's point of view. It is the basis of everything, and it is absolutely necessary for an animal painter to understand how the bones are arranged and how they move, before making any attempt to study the muscular system, which should then present very little difficulty. The artist who has learned instinctively to " see " the skeleton of any animal he is drawing knows enough anatomy to carry him a very long way.

In the following chapters, with the horse as our model, we shall draw the readers' attention to important structures as they occur in the different regions, point out prominent bone forms, &c. which appear on the surface, variations in other animals, and any features which call for the animal painter's special notice. Indeed, throughout these pages, our aim will be to treat the subject from an artist's point of view.

The " Natural " Skeleton consists of bones, cartilages and ligaments; most of the softer parts, however, get destroyed during the preserving process, and are therefore missing in " artificial " or " articulated " skeletons, as a rule, the costal or rib cartilages only being saved.

Most of the bones are developed from cartilage which gradually becomes ossified, and it is not until the animal reaches maturity that this process is completed. Some cartilages never ossify, but remain throughout life flexible parts of the framework.

Ligaments are composed of fibrous tissue and are of two kinds: white (inelastic) and yellow (elastic). Generally speaking, the white ligaments are those which unite the bones at the joints, whereas a yellow ligament may act as a mechanical brace, i.e. the great elastic ligament of the neck (Ligamentum Nuchæ), which will be more fully described later.

The fundamental part of the skeleton is the spine, which consists of a chain of vertebræ reaching from one end of the animal to the other, and to which are attached the skull, the ribs, and the haunch bones. All together constitute what may be termed the Vertebral Skeleton, to distinguish it from the skeleton of the limbs, which are its supports and means of propulsion.

95

2. *DIAGRAMMATIC SECTION OF A TYPICAL VERTEBRA*
(Front view)

A. *The Body.*
B. *Arch.*
C. *Superior Spinous Process.*
D. *Inferior Spinous Process (inconstant).*
E.E. *Transverse Processes.*
F.F. *Anterior Oblique Processes.*

The Vertebral Skeleton is divided into six regions, viz.: (1) Head. (2) Neck. (3) Thorax. (4) Loins. (5) Croup. (6) Tail.

The vertebræ of the Neck are named Cervical Vertebræ.

,,	,,	,, ,,	Thorax	,,	Dorsal or Thoracic Vertebræ	
,,	,,	,, ,,	Loins	,,	Lumbar	,,
,,	,,	,, ,,	Croup	,,	Sacral	,,
,,	,,	,, ,,	Tail	,,	Caudal or Coccygeal	,,

Individual vertebræ vary in size and shape in the different regions, and their number varies in different animals as the following table will show.

	Cervical.	*Dorsal.*	*Lumbar.*	*Sacral.*
Horse	7	18	6 or 5	5
Donkey	7	18	5	5
Ox	7	13	6	5
Sheep	7	13	6 or 7	4
Goat	7	13	6	4
Pig	7	14	6 or 7	4
Camel	7	12	7	4
Giraffe	7	14	5	4
Dog	7	13	7	3
Cat	7	13	7	3

A typical vertebra consists of a body—an arch (i.e. a segment of the tunnel through which the spinal cord passes), and various processes of which the most important to note are the Spinous process, situated above, and the Transverse processes on each side, as these constitute the principal levers of the spine to which important muscles are attached.

The head, being as it were a self-contained adjunct of the Vertebral Skeleton, can be dealt with independently of the other regions, and as it will require a rather lengthy description, we will give it a chapter to itself after we have explained those parts that are more intimately connected with the Spinal Column.

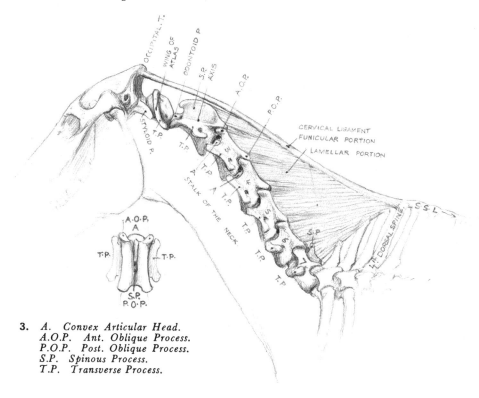

3. A. *Convex Articular Head.*
 A.O.P. *Ant. Oblique Process.*
 P.O.P. *Post. Oblique Process.*
 S.P. *Spinous Process.*
 T.P. *Transverse Process.*

BONES OF THE NECK. The skeleton of the neck consists of seven cervical vertebræ, movable upon each other; the degree of movement, however, varies in different parts.

The first two, the Atlas and Axis, call for special notice, not only because of the way in which they concur in the free movements of the head, but also because of their peculiar conformation, and the way in which they differ from all the other vertebræ.

In the first place, the *Atlas* (which supports the skull) deviates from the recognized type in that it has no body and no spinous process, but consists merely of a ring of bone with two large transverse processes spreading out like wings on either side. This vertebra is the shortest but, at the same time, the broadest of the series, its wings, extending right across the top of the neck, which here almost equals the width of the head. *The lateral borders of these processes are the only parts of the*

skeleton of the neck that are actually subcutaneous, and can therefore
always be identified on the surface.

**4. *MOBILITY OF THE UPPER END OF THE NECK TURNING
WITH THE HEAD***

The *Axis* (the second vertebra) claims our attention for three reasons.
First, because it provides the pivot on which the Atlas, and with it the
head, rotates. Secondly, because it is the longest and the largest of the
series; and thirdly, on account of the unique character of its spinous
process. This process consists of a large thin plate of bone, convex
above, standing up perpendicularly, extending the whole length of the
vertebra and overlapping the anterior end of the next one. Although no
part of the Axis is actually subcutaneous, its general shape and limits
can be readily detected on the living subject, in spite of,—or perhaps
because of the large muscles which occupy its sides.
 The chief movements between the skull and the Atlas bone are flexion
and extension, with a limited amount of lateral inclination and circum-
duction. Between the Atlas and the Axis the only possible movement is

rotation, i.e. a screw-driver action where the Atlas bone revolves around the odontoid process.

When the head is turned to one side or the other, the Atlas bone is forced to turn with it on account of the pressure of the styloid processes of the occipital bone, against its transverse processes. The Axis is bound to follow suit as no lateral movement is possible at the atlo-axoid joint, so that the two first vertebræ of the neck are always automatically involved in any turning movement of the head, and it is therefore at the junction of the second with the third cervical vertebra that the upper part of the neck (and the head) first derives its outward bending movements.

The remaining vertebræ of the neck are more uniform in character, and together they constitute what we may term the stalk of the neck, supporting the more flexible upper part, and moving freely in all directions from its base. Although none of them is subcutaneous, the vertebræ of this part of the neck can easily be located on the living subject by following the directions of the muscles which are attached to them. Their transverse processes are large, and those of the third, fourth and fifth can often be felt along the posterior border of the mastoido-humeralis muscle.

In the ox, the wings of the Atlas are rather more horizontal than in the horse. The vertebræ themselves are shorter, and the spinous processes of the last five more developed, especially that of the seventh, which is very long, and appropriately called " *Prominens.*"

BONES OF THE THORAX. *(See Plate 1.)* The skeleton of the Thorax is made up of the dorsal vertebræ above, the ribs, with their cartilages on each side, and the breast-bone or sternum below, so forming the framework of the case which contains the heart and lungs.

Vertebræ of the Thorax. A horse has eighteen dorsal vertebræ, each of which supports a pair of ribs. In direct contrast with the cervical vertebræ, their bodies are short, the transverse processes very small, and the spinous processes abnormally developed, especially of those situated between the shoulder-blades, where they rise to form the outline of the withers. The first of these processes measures but a finger's length; the second is twice as long, the fifth generally being the highest, and forming the apex of the withers. Afterwards they gradually diminish, until at the thirteenth or fourteenth their summits are level with those of the remaining vertebræ of the back. With the exception of the first three, these are all subcutaneous. *The summit of the fourth vertebra is the point where the upper outline of the neck joins the trunk. (Plate 1.)*

Ribs. The ribs are long curved bones of considerable elasticity, parallel with each other and descending in a slightly oblique direction backwards, on both sides of the thorax, of which they form the outer walls. Each one articulates with two vertebræ, its own, and the one

immediately preceding it. The first and last ribs are generally the shortest and the ninth the longest. They increase in width from the first to the sixth, and become narrower and more arched towards the posterior part of the thorax.

Costal Cartilages. To the lower end of each rib is attached a flexible cartilage. The cartilages of the first eight unite directly with the sternum ; those of the remaining ten have no direct contact with the sternum, but are successively united to each other from behind forwards, that of the last joining the preceding one and so on, until that of the ninth finally joins that of the eighth. For this reason the first eight ribs are called *sternal or true ribs,* the last ten, *asternal or false ribs.*

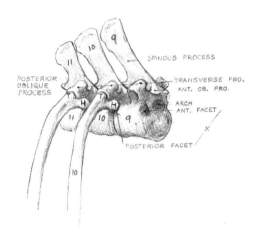

5. *H = Head of Rib, articulating with two Vertebræ.*
T = Tuberosity of Rib articulating with Transverse Process.
The Anterior facet of one Vertebra forms with the posterior facet of the one in front a cup for the reception of the head of the rib.

Sternum. (See Plate 1.) The sternum or breast-bone consists of alternating segments of bone and cartilage. It is shaped somewhat like a boat, having a prow in front, a keel underneath, and what might be likened to a rudder behind, the prow being represented by the *cariniform cartilage,* the keel by the prominent ridge below, and the rudder by the *ensiform cartilage.*

The Cariniform Cartilage is a continuation upwards and forwards of the keel of the sternum, and the point of union between the lower or anterior border of the neck and the trunk. It is approximately level with the points of the shoulders of a horse when standing collectedly, and may be felt above the median groove which separates the muscles of the two sides of the breast. Whatever the attitude, this cartilage is always stationary, and the fixed point from which the middle line of the front of the neck issues.

The keel is that part of the Sternum *(see Plate 1)* situated below the level of the costal cartilages, where it provides a large surface for muscular attachment. Deepest between the forelegs, it gradually diminishes and finally peters out at about the sixth rib. The subcutaneous edge of the keel can be traced at the bottom of the groove between the breast muscles, and also as it continues backwards to form the dividing line between the two sides of the brisket.

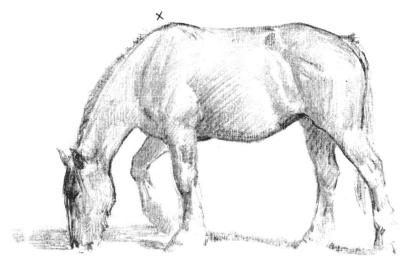

6. *FROM SKETCH BOOK*
The junction of the neck & the thorax is indicated by X.

The ensiform cartilage or xiphoid appendage is a horizontal prolongation of the posterior extremity of the sternum, and lies in the angle formed between the costal cartilages of the two sides as they converge towards their attachments on the sternum.

Comparative. The thorax of all quadrupeds is constructed on the same principle, and consists of dorsal vertebræ, ribs, their cartilages, and the sternum.

The ox has thirteen dorsal vertebræ *(see Plate 11)*, which are both longer and wider than those of the horse. The spinous processes do not rise above the shoulder-blades; those of the first five are nearly equal in length and all of them reach the surface. Consequently, the apex of the *first* is where the outline of the neck joins the trunk, and not that of the fourth as in the horse.

If we compare the neck of a horse grazing with that of a cow in the same attitude, we see the effect of this. In the horse, the outline descends almost abruptly in front of the shoulder-blades, whereas in the cow it continues considerably beyond them, and forms a decided angle where it leaves the apex of the first vertebra *(compare Plates 6 & 7)*.

The slight declination that is noticeable in the outline before reaching

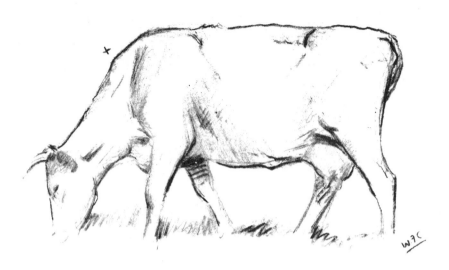

7. *FROM SKETCH BOOK*
X indicates the junction of neck and thorax.

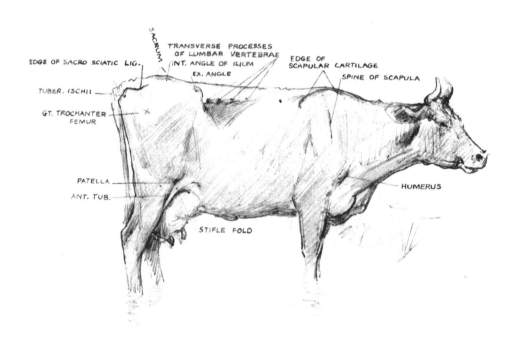

EDGE OF SACRO SCIATIC LIG.

SACRUM

TRANSVERSE PROCESSES
OF LUMBAR VERTEBRAE
INT. ANGLE OF ILIUM
EX. ANGLE

EDGE OF
SCAPULAR CARTILAGE

SPINE OF SCAPULA

TUBER. ISCHII

GT. TROCHANTER
FEMUR

PATELLA

ANT. TUB.

HUMERUS

STIFLE FOLD

8. *ANALYSIS OF SKETCH FROM NATURE*

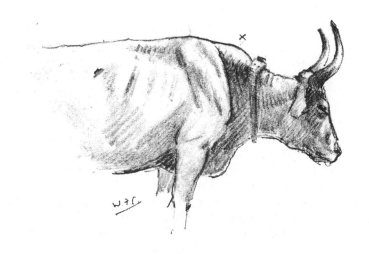

9. *INCIPIENT HUMP ON DRAUGHT OX (Italian)*

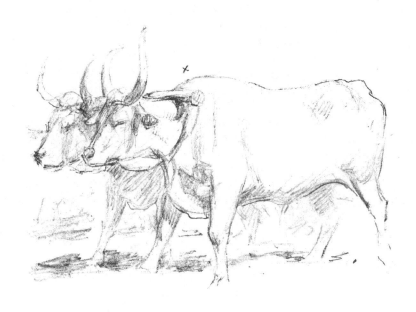

10. *WHITE ITALIAN OXEN*
 X. Incipient hump.

this point is not due to any appreciable difference in the length of the processes, but to the general downward curve of the spine itself *(see Plate 11)*.

In draught cattle the yoke is generally placed in the dip of the neck, just in front of these processes, and in most cases the surrounding parts become enlarged and callous, thus forming a sort of protective pad over the bones, which in many breeds has become hereditary, and is a feature much sought after by agriculturists abroad. This is supposed to be the origin of the hump in Indian cattle, which have been worked on the land from time immemorial.

In some parts of the Continent, however, the yoke is fixed to the horns, which seems both cruel and unpractical, the flexible neck having to bear the strain instead of the rigid trunk; moreover, the heads of the two beasts are so firmly linked together that no relief is possible.

After the fifth, the summits of the remaining vertebræ should be level in order to give the straight back so much admired by cattle breeders.

The ox has thirteen ribs on each side, of which eight are true and five false. The breast-bone projects further forward but has no cariniform cartilage. Although to some extent concealed by the dewlap, its situation can be easily located on the living subject by the conformation of the surrounding muscles.

The Carnivora have thirteen dorsal vertebræ, and consequently thirteen pairs of ribs, of which nine are true and four false. The last one on each side is a floating rib, i.e. its cartilage does not join the preceding one. The vertebræ are similar in character to those of the Ungulates. The spinous processes of the first nine slope backwards, the tenth is upright, and the remaining three slope forwards. The tenth is triangular and pointed, the posterior edge of the one preceding and the anterior edge of the one after, leaning against it, with their summits bunched together; the others are more or less equidistant, with considerable intervals between them. The last three dorsal vertebræ carry no posterior facets for articulation with the ribs behind them *(see Plate 5)*. These last ribs, therefore, are only in contact with one vertebra instead of two, which, doubtless, contributes to the greater mobility of this part of the spine in the Carnivora.

The tops of the processes are approximately level as far as the tenth, at which point the long arch of the back and loins, so characteristic of the Carnivora, is seen to commence.

The prominence that is so noticeable in the lion, tiger, &c. in the region corresponding to the withers of the horse is not due to the spinous processes of the dorsal vertebræ, but to the shoulder-blades rising above them. The dog, however, differs from them in this respect, that the top of the shoulder-blade is, as a rule, flush with the spine.

The ribs of the dog and cat are narrower, shorter and more arched than in the Ungulates. They are well separated and very elastic. Being

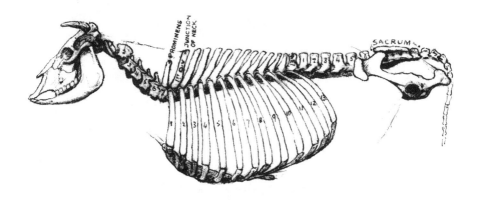

11.

OX
1—8 True ribs.
9—13 False.

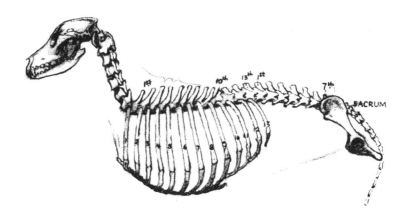

12.

GREYHOUND (Vertebral Skeleton)
9 True ribs.
4 False.

shorter, the joints formed between them and the costal cartilages are situated higher up in the body, and the cartilages are relatively longer than in the Ungulates. These joints may be clearly seen through the skin of a well-conditioned greyhound, as well as through the thicker skin of a lion.

The sternum of the Carnivora is very slender, and consists merely of eight segments of bone joined together, end to end, not unlike the vertebræ of the tail. It has no cariniform cartilage, but the anterior end of the first segment of bone is prominent and visible.

The collar bone or clavicle is to all intents and purposes non-existent in any of the animals we are discussing. A very small floating rudiment is to be found buried in the muscles between the point of the sternum and the point of the shoulder in both dog and cat, where it is function-less and invisible. It is, however, present in its entirety in climbing animals such as the squirrel. In the horse, the only trace to be found is a small tendinous intersection on the front of the mastoido-humeralis muscle.

In conclusion, it should be noted that the whole of the framework of the thorax of the Carnivora is very pliable, as compared with the solidity and immobility of the corresponding region in the Ungulates.

BONES OF THE LOINS. The skeleton of the loins consists of the lumbar vertebræ, of which in the horse there are generally six, although occasion-ally only five are present, the latter number being more usual in Arab horses.

Their chief characteristic is in the development of the transverse pro-cesses; these are long, thin, flat pieces of bone which project hori-zontally and at right angles on each side of the spine, and occupy almost the width of the loins. Of these the third is the longest and the two last the shortest *(see Plate 21, page 116)*. They are deeply buried in muscle, and although their tips come very near the surface, they are seldom visible on the living horse. *In the cow, however, the projecting ends of the first four are frequently very conspicuous.*

The spinous processes are very similar to those of the last dorsal vertebræ; their summits are subcutaneous and quite distinguishable on a lean subject.

The movements in the lumbar region are very limited in all the Un-gulates owing to the size and proximity of both spinous and transverse processes, and the strong ligaments which bind the vertebræ together. A slight amount of flexion occurs, but even this is very restricted.

The Carnivora have seven lumbar vertebræ; these are much longer and the processes slenderer, and consequently wider apart, so that they do not come in contact with each other or interfere with the action to the same extent. Unlike the lumbar vertebræ of the horse, ox, &c. which are, to all intents and purposes level, the loins of the dog and cat are normally arched.

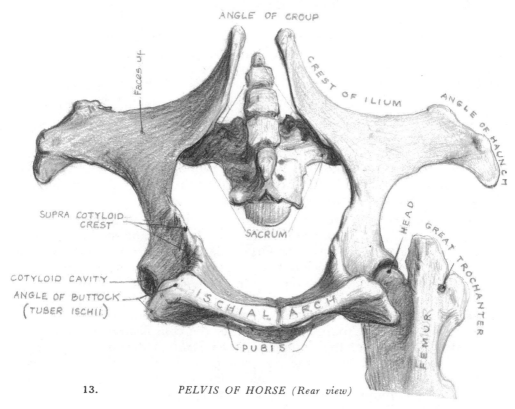

ANGLE OF CROUP

Faces up

CREST OF ILIUM

ANGLE OF HAUNCH

SUPRA COTYLOID CREST

SACRUM

HEAD

GREAT TROCHANTER

COTYLOID CAVITY

ANGLE OF BUTTOCK
(TUBER ISCHII)

ISCHIAL ARCH

PUBIS

FEMUR

13. *PELVIS OF HORSE (Rear view)*

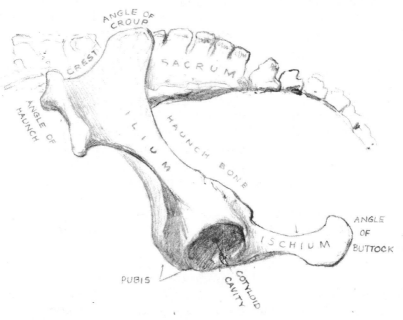

ANGLE OF CROUP

CREST

SACRUM

ANGLE OF HAUNCH

ILIUM

HAUNCH BONE

ISCHIUM

ANGLE OF BUTTOCK

PUBIS

COTYLOID CAVITY

14. *PELVIS OF HORSE (Side view)*

THE CROUP. The Croup, haunches and rump are various terms used to denote the stable part of the hindquarters between the loins and the tail. The skeleton of the croup consists of the Sacrum and the two Haunch Bones, which together form the Pelvis *(see Plates 13 & 14)*.

The *Sacrum* is a single bone resulting from the fusion of five vertebræ. It articulates in front with the last lumbar vertebra and behind with the first vertebra of the tail (both being movable joints), and is firmly united on each side with the haunch or innominate bones. Of the five vertebræ of which it is composed, the first two are the longest and help to form the prominence, which is called the " angle of the croup," the remainder sloping downwards to the root of the tail.

Each *Haunch Bone* results from the consolidation of three separate pieces *(Plates 13 & 14)* named the Ilium, the Ischium and the Pubis. The *Ilium* is the upper, anterior and largest part, and occupies about two-thirds of the length of the pelvis, that is to say, as far back as the Cotyloid Cavity, i.e. the socket on the outer side in which the head of the thigh-bone articulates. In shape it is triangular, with its base—" The Crest of the Ilium "—directed forwards, the inner angle of the Crest forming " the Angle of the Croup," and the outer the conspicuous prominence called " the Angle of the Haunch." The *Ischium* commences at the cotyloid cavity and forms the posterior part of the pelvis, joining its fellow of the opposite side in the middle line below the tail. The tuberosity of the ischium forms the rounded prominence called the " Angle of the Buttock " on each side of the tail. The *Pubis,* the lower section, constitutes the floor of the pelvis, and extends from the cotyloid cavity to the middle line, where it joins the pubis of the other side between the thighs.

Comparative. In all quadrupeds the pelvis is formed by the union of the sacrum and haunch bones, and the relative positions of its several parts are the same. Sometimes a portion may be concealed which in another animal is subcutaneous and vice versa, or the dimensions vary, but there are certain distinctive features which are common to all animals, and which the student should make a point of looking for. -

The first of these is the superior border of the sacrum which, in most animals, is a little below the level of the internal angles of the iliac bones. In the dog and cat, the sacrum is very small, and consists of only three vertebræ. *(Plates 17 & 17a.)*

Secondly, the crest of the ilium and its two extremities—the angle of the haunch and angle of the croup. In the horse, the anterior border or crest of the ilium is concave, the two angles only being subcutaneous and visible. This is also the case in the ox, but whereas in the former the concave border is deeply buried in the Gluteal Muscles, in the latter these muscles are, as a rule, less developed, so that the border can often be traced through them.

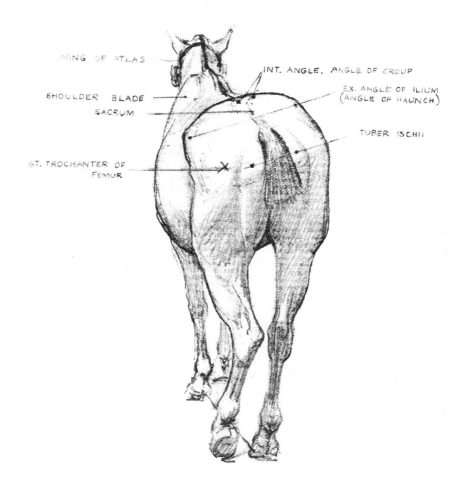

WING OF ATLAS

INT. ANGLE. ANGLE OF CROUP

EX. ANGLE OF ILIUM
(ANGLE OF HAUNCH)

SHOULDER BLADE

SACRUM

TUBER ISCHII

GT. TROCHANTER OF
FEMUR

15. *TO SHOW TILT OF PELVIS OF A HORSE RESTING,*
WEIGHT SUPPORTED ON DIAGONALS

Few horses, if left to themselves, stand equally on all four legs for any length of time. Most of them rest the hind limbs in turn. The Pelvis is then tilted over and the backbone rotating with it causes the whole of the body to swing in the same direction. In most cases the foreleg of the opposite side is at the same time slightly advanced. The weight of the animal is then supported by the other diagonal pair. The ox, when resting, simply advances the hind leg without flexing it, and the pelvis retains its normal horizontal position.

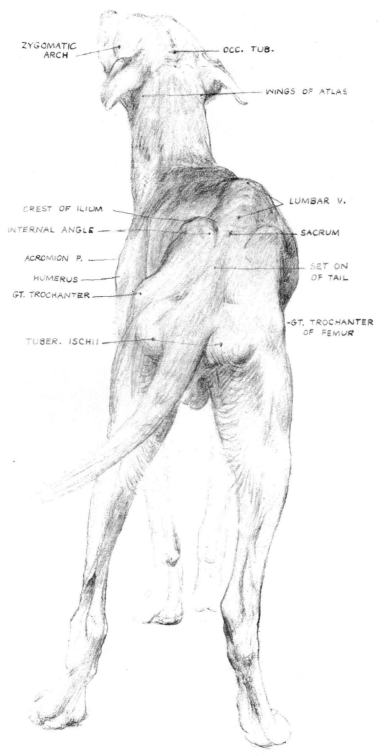

ZYGOMATIC ARCH

OCC. TUB.

WINGS OF ATLAS

LUMBAR V.

CREST OF ILIUM

INTERNAL ANGLE

SACRUM

ACROMION P.

SET ON OF TAIL

HUMERUS

GT. TROCHANTER

-GT. TROCHANTER OF FEMUR

TUBER. ISCHII

16. *PENCIL STUDY OF DOG IN VERY POOR CONDITION,*
ILLUSTRATING BONE FORMS

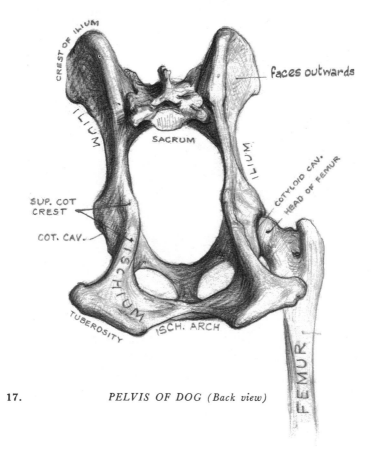

17. *PELVIS OF DOG (Back view)*

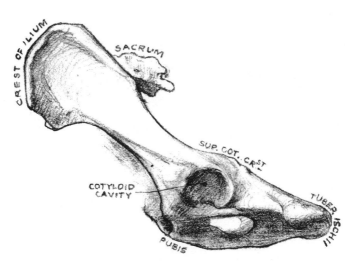

17a. *PELVIS OF DOG (Side view)*

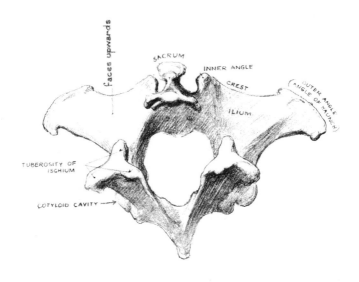

18. *OX. BACK VIEW OF PELVIS*

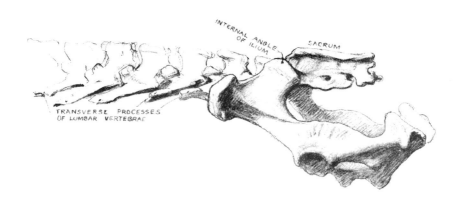

19. *OX*
Pelvis & Lumbar Vertebræ (Side view)

In the horse, the internal angle of the ilium is the highest point of the croup *(see Plate 14)*, slightly exceeding the height of the sacrum. In the ox, the superior border of the sacrum is higher, and the spinous processes are fused together, constituting a conspicuous ridge on the outline. On a lean cow, the internal angles of the crests of the iliac bones can often be seen on each side of the sacrum, but they never rise above it. In both horse and ox the external angle (the angle of the haunch) is very prominent. *(Plates 18, 19 & 20.)*

A third point to notice is the tuberosity of the ischium. This, although prominent in the horse and forming what is known as the angle of the buttock, is not actually subcutaneous, being covered by the prolongation of the semitendinosus muscle, which is attached to the sacrum above. This muscle, however, in the ox, sheep and goat, as also in Carnivora, does not reach above the ischium, so that the bone is entirely subcutaneous in these animals. Consequently, its shape is much more clearly defined in them than in the horse. If we examine the tuberosity of the ischium of a thin cow *(see Plate 20)* from behind, we see three clearly defined prominences, which should not be overlooked.

The pelvis of the ox *(see Plate 19)* is, as a rule, more horizontal than that of the horse *(see Plate 14)*, and the angles of the haunch and buttock more elevated as if they were bent upwards from the cotyloid cavity *(see Plate 19)*. In other words, the angle of the haunch, the cotyloid cavity and the ischium are almost in alignment in the horse, and the whole bone slopes obliquely backwards and downwards, whereas in the ox, a line drawn between the two extremities would pass above the cavity and be approximately horizontal.

In the Carnivora, the crest of the ilium *(see Plates 17 & 17a)* is convex and entirely subcutaneous, and the angles suppressed. As regards the dimensions: the width of the pelvis of the horse and ox is greater in front—i.e. across the angles of the haunches—and narrowest across the ischia. In the dog the reverse is the case, it being narrower in front than behind *(see Plate 17)*. In the lion and most of the cats, the pelvis is narrow and approximately the same width throughout.

It should be noted that in the Ungulates the gluteal surface of the ilium looks upwards, and in the Carnivora outwards *(Plates 13, 17 & 18)*.

THE TAIL. The Tail, the most flexible part of the spine, is composed of the Coccygeal Vertebræ, of which there are generally eighteen in the horse.

The first is the most developed and closely resembles the last segment of the sacrum, with which it generally becomes fused at maturity, thus forming a part of the sacrum itself.

Comparative. The vertebrae of the tail of the ox are proportionately larger than those of the horse, and the processes more developed and frequently clearly defined on the living animal.

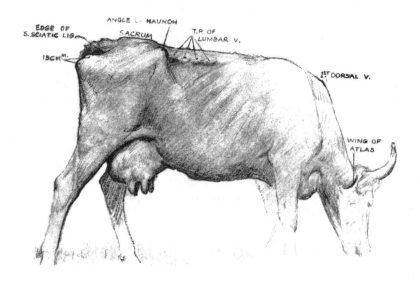

20. *Salient points of Vertebral skeleton as seen in the living animal, which are not affected by the movements of the limbs.*

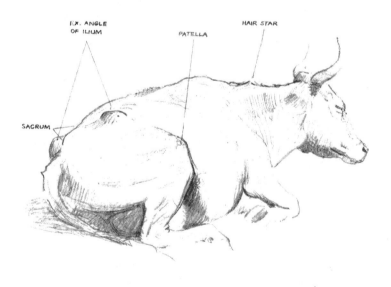

20a. *Note how the top of the neck joins the skull below the horn ridge.*

LIGAMENTS. Wherever bones are in contact to form a movable joint they are kept in place by an elaborate system of ligaments, which, whilst permitting the utmost mobility in certain directions, restrain it in others.

Few of these are superficial, and where they are, they tend rather to disguise the bone form and seldom exhibit any particular shape of their own, so that except for one or two that can be distinctly seen on the joints of the legs, it will not be necessary to describe them.

There are others, however, that may be termed the mechanical ligaments—some of which are elastic and some not—which serve as braces, or checks, of which in the vertebral skeleton the following call for notice : 1. The great elastic ligament of the neck, *Cervical Ligament* or *Ligamentum Nuchæ*. 2. The *Supraspinous Ligament* of the back and loins. 3. The *Sacro-sciatic Ligament*. 4. The Superior *Ilio-sacral Ligament*.

The *Cervical Ligament. (See Plate 3.)* This is perhaps the most important ligament we have to consider. It is composed entirely of elastic tissue, and acts as a powerful brace between the thorax, the skull and the cervical vertebræ. It supports the weight of the head when the animal is at rest without fatiguing the muscles. When the head is lowered, muscular effort is needed, but as soon as the muscles are relaxed this elastic apparatus contracts and helps to bring it back again to its original position. It consists of two distinct parts, a funicular and a lamellar. The *funicular portion,* which is a continuation of the supraspinous ligament of the back and loins (next to be described), leaves the withers at the fourth dorsal spine in the form of two parallel cords, which are attached anteriorly to the back of the occipital tuberosity of the skull. The *lamellar portion (see Plate 3)* is composed of two parallel sheets of elastic tissue united above to the posterior two-thirds of the funicular part, from which they descend in an obliquely forward direction to be attached to the spinous processes of all the cervical vertebræ except the first, and posteriorly to the spinous processes of the first three dorsal vertebræ. It therefore forms a powerful vertical support between the muscles of the two sides.

The funicular portion is visible on the surface, and forms the upper boundary of the muscular part of the neck separating it from the fatty elastic substance above, which constitutes the crest, and from which the mane grows.

Ox. A similar ligament, slightly differing in detail, but even more powerful, is present in the ox. The funicular portion leaves the trunk, however, at the first dorsal spine and not the fourth, as in the horse, which has the effect of shortening the neck and lengthening the body.

Carnivora. In the Carnivora it consists merely of a thin cord or of a few strands of fibrous tissue in continuation of the Supraspinous Ligament, and extending from the first dorsal spine to the spinous process of the axis.

It is deeply buried in the neck and has no influence on the outline.

The *Supraspinous Ligament of the Back and Loins.* This ligament is a thick cord running along the top of the spinous processes and extending from the spine of the sacrum to the fourth dorsal vertebra. Posteriorly it is composed of white inelastic tissue, but as it mounts the withers it becomes elastic and assumes the character of the funicular portion of the cervical ligament into which it merges. It is subcutaneous throughout its length, although muscular development on either

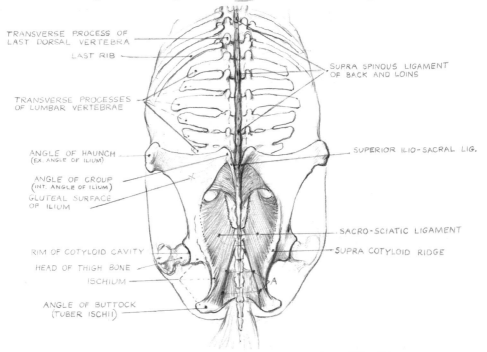

TRANSVERSE PROCESS OF
LAST DORSAL VERTEBRA
LAST RIB

TRANSVERSE PROCESSES
OF LUMBAR VERTEBRAE

ANGLE OF HAUNCH
(EX. ANGLE OF ILIUM)

ANGLE OF CROUP
(INT. ANGLE OF ILIUM)
GLUTEAL SURFACE
OF ILIUM

RIM OF COTYLOID CAVITY
HEAD OF THIGH BONE
ISCHIUM

ANGLE OF BUTTOCK
(TUBER ISCHII)

SUPRA SPINOUS LIGAMENT
OF BACK AND LOINS

SUPERIOR ILIO-SACRAL LIG.

SACRO-SCIATIC LIGAMENT
SUPRA COTYLOID RIDGE

21. *PELVIS & LUMBAR VERTEBRÆ OF THE HORSE, SHOWING THE SACRO-SCIATIC LIGAMENT, &c. SEEN FROM ABOVE*

These ligaments are practically the same in the Ox, in which animal the inner edges connecting the Sacrum with the Tuberosity of the Ischium are often visible.

side of it may cause it to be partially hidden in the profile view. It gives attachment to several muscles of the back and loins.

The *Sacro-sciatic Ligament.* This ligament forms the roof of the Pelvic Cavity and is one of the main braces of the pelvis *(see Plate 21)*.

It is quite invisible in the horse, being completely buried under the muscles of the croup. In the ox and the Carnivora, however, owing to a slightly different arrangement of these muscles *(see Plate 20)*, the edge of that part of the ligament which joins the ischial tuberosity is occasionally to be seen forming the external boundary of a triangular depression above the bone.

The *Superior Ilio-sacral Ligament.* *(See Plate 21.)* This is a thick short ligament which connects the internal angle of the ilium with the summit of the sacrum, where its fibres blend with those of the supra-spinous ligament of the back and loins. The ligaments of the two sides assume the form of the letter V as they converge towards the sacral spine, just behind the angle of the croup.

In conclusion we may mention also the *Pubio-femoral Ligament,* which, although it does not show, has an effect on the action of the thigh which deserves notice. This ligament, which is peculiar to solipeds, binds the upper end of the thigh-bone to the underneath of the pelvis, and therefore limits the outward action of the thigh, which explains why the horse, ass, &c. have not the same power of kicking out sideways that the cow enjoys.

CHAPTER II

THE BONES OF THE HEAD

UNLIKE the other parts of the body in which the skeleton is for the most part buried in muscle and can only be seen on the surface at certain points, the head owes its shape almost entirely to the bones, and except in the regions of the cheeks, nostrils and lips, the form of the skull predominates.

The Skull consists of two distinct pieces: 1. Comprising the Upper Jaw and the Cranium. 2. The Lower Jaw or Mandible, which hinges upon it, and is the only movable part of the skull.

The first part, which is made up of a number of bones inseparably

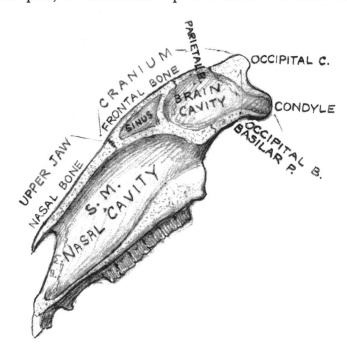

22. *VERTICAL SECTION THROUGH SKULL OF HORSE*

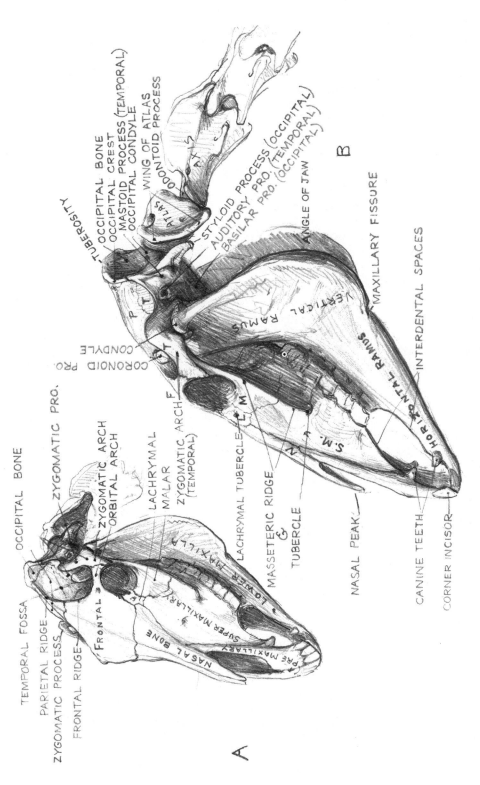

OCCIPITAL BONE (TEMPORAL)
OCCIPITAL CREST
MASTOID PROCESS (TEMPORAL)
OCCIPITAL CONDYLE
WING OF ATLAS
ODONTOID PROCESS

STYLOID PROCESS (OCCIPITAL)
AUDITORY PRO. (TEMPORAL)
BASILAR PRO. (OCCIPITAL)

ANGLE OF JAW

MAXILLARY FISSURE

INTERDENTAL SPACES

VERTICAL RAMUS

HORIZONTAL RAMUS

ATLAS

TUBEROSITY

CORONOID PRO.
CONDYLE

ZYGOMATIC ARCH (TEMPORAL)

S.M.

NASAL PEAK

CANINE TEETH

CORNER INCISOR

B

OCCIPITAL BONE

ZYGOMATIC PRO.

ZYGOMATIC ARCH
ORBITAL ARCH

LACHRYMAL
MALAR

LACHRYMAL TUBERCLE

MASSETERIC RIDGE
&
TUBERCLE

TEMPORAL FOSSA

PARIETAL RIDGE
ZYGOMATIC PROCESS

FRONTAL RIDGE

FRONTAL

SUPER MAXILLARY

LOWER MAXILLARY

PRE MAXILLARY

NASAL BONE

A

HORSE'S SKULL

23.

fitted together like the pieces of a jig-saw puzzle, forms a two compart-
ment case to contain the nasal apparatus and the brain. *(Plate 22.)*

The second part consists of the two sides of the lower jaw firmly and
immovably united at the chin.

The bones which are responsible for the shape of the cranium are the
Occipital, the Parietal, the Frontal and the Temporal Bones. Those of
the upper jaw are the Malar, the Lachrymal, the Nasal, the Super-
maxillary and the Premaxillary Bones.

Bones of the Cranium. The *Occipital Bone* occupies the summit,
the back and part of the base of the skull, the only parts that are visible
being the Occipital Tuberosity (the highest part of the skull) and the
Occipital Crests on either side. The remainder of the bone is concealed
in the neck. It is important to note, however, (1) the *Condyles,* which
articulate with the first vertebra of the neck. (2) the *Styloid Processes*
on either side of them behind the ears, and (3) the *Basilar Process,*
situated at the base of the cranium. *(See Plate 23, Fig. B.)*

The *Parietal Bone* just below and in front of the occipital gives the
convex shape to the upper part of the head, where it forms part of the
roof of the cranium. Arising in the middle line below the occipital
tuberosity are two sharply defined ridges (the Parietal Ridges). At first
parallel, they soon diverge outwards to be continued by the upper edges
of the frontal bone, thus constituting the anterior borders of the temporal
fossæ.

The *Frontal Bone,* or bone of the forehead, is situated below the
parietal, and extends outwardly over the eyes, to form the orbital arches.
The upper edges of these are continuous inwardly with the parietal
ridges just mentioned, and outwardly with the upper borders of the
zygomatic arches, and constitute the lower anterior boundaries of the
temporal fossæ. The junction of the orbital with the zygomatic arch is
at the corner which divides the front from the side of the cranium and
incidentally at the widest part of the head. Practically the whole of the
regions mentioned are subcutaneous.

The *Temporal Bone* consists of two distinct portions, one of which
helps to form the lateral wall of the cranium and is quite invisible within
the temporal fossa. The other external to it is prominent and con-
spicuous, and comprises the zygomatic process and the greater part of
the zygomatic arch.

On the under side of the zygomatic process is the glenoid cavity, which
receives the condyle of the lower jaw to form the temporo-maxillary
joint. Immediately behind is the external auditory process, a small pro-
jecting tube through which communication is established with the
middle ear *(see Plate 23),* and again immediately behind this, the
mastoid process, with its ascending crest, which joins the occipital crest
just above the ear.

If we now go back and follow the upper border of the zygomatic arch, we find that it is continuous with that of the orbital arch; it then rises to form the convexity of the zygomatic process (the prominence upon which the brow band normally rests) and dipping down in front of the ear it finally merges into the occipital crest, thus completing the girdle of the temporal fossa. The whole of this boundary line is practically subcutaneous and therefore of importance to the artist.

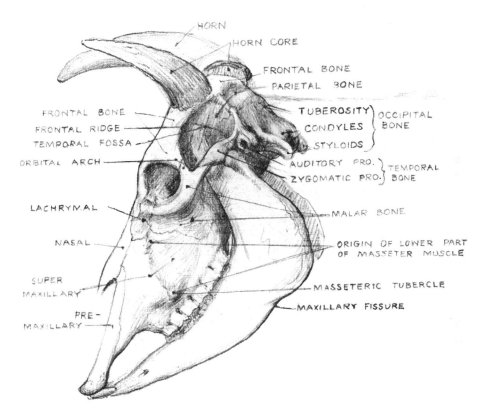

24. *SKULL OF OX IN PROFILE*

BONES OF THE UPPER JAW AND FACE. *The Malar or Zygomatic Bone* is situated on the outer side of the face below and behind the orbit of which it forms a part of the rim. It extends upwards below the zygomatic process of the temporal bone, where it contributes to the formation of the zygomatic arch. Its posterior border, sharp and prominent, is continuous with the under side of the arch, and descends perpendicularly down the side of the face to form the upper two-thirds of the masseteric ridge. The remainder of this ridge being situated on the supermaxillary bone will be referred to in the description of that bone.

Lachrymal Bone. The Lachrymal is a small bone situated below the inner corner of the eye, where it is wedged in between the malar, supermaxillary, nasal and frontal bones. Slightly convex near the rim of the orbit, it is chiefly notable because it carries a small tubercle to which the orbicular muscle of the eyelids is attached, and also because of a small depression, the lachrymal fossa, which, although of little consequence in the horse, is an important feature in Ruminants, forming in some cases a distinct pit below the inner corner of the eye.

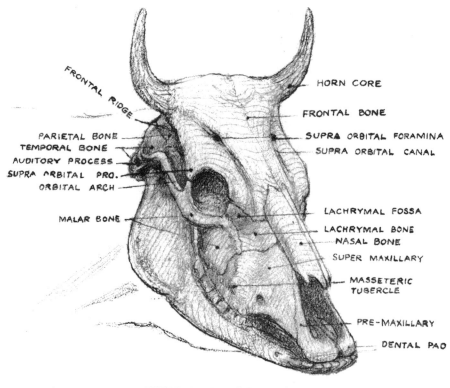

25. *SKULL OF OX (¾ Front view)*

Nasal Bones. A pair of long slender bones forming a narrow triangle running down the front of the face. Widest above, where they join the frontal and the lachrymal bones, they become narrower as they descend, and finally terminate in what is called the nasal peak. A distinct groove marks the junction of the two bones in the middle line of the face. Flat on the front of the head, the outer borders of the nasal bones are rounded and bend over rather sharply to meet the maxillary bones. The nasal bones are visible on the surface throughout the whole of their extent. The outer border of the nasal prolongation is a distinctive feature and forms the upper boundary of the false nostril.

The *Supermaxillary* is the largest bone in the upper jaw and is placed on the outer side of the nasal bone and below the lachrymal and the malar. Its principal features consist of the six large molar teeth which it carries and the maxillary spine, i.e. the continuation of the masseteric ridge already referred to, and which ends ·in the masseteric tubercle. Immediately below this point is a conspicuous convexity caused by the roots of the first three molars (in old age, when the teeth stop growing, the convexity subsides). The remaining three molars and their roots are completely hidden under the great muscle of the cheek. In front of the first molar, the border of the bone becomes thin and arched and

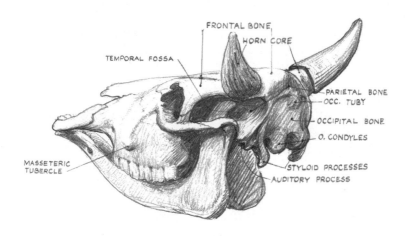

26. *SKULL OF OX (¾ Back view)*

forms the interdental space. It unites with the premaxillary bone a little behind the corner incisor, and in the male, the canine tooth or tusk emerges from between the two bones.

Slightly convex in front of the masseteric ridge, the surface of the bone becomes concave above the interdental space and along the line of its junction with the premaxillary. Comparatively little of this bone, is really subcutaneous, it being more or less covered by the facial muscles. These, however, are mostly thin, and do little to obliterate it.

The *Premaxillary Bone* is situated immediately in front of that last described. It joins its fellow in the middle line, and together they form the front of the upper jaw wherein are placed the six incisor or nipper teeth. Ascending above the corner tooth is a long narrow pillar-like process, which reaches the nasal bone behind its prolongation, and with which it forms an acute angle. This nasal process is an important

feature, and its presence is easily detected on the living animal. It forms the posterior boundary of the false nostril.

LOWER MAXILLA, MANDIBLE OR LOWER JAW BONE. The Lower Maxilla is the only movable part of the skeleton of the head and is composed of two large symmetrical bones. Separated above by the width of the cranium, they gradually converge towards the chin, where they meet and become firmly united in one solid piece which constitutes the body of the bone and forms a kind of shelf on which the tip of the tongue rests. The V-shaped interval between them is called the Intermaxillary Space, and contains the tongue, various muscles, glands, &c.

On the anterior border of the body are implanted the six incisor or nipper teeth, and on each side an inch or so behind them, the canines, or tusks (male only).

Each of the two lateral walls is, for descriptive purposes, divided into two parts—a horizontal and a vertical ramus. (If a jaw bone is placed on a table the applicability of these terms will be evident.)

The *Horizontal Ramus* carries on its superior border the six molar teeth. Between the canine and the first molar is the interdental space corresponding to that of the upper jaw. The surface of the posterior or lower border is smooth and rounded (becoming sharper and more defined in old age) and is practically in a straight line throughout its length. It ends at the *Maxillary Fissure,* a groove in which the facial vein and other vessels pass from one side of the bone to the other, and which limits the boundaries of the rami.

The *Vertical Ramus* bends sharply upwards, is broad and flat, and constitutes the basis of the cheek. The upper end divides into two branches: one—the shorter, external and posterior—ends in the condyle which articulates with the zygomatic process of the temporal bone; the other—internal and anterior—is the coronoid process, which ascends on the inner side of the zygomatic arch into the temporal fossa, constituting the movable insertion of the temporal muscle and easily detected when the horse is eating.

The posterior border of the vertical ramus commences at the maxillary fissure, is at first curved and rather broad, and after rounding the bend which corresponds to the angle of the jaw in human anatomy, it ascends almost perpendicularly until it ends in the condyle. The whole of the edge is subcutaneous, except in so far as it is partly overlapped above by the parotid gland.

A considerable part of the horizontal ramus is subcutaneous and is distinctly visible on the living animal. The whole outline of the lower jaw, from its articulation with the temporal bone to the chin, is due to the shape of the bone, and it should be particularly noted that the masseter muscle does not overlap the edge, as so many painters of horses seem to think.

With regard to the molar teeth it should be mentioned that the dental arches are wider apart and more curved outwards in the upper than the lower jaw, which is if anything slightly bent inwards, so that except when the lower jaw moves from side to side, as in grinding food, the lower molars do not influence the shape in any way.

THE HEAD—COMPARATIVE. *The Ox.* The chief characteristic of the head of the ox is its broad square forehead, due to the abnormal development of the frontal bone and the consequent displacement and modification of some of the others. In the horse, the occipital bone provides the culminating point of the skull, and is visible in the front view. In the ox, the top of the frontal bone is the highest part, and none of the occipital bone can be seen.

The *Occipital Tuberosity* is quite inconspicuous, being fused with the parietal bones at their junction, in the middle line behind the frontal bone *(see Plate 26)*. There are no occipital crests.

The *Frontal Bone* extends over the whole of the front of the upper half of the head, and forms a shield for the protection of the cranium. In the course of its development it has pushed aside the parietal bones and overrun the temporal fossæ. It bends over at the top of the head forming the horn ridge, and unites behind with the parietal bones. From each end a large process—the horn core—is projected. From the base of the horn core a well defined ridge (the Frontal Ridge) then descends and terminates over the outer corner of the eye, where it joins the malar bone and forms the orbital arch. This ridge constitutes the lateral boundary of the forehead, and at the same time forms the anterior rim of the temporal fossa, the latter, owing to the encroachment of the frontal bone, being relegated to the side of the head, and, as compared with the horse, much reduced in size.

It now becomes necessary to draw the readers' attention to two holes on this bone, the *Supra-Orbital Foramina (see Plate 25)* through which some nerves and arteries pass. These are situated nearer the middle line and higher up than in the horse. In themselves of no particular importance to the artist, they do, however, demand his attention, as they determine the course of a rather remarkable groove called the *Supra-Orbital Canal*, which reaches from the horn core almost as far down as the junction of the frontal with the lachrymal bone. Between this canal and the temporal fossa the bone is convex and tapers as it ascends towards the base of the horn.

The *Parietal Bones*, thrust backwards and outwards owing to the aforesaid encroachment of the frontal bone, are situated partly behind the summit of the head, where they form a narrow ledge extending from the base of one horn to that of the other, and partly at the sides of the skull and within the temporal fossæ, where they contribute to the forma-

tion of the external walls of the cranium. There are no parietal ridges.

The *Temporal Bone* is much the same as in the horse. It supplies the upper half of the zygomatic arch, and comprises the articulating surfaces for the reception of the condyle of the lower jaw, the auditory and the mastoid processes.

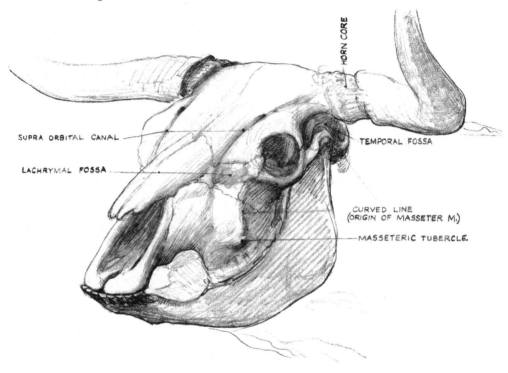

HORN CORE

SUPRA ORBITAL CANAL

LACHRYMAL FOSSA

TEMPORAL FOSSA

CURVED LINE
(ORIGIN OF MASSETER M.)

MASSETERIC TUBERCLE.

27. *BULL'S SKULL FORESHORTENED*

The *Zygomatic Arches* of the ox are slender and straight and less prominent than in the horse.

The *Malar Bone* is well developed, the upper end is forked, the anterior prong joining the frontal bone in the orbital arch, and the posterior articulating with the zygomatic process of the temporal bone, and forming the lower part of the zygomatic arch. The part which corresponds to the malar portion of the masseteric ridge of the horse, and which is continuous with the zygomatic arch, instead of descending perpendicularly in a straight line, curves forward under the outer half of the orbit, where it forms a conspicuous convexity.

The *Lachrymal Bones* carry no tubercles for the insertion of the orbicular muscles of the eyelids. The lachrymal fossa is more extensive and more deeply excavated.

The *Nasal Bones* are prominent, more arched, and narrower **above** and wider below than in the horse.

Supermaxillary Bone (see Plate 24). There is no maxillary spine in continuation of the malar ridges as in the horse for the attachment of the masseter muscle, the lower half of this muscle originating on a rough and

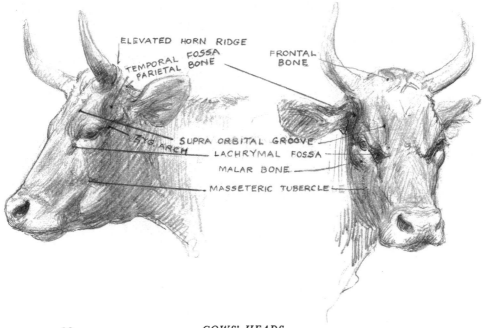

28. *COWS' HEADS*
Illustrating a few points mentioned in the text as seen on living animals.

rather indefinite track, which commences below the inner corner of the orbit, and curves down to terminate in the masseteric tubercle opposite the third molar tooth (approximately the same position as the termination of the masseteric ridge of the horse, with which it corresponds).

The *Premaxillary Bone* carries no nipper teeth, the biting surface being composed of a cartilaginous pad over the end of the bone, and there are no canine teeth in either the upper or lower jaw. In the *Lower Jaw Bone* there are six molars and eight nipper teeth. The lower border is convex (i.e. it will rock if placed on a table) and the angle of the jaw is thrust further back than in the horse. In all other respects it is very similar.

Smaller Ruminants. The skull of the sheep and goat is in many respects very like that of the ox. The frontal bone covers the forehead, but is narrower above, and does not form a ridge between the horns or

constitute the summit of the head. This bone is relatively short, and therefore the horns, when present, and which grow from its upper border, are situated closer to the eyes. They commence their growth in an upward instead of a horizontal direction.

The supra-orbital canal is not prolonged above the foramen. The skull bends backwards at the junction of the frontal with the parietal bones, which extend considerably in rear of the horns. The whole of the upper and lateral surfaces of this posterior portion are formed by the parietal bones, which are very thick and strong, and capable of giving and receiving hard knocks. Flat above and rounded at the sides, where they descend into the temporal fossæ, they unite behind with the occipital bone, the occipital tuberosity inclined backwards forming the apex of the skull, and the occipital crests the extreme posterior border of the visible part.

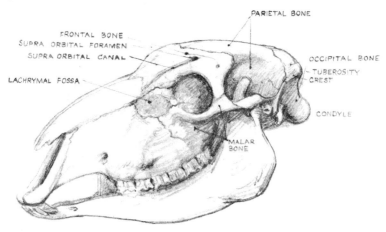

29. *SKULL OF SHEEP*

It should be noted that, in those animals which charge with their heads when fighting, the frontal bone is broad and strong, and the vulnerable temporal fossæ are small and placed at the sides of the head, whereas in those which use their teeth and claws the frontal bone is relatively small, and the temporal fossæ large and exposed in front.

Carnivora (see Plate 22. A.B.C.). In the Carnivora the summit of the head is occupied by the occipital bone, and the occipital tuberosity forms the culminating point, the descending crests on each side dividing the head from the neck. The parietal bones are domed as in the horse.

In the large Carnivora the parietal crests are very strongly developed and close together, forming a straight perpendicular wall down the centre of the forehead until they meet the apex of the frontal bone. There are, however, many variations in their conformation especially among the smaller animals and the dog. In some the crests are widely

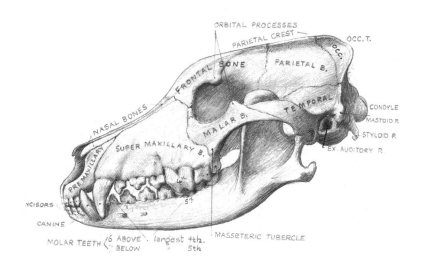

ORBITAL PROCESSES
PARIETAL CREST
OCC. T.
OCC.
PARIETAL B.
FRONTAL BONE
TEMPORAL
CONDYLE
MASTOID P.
NASAL BONES
MALAR B.
STYLOID P.
SUPER MAXILLARY B.
EX. AUDITORY P.
PREMAXILLARY
INCISORS
5th
CANINE
MOLAR TEETH ⎰ 6 ABOVE largest 4th.
 ⎱ 7 BELOW " 5th
MASSETERIC TUBERCLE

SKULL OF IRISH WOLFHOUND

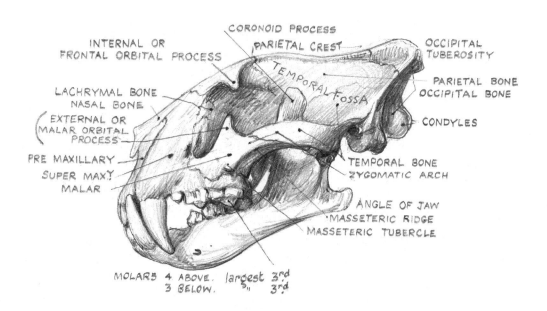

CORONOID PROCESS
INTERNAL OR
FRONTAL ORBITAL PROCESS
PARIETAL CREST
OCCIPITAL
TUBEROSITY
TEMPORAL FOSSA
PARIETAL BONE
OCCIPITAL BONE
LACHRYMAL BONE
NASAL BONE
EXTERNAL OR
MALAR ORBITAL
PROCESS
CONDYLES
PRE MAXILLARY
SUPER MAX.Y
MALAR
TEMPORAL BONE
ZYGOMATIC ARCH
ANGLE OF JAW
MASSETERIC RIDGE
MASSETERIC TUBERCLE
MOLARS 4 ABOVE. largest 3rd
 3 BELOW. " 3rd

30. *SKULL OF LION*

separated, with a more or less flat intervening surface. Sometimes, as in the domestic cat, they are hardly perceptible. Possibly width between the crests may be an indication of superior intelligence as it generally accords with a broad and spherical cranium.

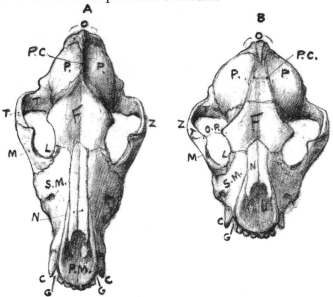

31. A. *SKULL OF LARGE DOG. OVAL CRANIUM. Parietal Crests touching and elevated.*
B. *SKULL OF SMALL DOG. SPHERICAL CRANIUM. Parietal Crests well separated and shallow.*
C. *Canine teeth. F. Frontal bone. G. Gap for reception of lower Canine tooth. L. Lachrymal bone. M. Malar bone. N. Nasal. O. Occipital. O.P. Orbital processes. P. Parietal bone. P.C. Parietal Crests. P.M. Premaxillary bone. S.M. Supermaxillary bone. Z. Zygomatic Arch.*

In the lion, tiger, &c. where the crests of the two sides are in contact, the cranium is narrow and oval shaped, although owing to the prominence of the zygomatic arches and the great size of the temporal muscles the forehead is broad and round, whereas in the dog—especially the smaller breeds—the roundness is more often due to the shape of the cranium than to muscular development.

The *Frontal Bone* is relatively small and unites with the parietal bones in the centre of the forehead. The central and superficial part is lozenge shaped, with a marked depression in the middle line, and bordered above by two ridges which are continuations of the parietal ridges as in the horse, and which diverge outwards until they reach the upper and inner corners of the orbits. Here, instead of continuing by becoming the upper rims of the orbital arches, as they do in the Ungulates, they suddenly bend back to form the inner rims of the orbits, thus making in each case a sharp angle which is called the *Internal* or *Frontal Orbital Process.*

The frontal bone does not extend over the eyes, and consequently there are no bony orbital arches. In their place are two ligaments, the Orbital Ligaments, which bridge the gaps between the frontal and the malar orbital processes.

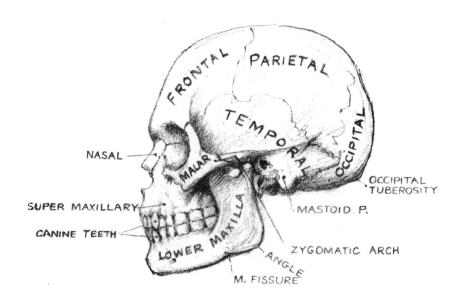

NASAL

SUPER MAXILLARY

CANINE TEETH

OCCIPITAL TUBEROSITY

MASTOID. P.

ZYGOMATIC ARCH

M. FISSURE

32. *SKULL OF MAN*

The *Temporal Bone* differs but little from that of other animals, except that the part which contributes to the formation of the zygomatic arch and rests on the malar bone is very large, and has a strong outward convexity *(see Plate 30)*.

The *Malar Bone* reminds one very much of the same bone in man *(see Plate 32)*. It gives the roundness to the cheek outside and below the eyes, and at the same time frames the outer half of the orbit, above which it divides into two branches, the one, quite short, curls inwards over the corner of the eye, and there ends in the *External* or *Malar Orbital Process*. The other branch is long and tapers backwards beneath the zygomatic process of the temporal bone to complete the formation of the zygomatic arch. The whole of the under part of the arch is therefore furnished by the malar bone.

The inferior border constitutes the masseteric ridge and terminates in a small tubercle above the last molar tooth.

The prominence of the zygomatic arches is characteristic of the Carnivora and accounts for the extreme width of the upper part of the head. Practically the whole outer surface is subcutaneous.

The *Lachrymal Bone* is very small and does not affect the external form in any way, being situated almost entirely within the orbit. There is no lachrymal fossa or tubercle.

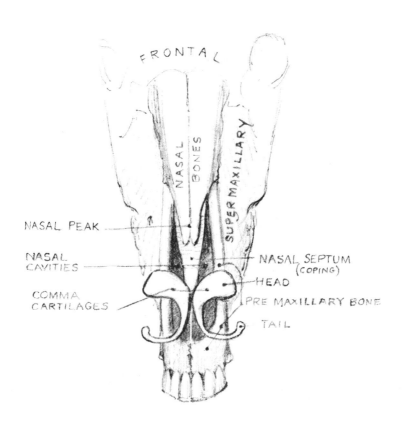

33. *FRAMEWORK OF NOSTRILS*

Supermaxillary Bone. There is no maxillary spine in continuation of that of the malar bone, the masseter muscle arising on the malar bone only. The dental border carries four molars (six in the dog) and one large canine tooth. In short-headed dogs the molar teeth grow very irregularly, sometimes bunched together, or even growing two abreast. There are no interdental spaces. The presence of the long root of the canine tooth is clearly discernible alongside the junction of the super and premaxillary bones.

Premaxillary Bones. The ascending nasal processes, so noticeable in the skull of the horse, are flat and inconspicuous. The premaxillary bones carry six small incisor teeth, of which the two centrals are the

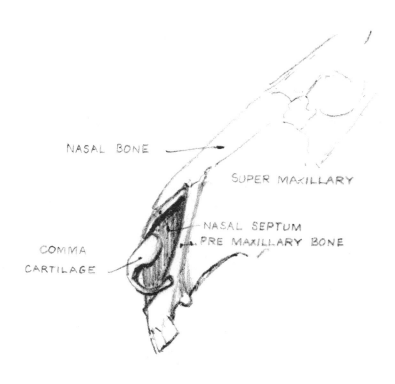

NASAL BONE

SUPER MAXILLARY

NASAL SEPTUM
PRE MAXILLARY BONE

COMMA
CARTILAGE

34. *FRAMEWORK OF NOSTRIL*

smallest and the two outside the largest. A short space intervenes between the outside incisors and the canine teeth in which the canines of the lower jaw are received when the mouth is closed.

Lower Maxilla or Jaw Bone. In the Lower Maxilla the following points should be noted: —

The short distance between the condyle and the angle of the jaw *(see Plate 30)*. The prominence of the angle with its projecting process for muscular attachment. The great size of the coronoid process to which the temporal muscle is attached. The depth and concavity of the ascending ramus, in which the masseter muscle is lodged.

It should also be remarked that at the temporo-maxillary articulation the only movement possible is a hinge action. The Carnivora do not grind their food, and the lower jaw therefore does not move sideways.

THE NOSE AND LIPS. The Nasal Cavity is divided into two compartments by an upright wall of cartilage called the Nasal Septum, which projects forwards beyond the end of the nasal bone, and is attached in front to the premaxillary bones at their junction above the central nipper

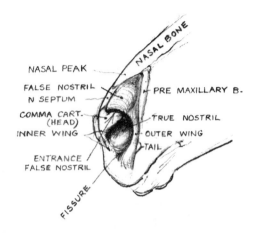

NASAL PEAK

FALSE NOSTRIL
N SEPTUM
COMMA CART.
(HEAD)
INNER WING
ENTRANCE
FALSE NOSTRIL

NASAL BONE

PRE MAXILLARY B.

TRUE NOSTRIL
OUTER WING
TAIL

FISSURE

35. *NOSTRIL*

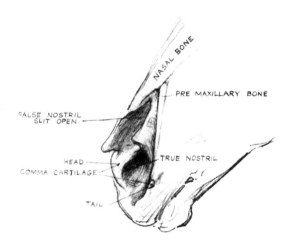

NASAL BONE

PRE MAXILLARY BONE

FALSE NOSTRIL
SLIT OPEN

TRUE NOSTRIL

HEAD
COMMA CARTILAGE

TAIL

36. *DIAGRAMMATIC FIGURE TO SHOW STRUCTURE OF FALSE NOSTRIL, FALSE NOSTRIL SLIT OPEN*

teeth. The upper border of this prolongation spreads out on each side like a coping, and is slightly wider than the nasal peak which rests upon it, and of which it forms a continuation that supports the framework of the nostrils (*see Plates 33 & 34*).

The *Nostrils.* The skeleton of the nostrils consists of two comma shaped cartilages placed back to back and movably attached in the middle line to the anterior extremity of the nasal septum. Each nostril is divided into two compartments, the nostril proper, through which the air passes direct into the nasal cavity, and the *false nostril,* a conical pouch of skin situated above it, and forming a cul-de-sac in the angle between the nasal peak and the premaxillary bone.

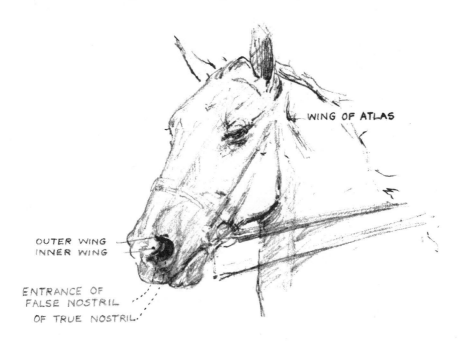

37. *HORSE'S HEAD, NOSTRILS OPEN*

The opening of the true nostril is bordered by two movable wings, covered inside and outside by skin and supported by the comma cartilages, which serve to keep it open. The inner wing is attached to the head and inner half of the cartilage.

The outer wing is united to the cartilage by its extremities only, the upper end being attached to the head of the comma with which it forms the internal angle or upper commissure of the nostril, the lower end joining the tail, the blunt tip of which can always be felt and generally seen immediately behind the pendulous lobe with which this wing terminates. In the relaxed state, the lobe of the outer wing meets the lower end of the inner wing and a relatively deep fissure is formed between them, but, when the nostril is dilated, the fissure widens out and is to a great extent obliterated.

Lips. Animals employ different methods of taking hold of their food. The horse, camel, sheep and goat, for instance, use their lips, the ox his tongue, and the Carnivora seize it with their teeth. Consequently we find considerable variation in the character of the lips.

The lips of the horse, &c. are very sensitive and very mobile; of the ox, thick and inert, and of the Carnivora, thin, limp and pendulous.

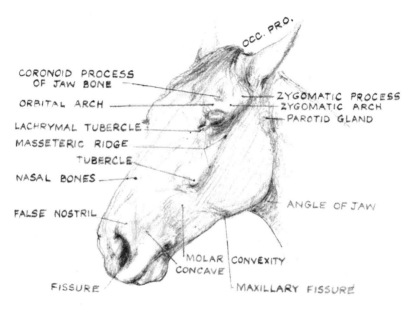

38. *HORSE'S HEAD, NOSTRILS CLOSED*

To illustrate a few of the points mentioned in Chapter II. as seen on the living animal.

With regard to the horse, perhaps the most remarkable feature is the curious development of the anterior portion of the upper lip, constituting an almost independent prehensile organ. We see it in action when a horse is grazing, or as it takes a piece of sugar from the hand of its mistress, when clearing up its manger, and on many other occasions. Shaped more or less like a kidney and divided below into two lobes, it is endowed with extraordinary mobility, and can be stretched out in front and moved from side to side.

In the sheep, camel, rabbit, &c. the two lobes are actually separated by a fissure, which enables the two halves to act independently of each other.

The lips are composed of muscular tissue and membrane and meet in the commissure which forms the angle of the mouth. They are surrounded by a continuous muscle which is not attached to any bone. This muscle *(orbicularis oris)* by its contraction, reduces the opening of the mouth and compresses the lips, and is the cause of the transverse wrinkles with which the otherwise smooth and rounded surface is broken up.

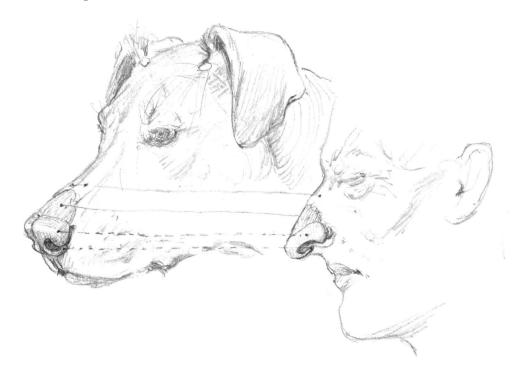

39. *NASAL CARTILAGES OF DOG COMPARED WITH MAN'S*

The anterior part of the lower lip is also very mobile. Underneath, and embedded between its borders, is the rounded prominence of the chin, a fibromuscular pad, generally called the tuft of the chin.

In the ox and those animals in which the nostrils and the anterior portion of the upper lip are combined to form the muffle, the lip is immovable, and the tongue, being employed for collecting the grass, is developed accordingly. The lips alone are incapable of picking things up.

The muffle of the ox is devoid of hair, moist, and either black or flesh coloured according to the breed. The tuft of the chin is large but not as distinct from the lower lip, as is the case in the horse. The tongue is very long and muscular.

The lips in Carnivora are thin and loose and the orbicular muscle very little developed. The upper lip as a rule falls over the lower lip. A peculiarity in the dog is that the lower lip is scalloped near the angle of the mouth *(see Plate 53)*.

In the Carnivora the mouth opens very wide—an obvious necessity—considering what their natural food consists of and how they kill, carry, and devour it.

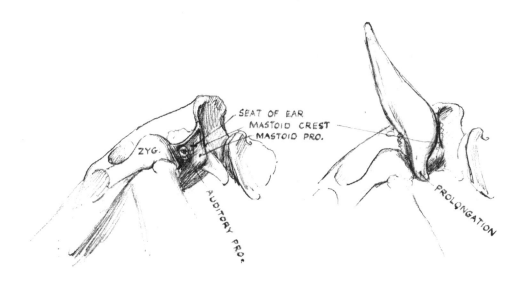

40. *The Mastoid process is not prominent, but being near the surface can easily be felt through the soft tissues behind the base of the ear. The Mastoid crest, however, is of more consequence as it forms the dividing line between ear and neck and affords attachment to important muscles.*

THE EAR. The Ear is a cartilaginous structure with a hollow base ending in a short funnel which leads down to the auditory process of the temporal bone. Three separate pieces contribute to its formation, namely the *Conchal*, the *Annular* and the *Scutiform Cartilages*.

The *Conchal Cartilage* is the largest and is entirely responsible for the visible shape. It is, in fact, the ear itself. Somewhat resembling a shell, it is composed of a more or less triangular sheet rolled upon itself in such a way as to form the funnel below, and at the same time, by bringing the two sides of the triangle together to frame the elliptical opening which gives entrance to the ear. The outer rim curves uninterruptedly from the apex to the base of the opening. The inner rim, on the other hand, is at first slightly bent inwards and then curves boldly outwards before rejoining its fellow.

The cartilage surrounding the base is firm and strong, becoming thinner and more flexible above and at its edges. It is to the lower and more rigid part that most of the muscular attachments are made.

On the outer side of the ear the cartilage is prolonged like a tongue over the annular cartilage and terminates beneath the **upper extremity** of the parotid gland.

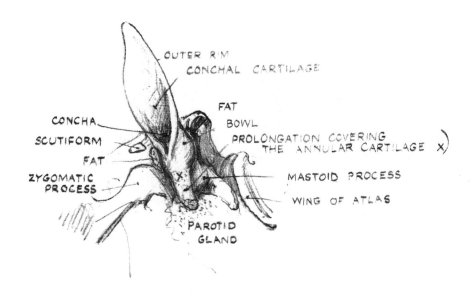

OUTER RIM
CONCHAL CARTILAGE
FAT
CONCHA
BOWL
SCUTIFORM
PROLONGATION COVERING
THE ANNULAR CARTILAGE X
FAT
ZYGOMATIC
PROCESS
MASTOID PROCESS
WING OF ATLAS
PAROTID
GLAND

41. *The bowl of the ear rests on a cushion of fat, which ensures its free movement.*

The *Annular Cartilage* is merely a small ring surrounding the end of the auditory process. It is itself partly enclosed within the terminal funnel of the concha, so that together they make a telescopic connection with the skull of great flexibility.

The *Scutiform Cartilage* is a small isolated plate lying on the surface of the temporal muscle in front of the base of the concha, where it serves as an intermediary between some of the ear muscles which arise on the surrounding crests, and the ear itself. It is not very conspicuous, but its position should be noted because it is the fixed point from which the ear derives most of its forward movements.

The *Auditory Process* (External Auditory Meatus or Canal) is a small tube of bone through which communication is established with the middle ear. Its upper extremity projecting upwards and a little forwards may be seen on the skull in the dip between the zygomatic and the mastoid processes *(see Plate 40).*

The ear is a very sensitive and mobile organ by means of which most of the emotions of dumb animals are expressed. Of facial expression in the human sense there is very little.

The general shape and proportions, as well as the degree of rigidity of the cartilages, vary considerably in different animals, although the same details of structure are preserved.

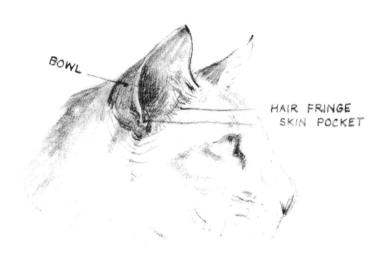

BOWL

HAIR FRINGE
SKIN POCKET

42. *DOMESTIC CAT, SHOWING SET ON OF EAR*

In the ox the ears are large and wide open, and when directed for-wards extend horizontally, only approaching the upright position when directed sideways or backwards in rear of the horns.

In the Carnivora the rims of the opening do not meet below as they do in the horse, but are set widely apart on the skull. For this reason the interior of the ear is more exposed than in the Ungulates.

In the domestic cat, the ear is short and broad and culminates in a sharp point.

In both dog and cat a curious little pocket, caused by the folding over of the skin, is generally present on the outer rim near the base, which should be noted, but of which no explanation is forthcoming.

In the dog, there is endless variety; some breeds are prick-eared, in others the upper part falls over in front; whilst in the bloodhound, beagle, &c. the ear is wholly pendulous, and yet when lifted, spread out

and examined, their similarities are clearly recognizable. The way in which the ear is carried greatly depends on the degree of firmness of the cartilage, the strength of the supporting muscles, and in great measure on the size and weight of the ear itself.

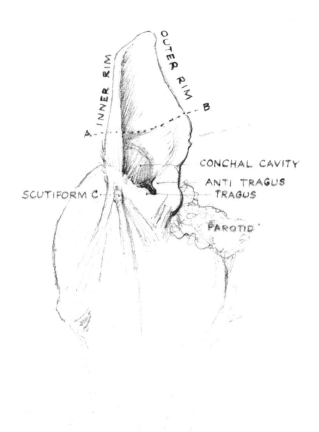

43. *EAR OF DOG, OPENED OUT TO SHOW ITS ACTUAL SHAPE*

The dotted line AB indicates the approximate position of the bend when the upper part falls over.

I have seen it stated somewhere that timid animals are as a rule prick-eared. Be this as it may, I have certainly come across a great many with prick ears that were extraordinarily plucky and pugnacious, and an equal number with flop ears that were great cowards. I think, perhaps,

Dogs.

44.

it would be more to the point to say that prick ears denote alertness and that the drooping ears suggest a placid nature. In animals which are always looking about them the ear muscles become highly developed, and the drooping ear may possibly be accounted for to some extent by the under development of these muscles.

It is, however, impossible to give adequate anatomical reasons for many of the variations which occur in different animals. The best plan for the student to adopt is to make innumerable careful pencil drawings of those parts which he finds it difficult to understand, to look out for features that repeat themselves on different subjects, and in this way he should soon learn to distinguish between the constant and the accidental.

CHAPTER III

MUSCLES OF THE HEAD

INTRODUCTORY. The *Muscles* are the fleshy parts of the body (i.e. the lean meat) which by contraction produce the power that moves the bones. The *Tendons* are the inextensible fibrous cords and bands by means of which the muscles are attached to them.

Aponeurosis and *Fascia* are synonymous terms used to denote the tendinous tissues enveloping the muscles and other structures. *Membrane* is another term applied to tissues of a similar character, but generally employed with reference to the linings and coverings of the more delicate organs.

Every muscle consists of bundles of fleshy fibres which contract under the influence of the motor nerves. The more stable attachment of a muscle is called the origin, the more movable the insertion.

Many muscles are split up into two or more portions, or " bellies " with different insertions. The muscle as a whole, as well as its sub-divisions, is wrapped up in *fascia* which, being adherent to the skeleton in many places, keeps it in position.

The swelling and shortening of a muscle in action completely alters its character. There is a very well known anatomical cast of a horse in which all the muscles and their subdivisions are equally emphasized irre-spective of what they are supposed to be doing, all apparently exerting their power with the same force. We draw attention to this because it is a very common fault with painters and sculptors who have a certain amount of anatomical knowledge and wish to display it, to make all the muscular forms equally distinct without taking into consideration the fact that they vary in shape and volume according to whether they are in action or not. When a muscle contracts it bulges, and the amount of shortening depends upon the force applied. Muscle has the capacity of contracting about one quarter of its length, so that its scope of action is in proportion to that length. The strength of a muscle is determined by the number of fibres it contains, i.e. its volume.

A cast of an animal taken after death, or a cast from a dissection, should be used with discretion. Such a cast, although it may look very life-like to the casual observer, may be very misleading to an artist unless he can visualize the effect that action would have had on the living

muscles. Dead muscles are inactive, and the mere fact of bending a limb after death will not produce the form of the living. The flesh no longer contracts and expands, but being flabby and inert is simply compressed into a shapeless mass, and at the same time the tendons are loosened instead of being taut.

To an artist, however, who knows what the absence of life means to the muscle, such a cast is of inestimable value. The bones do not change, he can verify them, and he is able to see exactly where and how the tendons are attached, and if he is a student of nature he will be able to visualize the muscular form; but he should never sit down and slavishly copy it into his work under the impression that it is a true representation of living nature.

Nomenclature of the Muscles. Certain difficulties present themselves with regard to the naming of the muscles. As far as possible, of course, it is convenient to employ those used in human anatomy, as it enables the student who has some knowledge of that branch of the subject to identify them. A great many of the human names are obviously inappropriate and others have been substituted. Even so, there are still a few for which the human names are employed regardless of their unsuitability.

In the horse we shall find a few important muscles which at first sight seem to have no obvious analogies in the human body. These have acquired names of their own. Such, for instance, are the great Mastoido-humeralis muscle of the neck and the Long Vastus in the hind limb.

In different books we often find different names applied to the same muscle. In the following chapters we shall endeavour as far as possible to use the names by which the muscles are best known in animal anatomy, giving in brackets some of the more familiar synonyms.

MUSCLES OF THE HEAD

Deep Layer.	Horse Plate		Ox Plate	Dog Plate
Temporalis 46		51	49B
Deep Buccinator (Molaris)	... 46		52	49C
Orbicularis Oris 46		—	—
Depressor Labii Sup. Inf.	... 46		—	—
Levator Labii Sup. Prop.	... 47		52	49C
Transversalis Nasi 46		—	—
Dilatator Naris Lateralis	... 47	caninus	52	49C
Orbicularis Palpebrarum	... 46		52	49C
Corrugator Supercilii 46	frontalis	52	—
Eye. Lids.				
Nictitans Membrane ...	46		—	—
Caruncula Lachrymalis				

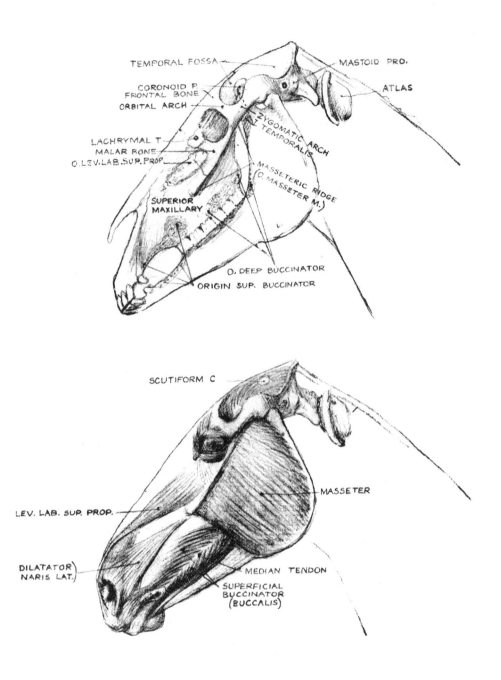

TEMPORAL FOSSA

MASTOID PRO.

CORONOID P.
FRONTAL BONE

ATLAS

ORBITAL ARCH

ZYGOMATIC ARCH
TEMPORALIS

LACHRYMAL T.
MALAR BONE
O. LEV. LAB. SUP. PROP.

MASSETERIC RIDGE
(O. MASSETER M.)

SUPERIOR
MAXILLARY

O. DEEP BUCCINATOR

ORIGIN SUP. BUCCINATOR

SCUTIFORM C

MASSETER

LEV. LAB. SUP. PROP.

DILATATOR
NARIS LAT.

MEDIAN TENDON

SUPERFICIAL
BUCCINATOR
(BUCCALIS)

HORSE'S HEAD. DE

45. *Bone Formation & Muscle origins.*

47. *Middle Layer.*

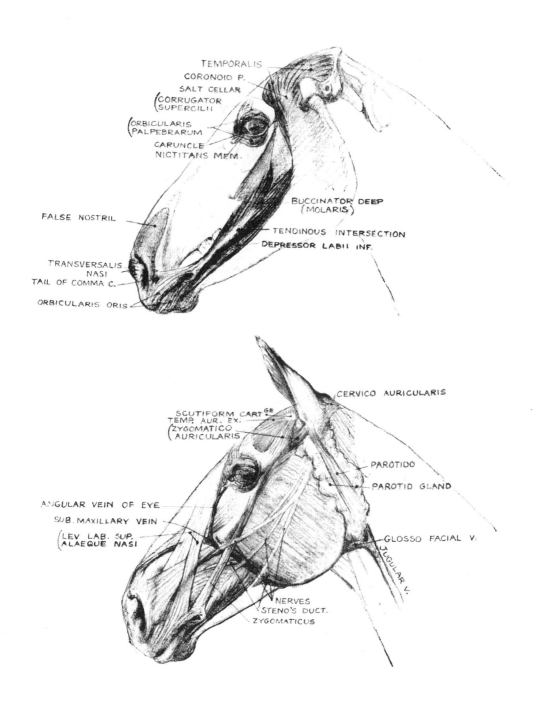

TEMPORALIS
CORONOID P.
SALT CELLAR
(CORRUGATOR
(SUPERCILII
(ORBICULARIS
(PALPEBRARUM
CARUNCLE
NICTITANS MEM.

BUCCINATOR DEEP
(MOLARIS)
TENDINOUS INTERSECTION
DEPRESSOR LABII INF.

FALSE NOSTRIL

TRANSVERSALIS
NASI
TAIL OF COMMA C.

ORBICULARIS ORIS

CERVICO AURICULARIS

SCUTIFORM CART GE
TEMP. AUR. EX.
(ZYGOMATICO
(AURICULARIS

PAROTIDO
PAROTID GLAND

ANGULAR VEIN OF EYE
SUB. MAXILLARY VEIN
(LEV. LAB. SUP.
(ALAEQUE NASI

GLOSSO FACIAL V.
JUGULAR V.

NERVES
STENO'S DUCT.
ZYGOMATICUS

PERFICIAL MUSCLES

. Deep Muscles. Zygomatic Arch re-
d to show the attachment of the Temporal
cle.

. Final Muscles.

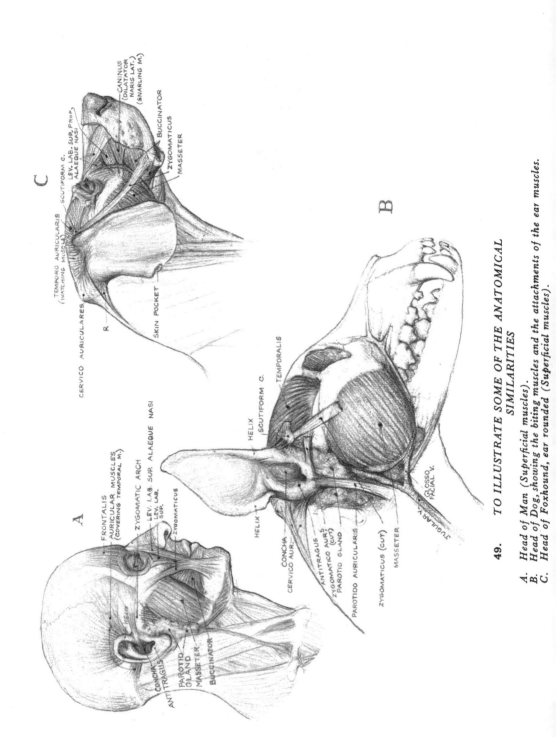

C

TEMPORO AURICULARIS
(WATCHING MUSCLE)

SCUTIFORM C.

CANINUS
(DILATATOR
NARIS LAT.)
(SNARLING M.)

LEV. LAB. SUP. PROP.
ALAEQUE NASI

BUCCINATOR

ZYGOMATICUS

MASSETER

R.

CERVICO AURICULARES

SKIN POCKET

A

FRONTALIS

AURICULAR MUSCLES
(COVERING TEMPORAL M.)

ZYGOMATIC ARCH

LEV. LAB. SUP. ALAEQUE NASI
LEV. LAB.
SUP.

ZYGOMATICUS

HELIX

CONCHA

ANTITRAGUS

PAROTID
GLAND

MASSETER

BUCCINATOR

B

HELIX

HELIX

SCUTIFORM C.

TEMPORALIS

CONCHA
CERVICO AUR.

ANTITRAGUS

ZYGOMATICO AUR.S
(CUT)

PAROTID GLAND

PAROTIDO AURICULARIS

ZYGOMATICUS (CUT)

MASSETER

JUGULAR V.

GLOSSO-
FACIAL V.

**49. TO ILLUSTRATE SOME OF THE ANATOMICAL
SIMILARITIES**

A. *Head of Man (Superficial muscles).*
B. *Head of Dog, showing the biting muscles and the attachments of the ear muscles.*
C. *Head of Foxhound, ear rounded (Superficial muscles).*

Superficial.

Superficial Buccinator	47	52	—
Masseter	47	51, 52	—
Levator Labii Superior :				
alaeque Nasi	48	52	49C
Zygomaticus	48	52	49C
Zygomatico-auricularis	...	48	52	49B
Temporo-auricularis	48	52	49
Cervico-auricularis	48	51	49B, C 50
Parotid Gland	48	52	49B
Parotido-auricularis muscle	...	48	51A, 52	49B
Superficial nerves, veins, &c.	...	48	—	—

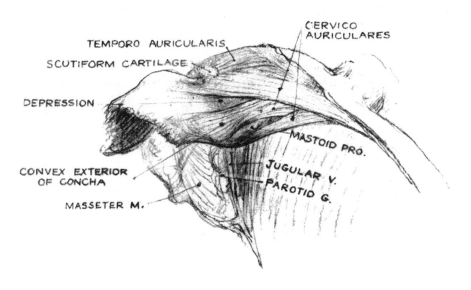

50. *EAR MUSCLES OF DOG, from behind*

MUSCLES OF THE HEAD, DEEP LAYER (HORSE). *Temporalis.* This is one of the chief biting muscles and arises from the whole of the temporal fossa and its surrounding crests. It is inserted on the coronoid process and the anterior border of the vertical ramus of the lower maxilla.

Its chief function is to elevate the lower jaw and close the mouth. It also assists in the lateral movements of the jaw.

A conspicuous hollow (nicknamed the " Salt Cellar ") results from the convergence of the frontal, orbital and zygomatic portions of the muscle to their attachments on the front of the coronoid process, which is very noticeable when a horse is munching his corn.

In the Carnivora the biting muscles are strongly developed. The temporalis is very massive and completely fills the temporal fossa, giving the broad rounded appearance to the upper part of the head, which is so well exhibited in the tiger, lion, &c.

In the ox and other Ruminants the temporal muscles are relatively small and face outwards in conformity with the bone structure.

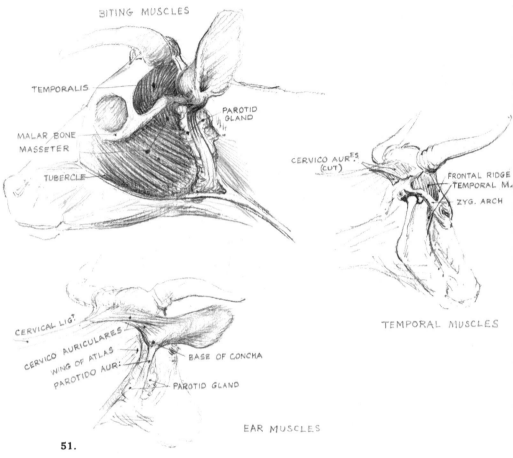

BITING MUSCLES

TEMPORALIS

PAROTID GLAND

MALAR BONE
MASSETER

CERVICO AUR^{ES} (CUT)

TUBERCLE

FRONTAL RIDGE
TEMPORAL M.

ZYG. ARCH

CERVICAL LIG^T

CERVICO AURICULARES
WING OF ATLAS
PAROTIDO AUR.

BASE OF CONCHA

PAROTID GLAND

TEMPORAL MUSCLES

EAR MUSCLES

51.

Buccinator (Alveolo Labialis). This muscle is situated at the side of the face, and consists of two planes, a deep and a superficial (sometimes described as separate muscles and named respectively Molaris and Buccalis).

The *deep plane* (Molaris) *(see Plates 45 & 46)* arises by two heads (1) from the supermaxillary bone above the last three molars, and (2) from the anterior border of the vertical ramus of the lower jaw, just behind the last molar tooth, and is inserted into the orbicularis muscle at the angle of the mouth. Excepting the tendon of insertion none of the

deep muscle is visible, the upper part being completely hidden beneath the masseter muscle, and the lower part covered by the buccalis.

The *superficial plane* (Buccalis) *(see Plate 47)* consists of two muscular portions, an anterior and a posterior, originating one on the upper jaw, the other on the lower, which converge and are inserted on a tendinous intersection in the middle line of the deep portion *(see Plate 46)*.

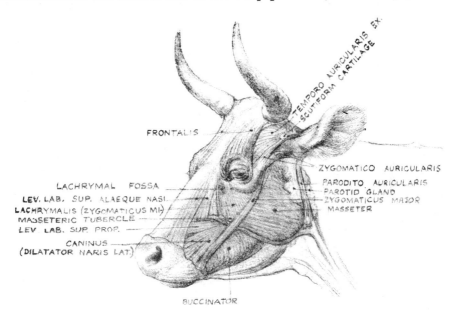

FRONTALIS

TEMPORO AURICULARIS EX.
SCUTIFORM CARTILAGE

ZYGOMATICO AURICULARIS
PARODITO AURICULARIS
PAROTID GLAND
ZYGOMATICUS MAJOR
MASSETER

LACHRYMAL FOSSA
LEV. LAB. SUP. ALAEQUE NASI.
LACHRYMALIS (ZYGOMATICUS MI)
MASSETERIC TUBERCLE
LEV. LAB. SUP. PROP.
CANINUS
(DILATATOR NARIS LAT.)

BUCCINATOR

52. *SUPERFICIAL MUSCLES*

The anterior part arises on the supermaxillary bone above the first molar tooth and from the interdental space, the posterior from the interdental space only of the lower maxilla.

The function of the buccinator muscle is to press the food between the molar teeth when eating. It is not a biting muscle and takes no part in moving the jaw. It adds fullness to the cheek below the masseter muscle, and a slight depression in the middle line generally indicates the position of the tendinous intersection, which is most noticeable when the muscle is in action.

This muscle is well developed in all Ruminants and very noticeable in a cow that is chewing the cud.

In the Carnivora, the buccinator is relatively thin. The buccal and molar portions are not superposed but combine to form a single muscle consisting of one plane only *(see Plate 49)*. The posterior border is generally clearly defined.

Orbicularis Oris (Labialis). This muscle forms a ring round the mouth and shapes the lips. It is not attached to any bone and

has neither beginning nor ending *(see Plate 46)*. It may be considered as consisting of two parts, the one for the upper, the other for the lower lip, which meet at the corners of the mouth. By contracting it closes the mouth.

It is well developed in those animals which grip their food with their lips or suck their drink (such as the horse and ox) but is very rudimentary in the Carnivora, which employ teeth and tongue for these purposes.

Depressor Labii Inferioris (see Plate 46). This muscle lies alongside the posterior border of the buccinator with which it is intimately connected at its origin on the ramus of the lower jaw. It is inserted by a tendon into the lower lip, which as its name implies, it depresses, and if acting alone it draws to one side. The tendon shows quite clearly on the horse as it proceeds to its insertion between the lip and the chin, but is either absent or very rudimentary in most other animals, in which the muscle is generally confounded with the buccinator throughout its length.

Levator Labii Superioris Proprius (see Plates 45 & 47). Arises from the surface of the supermaxillary and malar bones. Its tendon crosses the upper end of the false nostril and joins its fellow below the nasal peak. The united tendons, after passing over the transverse muscle of the nose, spread out fanwise to be inserted into the thick anterior part of the upper lip. When the muscles of the two sides act together they raise the lip and when acting singly they draw it to one side or the other. This is a fairly thick muscle, showing clearly on the living animal, and the tendon is usually well defined, especially when a horse is grazing. In the ox *(see Plate 52)* and the Carnivora *(see Plate 49c)* it arises from the supermaxillary bone only.

Transversalis Nasi. A thick short muscle connecting the upper ends of the comma cartilages. It is covered by the tendon of the preceding muscle. By contracting, it draws the comma cartilages towards the middle line, dilating the nostril inwardly *(see Plate 46)*. Absent in the ox and Carnivora.

Dilatator Naris Lateralis (Caninus) (Gt. Supermaxillo-Nasalis). A thin triangular muscle situated on the side of the face. It arises on the supermaxillary bone just below the masseteric tubercle and spreads out to its insertion over the external wing of the nostril, some of its posterior fibres being attached to the tail of the comma cartilage, and others intermingling with the orbicularis muscle of the mouth *(see Plate 47)*.

The posterior edge of this muscle is generally well defined on the living subject. In the ox, &c. this muscle divides into three parts, the superior passing under the anterior branch of the Levator Labii Superioris Alæque Nasi and terminating behind the nostril, the inferior portions being inserted in the texture of the upper lip *(see Plate 52)*. In Carnivora it is undivided and blends with the special elevator of the

upper lip. It goes to the upper lip only (a snarling muscle) *(see Plate 49c)*.

Orbicularis Palpebrarum (see Plate 46). This is a sphincter muscle extending round the margin of the orbit, with a fixed attachment on the lachrymal tubercle. By contracting, it closes the eye.

Corrugator Supercilii (see Plate 46). A small triangular muscle arising on the frontal bone and joining the orbicularis palpebrarum above the upper anterior corner of the eye. It draws the orbicularis muscle upwards and wrinkles the skin but has no effect upon the eyelids, which have a special muscle to operate them situated within the orbits. In the ox this muscle forms part of the frontal muscle, which covers the greater part of the forehead *(see Plate 52)*.

The *Eyelids* are membranous structures covered by the skin and bordered by a fibrous rim on which the eyelashes grow. The rims meet to form the inner and outer corners of the eye, the outer corner forming an acute angle and situated higher up than the inner, which is more open and lodges the caruncle. When not excited the edge of the upper lid is almost straight and horizontal, that of the lower being concave upwards.

Nictitans membrane or third eyelid (see Plate 46). Situated at the inner corner of the eye, it is of a brownish colour and generally visible. It can be drawn across the eyeball to remove any foreign matter from the surface.

Caruncula Lachrymalis (see Plate 46). A small round membranous pad, situated in the extreme corner of the inner angle of the eye, generally of a dark colour.

Eyelashes. Much more numerous in the upper than the lower lid, which has the effect of softening the edge of the upper lid contrasting it with the sharp naked edge of the lower.

MUSCLES OF THE HEAD. SECOND LAYER, SUPERFICIAL. *Masseter* (Horse) *(see Plate 47)*. A very important masticatory muscle. It is very evident on the surface, occupying as it does a large part of the side of the head. It consists of superposed planes and is divided into several different bellies. It is covered for the most part by a thick aponeurosis, and finally a number of distinctly visible nerves pass perpendicularly over the surface to be lost among the muscles of the lower part of the face *(see Plate 38)*. This muscle arises from the whole length of the masseteric ridge and inferior border of the zygomatic arch and is inserted on the external surface of the vertical ramus of the lower jaw. In conjunction with the temporalis muscle it raises the lower jaw and closes the mouth.

In the ox, neither the masseter nor the temporalis are as much developed as in the horse *(see Plates 51 & 52)*. In the Carnivora *(see Plate 49B)* the masseter is very strong, and although not occupying so

large an area, is very much thicker and externally more convex in contradistinction to the flatter surface which this muscle presents in the horse.

Levator Labii Superioris Alæque Nasi (Horse) *(see Plate 48)*. A thin broad muscle divided into two portions, an anterior and a posterior, between which the lateral dilator of the nostril passes. It arises by an aponeurosis from the frontal and nasal bones in front of the eye. The anterior and widest portion is inserted on the outer wing of the nostril underneath the lateral dilator and on the antero-lateral part of the upper lip, where it mixes with the orbicularis muscle, the posterior portion, after passing over the lateral dilator, being inserted a little in front of the corner of the mouth where, like its fellow, it is again confounded with the orbicularis muscle. This muscle has little visible effect, and except in so far as it simplifies the surface over which it passes, is practically indistinguishable until it nears the corner of the mouth.

Its disposition in the Ruminants differs somewhat from that which we find in the horse *(see Plate 52)*. It divides into two branches, of which the anterior is the larger, and passes over both the levator labii superioris proprius and the lateral dilator of the nostril, whilst the posterior, little developed, passes beneath them to be inserted on the upper lip. Its name sufficiently describes its action.

In the dog and cat *(see Plate 49c)* the anterior portion is the larger, and passing over the special elevator of the upper lip disappears under the whisker bed. The posterior division is quite rudimentary. It is quite unimportant so far as the shape is concerned, in fact all the superficial muscles of this region combine to obscure the underlying forms, and so to simplify the surface and present no definite features in themselves. It helps to raise the upper lip and uncover the canine tooth, and in so doing wrinkles the skin over the nose.

Zygomaticus (Zygomatico-labialis) *(see Plate 48)*. A thin ribbon-like muscle arising from the masseteric ridge and the surface of the masseter muscle a little below the level of the eye and terminating on the orbicularis muscle at the corner of the mouth. It draws back the corner of the mouth.

It is more developed in the ox and arises higher up, i.e. from the zygomatic arch behind the eye, where it is almost in continuation with the zygomatico-auricularis muscle. In the cat and dog these two are actually united and form a single muscle reaching from the scutiform cartilage to the mouth. It corresponds to the great zygomaticus of man (one of the principal laughing muscles).

Parotid Gland. This salivary gland is a rather important feature which it is necessary to explain before we deal with the ear muscles *(see Plate 48)*. It is rather like a sponge placed in the hollow between the jaw and the wing of the atlas bone, it spreads over the upper edge of

the jaw-bone and reaches above it as far as the root of the ear, whilst its lower border is enclosed in the angle between the jugular vein and the glosso-facial vein.

Communication is established with the mouth by means of a vessel called " Steno's duct " that leaves the lower end of the gland and, following the course of the facial vein, pierces the buccinator muscle opposite the third molar tooth *(see Plate 48)*. This duct is partly superficial and may be easily mistaken for a vein.

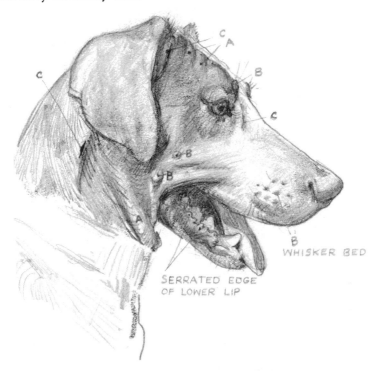

WHISKER BED

SERRATED EDGE
OF LOWER LIP

53 *HEAD OF DOG, MOUTH OPEN*
 A. Showing skin folds contradicting direction of Superficial muscles.
 B. Nerve bosses from which feelers grow.
 C. One or two fringes formed by the opposition of hair growths.

The parotid gland is often very prominent; it gives a softening effect to the upper edge of the jaw-bone. It sinks into the hollow below the ear when the head is extended and bulges out when the head is flexed and the neck arched.

Zygomatico-auricularis (Attoleus anticus) (the anterior auricular of man). This muscle consists of two parts, an anterior and a posterior, arising together on the zygomatic arch *(see Plate 48)*.

The anterior and larger branch crosses the temporalis muscle and is inserted on the outer side of the scutiform cartilage, the posterior being attached to the base of the concha below the opening. It draws the ear forward.

In the Carnivora only the posterior division of this muscle is so called, the anterior portion having joined up with the zygomaticus *(see Plate 49B)*.

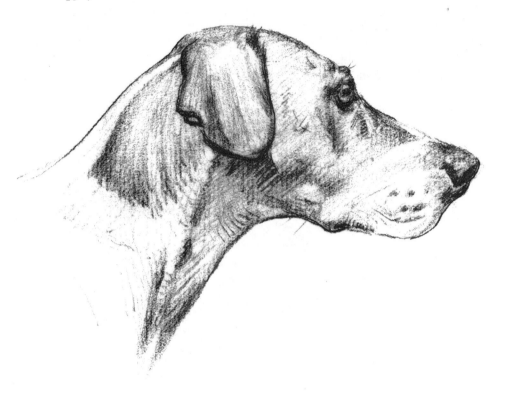

54. *HEAD OF FOXHOUND (Ear rounded)*

The *Temporo-auricularis* is thin and broad and covers the temporal muscle. It arises from the whole of the parietal and frontal ridges and is inserted on the scutiform cartilage and on the base of the concha, its superior border mixing with the cervico-auricularis muscle between the ears *(see Plate 48)*. It rotates the concha inwards and brings the opening of the ear forward.

The cervico-auricularis situated behind the preceding extends from the cervical ligament to the back of the concha and rotates it in the opposite direction, causing the opening to be directed backwards and downwards.

In the dog and cat the temporo-auricularis unites with its fellow of the opposite side in the middle line. Acting together, they draw the ears inwards, forming perpendicular wrinkles between them. It is sometimes called the " watching muscle " *(see Plate 49C)*.

Parotido-auricularis (see Plate 48). This is a long thin muscle which arises from the surface of the parotid gland, and is inserted on the base of the concha below the opening just behind the insertion of the posterior

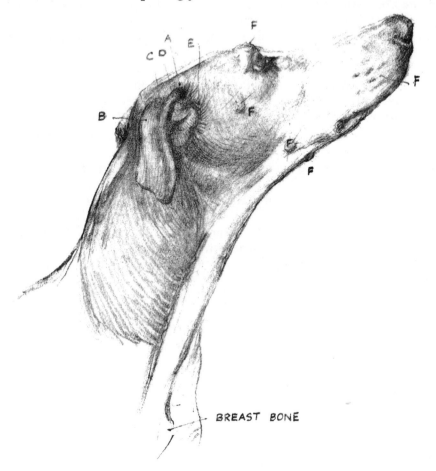

55. *HEAD OF A GREYHOUND*

A. *Position of Scutiform Cartilage.*
B. *Concha.*
C. *A slight depression between the Concha and the Skull.*
D. *Helix.*
E. *Hair fringe.*
F. *Nerve bosses.*

branch of the zygomatico-auricularis muscle. It inclines the ear outwards.

SUPERFICIAL VEINS OF THE FACE. *Submaxillary or facial vein.* This vein originates from the union of the angular vein of the eye with a nasal branch arising on the surface of the false nostril and which meet at a

point an inch or so in front of the masseteric tubercle. It then passes along the lower border of the masseter muscle, crosses over the edge of the jaw-bone at the maxillary fissure, and continuing on the inner side of the bone enters the jugular vein below the parotid gland *(see Plate 48)*. This last part of the vein is generally known as the glosso-facial vein and has a very subtle effect on the modelling of the throat of a well-bred horse.

The facial veins are, as a rule, well marked in Ruminants, the angular vein of the eye being particularly noticeable in the sheep. In dogs of the greyhound and borzoi type the veins are large and the nasal branch generally very distinct, as is the anterior part of the submaxillary.

Jugular Vein. The Jugular Vein results from the union of two large veins in the hollow space behind the temporo-maxillary joint, i.e. below the ear. Concealed at its origin by the parotid gland, it becomes visible as it emerges below it to pass down the neck in the groove which separates the sterno-maxillaris and the mastoido-humeralis muscles. After uniting with its fellow of the opposite side at the base of the neck, it enters the thoracic cavity between the first two ribs. Other veins join it at various points, notably the submaxillary or facial vein below the parotid gland, and the cephalic or plate vein near the entrance to the chest.

CHAPTER IV

THE NECK is operated by groups of muscles, some of which move individual vertebræ upon each other, and others with a longer range of action, and a more regional function.

The first category comprises three pairs of muscles, namely, the *Semispinales,* the *Intertransversales* and the *Longus Colli.* Each of these is divided up into a succession of short bundles, and each bundle has its fixed attachment on one vertebra and its movable insertion on the one in front, so that there are practically six separate muscles operating between each two vertebræ.

The *Semispinalis Colli* is a continuation in the neck of the semispinalis of the back and loins (one of the erectors of the spine which is buried under the longissimus dorsi muscle). Each division of this muscle arises on the posterior oblique process of one vertebra and is attached anteriorly to the spinous process of the one in front, its final attachment being on that of the second vertebra, the axis *(see Plate 56).*

Intertransversales Colli. These occupy the concave channel between the oblique and transverse processes on each side of the vertebræ and pass successively forwards from one bone to the next. They also terminate on the axis.

Longus Colli (Subdorso-Atloideus). This muscle, taken as a whole, reaches from the dorsal region to the atlas bone. It consists of two quite distinct portions, a posterior (dorso-cervical), and an anterior (cervical).

The posterior or dorsal part arises from the inferior surfaces of the first six dorsal vertebræ, and is inserted by a strong tendon on the inferior tubercle of the sixth cervical vertebra. By its action it lowers the whole neck.

The anterior or neck portion, however, conforms to the character of the other cervical muscles and, like them, consists of separate fleshy bundles passing upwards and inwards from the transverse process of the one vertebra to the inferior surface of the body of the next in front, finally terminating on the inferior tubercle of the atlas bone. This part of the muscle flexes the vertebræ upon each other whether the neck is raised or lowered.

The massive character of the upper part of the anterior extremity of the neck and its conformity with nearly all the movements of the head

159

are especially noticeable features in the horse, and are accounted for by the thick muscles which envelop the two first cervical vertebræ and join them to the skull.

This group consists of three muscles: The large oblique muscle of the head, Axoido-atloideus; the small oblique muscle of the head, Atloido-occipitalis; the posterior straight muscle, Axoido-occipitalis.

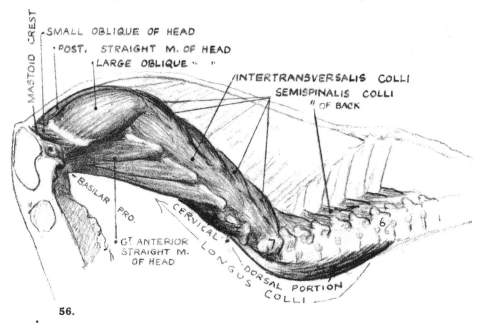

MASTOID CREST

SMALL OBLIQUE OF HEAD
POST. STRAIGHT M. OF HEAD
LARGE OBLIQUE " "

INTERTRANSVERSALIS COLLI
SEMISPINALIS COLLI
" OF BACK

BASILAR PRO.

Gᵗ ANTERIOR STRAIGHT M. OF HEAD

CERVICAL LONGUS

DORSAL PORTION COLLI

56.

The Large Oblique Muscle of the Head (see Plate 56). This is very thick and fleshy, arising from the whole of the upright surface of the spinous process of the axis and inserted on the posterior surface of the wing of the atlas. By its action it rotates the atlas bone on the odontoid process of the axis, the head conforming as was explained in the chapter dealing with the bones.

The Small Oblique Muscle of the Head arises on the anterior surface of the wing of the atlas, and is inserted on the styloid process, the mastoid crest and the occipital bone as far as the tuberosity. It extends the head on the atlas; its action, however, is extremely limited.

The Posterior Straight Muscle of the Head fills the interval between the upper borders of the two last mentioned muscles and the cord of the cervical ligament, and reaches from the posterior extremity of the axis to the apex of the skull, and so completes and rounds off the surface of this conspicuous muscular mass. It arises from the whole length of the upper edge of the spinous process of the axis and is inserted on the occipital bone underneath the insertion of the small oblique. It is an extensor of the head.

These muscles are especially strongly developed in most of the Carnivora, the girth of this part of the neck often exceeding that of the head, a circumstance which enables some dogs to slip their collars so easily.

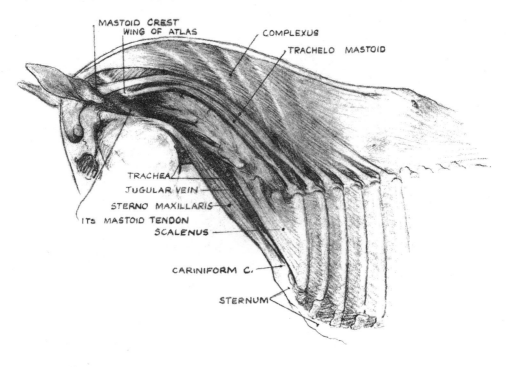

57.

The Great Anterior Straight Muscle or Long Flexor of the Head lies below the vertebræ of this region. Deep seated and quite unseen, it is, nevertheless, a very important muscle because of its direct action between the stalk of the neck and the head *(see Plate 56)*. It arises on the transverse processes of the third, fourth and fifth cervical vertebræ, and is inserted on the basilar process at the base of the cranium. Its anterior extremity passes below the atlas and axis but is not attached to them. The result of this is that, when in action, it not only flexes the head but brings the parts described in the preceding paragraphs down with it, and is therefore a considerable factor in producing the graceful curve which contributes so much to the beauty of the neck of the horse.

In the ox, this is a more powerful muscle and reaches as far back as the sixth vertebra of the neck. It is not, however, attached to the skull but terminates on the base of the atlas bone. It does not, therefore, arch the neck as it does in the horse.

The *Complexus Major* is a large triangular muscle occupying the area between the vertebræ of the neck and the cord of the cervical ligament and extending from the thorax to the skull. It arises from the transverse processes of the first six dorsal vertebræ and from the summits of their spinous processes and is inserted by means of a strong flat tendon on the

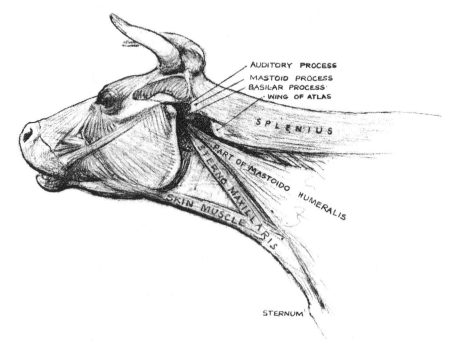

58. *To show attachments of Sterno-maxillaris and the Anterior portion of Mastoido-humeralis on the Basilar process. Also the fleshy band of the Cervical Panniculus (skin muscle) that goes to the lower jaw.*

occipital protuberance. Aponeurotic at its origin in front of the withers, it gradually becomes muscular as it ascends the neck. It is intersected at intervals by tendinous bands running obliquely downwards and backwards. This muscle is a powerful extensor of the head.

The *Trachelo-mastoid* (or Complexus Minor) *(see Plate 57)* is composed of two long slender and parallel portions (practically two muscles), which arise along with the complexus major from the transverse processes of the two first dorsal and the oblique processes of the last five cervical vertebræ and are inserted by separate tendons (1) on the mastoid crest, (2) on the wing of the atlas bone. It inclines the head and upper part of the neck to one side, or with its fellow of the opposite side extends them. When in action the round atloid tendon shows clearly on the surface, and owing to its receiving slips from the splenius and

mastoido-humeralis muscle (as will be explained), it is frequently brought into prominence through their agency as well as by that of the muscle to which it primarily belongs. The tendon of the upper or mastoid part, being flat, is less noticeable.

Scalenus (*see Plate 122,* Chapter VII.). A triangular muscle connecting the first rib with the stalk of the neck and with its consort forming a kind of porch over the entrance to the chest. It arises on the surface of the first rib and is inserted by successive digitations on the transverse processes of the last four cervical vertebræ. It bends the neck to one side, or if acting with its fellow draws it downwards. It is quite invisible in the horse and ox.

In the Carnivora it is prolonged backwards over the thorax as far as the eighth rib, and the posterior extremity may occasionally be detected passing out from beneath the shoulder-muscles. It is, however, of very little consequence.

Sterno-maxillaris (Sterno-mastoid) *(see Plate 57).* This is a long fleshy muscle, tapering at both ends, arising from the cariniform cartilage at the anterior extremity of the sternum and ending above in a flat tendon which is inserted on the posterior border of the lower jaw just above the curve (an attachment peculiar to solipeds and from which it derives its name in equine anatomy). It has a second attachment in the form of a thin aponeurosis, which leaves the terminal tendon, and after passing beneath the parotid gland joins the anterior border of the mastoido-humeralis muscle with which it is inserted on the mastoid process of the temporal bone. In its lower two-thirds this muscle is in close contact with its fellow; in the middle line the two muscles then gradually separate to go to their respective attachments on each side of the throat. The jugular vein lies along its posterior border.

This muscle is rather different in the ox in that it has no direct attachment either on the mastoid process or the inferior maxillary bone, but is inserted on the basilar process (under the cranium), along with a deep portion of the mastoido-humeralis, which also has an attachment there. It is partially covered by the cervical panniculus (skin muscle) from which a strong band is deflected to the lower jaw in a way that suggests that this band represents the sterno-maxillaris of the horse, which, however, is not the case.

In the Carnivora this muscle is very properly called the sterno-mastoid as it is inserted on the mastoid process.

The *Trachea,* or Windpipe, passes down the neck behind the sterno-maxillaris muscle, but the only place in which it affects the surface in any way is at the throat where, covered by the upper end of the subscapulo-hyoideus muscle, it bridges the gap between the jaw and the front of the neck.

Longissimus Dorsi. This is the longest and the largest muscle in the

TRACHELO MASTOID

COMPLEXUS

LONGISSIMUS DORSI

INNER PART
MIDDLE
OUTER
COMMON MASS

RETRACTOR COSTAE

GLUTEAL DEPRESSION

SACRO COCCYGEUS-SUP.
LAT.
INF.

ISCHIO COCCYGEUS

SACRO SCIATIC LIG.

CRURAL ARCH
HOLLOW OF FLANK
CORD OF THE FLANK
INTERNAL OBLIQUE

RECTUS ABDOMINIS

SCALENUS

1ST EXTERNAL INTERCOSTAL

1ST INTERNAL "

59. MUSCLES OF THE VERTEBRAL SKELETON

body and is mainly responsible for the form of the back and loins. It reaches from the pelvis to the middle of the neck and arises from the sacrum, and from the external angle, the crest, and the inferior surface of the ilium *(see Plate 59)*.

Very thick in the loins, where it constitutes what is known as the " Common Mass," whose volume and sectional shape is well exhibited in the upper cut of a sirloin of beef, it soon resolves itself into three more or less distinct branches, a middle (deep), an inner (superior), and an outer branch from each of which successive bundles of fibres are detached to be inserted on the various bone prominences in their respective tracks. Those of the middle and most voluminous portion are directed forward and downward to be inserted on the oblique processes of the lumbar, and on the transverse processes of all the dorsal and the last four cervical vertebræ. Those of the upper portion pass obliquely forward and inward to the spinous processes of the same vertebræ, and the fasciculi of the external branch deviate slightly outwards to gain their attachments on the transverse (costal) processes of the lumbar vertebræ and the upper extremities of the last fifteen or sixteen ribs.

As it approaches the shoulder region, the middle portion—hitherto buried beneath the other two—emerges to pass to its insertions on the transverse processes of the neck and becomes completely detached from the upper portion, which continues independently to its final terminations on the spinous processes. Through the gap thus left between the separated parts, the complexus and trachelo-mastoid muscles pass upward to their attachments on the neck and head *(see Plate 59)*.

The longissimus dorsi is covered by a thick aponeurosis from which the latissimus dorsi and other muscles derive their origins, and a triangular depression on the posterior part of the loins marks the seat of the anterior extremity of the middle gluteus muscle.

In a well covered horse the muscles of the two sides rise above the lumbar spines, which then lie in the dividing groove—a circumstance which has given rise to the term " double-backed," applied to such animals.

After leaving the loins the fleshy part of the muscle follows the downward inclination of the ribs, and the spines, but thinly covered, gradually make their appearance to form the outline of the forward part of the back and withers, while a slight concavity behind the angle of the shoulder-blade indicates the divergence of the two parts of the muscle.

This muscle is a very powerful extensor of the spine. By its cervical portion it elevates the stalk of the neck, or if one side acts alone it inclines it to that side. Very similar in other animals and especially strongly developed in the loins of the Carnivora.

Tail Muscles. With regard to the mechanism of the tail it will be sufficient to say that it is operated by four pairs of muscles, the *Sacro-coccygeus* superior, inferior and lateralis, and the *Ischio-coccygeal* or triangular muscles of the tail.

The first three pairs commence on the sacrum and are inserted on the various prominences of the coccygeal vertebræ. They are enclosed in a strong aponeurotic sheath and are individually indistinguishable. The fourth, the ischio-coccygeal or triangular muscle of the tail, is, however, of more importance especially in the Carnivora and the Ruminants, in which it is more strongly developed and, owing to the absence of some muscles which in the horse partially cover it, more exposed. It arises on the supracotyloid crest, and after passing beneath the sacro-sciatic ligament, is inserted on the transverse processes of the two first coccygeal vertebræ. Alone it draws the tail to one side, or acting with its fellow, depresses it.

Intercostal Muscles. The intercostal muscles fill the spaces between the ribs and costal cartilages. They are disposed in two layers—an external and an internal. The external intercostals arise on the posterior border of the one rib and are inserted on the outer surface of the succeeding one. They do not, however, extend below to occupy the spaces between the cartilages. The internal muscles, on the other hand, occupy the spaces between both ribs and cartilages, and in the latter region are very thick and muscular. In other respects they are almost a reversed facsimile of the outer muscles, their origins being on the anterior border of a posterior rib, and their insertions on the rib next in front, so that the fibres of the two layers are crossed. The internal layer has no effect upon the surface form, and the chief point to notice with regard to the external muscles is that they overlap the anterior half of each rib, leaving only a narrow strip of bone exposed. These belong to what we might call the " bellows " muscles, as they work the ribs when breathing, inflating and deflating the chest.

Rectus Abdominis or the Great Straight Muscle of the Abdomen. This is a powerful muscle extending from the thorax to the base of the pelvis. It is attached in front to the cartilages of the last five true ribs and the inferior face of the sternum, and behind to the anterior border of the pubis. It joins its fellow under the belly in a tendinous intersection called the " white line." It is thickest in the abdominal region, and is intersected at intervals by a number of irregular tendinous bands. Covered by the oblique muscles and the thick abdominal tunic it has little influence on the form except as forming a part of a large muscular mass. The upper border may occasionally be seen, however, especially in a horse that is distressed, or when coughing. The rectus abdominis is the principal flexor of the spine. Except that it is rather wider in the ox, and that in the Carnivora, owing to its being more thinly covered, it is more visible, there are no particular differences to note.

Internal or Small Oblique Muscle of the Abdomen. This is a thick heart-shaped muscle situated in the region of the flank. From its origin on the external angle of the ilium and the adjoining part of the crural

arch, [1] its fibres spread out like a fan, to be continued in a wide aponeurotic expansion, which envelops the posterior half of the rectus abdominis muscle, and eventually unites in the middle line of the abdomen with the " linea alba," which it helps to form, and which reaches from the end of the sternum to the pubis.

Anteriorly a strong band of this muscle is inserted on the *inner face* of the last few costal cartilages and constitutes what is called the " cord of the flank," whilst it is continued above by a fibrous tissue that is confounded with the aponeurosis over the loins, so forming the floor of the triangular depression, which goes by the name of the " hollow of the flank," and which is enclosed by the edge of the longissimus dorsi muscle, the last rib and the cord. In the horse, owing to the ribs reaching so far back, this hollow is relatively small, and except in emaciated animals not very apparent, although some indication of it is always to be found. In the large-bellied Ruminants, however, such as the cow and the goat, it is a very conspicuous feature, both as regards its area and its depth.

In the Carnivora there is no definite muscular form that can be likened to the cord of the flank, the muscular portion of the small oblique occupying the whole space between the ribs and loins.

Retractor Costæ (see Plate 59). This is a small, triangular, fleshy muscle, which arises on the extremities of the first two or three lumbar transverse processes, and is inserted on the posterior border of the upper end of the last rib. By some authorities it is considered as a part of the internal oblique muscle, with which it is confounded. It is of some importance because it tends to obliterate the acute angle between the rib and the edge of the longissimus dorsi muscle and helps to round off the upper boundary of the hollow of the flank.

Splenius. This is a large triangular muscle between the cervical vertebræ and the upper outline of the neck and covering the complexus and the oblique muscles of the head. It arises from the cord of the cervical ligament and from the aponeurosis of the complexus muscle, through which it is attached to the spines of the anterior dorsal vertebræ. Its fleshy fibres, directed forwards from the withers, soon resolve themselves into five distinct flattened digitations, which are inserted in the following manner. The uppermost and thinnest spreads over the oblique muscles of the head, and after uniting with the mastoid tendon of the trachelo-mastoid muscle is inserted on the mastoid process and the crest above. The second and more muscular digitation joins the atloid tendon of the same muscle, and the remaining three are successively inserted on the transverse processes of the third, fourth and fifth cervical vertebræ *(see Plate 60).*

[1] The Crural Arch is formed by a strong aponeurotic band (Poupart's Ligament) which connects the external angle of the ilium with the pubis and constitutes the dividing line between the posterior part of the abdomen and the inside of the thigh.

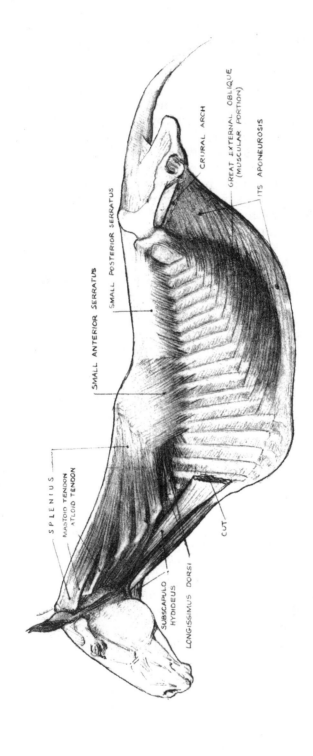

SPLENIUS

MASTOID TENDON

ATLOID TENDON

SUBSCAPULO
HYOIDEUS

LONGISSIMUS DORSI

CUT

SMALL ANTERIOR SERRATUS

SMALL POSTERIOR SERRATUS

CRURAL ARCH

GREAT EXTERNAL OBLIQUE
(MUSCULAR PORTION)

ITS APONEUROSIS

60. *THE SPLENIUS, THE SMALL ANTERIOR SERRATUS &*
SMALL POSTERIOR SERRATUS MUSCLES, &c.

In the dog and cat the splenius is thick and fleshy and contributes largely to the roundness of the neck. In the ox, &c. it is poorly developed, and only the upper part is present. It is inserted as in the horse on the skull and atlas bone but has no attachments on the other vertebræ; it therefore only serves to extend the head and does not elevate the neck.

Small Anterior Serratus arises on the summits of the anterior dorsal spines as far as the thirteenth (No. 1 excepted) and is inserted on nine ribs commencing with the fifth.

Small Posterior Serratus is a similar muscle arising on the spinous processes of the last eight dorsal vertebræ and inserted by successive digitations on the upper extremities of the last eight ribs. It therefore partially covers the preceding muscle.

Neither is of any consequence in the horse or the ox, but in the Carnivora the anterior serratus (*see Plate 122,* Chapter VII.) is strongly developed and is attached to eight ribs—third to tenth—and has a definite surface effect, giving fullness above and behind the dorsal angle of the shoulder-blade—a region which it will be remembered in the horse shows some concavity.

The posterior muscle has but three digitations and is of minor importance. Like the intercostals, these also assist in pumping the bellows.

Great External Oblique Muscle of the Abdomen (see Plate 60). This is a very large muscle, partly fleshy and partly aponeurotic. It extends from the pelvis to the chest and covers the greater part of the small oblique and the whole of the stomach. The muscular portion is situated at the side of the body, where it adds considerably to the bulk. It arises on the lower anterior tubercle of the angle of the haunch, and following the direction of the cord of the flank—which it helps to form—is inserted by successive digitations on the posterior edges of the last fourteen ribs. Inferiorly and posteriorly the muscular portion is succeeded by a wide aponeurotic expansion, which in its turn is attached to the inferior surfaces of the false ribs and along the whole length of the " linea alba." The free posterior edge of the aponeurosis, between the angle of the haunch and the pubis, is the chief factor in the formation of the crural arch.

Abdominal Tunic. This is an immense bandage composed of elastic fibrous tissue which covers the whole of the great oblique muscle. It is very thick posteriorly and on each side of the median line, becoming thinner in front and over the fleshy parts of the muscle. It acts as a sling to support the weight of the intestines and increases in thickness in proportion to the size and weight of the stomach. It is very wide and thick in the ox. It has little visible effect except that it prevents us seeing much definition in the muscles under the abdomen and is therefore not shown in the diagrams.

CHAPTER V

UNGULATES use their limbs solely as a means of getting from one place to another, and their action is restricted to a backward and forward movement which can be performed with a simpler arrangement of bones and muscles than is needed by an animal that uses them for climbing, grasping, digging, &c., as well as for locomotion, with the result that parts which have ceased to function have wasted away and only the useful structures have continued in their development.

The anterior limb of every quadruped consists of four regions corresponding to the shoulder, arm, forearm and hand of man, and the bones which constitute the framework are known by the same names in both human and animal anatomy.

The shoulder-blade is called the Scapula; the arm-bone the Humerus, the bones of the forearm the Radius and Ulna, and those which correspond to the wrist, hand and fingers are named respectively the Carpus, the Metacarpus and the Phalanges.

Scapula. The Scapula is a flat triangular bone, whose three borders respond to the neck, the spine and the ribs, and are respectively named the Cervical, the Vertebral and the Axillary (or Costal) borders *(see Plate 66)*.

The junction of the cervical with the vertebral border is called the cervical angle, of the vertebral and axillary the dorsal angle, and the lower end where the scapula joins the humerus is called the humeral angle.

Externally the bone is divided lengthways by an upright plate called the Spine. On each side of the spine are the supra- and the infraspinous fossæ in which the supraspinatus and the infraspinatus muscles are lodged.

The spine is surmounted by a rough prominence, the tuberosity, on which the Trapezius muscle is inserted. It terminates inferiorly in the Acromion process, this latter being well developed in Carnivora, as it is in man, but very rudimentary in the Ungulates and practically absent in the horse family.

At the lower extremity of the anterior or cervical border is the Coracoid process, which affords attachment to the superior tendon of the Biceps muscle, and finally attention should be drawn to the thick

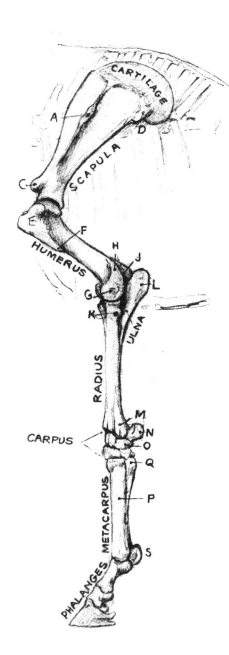

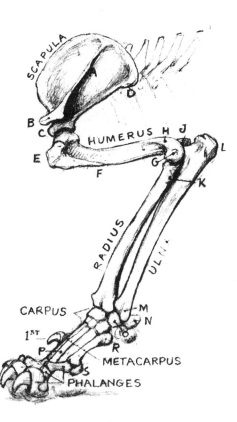

A. Tuberosity of Spine of Scapula.
B. Acromion process.
C. Coracoid process.
D. Dorsal angle.
E. External tuberosity of humerus.
F. Deltoid tubercle.
G. Outer condyle of humerus.
H. Supra-condyloid ridge.
J. Olecranon fossa.
K. Sup. Ex. tuberosity of Radius.
L. Olecranon process.
M. External Malleolus.
N. Pisiform bone.
O. Cuneiform bone.
P. 3rd Metacarpal (=Cannon bone).
Q. 4th Metacarpal bone.
R. 5th Metacarpal bone.
S. Sesamoid bones.

61. BONES OF FORE LIMB OF HORSE

62. *BONES OF FORE LIMB OF LION*

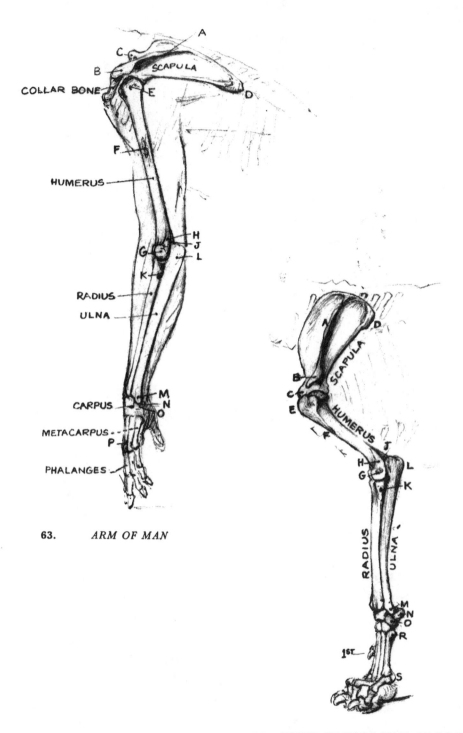

A

C

SCAPULA

B

COLLAR BONE

E

D

F

HUMERUS

H
J
G
L

K

RADIUS

ULNA

CARPUS

M
N
O

METACARPUS

P

PHALANGES

63. ARM OF MAN

D

B

SCAPULA

C

E

HUMERUS

F

J

H
G

L

K

RADIUS

ULNA

M
N
O
R

1ST

S

64. BONES OF FORE LIMB OF DOG

and tuberous dorsal angle, as although not actually subcutaneous, its position is easily identified on the living animal by reason of the edges of some important muscles which converge upon it.

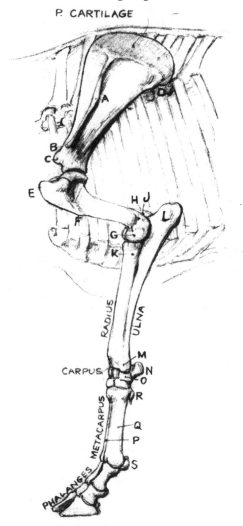

65. *BONES OF FORE LIMB OF OX*

Reference to Plates 61, 62, 63, 64, 65 & 66 will sufficiently explain the relative positions of the various angles, borders, processes, &c. and will enable the reader to appreciate how closely they correspond in different animals notwithstanding the variations in shape and development.

The scapula of an Ungulate has one peculiarity which differentiates it from that of the Carnivora, and that is that the muscle-bearing surface is prolonged upwards by a flat, flexible cartilage which is a part of the

original skeleton that never becomes entirely ossified. This, then, and the under development of the acromion process already alluded to, are the outstanding points of difference between them.

In the horse the spine divides the scapula into two unequal parts, the supraspinous fossa being about half the width of the infraspinous fossa.

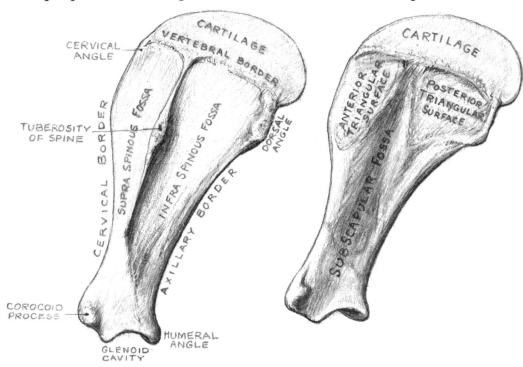

66 & 67.

Left. LEFT SCAPULA OF HORSE (Outer face).
Right. RIGHT SCAPULA OF HORSE (Inner face).

The tuberosity of the spine shows on the surface as a rough ridge some three or four inches in length, and for the rest of the way the edge may be detected in the groove between the muscles which occupy the fossæ on each side of it.

The most conspicuous parts of the scapula are the spine, the dorsal angle and the vertebral border, or in an Ungulate the top of the prolonging cartilage. Having recognized these, the artist should have no great difficulty in " seeing " the rest of the bone, although it is so buried in muscle.

In the ox *(see Plate 65)* the vertebral border is proportionately longer and the spine placed further forward, so that as compared with the horse the supraspinous fossa is narrower and the infraspinous fossa wider. The spine curves forward from the tuberosity and terminates in a definite, though rudimentary acromion process, which gives rise to a very small

slip of the deltoid muscle. The superior border of the prolonging cartilage is approximately flush with the summits of the dorsal vertebræ.

In the Carnivora *(see Plates 62 & 64)* the spine is more elevated and terminates in a well developed and salient acromion process. The fossæ are more hollowed out to provide room for thicker muscles.

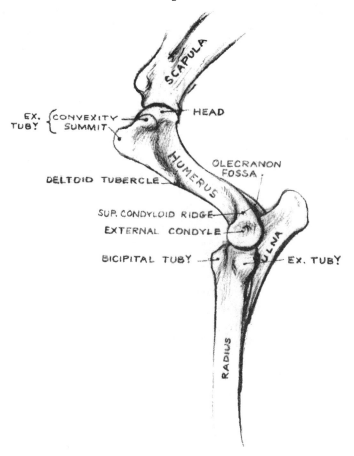

68. *HUMERUS & ADJOINING BONE STRUCTURES OF HORSE, EXTERNAL VIEW*

The position of the spine varies in different subjects. As a rule, in a dog it divides the surface of the bone into two almost equal halves, but in the cats the supraspinous fossa is considerably the wider of the two, and the cervical border more arched, in some cases making one sweeping curve which almost obliterates the cervical angle. In the large Carnivora the vertebral border stands well up above the level of the dorsal spines, and is a very noticeable feature in the lion and tiger, &c. The dog, however, is an exception in that the top of the shoulder-blade is generally level with the tops of the spines.

The scapula is attached to the trunk by muscles only. In none of the animals under review is there any collar-bone connecting it with the sternum to complete the shoulder-girdle as there is in man. A horse jumping lands on its forefeet, and owing to the elasticity of this muscular union does not run the risk of dislocation or fracture, as would be the inevitable result if there were a rigid bone attachment.

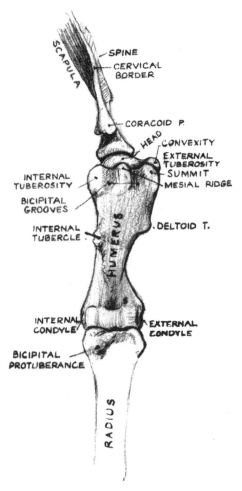

69. *LEFT HUMERUS OF HORSE (Front view)*

The main union of the fore limb with the trunk is effected by means of the great serratus muscle, which is attached to the posterior triangular surface, and binds the underneath of the upper extremity of the shoulder-blade to the ribs *(see Plate 67)* and whilst retaining it in position allows a considerable amount of movement to take place. It is only the upper end of the scapula that is really in close contact with the trunk and that

can be said to be in any way fixed. For the remainder of its length it is detached from the body and sways backwards and forwards in conformity with the movements of the leg.

Humerus. As compared with the Carnivora, the humerus of an Ungulate is a short bone measuring in the horse approximately the same length as the scapula minus the cartilage. The chief points to which we would draw attention are: At the anterior extremity: —

The *Head,* which articulates in the glenoid cavity of the scapula.

The *External Tuberosity* consisting of the Summit, which constitutes what is generally called the Point of the Shoulder, and the Convexity, a rounded prominence, situated a little above and behind it.

The *Internal Tuberosity,* occupying a corresponding position on the inner side of the bone, but not as prominent. Between the tuberosities on the front of the bone is the bicipital groove, divided into two channels by a mesial ridge. On the outer side of the bone, below the external tuberosity, is a flattened triangular area which, although not actually subcutaneous, is quite distinguishable on the surface. All three angles are salient bone points, the two above being the convexity and the summit, and the third the deltoid tubercle, a conspicuous landmark upon which several muscular forms converge *(see Plate 68).*

At the lower extremity of the humerus we have to notice: —

The *external and internal condyles,* articulating with the bones of the forearm, and surmounted by the Supracondyloid Ridges curving upwards over the back of the bone. Between the ridges is the deeply excavated Olecranon fossa, which receives the beak of the Olecranon process of the ulna when the leg is fully extended on the humerus *(see Plate 72).*

On the inner surface of the shaft and almost opposite the deltoid tubercle is a rough excrescence known as the Internal tubercle, on which the tendons of the teres major and the latissimus dorsi muscles are inserted *(see Plate 69).*

There is very little difference to notice in the humerus of the ox except that the great tuberosity projects further forward.

In Carnivora, the humerus is a longer and more elegant bone, with a relatively small tuberosity *(see Plates 62 & 64).*

Radius and Ulna. Although the forearm of a horse nominally consists of two bones, these are so firmly united in the adult animal that they constitute a single structure with no independent movement.

In man, the radius and the ulna are separate bones, and reach from the elbow to the wrist *(see Plate 63),* and in bringing the hand round from the supine to the prone position the radius crosses the ulna in an oblique direction, so that the thumb comes on the inside and the knuckles face forwards, which is the normal position of the hand in all quadrupeds, as it is with any one of us who attempts to walk on all fours, so that

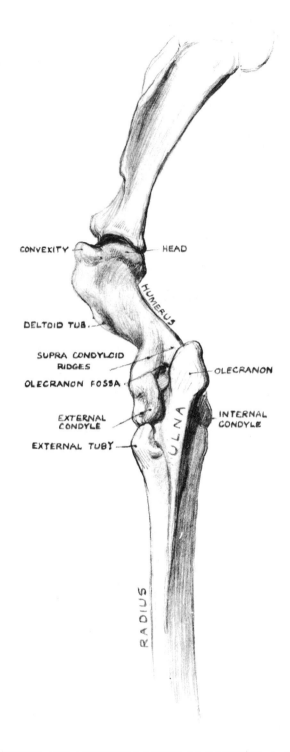

CONVEXITY HEAD

HUMERUS

DELTOID TUB.

SUPRA CONDYLOID
RIDGES

OLECRANON

OLECRANON FOSSA

EXTERNAL
CONDYLE

INTERNAL
CONDYLE

EXTERNAL TUBY

ULNA

RADIUS

70. *HUMERUS AND ADJOINING BONES OF HORSE (Back view)*

what we are pleased to call the front might just as well be called the back, which would simplify comparisons between man and animals.

In the horse, the radius is the main bone of the forearm, only the upper end of the ulna being developed. This, however, forms a very important part of the skeleton, and is the principal lever of the foreleg.

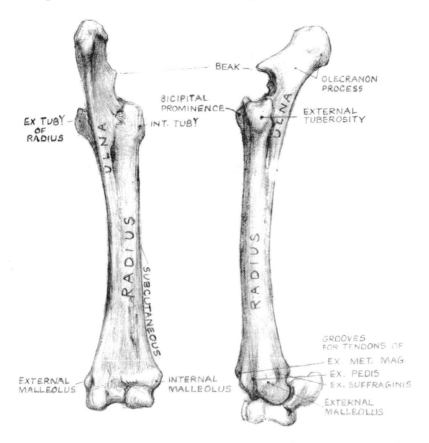

71 & 72. *Left. POSTERIOR VIEW OF BONES OF LEFT FOREARM OF HORSE*
Right. EXTERNAL VIEW OF BONES OF LEFT FOREARM OF HORSE

The anterior surface of the shaft of the radius is rounded and smooth to permit of the easy gliding of muscles which pass over it, whereas the back is flat and rough to provide a hold for muscles, which arise upon it. At its upper extremity, on either side of the elbow joint, are the external and internal tuberosities.

The external tuberosity is prominent and distinctly visible below the external condyle of the humerus, with which it is connected by a strong and well defined ligament.

The internal tuberosity, on the other hand, is flat and inconspicuous on the inside of the leg, but projects forwards to form the bicipital prominence on which the lower tendon of the biceps muscle is inserted *(see Plate 69)*.

The chief points to note at the lower extremity are the external and internal malleoli on either side, and in front, three grooves for the passage of tendons. The external malleolus is the less salient of the two, although it is distinctly visible between the muscles which pass to the front and those passing behind the knee, where it often catches the light when all other details are obscured. The internal malleolus, on the other hand, is sharply defined and prominent.

The Ulna. The Ulna of the horse is firmly welded to the back of the radius. It contributes to the formation of the elbow joint, and projecting upwards and backwards constitutes the Olecranon process. Below, it degenerates into a mere splinter, and terminates about half-way down the outside posterior edge of the radius. The outer surface is flat, the inner surface is concave and forms a sort of containing wall for muscles passing down the back of the leg.

The olecranon process is thick and solid, and its summit constitutes the point of the elbow on which the tendon of the large triceps muscle of the arm is inserted. The anterior border is at first slightly concave, below it projects forward to form the Beak of the Olecranon *(see Plate 72)*, which during extension interlocks with the humerus in the olecranon fossa, making it impossible for the forearm to be brought into a straight line with the arm, and at the same time limiting the lateral movement at the elbow joint.

The olecranon has considerable influence on the form of this region and, being partly subcutaneous, is easily identified. In the standing position the elbow is to some extent overshadowed by the fleshy triceps muscle, but when the leg is in action, either flexed or extended, its shape is clearly revealed.

Chauveau in his *Anatomy of the Domesticated Animals* tells us that " the development of the ulna is in direct relation to the division of the foot" and that " the closeness of union between the radius and the ulna is in increased proportion as the animal exclusively employs its inferior extremity for standing or walking, so that we find that in solipeds the ulna is a rudimentary bone firmly united with the radius, and that in the five-toed animals it reaches its extreme development, and in those which dig, climb, &c., or use the limb as an organ of prehension, the bones move upon each other with a facility which is only surpassed in man."

In the dog and cat, the forearm is relatively long, and the two bones are approximately equal in volume *(see Plates 62 & 64)*.

The upper extremity of the ulna is situated behind the radius as

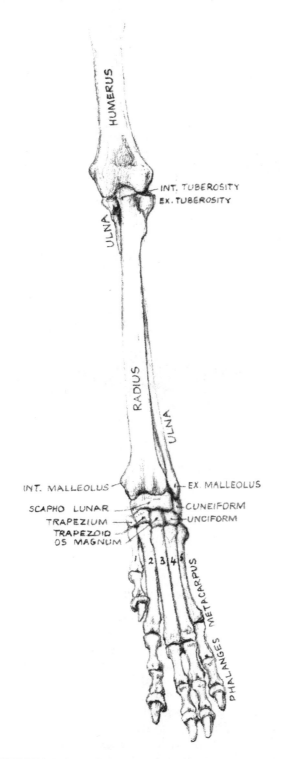

73. *SKELETON OF LEFT FORELEG OF DOG, FOOT EXTENDED*
(Front view)

in the horse, but the lower end passes to the outside and articulates with the two external bones of the first row of the carpus; so that at the upper end of the forearm the tuberosity of the radius is the most external bone point and inferiorly the head of the ulna.

The anterior surface of the radius is convex from side to side, widening out considerably below, where it shows three grooves for the passage of the extensor tendons similar to those in the horse.

The internal malleolus is prominent and sharp, and the ascending shaft on the inside is subcutaneous as far as the middle of the bone. The external malleolus is formed by the lower end of the ulna.

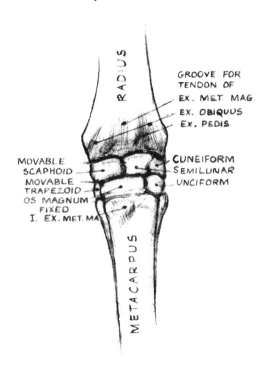

74. *LEFT KNEE OF HORSE (Front view)*

Forearm (Ox). In the ox the forearm is short and broad and has the inward inclination which is characteristic of all the Ruminants and is especially marked in sheep, goats, deer, &c., whose knees very often nearly touch. A similar tendency is occasionally met with in horses, when it is termed " calf kneed," and is a decided fault.

Both bones extend the full length of the forearm, the *(see Plate 65)* radius in front, and the ulna behind. As in the horse, however, they are welded together and cannot move independently of each other.

The ulna, although so much longer, shows on the surface in almost exactly the same way as in the horse.

The olecranon process is similar in shape, but heavier and larger, and is more constantly visible owing to the fact that the triceps muscle is less developed and does not overhang it. The lower extremity is fused with the radius in a single bone form, which externally almost exactly resembles the malleolus of the horse.

Carpus. The Carpus constitutes the knee of the horse and corresponds to the human wrist. It consists of a group of irregular bones arranged in two tiers, between the radius and the metacarpus.

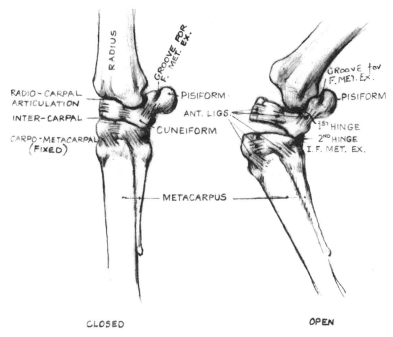

75 & 76. *LEFT KNEE JOINT OF HORSE (Outside view)*
Carpal Ligaments

Owing to the way in which they interlock and are covered by ligaments and tendons, individual bones are practically indistinguishable, and it is hardly necessary therefore to go into a detailed examination of them, as the diagrams will sufficiently explain their situations.

If we regard the upper tier as a movable unit and the lower as a fixed prolongation of the metacarpus, the knee resolves itself into a joint operated by two hinges, one of which acts between the radius and the upper tier, forming the radio-carpal articulation, and the other between the two tiers, the inter-carpal articulation.

Attention should, however, be drawn to the Pisiform or Accessory Carpal bone, as this does not enter into the formation of either of the hinges, but projects behind from the outer side of the upper row and forms a lever upon which some of the muscles which bend the knee are

inserted. It also gives attachment to several important ligaments which contribute appreciably to the shape, and is itself a conspicuous feature at the back of the leg. A groove on the external surface of this bone conducts the outer tendon of the external flexor of the metacarpus towards its insertion on the outer splint bone *(see Plate 76)*.

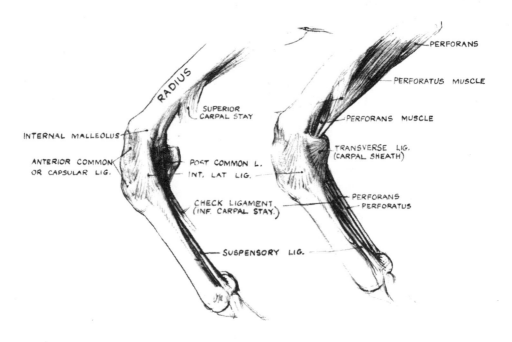

77 & 78. *CARPAL LIGAMENTS. INSIDE VIEW OF RIGHT KNEE OF HORSE*

Left. The Transverse Carpal Ligament is omitted in order to show the position of the Posterior Common Ligament and the origin of the Inferior Carpal Stay or " Check Ligament."

Right. The Transverse Ligament is in place, so completing the Carpal Sheath and showing how the back tendons pass through it.

The bones of the knee are held together by an elaborate system of ligaments. Some definitely influence the shape, others tend to conceal it. We shall draw attention to the most important of these, as well as to a few that, although not visible, perform some special functions in connection with the working of the joint.

The adjoining bones in each row are first united by interosseus ligaments, interposed between their lateral surfaces; they are then again bound together by transverse bands crossing the joints in front (anterior ligaments), as well as others behind. Each row thus becomes a united flexible structure capable of absorbing shock, and of adapting itself to the other bones with which it comes in contact *(see Plates 75 & 76)*.

The inferior row of bones is then attached to the upper ends of the metacarpal bones by a series of more or less vertical ligaments, which are sufficiently elastic to permit of a limited amount of gliding movement, but preclude the possibility of flexion or extension at the carpo-meta-carpal articulation. So far as the major movements are concerned, this

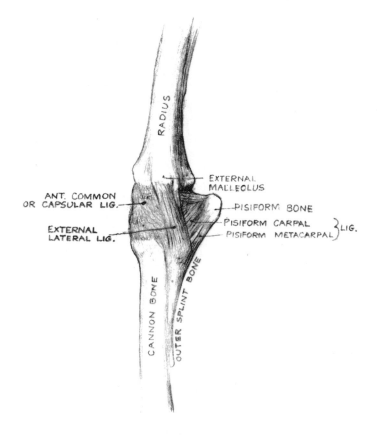

79. *CARPAL LIGAMENTS*
Outside view of left knee of horse.

articulation may therefore be ignored, and the second row of carpal bones may be regarded as an upward extension of the metacarpus, in all of whose movements it concurs.

Placed over these and completely enveloping them are four ligaments, which are common to both rows, and unite them with the radius above and the metacarpus below. These comprise the anterior and posterior common ligaments and the internal and external lateral ligaments.

The *Anterior Common Ligament* (Capsular ligament of the knee) covers the whole of the front of the knee, extends on each side, and blends

with the lateral ligaments. It is attached to the articular rim of the radius, to the anterior surfaces of the carpal, and to the upper edges of the metacarpal bones. This ligament is only taut when the knee is bent, and when extended it tends to bulge opposite the closed horizontal joints.

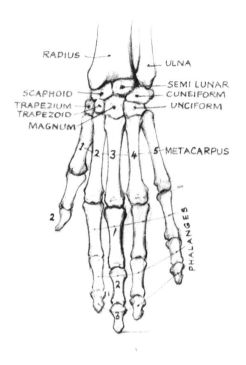

80. *BONES OF A MAN'S LEFT HAND*
 (Back to the front.)

The *Posterior Common Ligament (see Plate 77).* This is an extremely powerful ligament. It unites the carpal bones with the radius and the cannon bone, and forms the basis of the two hinges on which the knee works. At the same time it constitutes the anterior wall of the carpal sheath through which the back tendons pass. This ligament has a considerable effect in preventing over extension of the knee joint.

Lateral Ligaments of the Knee. A powerful ligament on each side of the knee unites the radius with the metacarpus, contributing largely to the shape. The external ligament *(see Plate 79)* is attached above to the tuberosity at the lower end of the radius (external malleolus) and below to the external splint bone, and by its deep surface to the carpal bones and ligaments over which it passes, and a similar ligament unites

the corresponding bones on the inside of the knee, but is more triangular
in shape as it widens out below to reach the anterior surface of the head
of the cannon bone *(see Plates 77 & 78)*.

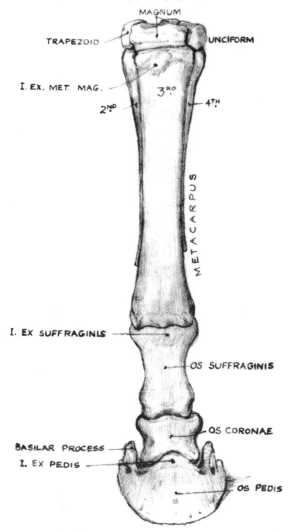

81. *BONES OF LEFT FORELEG OF HORSE FROM SECOND
KNEE JOINT DOWNWARDS*
(Front view, standing.)

A group of three ligaments unites the pisiform with the external carpal
and metacarpal bones. Of these, the only one that has any definite
influence on the surface is attached to the lower border of the pisiform
bone by its superior extremity and inferiorly to the back of the outer
splint bone a little below the head. The lower edge is clearly defined

and forms the posterior outline ot the knee. A short ligament connects the upper border of the pisiform bone with the back of the lower ex-

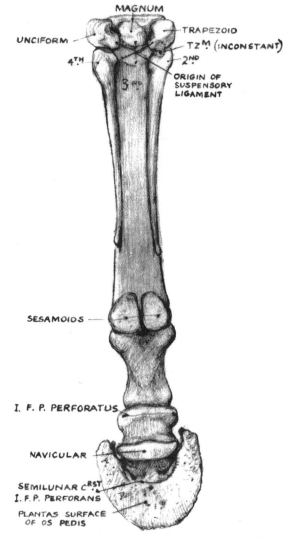

MAGNUM

UNCIFORM

TRAPEZOID

TZ ᴹ· (INCONSTANT)

4ᵀ·ᴴ

2ᴺᴰ·

3 ᴿᴰ·

ORIGIN OF
SUSPENSORY
LIGAMENT

SESAMOIDS

I. F. P. PERFORATUS

NAVICULAR

SEMILUNAR C ᴿˢᵀ·

I. F. P. PERFORANS

PLANTAS SURFACE
OF OS PEDIS

82. *BONES OF LEFT FORELEG OF HORSE FROM SECOND
KNEE JOINT DOWNWARDS*
(Back view, foot lifted.)

*A small rudimentary bone no bigger than a cherry stone is occasionally found
embedded in the tissues at the back of the knee (position marked TZM.) This is a
vestige of the Trapezium, which in man and Carnivora supports a first metacarpal
bone with thumb or dew-claw as the case may be.*

tremity of the radius. It serves to retain the pisiform in position, and to some extent prevents over extension of the knee joint *(see Plate 79).*

Transverse Carpal Ligament (see Plate 78). This is a very important

ligament situated behind the knee. It spreads fanwise from the pisi-form bone to the internal lateral ligament and the upper end of the splint bone, and forms the posterior wall of the carpal sheath. Its boundaries are indefinite, being confused above with the antibrachial fascia (which binds the muscles of the forearm to the bones), and below with a corresponding expansion which envelops the metacarpal region.

Metacarpus. The Metacarpal Region in the horse contains three bones, i.e. the Cannon, and the two Splint Bones *(see Plates 81 & 82)*.

The cannon bone corresponds to the third or middle bone of a man's hand and the splint bones to the second and fourth; there are no traces of the first or fifth.

These three bones, which are separable in early life, become con-solidated at maturity, and in conjunction with the lower tier of the carpal bones, which (as has been already explained) are closely united with them, form a compound structure that derives all its movements from the inter-carpal articulation (i.e. the lower knee hinge).

The large metacarpal, or cannon bone, is a long, round bone, and is the only one of the three that is fully developed and reaches the fetlock joint.

A rounded prominence on the front of the upper end and on the inner side of the middle line, gives attachment to the principal extensor of the metacarpus, and makes a definite break in the profile outline below the knee.

The lower extremity shows no appreciable enlargement and does not project forwards *(see Plate 84)*, the rounded shape of the fetlock joint being almost entirely due to the strong lateral ligaments and the soft structures surrounding the joint.

The splint bones are rudimentary metacarpal bones, whose well developed heads project on each side behind the head of the cannon bone, giving attachment to important muscles and ligaments. Inferiorly each bone becomes slightly detached from the main bone and terminates in a small button about a hand's breadth above the fetlock joint, the inner bone as a rule reaching a little lower than the outer. They are both subcutaneous, and with the cannon are responsible for much of the form and modelling of this region.

The measurement round the leg below the knee depends to a great extent on the development of the upper extremities of the splint bones and is a point of some consequence, as it is an indication of the strength of the muscles, &c. attached to them.

The shank or cannon of the ox is a single bone resulting from the fusion of the third and fourth metacarpals. A groove down the centre indicates the line of union of the two bones, and the duplication of the lower extremity provides the articulating surfaces for the two digits. There are no splint bones like those of the horse, the second and fifth metacarpal bones being represented merely by two fragments of bone

embedded in the carpal ligaments on either side of the head of the main bone and quite unidentifiable on the surface.

Digit. The skeleton of the horse's digit, which corresponds to a man's second finger *(see Plate 80),* consists of three phalanges with accessory Sesamoid bones.

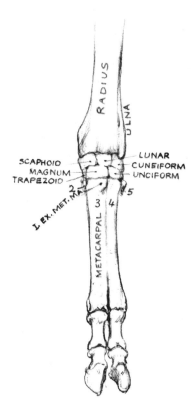

83. *BONES OF THE LEFT FORELEG OF OX (Front view)*

The first phalanx is called Os Suffraginis, or the large Pastern Bone, the second Os Coronæ, and the third Os Pedis, or the Coffin Bone.

The first phalanx is the largest and longest and reaches from the fetlock joint to within a short distance of the top of the hoof, where it articulates with the upper extremity of the second phalanx to form the Pastern Joint.

The Sesamoids are two small bones firmly connected by ligaments with the back and upper end of the first phalanx, thus forming a slightly movable extension to articulate with the cannon bone.

A depression on the external surface of each sesamoid affords attachment to the metacarpal portion of the suspensory ligament, and

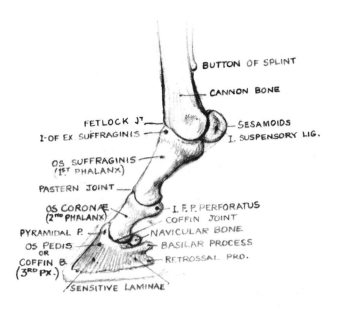

BUTTON OF SPLINT

CANNON BONE

FETLOCK JT.

I. OF EX. SUFFRAGINIS

SESAMOIDS

I. SUSPENSORY LIG.

OS SUFFRAGINIS
(1ST PHALANX)

PASTERN JOINT

OS CORONAE
(2ND PHALANX)

I. F. P. PERFORATUS

COFFIN JOINT

PYRAMIDAL P.

NAVICULAR BONE

OS PEDIS
OR
COFFIN B.
(3RD PX.)

BASILAR PROCESS

RETROSSAL PRO.

SENSITIVE LAMINAE

84. *BONES OF THE LEFT FOREFOOT OF HORSE*

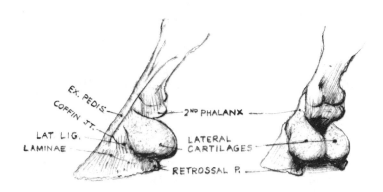

EX. PEDIS

COFFIN JT.

2ND PHALANX

LAT LIG.

LAMINAE

LATERAL
CARTILAGES

RETROSSAL P.

85 & 86. *LATERAL CARTILAGES OF LEFT FOREFOOT OF HORSE*
Left. Outside profile view.
Right. ¾ Back view.

posteriorly a channel is formed between them for the passage of the back tendons.

The second phalanx is a short, wide bone, situated partly above and partly within the hoof. The greater part is buried in the structure of the foot, only the rim and a very small portion of the upper extremity being subcutaneous. We should, however, note two prominences, one on either side, at the back and immediately below the pastern joint, on which the branch tendons of the F.P. Perforatus muscle are inserted. It is from here that the downward slope of the heels is seen to commence.

The third phalanx is wholly buried in the hoof *(see Plate 92)* and articulates with the second phalanx and the navicular bone at the coffin or pedal joint. The positions of the following attachments should, however, be noted : —

(1) The Pyramidal process, in front, on which the extensor pedis tendon is inserted.

(2) The Semi-lunar crest *(see Plate 82)*, underneath, which gives attachment to the expanded terminal extremity of the perforans tendon, and

(3) The Basilar processes, projecting backwards from each wing on which the lateral cartilages originate.

The coffin bone is attached to the inside of the hoof wall by means of the laminæ *(see Plate 84)* i.e. thin parellel and vertical leaves of sensitive tissue arising on the outer surface of the bone, which interdigitate and unite with corresponding strips of horny tissue thrown out from the inner surface of the wall, together forming a strong resilient bond between the bone and the hoof, which acts as a sling, and sustains most of the weight of the forehand.

Navicular Bone or Sesamoid of the Third Phalanx (see Plate 82). This is a small shuttle-shaped bone lying behind the coffin joint. It forms a backward extension of the third phalanx for articulation with the second, much in the same way as the two sesamoids of the first phalanx complete the articulation with the cannon bone at the fetlock joint.

Lateral Cartilages of the Foot. These cartilages, which are peculiar to solipeds, consist of two flexible plates originating within the hoof from the basilar processes of the coffin bone. They cover the sensitive frog, to which they are closely adherent, and after blending with the lateral ligaments of the coffin joint extend upwards and forwards as far as the neck of the second phalanx and the extensor pedis tendon. Thickest and most convex at the heels, they become thin as they approach the anterior part of the pastern *(see Plates 85 & 86)*.

They are very liable to external injury, causing them to become ossified, when rough excrescences often appear on the surface, and the whole structure becomes enlarged and distorted. This condition is known as " side bone " and, although not always producing lameness, is very unsightly.

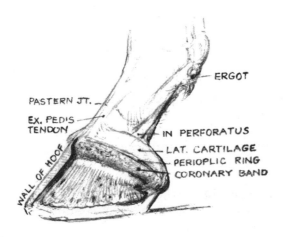

PASTERN JT.
EX. PEDIS TENDON
WALL OF HOOF
ERGOT
IN PERFORATUS
LAT. CARTILAGE
PERIOPLIC RING
CORONARY BAND

87. LEFT FOOT OF HORSE
The outer wall of hoof has been removed to disclose the internal structure.

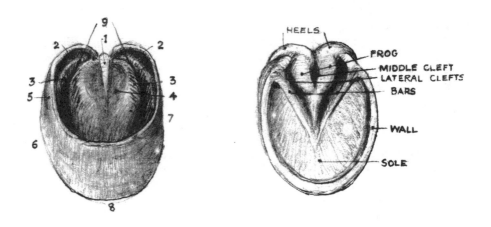

HEELS
FROG
MIDDLE CLEFT
LATERAL CLEFTS
BARS
WALL
SOLE

88 & 89. RIGHT HOOF
Left. From Above. Right. From Below.
1. Frog stay or Spine of frog. 2. Cavity for Coronary Cushion. 3. Horny Laminæ. 4. Inner surface of Horny frog. 5. Periople. 6. Outer quarter. 7. Inner quarter. 8. Toe. 9. Seat of Wings of Coffin bone.

Their inferior borders are overlapped by the Coronary Band or Cushion. This band consists of highly sensitive elastic tissue, and is enclosed between the digital structure and the upper part of the hoof, which is hollowed out for its reception *(see Plate 88)*.

The coronary band corresponds to the quick of a man's finger nail and has a similar function in that it generates and continually reproduces new horn. Owing to its exposed position and to the thinness of the surrounding wall, this sensitive structure is very liable to external injury. The coronet gets enlarged and mis-shapen and, owing to the inability of the injured part to produce healthy horn, fissures and indentations often make their appearance on the hoof below the injury, disfigurements that the artist should be most careful not to imitate *(see Plate 87)*.

Hoof. The hoof consists of the Wall or Crust, the Sole and the Frog, which together form a circular box to contain the sensitive digital structures *(see Plates 88 & 89)*.

The Wall, which is the only part visible in the standing position, is composed of solid horn and is shaped something like a tennis player's eyeshade, with the ends bent sharply inwards. These inflected portions (which can only be seen when the foot is lifted) are called the bars of the hoof and gradually taper away in the direction of the toe. They should be strong and sufficiently widely separated to allow room between them for a well developed frog.

The front of the hoof is called the Toe, the sides the Quarters, and the back the Heels.

The horn of the wall is thickest at the toe, and gradually diminishes in thickness in the quarters, and is thinnest at the heels. It is also very thin immediately below the coronet, where the reader will remember it is excavated for the accommodation of the coronary cushion. The inner quarter is nearly upright, the outer a trifle more sloping, and the front of the hoof of an average horse at an angle of from fifty to sixty degrees with the base. The ground surface should be more generously curved in front and on the outside than on the inner with the toe pointing forwards. The exterior should be smooth and straight from above downwards. Any tendency to concavity is a sign of disease.

The outer surface of the hoof is covered by a thin, and very elastic, horny skin called the Periople, which is secreted in the Perioplic Ring *(see Plate 87)* a narrow fillet, analogous to the coronary band of which it is a dependency, which encircles the top of the hoof at its junction with the ordinary skin of the limb. The periople spreads over the hoof like a varnish, and gives to the surface the bluish glaze that is characteristic of a healthy foot in its natural state. Partly as the result of wear, but chiefly owing to the farrier's rasp, it seldom extends much below the middle of the hoof. It is thickest under the coronet and near the heels *(see Plate 88)*, where it blends with the bulbs of the frog, fading away

below in a number of delicate horizontal rings until, on nearing the lower border of the hoof, it generally vanishes altogether.

The Sole consists of two parts, the invisible, sensitive sole, a velvety substance growing from the under surface of the coffin bone, and the external, horny sole, which is produced from it. The external sole should be concave, and the horn of which it is composed, strong and firm, in order to protect the underlying structure *(see also Plate 92)*.

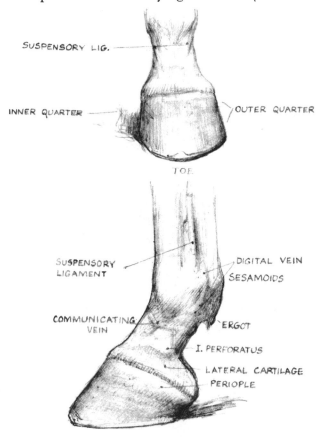

90 & 91. *LEFT FORE FOOT*
Top. The inner quarter is nearly upright and the outer a trifle more sloping.

The Frog is a resilient non-slipping pad, corresponding to the phalangeal pad of Carnivora, and intended by nature to take its share in supporting the animal's weight. Like the sole, it is divisible into two parts—the external horny frog and the internal sensitive frog or plantar cushion.

The Horny Frog is a wedge-shaped structure mortised into the horny sole and enclosed between the bars of the hoof *(see Plate 89)*. It consists of two converging ridges divided posteriorly by the middle cleft,

and is separated from the bars by two deep fossæ called the lateral clefts. The bases or bulbs are rounded and prominent, and divided by a shallow furrow originating in the middle cleft, and which is continued upwards between the lateral cartilages. The horn of which the frog is composed and which is reproduced from the sensitive frog, is softer and more pliable than that of the other parts of the hoof.

The Sensitive Frog *(see Plate 92)* is composed of elastic fibrous tissue and fat and is enclosed in the cavity formed by the horny frog, the lateral cartilages and the perforans tendon.

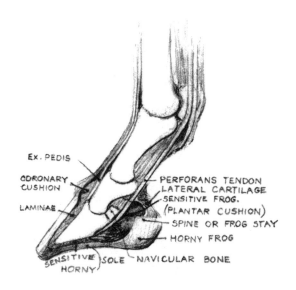

92. *SECTION AT MIDDLE LINE*
This shows position of bones and contents of hoof.

In the Carnivora, the carpal bones are arranged in two rows and in exactly the same order as in the horse. In the upper row, however, the scaphoid and the semi-lunar are fused together and form a single bone called the Scapho-lunar, making it the largest of the group. It is in contact above with the whole of the under surface of the radius and below with all four bones of the lower row.

The cuneiform and the pisiform occupy the same relative positions as in the horse, but owing to the full development of the ulna, they articulate with that bone instead of the radius.

In the lower row the only difference we have to remark is that the Trapezium, which is inconstant in the horse, is always present in Carnivora. It articulates with the first metacarpal bone and is the basis of the dew-claw.

Similarly, the Trapezoid constitutes the basis of the second metacarpal bone, the Os Magnum of the third, and the Unciform supports both the fourth and fifth.

Metacarpus (Carnivora). Of the five metacarpal bones, the first and innermost is barely half the length of the shortest of the others. Of the remainder, which constitute the main part of the paw and support the walking digits, the third and fourth are the longest and descend below the second and fifth, causing a slight crescent-shaped concavity to form above their articulations with the phalanges. The first phalanges of the

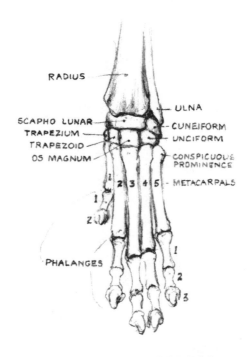

93. *LEFT FOREFOOT OF DOG*

two middle toes are more horizontal and their knuckles more elevated than the second and fifth, which are generally inclined downwards in the standing position.

Sesamoids. At the back of the lower extremity of each metacarpal bone is a pair of sesamoid bones, helping to form the metacarpo-phalangeal joints in the same way as those of the horse contribute to the formation of the fetlock joint. They give attachment to the interosseus muscles, which correspond to the suspensory ligament in a horse's leg, and posteriorly resolve themselves into four grooves for the passage of the flexor tendons on their way to their insertions on the last two bones of each toe.

Digits (Carnivora) (see Plate 93). The first, the dew-claw, consists of two phalanges. It corresponds to a man's thumb, but unlike its human counterpart cannot make contact with the other digits, nor does it reach the ground when the animal is standing upright. The other four digits represent the fingers and have each of them three phalanges. The two central toes are the longest.

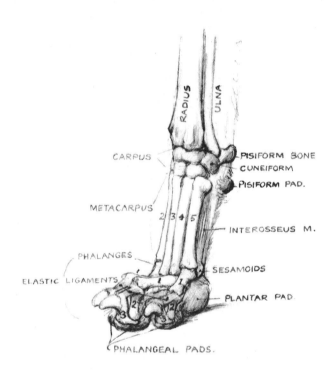

94. *LEFT FORE FOOT OF DOG (¾ front view)*

In the cat, the last phalanx of each toe is provided with a sheath or hood in which the base of the nail is received, and which in repose is automatically drawn back in a depression excavated on the outer side of the second phalanx (see Plate 96), this action being effected by means of a special elastic ligament which connects the top of the sheath with the base of that bone. It does not fold back in line with the second phalanx, but rests alongside it. Muscular action is needed to extend the claws, and this is performed by the perforans muscle. Withdrawal is mechanical and is effected by means of this ligament.

In the dog there is a ligament of a similar character but less elastic. It is attached posteriorly to the *upper* extremity of the second phalanx and not the *lower* as in the cat, and by connecting the root of the nail

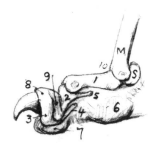

95. *THIRD DIGIT OF CAT, TIGER, &c. (CLAW WITHDRAWN)*

1. *First Phalanx.*
2. *Second Phalanx.*
3. *Third Phalanx.*
4. *Tendon of Perforans M.*
5. *Tendon of Perforatus M.*
6. *Plantar Pad of Carnivora = Ergot of Horse.*
7. *Phalangeal Pad of Carnivora = Frog of Horse.*
8. *Hood of Claw.*
9. *Elastic Ligament of Digit.*
10. *Metacarpo-phalangeal joint = Fetlock of Horse.*
M. *Third Metacarpal Bone.*
S. *Sesamoid Bones.*

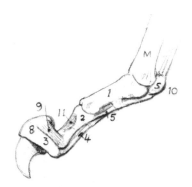

96. *THIRD DIGIT OF CAT, &c. (CLAW EXTENDED)*

1. *First Phalanx.*
2. *Second Phalanx.*
3. *Third Phalanx.*
4. *Tendon of Perforans M.*
5. *Tendon of Perforatus M.*
8. *Hood of Claw.*
9. *Elastic Ligament of Digit.*
10. *Metacarpo-phalangeal joint = Fetlock of Horse.*
11. *Depression for Reception of Hood when drawn back.*
M. *Third Metacarpal Bone.*

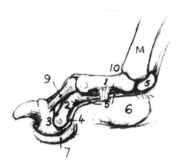

97. *THIRD DIGIT OF DOG*

1. First Phalanx.
2. Second Phalanx.
3. Third Phalanx.
4. Tendon of Perforans M.
5. Tendon of Perforatus M.
6. Plantar Pad of Carnivora = Ergot of Horse.
7. Phalangeal Pad of Carnivora = Frog of Horse.
9. Elastic Ligament of Digit.
10. Metacarpo-phalangeal joint = Fetlock of Horse.
M. Third Metacarpal Bone.
S. Sesamoid Bones.

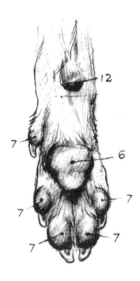

98. *FOREPAW OF DOG. PADS*

6. Plantar Pad of Carnivora = Ergot of Horse.
7. Phalangeal Pad of Carnivora = Frog of Horse.
12. Pisiform Pad.

with the top of the knuckle it bridges the V-shaped gap between the bones and forms part of the upper outline of the toe, giving the impression that there are only two bones and not three. It retains the last phalanx in the normal position when at rest, and restores it after being fully extended. From overwork and in old age this ligament often becomes permanently stretched, causing the toes to spread and the knuckles to drop.

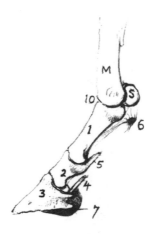

99. *DIGIT OF HORSE*

1. First Phalanx.
2. Second Phalanx.
3. Third Phalanx.
4. Tendon of Perforans M.
5. Tendon of Perforatus M.
6. Plantar Pad of Carnivora = Ergot of Horse.
7. Phalangeal Pad of Carnivora = Frog of Horse.
10. Metacarpo-phalangeal joint = Fetlock of Horse.
M. Third Metacarpal Bone.
S. Sesamoid Bones.

Pads. The forepaw of both cat and dog is furnished with seven pads composed of fibrous tissue and fat, and covered with thick skin, viz. (1) the Plantar Pad, a large three-lobed cushion situated in the middle of the foot under the metacarpo-phalangeal joints, and therefore taking most of the weight in the standing attitude; (2) five Phalangeal Pads, one under the last joint of each toe; and (3) a small round knob at the back of the knee called the Pisiform Pad.

In solipeds the phalangeal pad of the third digit is preserved, and has developed into the frog, the plantar pad, which has ceased to function, being represented by the Ergot, a small horny substance embedded in hair at the back of the fetlock.

There is no sign of a pisiform pad in any of the Ungulates.

Suspensory Ligament. This is a powerful mechanical brace supporting the fetlock joint. With the aid of the back tendons it serves to maintain the normal angle between the cannon bone and the digit, whereby the muscles are relieved of strain, and the horse is able to stand for long periods without fatigue and even to sleep without falling.

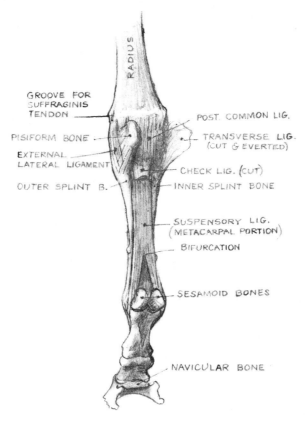

100. *SUSPENSORY LIGAMENT OF LEFT FORELEG OF HORSE (Back view)*

It corresponds to one of the interosseus muscles of man and the Carnivora and is sometimes referred to under that name, and although composed for the most part of inextensible fibrous tissue, it still retains some fleshy fasciculi, which give it a certain amount of elasticity, and at the same time serve as a reminder of its muscular origin.

It consists of a metacarpal and two lateral phalangeal portions *(see Plate 101)*. The first, the main portion, is a very strong, flat band reaching from the knee to the fetlock. It arises from the posterior surface of the lower row of carpal bones and the back of the upper end of the cannon bone *(see Plate 82)*. On approaching the fetlock it splits into two branches, which are respectively attached to the outer surfaces

of the sesamoid bones; a continuation of each of these branches then passes obliquely forwards over the large pastern bone and joins the extensor pedis tendon, through whose agency it reaches its final attachment on the last phalanx (coffin bone).

This ligament does not, as is sometimes supposed, actually prevent

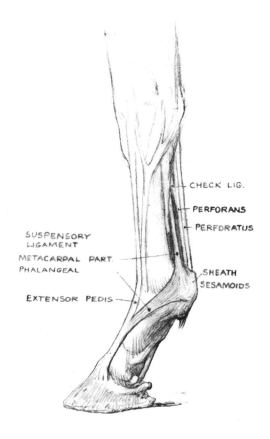

CHECK LIG.

PERFORANS

PERFORATUS

SUSPENSORY LIGAMENT

METACARPAL PART.

PHALANGEAL

SHEATH

SESAMOIDS

EXTENSOR PEDIS

101. *SUSPENSORY LIGAMENT OF HORSE*

over extension of the fetlock joint, if by that we understand the pastern and foot being carried forward, so as to make a more acute angle with the cannon bone than in the standing attitude, as can easily be proved by reference to instantaneous photographs of horses in action. If we take, for instance, a representation of a horse galloping, we see there is a moment in every stride when the whole of the animal's weight is borne by one foreleg and that in that fraction of time, as the leg becomes vertical, the base of the fetlock actually brushes the ground, the pastern being horizontal or even sloping upwards. The same thing occurs to a lesser extent in the trot and the walk; in fact, whenever

extra pressure is brought to bear, the fetlock drops and the angle is re-
duced, to be automatically restored as soon as the extra pressure is
removed. In a clean leg the edges of the main portion should resemble
a piece of tightly strained whipcord and the lower borders of the
flattened phalangeal prolongations be clearly defined as they leave the
fetlock to cross the pastern.

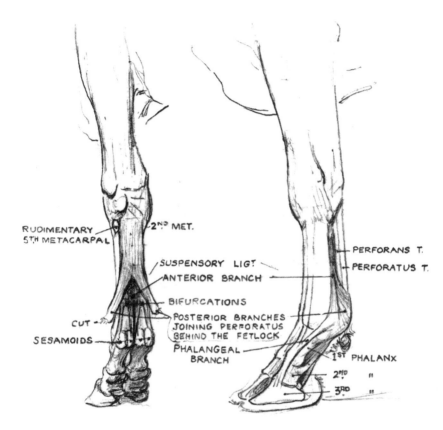

102 & 103. *SUSPENSORY LIGAMENT OF OX, LEFT FORE LEG*

The suspensory ligament of the ox, sheep, goat, &c. commences as a
single band at the back of the knee, but towards the lower end of the
metacarpus it divides into two parts, each of which is afterwards almost
a replica of the single ligament of the horse, with similar attachments on
the sesamoid bones and other parts of its respective digit.

There is, however, one remarkable feature to be noted, and that is
that from about the middle of the metacarpal portion a wide band is
detached posteriorly, which divides and sends off a strong branch on
either side to join the perforatus tendons, forming a double ring behind
the fetlock joint through which the two perforans tendons pass, and at

the same time constituting a mechanical brace to take the strain off the perforatus muscle when the animal is standing—much in the same way as the check ligament of the horse relieves the perforans muscle—as will shortly be explained.

The suspensory ligament of the ox, &c. contains a much larger proportion of muscular tissue than that of the horse, making it more sensitive and less efficient as a passive support. The posterior portion, however, gives it additional strength, and by concealing the crevices, &c. tends rather to simplify the form than to add to the detail.

In the dog, cat, &c. this ligament is replaced by four interosseus muscles, analogous to those in the palm of the human hand, and which act as flexors to bend the first phalanges of the principal digits on the metacarpal bones.

CHAPTER VI

MUSCLES OF THE FORE LIMB

THESE may be divided into five groups, which will be dealt with in the following order: —

1. Those acting on the foot.

2. Arising on the bones of the forearm and acting on the cannon bone.

3. Arising on the arm-bone and acting on the forearm.

4. Arising on the shoulder-blade, acting on the forearm.

5. Arising on the shoulder-blade and acting on the arm.

GROUP I. MUSCLES WHICH ACT UPON THE FOOT OF THE HORSE. *Flexor Pedis Perforans* and *Flexor Pedis Perforatus* (or the deep and superficial flexors of the foot). These two muscles, with their tendons, reach from the elbow to the foot, and their muscular bellies form the basis of the fleshy mass at the back of the forearm. A few inches above the knee they are succeeded by strong tendons which pass together through the carpal sheath, down the back of the leg, then through the sesamoid groove, to be finally inserted in the following manner.

On reaching the middle of the great pastern bone, the posterior tendon (perforatus) splits into two branches, which are inserted one on each side of the upper end of the second phalanx. Meanwhile, the single perforans tendon, after passing through the fork so formed, widens out, glides over the navicular bone, and is inserted on the semi-lunar crest of the third phalanx.

A little above the middle of the cannon bone, the perforans tendon is joined by a strong band, the Subcarpal or " Check " ligament *(see Plate 104)*, which is detached from the posterior common ligament, and in the standing position the tension is transferred to this ligament, automatically preventing over extension at the coffin joint, and the muscular portion above is in this way relieved of the strain.

In the same way, the perforatus tendon *(see Plate 104)*, before entering the carpal sheath, receives a strong ligamentous band from the inner edge of the radius. This is called the Superior Carpal ligament, and has a similar function, in support of the pastern joint.

The back tendons, as they are generally called, should be parallel with the cannon bone and absolutely straight from the knee to the fetlock. The slightest curvature is an indication of a sprain.

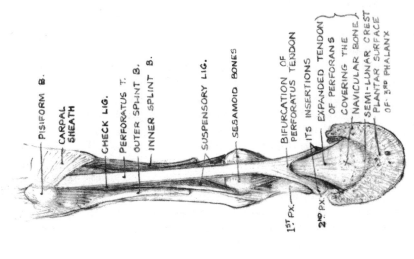

PISIFORM B.

CARPAL
SHEATH

CHECK LIG.

PERFORATUS T.

OUTER SPLINT B.

INNER SPLINT B.

SUSPENSORY LIG.

SESAMOID BONES

BIFURCATION OF
PERFORATUS TENDON

ITS INSERTIONS

EXPANDED TENDON
OF PERFORANS
COVERING THE
NAVICULAR BONE.

SEMI-LUNAR CREST

PLANTAR SURFACE
OF 3RD PHALANX

1ST PX.

2ND PX.

105. *LEFT FOOT OF HORSE, LIFTED*

This shows the insertions of the Perforatus and Perforans muscles. The Plantar cushion (i.e. the sensitive frog) covers the lower end of the Perforans tendon, the tendon passing between it and the navicular bone.

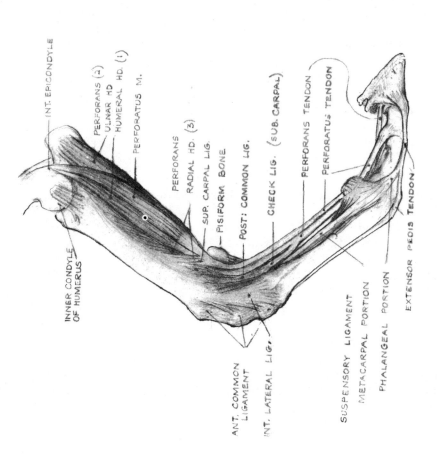

INT. EPICONDYLE

PERFORANS (2)
ULNAR HD
HUMERAL HD. (1)

PERFORATUS M.

PERFORANS
RADIAL HD. (3)

SUP. CARPAL LIG.

PISIFORM BONE

POST: COMMON LIG.

CHECK LIG. (SUB. CARPAL)

PERFORANS TENDON

PERFORATUS TENDON

INNER CONDYLE
OF HUMERUS

ANT. COMMON
LIGAMENT

INT. LATERAL LIG.

SUSPENSORY LIGAMENT

METACARPAL PORTION

PHALANGEAL PORTION

EXTENSOR PEDIS TENDON

104. *INSIDE VIEW OF RIGHT FORE LEG OF HORSE, FLEXED*

This shows course of Perforatus and Perforans muscles, with their check ligaments slack, i.e. not acting. (The Carpal sheath is omitted.)

The perforans, which is considerably the larger and more powerful of the two muscles, arises by three heads: (1) The humeral head, from the inner epicondyle of the humerus; (2) the ulnar head, from the inner surface and posterior border of the olecranon process; and (3) the radial head, from the lower part of the posterior surface of the radius. Each is succeeded by a separate tendon, and these unite above the carpus to form the single strong tendon already described, and which lies in front of that of the perforatus for the remainder of its length. Except for a small part of the ulnar head, just below the elbow, and an even smaller piece of the radial head at the lower end of the forearm *(see Plate 108)*, the perforans muscle is too deeply buried to be seen.

The perforatus muscle consists of a single fleshy head, which arises, along with the internal head of the perforans (to which it is closely adherent), from the inner epicondyle of the humerus *(see Plates 106 & 107)*. It partially covers the latter muscle and is itself almost entirely concealed by the flexors of the metacarpus, as we shall presently see, and has therefore no direct influence on the surface.

The action of both these muscles is to flex the digit on the cannon bone, the perforatus acting mostly on the fetlock joint, and the perforans, which has to lift the greater weight, being primarily responsible for bending the pastern and coffin joints. At the latter joint, however, owing to its being enclosed within the hoof, there is very little movement.

In other than solipeds, the tendons of the perforatus and perforans muscles split up into as many branches as there are digits to be served, and after so dividing, each branch comports itself in exactly the same way as does the corresponding tendon in the horse.

In the cloven-footed animals we therefore find two branches of each tendon, and in the dog, cat, &c. four branches of the perforatus, one being attached to the second phalanx of each of the principal toes (none going to the dew-claw), and five of the perforans.

Carnivora. In the horse, ox, &c. the muscular portions of the perforans and perforatus are almost entirely concealed beneath the flexors of the metacarpus. In the dog and cat, however, these latter are relatively slender muscles and wider apart, allowing the flexors of the foot to come to the surface between them, the perforatus muscle being particularly noticeable on the inside of the forearm from its origin on the humerus until it is lost in the carpal region *(see Plates 113 & 115)*.

Extensor Pedis (Horse). (Anterior Extensor of the Phalanges.) This muscle, which corresponds to the Extensor Communis digitorum of man, extends from the lower end of the arm-bone to the foot *(see Plate 108)*. It arises from a depression in front of the external condyle of the humerus, from the anterior edge of the lateral ligament of the elbow joint, and from the external tuberosity and the upper part of the shaft of the radius.

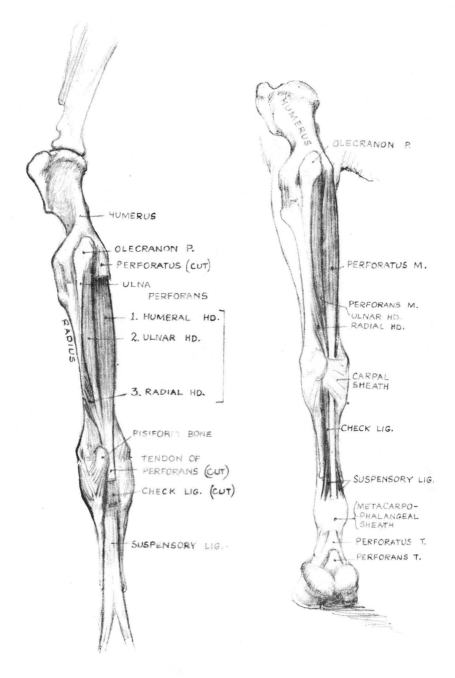

HUMERUS

OLECRANON P.
PERFORATUS (CUT)
ULNA
PERFORANS
1. HUMERAL HD.
2. ULNAR HD.

3. RADIAL HD.

RADIUS

PISIFORM BONE

TENDON OF
PERFORANS (CUT)

CHECK LIG. (CUT)

SUSPENSORY LIG.

HUMERUS

OLECRANON P.

PERFORATUS M.

PERFORANS M.
ULNAR HD.
RADIAL HD.

CARPAL
SHEATH

CHECK LIG.

SUSPENSORY LIG.

METACARPO-
PHALANGEAL
SHEATH
PERFORATUS T.
PERFORANS T.

106. *PERFORANS MUSCLE*

*The main tendon cut behind the knee in order to show positions of the " check "
and suspensory ligaments underneath.*

107. *LEFT FORELEG OF HORSE (Back view)*
This shows Perforatus and Perforans muscles.

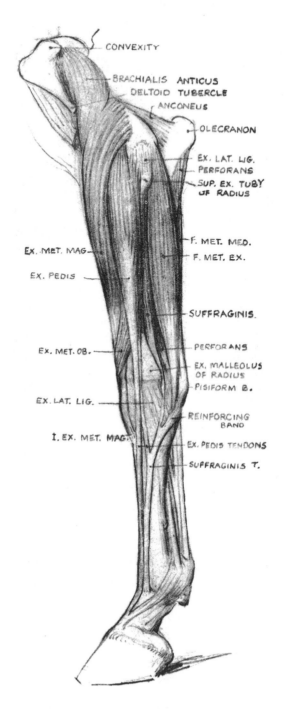

CONVEXITY

BRACHIALIS ANTICUS
DELTOID TUBERCLE
ANCONEUS

OLECRANON

EX. LAT. LIG.
PERFORANS
SUP. EX. TUBY
OF RADIUS

F. MET. MED.
F. MET. EX.

EX. MET. MAG.

EX. PEDIS

SUFFRAGINIS.

PERFORANS

EX. MET. OB.

EX. MALLEOLUS
OF RADIUS
PISIFORM B.

EX. LAT. LIG.

REINFORCING
BAND

I. EX. MET. MAG.

EX. PEDIS TENDONS

SUFFRAGINIS T.

108. *THE EXTERNAL VIEW OF THE LEFT FORE LEG OF
THE HORSE (SUPERFICIAL MUSCLES)*

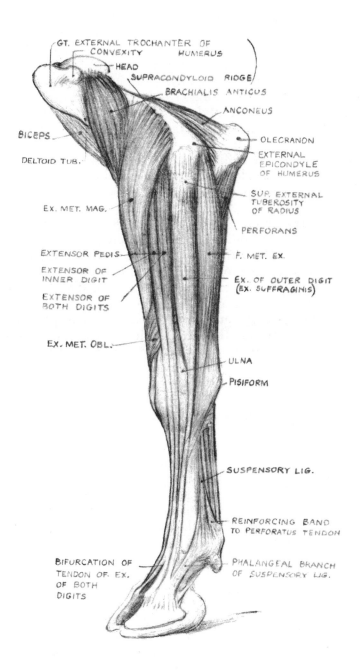

GT. EXTERNAL TROCHANTER OF
CONVEXITY HUMERUS
HEAD
SUPRACONDYLOID RIDGE
BRACHIALIS ANTICUS
ANCONEUS
BICEPS
OLECRANON
DELTOID TUB.
EXTERNAL
EPICONDYLE
OF HUMERUS
SUP. EXTERNAL
TUBEROSITY
OF RADIUS
EX. MET. MAG.
PERFORANS
EXTENSOR PEDIS
F. MET. EX.
EXTENSOR OF
INNER DIGIT
EX. OF OUTER DIGIT
(EX. SUFFRAGINIS)
EXTENSOR OF
BOTH DIGITS
EX. MET. OBL.
ULNA
PISIFORM
SUSPENSORY LIG.
REINFORCING BAND
TO PERFORATUS TENDON
BIFURCATION OF
TENDON OF. EX.
OF BOTH
DIGITS
PHALANGEAL BRANCH
OF SUSPENSORY LIG.

109. *FORELEG OF OX (Outside view)*

On reaching the lower third of the forearm, the muscular portion is succeeded by two unequal tendons, which are confined in a common sheath, and pass together through the most external of the three grooves on the front of the lower end of the radius, and over the first row of carpal bones and then part company. The main anterior tendon continues down the front of the cannon bone, and after being attached to the capsular ligament of the fetlock joint and the anterior surfaces of the two first phalanges, and being joined by the phalangeal branches of the suspensory ligament, it widens out and is finally inserted on the pyramidal process of the coffin bone.

The small posterior tendon on leaving the main tendon turns outwards to unite with the tendon of the suffraginis muscle in front of the head of the outer splint bone.

By its action this muscle successively extends the phalanges and to some extent assists in extending the metacarpus on the forearm.

In the ox, &c. *(see Plate 109)* the extensor pedis is represented by two parallel muscles, whose tendons are enclosed in a common sheath as they pass over the knee. The anterior muscle, which is slightly the narrower, constitutes the proper extensor of the inner digit, and its tendon is inserted on the two last phalanges of that digit. The posterior muscle, whose tendon after crossing the fetlock joint divides into two parts, acts as an extensor of both digits, and also serves to draw the toes together.

In the dog, cat, &c. this muscle is known as the " common extensor of the digits." The fleshy portion is undivided and about half-way down the forearm is succeeded by a tendon which, after passing over the carpus, splits into four parts, which are severally inserted on the four outer toes.

A small unimportant muscle, the extensor of the two inner digits, which arises on the shaft of the radius underneath the foregoing, furnishes a slender tendon which comes to the surface below the wrist, and turning inwards, divides and sends off a slip to be attached to the dew-claw and another to the second digit. It corresponds to the proper extensor of the thumb and index finger of man.

Extensor Suffraginis. (Lateral Extensor of the Phalanges) *(see Plates 108 & 112)*. In the horse this is a poorly developed muscle, wedged in between the extensor pedis and the external flexor of the metacarpus, and succeeded by a long tendon that commences a short distance above the knee and terminates on the upper extremity of the large pastern bone (Os Suffraginis) just below the fetlock joint.

The fleshy portion *(see Plate 112)*, enclosed in a special sheath, arises from the lateral ligament of the elbow joint the supero-external tuberosity and posterior edge of the radius, and from the adjacent edge of the ulna.

The upper half is to some extent concealed by the muscles in front and behind, but about the middle of the forearm, as these muscles separate,

the lower part comes into view, and soon gives place to a small tendon that enters the groove on the lower tuberosity of the radius (external malleolus) and passes down the outside of the knee. As it crosses the upper extremity of the outer splint bone it is joined by a strong, fibrous band from the posterior carpal region, and a little later by the thin outer tendon of the extensor pedis muscle. The tendon now expands, and

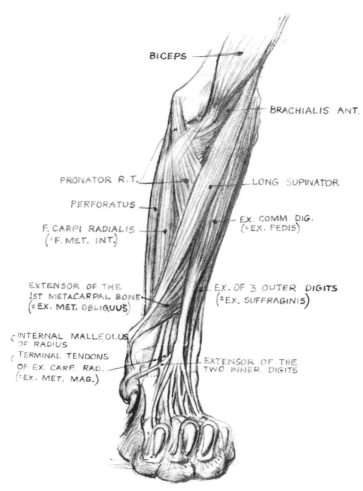

BICEPS

BRACHIALIS ANT.

PRONATOR R.T.

LONG SUPINATOR

PERFORATUS

EX. COMM. DIG.
(=EX. PEDIS)

F. CARPI RADIALIS
(=F. MET. INT.)

EXTENSOR OF THE
1ST METACARPAL BONE
(=EX. MET. OBLIQUUS)

EX. OF 3 OUTER DIGITS
(=EX. SUFFRAGINIS)

INTERNAL MALLEOLUS
OF RADIUS

TERMINAL TENDONS
OF EX. CARP. RAD.
(=EX. MET. MAG.)

EXTENSOR OF THE
TWO INNER DIGITS

110. *THE MUSCLES OF THE LEFT FORE LEG OF THE LION,
FRONT VIEW*

after passing over the lower end of the cannon bone, is finally inserted on the upper rim of the first phalanx.

Like all the tendons which pass over the knee, it is enclosed in a synovial sheath and embedded in the aponeurosis that envelops that region.

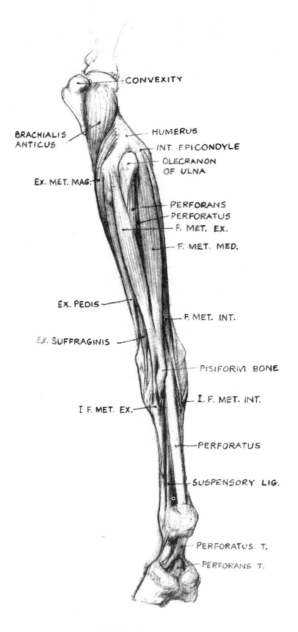

CONVEXITY

BRACHIALIS ANTICUS

HUMERUS

INT. EPICONDYLE

OLECRANON OF ULNA

Ex. MET. MAG.

PERFORANS
PERFORATUS
F. MET. EX.

F. MET. MED.

Ex. PEDIS

F. MET. INT.

Ex. SUFFRAGINIS

PISIFORM BONE

I. F. MET. INT.

I F. MET. EX.

PERFORATUS

SUSPENSORY LIG.

PERFORATUS T.

PERFORANS T.

111. *SUPERFICIAL MUSCLES OF THE LEFT FORE LEG OF THE HORSE, BACK VIEW*

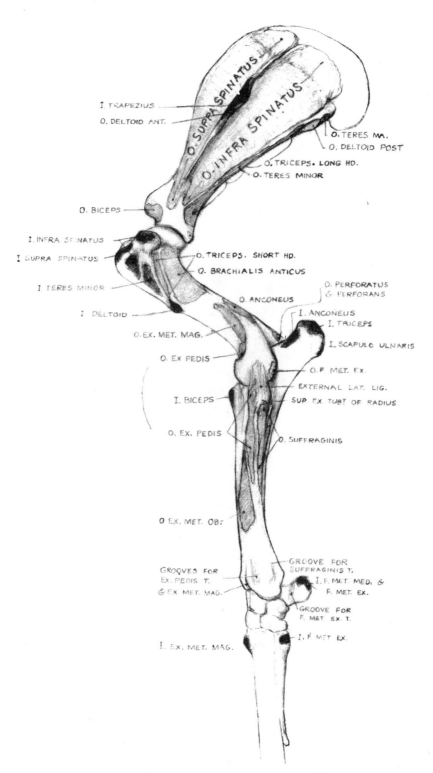

I. TRAPEZIUS
O. DELTOID ANT.

O. SUPRA SPINATUS
O. INFRA SPINATUS

O. TERES MA.
O. DELTOID POST
O. TRICEPS. LONG HD.
O. TERES MINOR

O. BICEPS

I. INFRA SPINATUS
I. SUPRA SPINATUS

I. TERES MINOR

I. DELTOID

O. TRICEPS. SHORT HD.
O. BRACHIALIS ANTICUS

O. PERFORATUS
& PERFORANS

O. ANCONEUS

I. ANCONEUS
I. TRICEPS

O. EX. MET. MAG.

I. SCAPULO ULNARIS

O. EX PEDIS

O. F. MET. EX.
EXTERNAL LAT. LIG.

I. BICEPS

SUP. EX. TUB? OF RADIUS

O. EX. PEDIS

O. SUFFRAGINIS

O. EX. MET. OB.

GROOVE FOR
SUFFRAGINIS T.

GROOVES FOR
EX. PEDIS T.
& EX MET. MAG.

I. F. MET. MED. &
F. MET. EX.

GROOVE FOR
F. MET. EX. T.

I. EX. MET. MAG.

I. F. MET. EX.

112. *LEFT FORE LIMB OF HORSE (Outside view)*
This shows origins in grey and insertions in black.

Comparative (see Plate 109). In the ox, &c. this is a much larger muscle and is exposed throughout its length. It constitutes the proper extensor of the external digit and, after being joined by the external

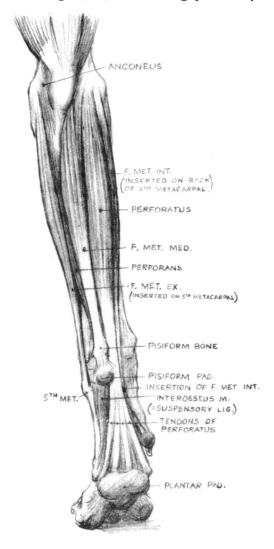

ANCONEUS

F. MET. INT.
(INSERTED ON BACK
OF 2ND METACARPAL)

PERFORATUS

F. MET. MED.

PERFORANS

F. MET. EX.
(INSERTED ON 5TH METACARPAL)

PISIFORM BONE

PISIFORM PAD.
INSERTION OF F. MET. INT.
INTEROSSEUS M.
(=SUSPENSORY LIG.)
TENDONS OF
PERFORATUS

5TH MET.

PLANTAR PAD.

113. *BACK VIEW OF LEFT FORELEG OF DOG*
Names given as in the Horse. (See Plate 112.)

phalangeal band of the suspensory ligament, is inserted on the last two phalanges of that digit. The effect of the simultaneous action of the extensors of the inner and outer digits is to draw the toes apart.

In the dog, cat, &c. (see Plate 110) the suffraginis muscle is represented by the extensor of the three outer digits. It consists of a single

fleshy belly, whose tendon divides inferiorly into three branches, which unite in the metacarpal region with the three outer tendons of the common extensor.

The tendons, which operate the digits, are so numerous and complicated in these animals that it is useless to attempt to individualize them. The bones, after all, are the foundation of the form and the superficial details merely the ornament, and how they are to be treated must depend on the artistic sense of the painter. A general impression or intelligent suggestion of such facts is always far more convincing than an elaborate map of the facts themselves.

GROUP 2. The action of bending the knee is performed by the three Flexors of the Metacarpus.

Flexor Metacarpi Externus (Posterior Ulnar), (Extensor Carpi Ulnaris) *(see Plates 108 & 111)*. This muscle consists of a single fleshy body with a double terminal tendon, and is situated between the extensor suffraginis (which it partially overlaps), and the middle flexor of the metacarpus. It arises from the external epicondyle of the humerus and, inclined slightly inwards and backwards, ends in a strong tendon that divides into two unequal branches, an internal and an external. The internal or posterior branch is short and broad, and after uniting with the tendon of the middle flexor, is inserted on the summit of the pisiform bone. The external, small and round, after leaving the main portion, passes through a groove on the external surface of the pisiform bone and is inserted on the head of the external splint bone.

In the dog, cat, &c. this muscle has no attachment on the pisiform bone, and does not join the middle flexor of the metacarpus, but ends in a strong, round tendon, which is inserted on the head of the fifth metacarpal bone.

Flexor Metacarpi Medius (Oblique Flexor of the Metacarpus), (Flexor Carpi Ulnaris) *(see Plate 111)*. This is almost the counterpart of the preceding muscle on the opposite side of the forearm. It arises by two heads, an outer, the strongest, which has its origin on the internal epicondyle of the humerus, and an inner, small and thin, which arises from the olecranon process of the ulna. The two portions soon unite and terminate in a single tendon which, after joining the tendon of the external flexor, is inserted with it on the pisiform bone. In the narrow triangle which separates the fleshy bodies of the two muscles, the upper extremity of the ulnar head of the perforans muscle, and a small portion of the perforatus, come to the surface.

Flexor Metacarpi Internus (Flexor Carpi Radialis) *(see Plates 111 & 119)*. This muscle arises along with the middle flexor from the inner epicondyle of the humerus and ends in a round tendon, which passes in a synovial sheath through the ligaments on the inside of the knee, and is inserted on the head of the inner splint bone. This latter portion is

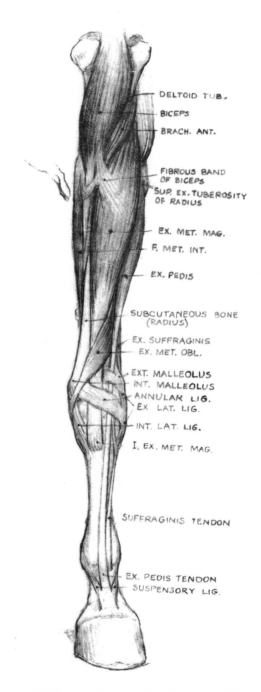

DELTOID TUB.

BICEPS

BRACH. ANT.

FIBROUS BAND
OF BICEPS
SUP. EX. TUBEROSITY
OF RADIUS

EX. MET. MAG.

F. MET. INT.

EX. PEDIS

SUBCUTANEOUS BONE
(RADIUS)

EX. SUFFRAGINIS
EX. MET. OBL.

EXT. MALLEOLUS
INT. MALLEOLUS
ANNULAR LIG.
EX. LAT. LIG.

INT. LAT. LIG.

I. EX. MET. MAG.

SUFFRAGINIS TENDON

EX. PEDIS TENDON
SUSPENSORY LIG.

114. *LEFT FORE LEG OF HORSE (SUPERFICIAL MUSCLES)*

therefore quite hidden. The fleshy belly of the muscle fills the space between the middle flexor and the back of the radius, and the large sub-cutaneous vein of the forearm lies in the groove between them.

In the dog, cat, &c. the flexor metacarpi internus is inserted on the back of the upper extremity of the second metacarpal bone (index). A relatively wide interval separates it from the middle flexor, exposing the perforatus muscle *(see Plates 113 & 115)*.

MUSCLES WHICH STRAIGHTEN THE KNEE. *Extensor Metacarpi Magnus* (Anterior Extensor of the Metacarpus) (Extensor Carpi Radialis of Man and Carnivora). This is a powerful muscle on the front of the forearm. It commences above and in front of the elbow joint and ends on the head of the cannon bone. It arises from the external supra-condyloid ridge of the humerus, from the fascia that covers the brachialis anticus muscle, and from the capsular ligament of the elbow joint *(see Plates 108 & 112)*.

The muscular portion, thick and prominent above, gradually tapers downwards, and in the lower third of the forearm is succeeded by a strong tendon which, after passing through the middle groove on the lower end of the radius and over the knee, is inserted on the protuber-ance on the front and a little to the inside of the upper extremity of the principal metacarpal bone.

The tendon is kept in place by means of a broad annular ligament that blends with the anterior common ligament of the carpus and is a development of the antibrachial fascia. This is the principal muscle employed in straightening the knee joint.

In the cat and dog this muscle divides into two portions, corresponding to the long and short radial muscles of man, and ends in two tendons, which pass together through the middle groove on the radius, and are separately inserted on the upper extremities of the second and third metacarpal bones *(see Plates 110, 115 & 116)*.

In the ox, the muscle comports itself in the same way as it does in the horse, and the tendon is inserted on the front of the upper end of that part of the shank-bone which corresponds to the third metacarpal, i.e. the inner half *(see Plate 109)*.

Extensor Metacarpi Obliquus (Extensor Ossis Metacarpi Pollicus of Man and Carnivora) *(see Plates 108, 112 & 114)*. This is a thin tri-angular muscle arising on the outer border of the middle third of the radius underneath the extensor pedis muscle. On emerging from beneath the latter it crosses over the principal extensor of the meta-carpus and is succeeded by a narrow tendon that passes through the most internal of the three radial grooves and over the inner surface of the knee, and after blending with the internal lateral ligament is in-serted on the head of the inner splint bone *(see Plate 119)*. It assists in

the extension of the knee joint and at the same time rotates the cannon bone slightly outwards.

Although not in any way prominent and hardly affecting the profile outline of the leg, this muscle has a decided influence on the surface, as

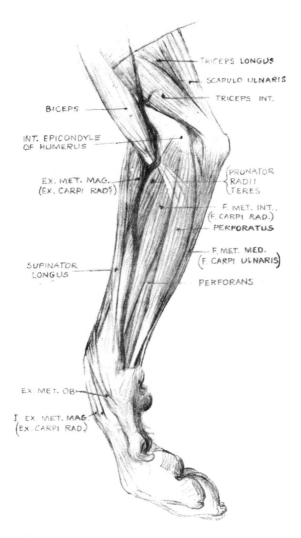

TRICEPS LONGUS

SCAPULO ULNARIS

TRICEPS INT.

BICEPS

INT. EPICONDYLE OF HUMERUS

EX. MET. MAG. (EX. CARPI RAD?)

PRONATOR RADII TERES

F. MET. INT. (F. CARPI RAD.)

PERFORATUS

F. MET. MED. (F. CARPI ULNARIS)

SUPINATOR LONGUS

PERFORANS

EX. MET. OB.

I. EX. MET. MAG. (EX. CARPI RAD.)

115. *INSIDE VIEW OF DOG'S RIGHT FORELEG*

owing to its facing at a different angle it often catches light when the more vertical planes are in shadow. This muscle represents the long abductor and short extensor of the thumb of man, and in the absence of that digit in the horse, &c. is attached to the nearest available bone prominence, which is the nead of the internal rudimentary metacarpal or splint bone.

In the ox, sheep, &c. it terminates on the inside of the upper extremity of the shank, and in the Carnivora it goes to the metacarpal bone of the dew-claw *(see Plates 110 & 116)*. It is more strongly developed in the cat than in the dog.

The following muscles, which move the radius upon the ulna, are absent in the horse and all those animals in which the bones of the forearm are fused together, but are preserved in the Carnivora and developed in different species according to the mobility of the limb.

Supinator Longus. This is a long, thin muscle extending from the middle of the outer surface of the arm to the inner side of the wrist. It arises from the outer surface of the shaft of the humerus *(see Plates 110 & 116)*, and from the fascia that covers the brachialis anticus muscle, and is inserted on the internal malleolus of the radius. Its chief function is to flex the forearm on the arm at the elbow joint. It also serves in a minor degree as a supinator and turns the palmar surface of the paw slightly inwards. This muscle is well developed in the large cats, but as a rule very rudimentary in the dog.

Pronator Radii Teres (see Plates 110, 115 & 116). This is a fleshy muscle arising from the inner condyle of the humerus and passing obliquely across the upper extremity of the forearm to its insertion on the front of the radius.

Short Supinator. Although of no consequence so far as the external form is concerned, this deep muscle actually plays a more important part in the pivoting movement of the radius than the long supinator does. It arises from the outer condyle of the humerus and the external lateral ligament of the elbow, and after winding over the upper end of the radius is inserted on its inner edge. It rotates the radius outwards, and is therefore a direct opponent of the pronator radii teres *(see Plate 116)*.

Square Pronator. This muscle, deeply buried in the muscles at the back of the forearm, arises on the back of the ulna, and is inserted on the inner edge of the radius and extends obliquely downwards from just below the elbow to a little above the wrist. It turns the radius inwards. Not shown in the diagrams.

The muscles of the fore limb, like those of every other part of the body, are enveloped in fibrous tissue, which in some places gives attachment to other muscles, and as we shall shortly have occasion to refer to some of these attachments, it may be well before doing so to say a few words explaining the nature of this investment.

It originates as a delicate membrane, which first of all envelops the bones and, radiating from them, gradually covers and penetrates every region conveying blood vessels and nerves, ensheathing the muscles, and clothing and lining every component part—indeed, we are told that if it

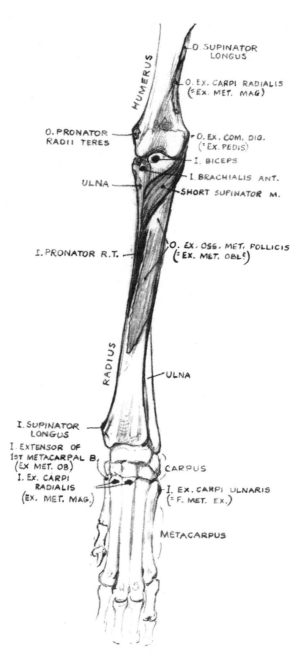

O. SUPINATOR
LONGUS

O. EX. CARPI RADIALIS
(=EX. MET. MAG)

HUMERUS

O. PRONATOR
RADII TERES

O. EX. COM. DIG.
(=EX. PEDIS)

I. BICEPS

ULNA

I. BRACHIALIS ANT.

SHORT SUPINATOR M.

I. PRONATOR R.T.

O. EX. OSS. MET. POLLICIS
(=EX. MET. OBL⁵)

RADIUS

ULNA

I. SUPINATOR
LONGUS

I. EXTENSOR OF
1ST METACARPAL B.
(EX. MET. OB)

CARPUS

I. EX. CARPI
RADIALIS
(EX. MET. MAG.)

I. EX. CARPI ULNARIS
(=F. MET. EX.)

METACARPUS

**116. ORIGINS (O) AND INSERTIONS (I) OF MUSCLES OF
LEFT FORE LEG OF DOG**

were possible to preserve this casing and dissolve or extract everything else, there would remain a perfect mould of the whole of the animal's anatomy.

It is, however, with the more superficial aponeurosis that we are chiefly concerned, forming as it were the outer cover, and which is only separated from the skin by some loose connective tissue, fat, blood vessels, &c.

This superficial layer varies in density in different places according to local requirements. It blends with the ligaments and is firmly attached to all the subcutaneous bone surfaces. It also sends down partitions, or septa, between the muscles, which in many places reach the deeper bone surfaces. In this way not only are individual muscles enclosed in separate sheaths, but groups of muscles and whole. regions are again ensheathed.

It is largely due to the way in which the septa sink in between the muscles that some are more clearly defined than others. Where two or three fleshy bellies are enclosed in a single sheath, or a considerable area is covered by aponeurosis, interior dividing lines get lost and the surface is simplified.

Antibrachial Aponeurosis is the name given to the fascia that covers the muscles of the forearm, around which it forms a very strong resisting envelope, supporting them during contraction, retaining them in position and guiding them to their various destinations. Its principal attachments are on the posterior edge of the ulna, the inner surface of the shaft of the radius, and on both sides of the inferior extremity of that bone. Septa, which it gives off from its inner face, pass on either side of the extensor suffraginis to become fixed to the outer border of the radius, so forming a special sheath for that muscle, and isolating it from its neighbours. Similar partitions separate the great extensor of the metacarpus from the extensor pedis, and the internal from the middle flexors of that region, and in each case they help to emphasize the form.

The aponeurosis is very thick around the elbow and on the back of the forearm, and again in the carpal region, where it not only blends with the ligaments and forms the sheaths and bands that retain the tendons of the extensor muscles in their grooves on the radius, but it also contributes to the formation of the carpal sheath. It extends upwards on the inside of the limb as far as the middle of the humerus, where it gives attachment to the scapulo-ulnaris muscle, while on the outside it receives a strong, fibrous band from the biceps, both of which act upon it as tensors.

Although no longer distinguished by any particular name, this fibrous envelope is continued down the lower leg like a close-fitting stocking, and forms the bases of all the tunnels, sheaths and fibrous expansions which guide the tendons to their objectives, maintain them in position, and generally give strength and rigidity to the limb.

GROUP 3. MUSCLES OF THE ARM. The elbow joint works in the opposite direction to the other joints of the fore limb. Consequently we find the flexor muscles are situated on the front of the arm-bone and the extensors behind it.

Of the muscles which operate this joint, some have their origins on

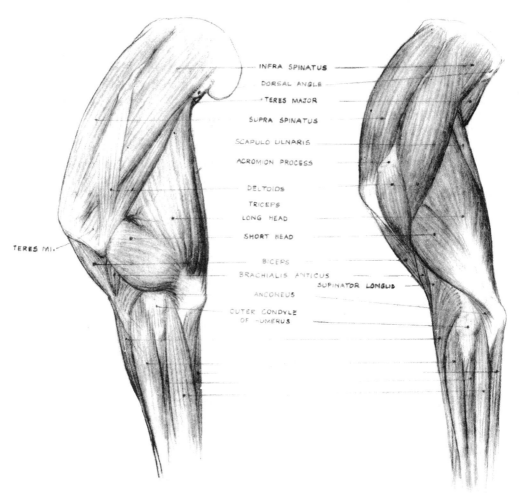

INFRA SPINATUS

DORSAL ANGLE

TERES MAJOR

SUPRA SPINATUS

SCAPULO ULNARIS

ACROMION PROCESS

DELTOIDS

TRICEPS

LONG HEAD

SHORT HEAD

TERES MI.

BICEPS

BRACHIALIS ANTICUS

SUPINATOR LONGUS

ANCONEUS

OUTER CONDYLE
OF HUMERUS

117 & 118. *PROFILE VIEW OF LEFT SHOULDER & ARM OF*
HORSE & GREYHOUND
Note different development of Deltoid muscles.

the humerus, others on the scapula. The former act directly between the arm and the forearm, and will therefore be dealt with first ; next we will describe those which arise on the scapula and which, although inserted on one or other of the bones of the forearm, and acting upon the elbow joint, are also involved in movements of the scapulo-humeral articula-

tion, and finally we will describe those which, arising on the shoulder-blade and ending on the arm-bone, are responsible for the movements at that articulation only.

Brachialis Anticus (Short Flexor of the Forearm), (Humero-radialis), (Humeralis Obliquus) *(see Plates 108, 112 &114)*. This is a thick, fleshy muscle arising on the posterior surface of the upper extremity of the humerus. It occupies the musculo-spiral groove, whose course it exactly follows in curving round from the back to the front of the bone. It tapers inferiorly and terminates in a flat tendon, which passes below the bicipital tuberosity and under the internal lateral ligament of the elbow, to be finally inserted on the inner edge of the radius, and the ligament which unites that bone with the ulna. It is covered by dense fascia, from which some of the anterior fibres of the large extensor originate. It flexes the forearm directly on the humerus. It varies in length and volume according to the size of the humerus, but is otherwise much the same in all animals.

In the dog and cat the inferior tendon is attached to the ulna *(see Plates 110 & 116)*.

Triceps Brachialis. This is the principal extensor of the forearm, but inasmuch as it consists of three distinct heads and forms practically three distinct muscles, one of which arises on the scapula, and the others on the humerus, we will deal with them separately and, in accordance with the plan foreshadowed, will take the two humeral heads first.

External or Short Head of the Triceps. (Short Extensor of the Fore-arm) (Humero-olecranius Externus) *(see Plate 117)*. This is a short, thick quadrangular muscle arising on the curved ridge that extends upwards from the deltoid tubercle to the base of the articular head of the humerus (see Plate 112). It is flattened and aponeurotic at its origin, where it covers the upper part of the brachialis anticus. It then becomes thick and fleshy, and terminates in a short, broad tendon that joins the tendon of the scapular portion (long head) and is inserted with it on the olecranon process of the ulna. It is a powerful extensor of the forearm. This muscle is mostly superficial and a conspicuous feature on the outside of the arm. It is covered at its origin by the deltoid, and its upper border blends with the long head.

Internal or Small Head of the Triceps. (Humero-olecranius Internus.) This muscle is situated on the inside of the arm opposite the muscle just described, and reaches from the middle of the inner surface of the shaft of the humerus to the inner side of the summit of the olecranon.

Like the preceding, it is a powerful extensor of the forearm. Although not visible in the horse, it is sometimes possible to see the lower part of this muscle on the inside of the arm of a greyhound when the limb is stretched out *(see Plate 119)*.

Anconeus. (Humero-olecranius minor) *(see Plates 108 & 112)*. This

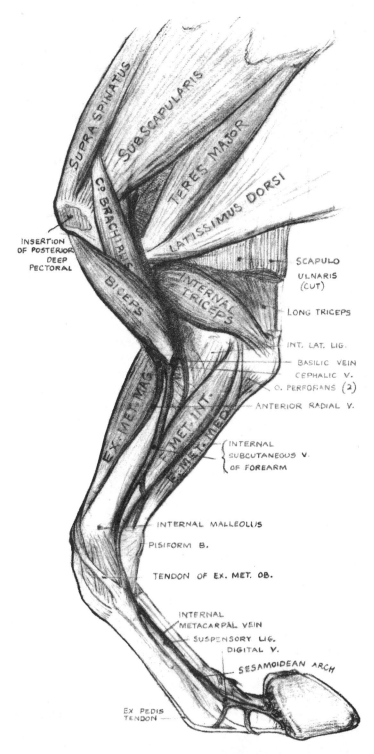

SUPRA SPINATUS

SUBSCAPULARIS

TERES MAJOR

C. BRACHIALIS

LATISSIMUS DORSI

INSERTION
OF POSTERIOR
DEEP
PECTORAL

SCAPULO
ULNARIS
(CUT)

BICEPS

INTERNAL
TRICEPS

LONG TRICEPS

INT. LAT. LIG.

BASILIC VEIN

CEPHALIC V.

O. PERFORANS (2)

ANTERIOR RADIAL V.

EX. MET. MAG.

F. MET. INT.

F. MET. MED.

INTERNAL
SUBCUTANEOUS V.
OF FOREARM

INTERNAL MALLEOLUS

PISIFORM B.

TENDON OF EX. MET. OB.

INTERNAL
METACARPAL VEIN

SUSPENSORY LIG.

DIGITAL V.

SESAMOIDEAN ARCH

EX PEDIS
TENDON

119. *THE MUSCLES AND VEINS OF THE RIGHT FORE LEG*
OF THE HORSE, INSIDE VIEW

is a small thick muscle arising on the margin of the olecranon fossa of the humerus and inserted on the front and outer side of the olecranon. It is overshadowed by the short external head of the triceps muscle and very inconspicuous. This muscle helps to extend the forearm, and also by reason of its having some attachment on the capsular ligament of the elbow joint, it prevents the latter being nipped between the bones during extension.

GROUP 4. MUSCLES ACTING BETWEEN THE SHOULDER-BLADE AND THE FOREARM. *Biceps Brachii.* (Long Flexor of the Forearm) (Scapulo-radialis) (Coraco-radialis), *(see Plates 112, 114, 119 & 120)*. This is a muscle of considerable volume, situated on the front of the arm, and acting between the lower end of the scapula and the upper end of the radius. It arises from the base of the coracoid process by a strong round tendon, which soon flattens out to be moulded upon the bicipital grooves and the mesial ridge of the humerus over which it runs as over a well-oiled pulley.

The fleshy portion commences just below the point of the shoulder. It is thickest in the centre and then tapers downwards and inwards to terminate in a short strong tendon that is inserted on the bicipital pro-tuberance of the radius and the capsular ligament of the elbow joint.

This muscle is intersected by numerous strands of fibrous tissue, one of which, much stronger than the others, traverses the muscle from end to end, connects with the upper and lower tendons, and then spreads over the outer surface of the forearm and blends with the antibrachial aponeurosis, over the extensor metacarpi magnus muscle. This cord, which in no way interferes with the contraction of the muscle, prevents it stretching, and so automatically opposes flexion at the shoulder joint when the horse is standing.

Conversely, when the leg is raised and the shoulder joint is flexed, flexion of the elbow joint automatically follows. In fact, within certain limits which are determined by the length of the cord, the shoulder and elbow joints must always conform to each other's movements.

These are points of some consequence, in view of the fact that we so frequently see paintings of horses in which the relationship between the movements of the foreleg and the shoulder is not appreciated, and in which the slope of the shoulder-blade is exaggerated without any cor-responding advancement of the leg, and vice versa.

As it has no attachment on the humerus, this muscle has no direct in-fluence on the movement of that bone. It can act from either extremity. If, for instance, the leg is fixed, the result of the muscle contracting is to extend the scapula on the humerus, i.e. make it more upright. Acting from the other end, with the shoulder-blade fixed, muscular contraction causes flexion of the forearm. It also serves as a tensor of the anti-brachial aponeurosis.

The biceps muscle is enclosed in an aponeurotic sheath, which com-

pletely separates it from the surrounding muscles, and ensures its free movement between them. The upper end of the sheath is fixed to the ridges which constitute the inner and outer boundaries of the bicipital groove. In this region the aponeurosis is very thick and gives partial attachment to the supraspinatus and the posterior deep pectoral muscles, which act upon it as tensors.

In the cat, dog, &c. the biceps is a relatively slender muscle. The inferior tendon bifurcates and sends off a slip to the inside of the forearm as in man, and not to the outside as in the horse.

The Long Head of the Triceps. (Large Extensor of the Forearm) (Scapulo-olecranius Magnum). This is a large flat triangular muscle occupying the space between the back of the shoulder-blade and the arm-bone *(see Plate 117)*. It arises from the dorsal angle and the axillary border of the scapula, and after uniting with the external, or short head, is inserted by a strong tendon on the summit of the olecranon process of the ulna. It is covered at its origin by the posterior part of the deltoid muscle, but for the remainder of its extent is entirely superficial. It is both an extensor of the forearm and a flexor of the shoulder joint.

Scapulo-ulnaris. ·(Long Extensor of the Forearm) (Tensor fasciæ antibrachii.) This is a thin flat muscle almost entirely concealed by the long head of the triceps, only a narrow strip occasionally showing behind the latter *(see Plates 117 & 119)*. It arises from the dorsal angle and axillary border of the scapula, and is attached below to the posterior surface of the olecranon and to the antibrachial aponeurosis on the inner side of the arm. It is principally a tensor of the aponeurosis; it also supplements the action of the preceding muscle.

In the dog and cat, the long head of the triceps does not reach up as far as the dorsal angle *(see Plate 118),* but arises from the lower two-thirds of the posterior border of the scapula, and the scapulo-ulnaris is, in consequence, more exposed behind it than in the horse.

GROUP 5. We now come to those muscles which act exclusively upon the *Scapulo-humeral articulation.* Although this is a ball and socket joint, and therefore ostensibly capable of movement in all directions, we find that in the horse, owing to the way in which the arm is tied to the body, action is almost exclusively confined to flexion and extension, and that only a very small amount of abduction, adduction, or rotation of the humerus is possible, and this in spite of the fact that there are no lateral ligaments to restrict these movements as in the other joints of the leg.

The only ligament in the shoulder joint is the capsular ligament. This is very thin and loose and has no restraining influence so far as confining the movement in any particular direction is concerned.

This office is, however, performed by the very strong muscles and

tendons which envelop the joint, of which the tendon of the infraspinatus muscles acts as an external lateral ligament and that of the subscapularis as an internal ligament, the joint being further supported in front by the supraspinatus tendons and the very strong aponeurosis of the biceps muscle, with which they are united.

Subscapularis. (Subscapulo-Trochineus) *(see Plate 119).* This is a powerful muscle arising from the inner surface of the scapula (sub-scapular fossa) and ending in a strong wide tendon which is inserted on the internal tuberosity of the humerus. The tendon covers the scapulo-humeral articulation inwardly, and takes the place of an internal lateral ligament.

Teres Major. (Adductor of the Arm) (Subscapulo-humeralis) (Teres Internus). This is a flat, fleshy muscle situated immediately behind the preceding, with which it is confounded at its origin. It arises from the dorsal angle of the scapula and is inserted by a flat tendon, which unites with that of the latissimus dorsi muscle on the internal tubercle of the humerus.

Coraco-humeralis. (Middle Scapulo-humeralis) (Coraco-brachialis) (Omo-brachialis). This slender muscle arises from the inner part of the coracoid process of the scapula and divides into two branches, one of which is inserted on the front, and the other on the inner surface of the humerus.

These three muscles are all of them invisible, being situated in the internal scapular region. They are all of them adductors and inward rotators of the arm, which means that they draw the arm towards the body, and at the same time cause it to pivot on its own axis, which has the effect (there being no lateral play at the elbow) of inclining the leg inwards.

The next three muscles belong to the external scapular region and have a precisely opposite action to those just described. They are abductors and outward rotators of the arm, all of them having their movable attachments on the external surface of the humerus. Acting in conjunction with the foregoing, they assist in flexing the arm on the shoulder.

Teres Minor. (Short Abductor of the Arm) (Scapulo-humeralis minor). This is a small elongated muscle almost entirely concealed beneath the posterior branch of the deltoid muscle, and covering in its turn the teres major. It arises on the posterior border of the scapula and is inserted by means of a broad flat tendon on the outer surface of the humerus above the deltoid tubercle *(see Plate 112).* The tendon of insertion which is the only part that is superficial is, however, so thin and closely moulded upon the bone that it is practically impossible to distinguish it on the living animal *(see Plate 117).*

Infraspinatus. (Postea Spinatus) (Subacromio Trochiterius) *(see Plates 112 & 117).* This is a large flat muscle arising from the whole of the infraspinous fossa and from the scapular cartilage, as well as from the deep face of the scapular aponeurosis. It narrows inferiorly, and is inserted on the convexity and the side of the summit of the external tuberosity of the humerus. In the same way as the terminal tendon of the subscapularis muscle serves as an internal lateral ligament of the shoulder joint, so does the tendon of the infraspinatus muscle act as an external ligament. It is an abductor and outward rotator of the humerus.

Deltoid. (Long Abductor of the Arm) (Teres Externus) (Scapulo-humeralis Magnus) *(see Plate 117).* This muscle is covered by and adherent to the scapular aponeurosis. It consists of two distinct parts, which unite inferiorly, and have a common insertion on the humerus. The posterior portion, which is the stronger of the two, tapering at both ends and thickest in the middle, arises from the dorsal angle of the scapula.

The anterior portion, thin and aponeurotic above and thickening below, arises from the tuberosity of the spine of the scapula, and after crossing the lower part of the infraspinatus muscle joins the posterior portion, and is with it inserted on the deltoid tubercle of the humerus. It is a strong abductor of the humerus and also causes it to rotate outwards. It acts also as a tensor of the scapular aponeurosis.

The attachments of the deltoid of the ox, &c. are very much the same as in the horse, but the muscle is very little developed, and it is almost impossible to recognize it on the surface. Owing to the presence of a small acromion process, a third head arising therefrom may be discovered by dissection. It is, however, of no consequence.

In the Carnivora, this muscle assumes quite a different character and much resembles the scapular portion of the human deltoid. The posterior branch which in the horse arises from the dorsal angle is absent, but a very strong head arises from the whole of the posterior edge of the scapular spine and almost entirely covers the infraspinatus muscle, and an anterior portion, also strongly developed, has its origin on the acromion process, and these are jointly inserted on the deltoid ridge of the humerus *(see Plate 118).*

Supraspinatus. (Antea Spinatus) (Supra-acromio Trochiterius) *(see Plates 112, 117 & 120).* This muscle arises from the whole of the supraspinous fossa and from the prolonging cartilage above it, and divides inferiorly to be inserted on the inner and outer tuberosities of the humerus and on the bicipital aponeurosis, which covers the tendon of origin of the biceps, so that, while the upper part faces outwards, the remainder gradually inclines more towards the neck, until on reaching the scapulo-humeral angle, the lower extremity looks directly forwards, thus giving the muscle the appearance of being twisted inwards from above. This

muscle is an extensor of the arm, and a tensor of the bicipital aponeurosis. It also acts as a powerful ligament of the shoulder joint.

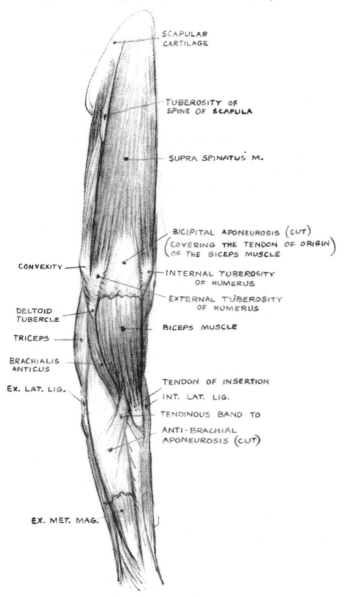

SCAPULAR CARTILAGE

TUBEROSITY OF SPINE OF SCAPULA

SUPRA SPINATUS M.

BICIPITAL APONEUROSIS (CUT) (COVERING THE TENDON OF ORIGIN OF THE BICEPS MUSCLE)

CONVEXITY

INTERNAL TUBEROSITY OF HUMERUS

EXTERNAL TUBEROSITY OF HUMERUS

DELTOID TUBERCLE

BICEPS MUSCLE

TRICEPS

BRACHIALIS ANTICUS

TENDON OF INSERTION

EX. LAT. LIG.

INT. LAT. LIG.

TENDINOUS BAND TO

ANTI-BRACHIAL APONEUROSIS (CUT)

EX. MET. MAG.

120. *MUSCLES OF RIGHT SHOULDER & ARM OF HORSE*
(Front view)

In the Carnivora, this is a large muscle conforming to the dimensions of the fossa in which it arises. It terminates in a single inferior tendon on the summit of the great tuberosity of the humerus *(see Plate 118)*.

Scapular Aponeurosis. This is very thick over the supra- and infra-spinatus and deltoid muscles, and is firmly attached to the spine of the scapula and to the cartilage. It is made tense by the deltoid and the anterior deep pectoral muscles. Its deep surface is adherent to some of the muscles which it covers, and its outer surface gives attachment to some muscles which connect the limb with the trunk.

This concludes our examination of the muscles which belong exclusively to the fore limb and are solely employed in the movements of its different parts upon each other.

In the next chapter we will explain how the limb is attached to the body and describe the action of the muscles connecting them.

Before doing so, however, we will interpose a short description of the principal veins to be noted in the regions we have been discussing.

VEINS OF THE FORE LIMB. *(See Plate 119).* Most of the large veins are too deeply situated to call for any special descriptions. They are, however, connected by numerous communicating branches, some of which come to the surface and may be seen crossing the muscles in various places.

The only superficial vessel of any consequence is the large subcutaneous vein of the forearm, which shows distinctly on the inside of the limb from its origin at the knee until it disappears among the chest muscles. This vein is an upward continuation of the internal metacarpal vein, which in its turn is one of a group arising from the junction of the digital veins above the fetlock joint.

The *Digital Veins* result from the confluence of a number of small vessels which originate in the foot and form a close network over the lateral cartilages. Passing upwards along the posterior borders of the large pastern bone and on each side of the fetlock joint, they enter the space between the suspensory ligament and the back tendons, where they unite to form the sesamoidean arch which gives rise to the meta-carpal veins *(see Plate 119).*

Two connecting branches, which may often be seen on the surface, cross the front of the pastern. The lower one passes over the extensor pedis tendon at or near the pastern joint, and the upper one encircles the digit just below the fetlock, passing under the tendon.

The *Metacarpal Veins* are in themselves of little consequence, and except for one or two small branches that cross the suspensory ligament, hardly noticeable. This group consists of three, an internal and an external (both superficial), which lie in the grooves in front of the perforans tendon, and one deeply situated between the suspensory ligament and the cannon bone. The internal superficial vein is the largest of the three, and after passing up the inner side of the back of the knee

and receiving contributions from the other two, it forms the main root of the internal subcutaneous vein of the forearm.

Internal Subcutaneous Vein of the Forearm. This is the most important of them all. It first comes into view behind the internal malleolus and continues along the posterior edge of the radius until, on reaching the upper third of the forearm, it crosses over the bone, and a little below the insertion of the biceps muscle divides into two branches, an anterior (the Cephalic or Plate vein), and a posterior (the Basilic vein).

The Basilic vein passes behind the biceps muscle, penetrates the superficial pectoral muscle, and disappears from view.

The Cephalic vein crosses the tendon of the biceps in front of the elbow joint, and following the groove that divides the mastoido-humeralis from the anterior superficial pectoral muscle, eventually flows into the jugular vein.

The *Anterior Radial Vein* has its origin in a number of small vessels that are spread over the anterior surface of the knee and the lower end of the radius. It lies along the inner edge of the large extensor of the metacarpus, and joins either the internal subcutaneous vein or the cephalic vein (more often the latter), in front of the insertion of the biceps muscle.

CHAPTER VII

MUSCLES ATTACHING THE SHOULDER-BLADE TO THE TRUNK

Serratus Magnus. This is a large fan-shaped muscle connecting the shoulder-blade with the thorax. It arises from the first eight or nine ribs by as many digitations, and is inserted on the posterior triangular surface of the scapula. It maintains the upper part of the shoulder-blade in position against the ribs and, with its fellow of the opposite side, forms a sling to support the body when the animal is standing. With the ribs as the fixed base, muscular contraction, by lowering the dorsal angle of the scapula, raises the point of the shoulder. Acting from the other end, it raises the ribs and so assists breathing.

The four posterior digitations cross the first five of the great oblique muscle of the abdomen giving its lower border the serrated outline from which it derives its name. This is the only part of the muscle that is visible on the surface, the remainder being hidden by the shoulder-blade, the long head of the triceps, and the latissimus dorsi muscle *(see Plate 132).*

In the ox, this muscle arises from the first eight ribs, and the posterior digitations are visible below the latissimus dorsi muscle in the same way as in the horse *(see Plate 129).*

In the dog, cat, &c. the serratus magnus does not extend below the latissimus dorsi muscle, and none of it is superficial. It does, however, to some extent conceal the ribs and add to the bulk behind the shoulder *(see Plate 122).*

Levator Anguli Scapulæ. (See Plate 121.) This muscle connects the scapula with the vertebræ of the neck. It arises by separate digitations from the transverse processes of the last five cervical vertebræ and is inserted on the anterior triangular surface of the scapula, uniting behind with the serratus magnus, and above with the rhomboid muscle.

In man, this muscle draws the cervical angle of the shoulder-blade upwards, hence its name *(see Plate 141).* In quadrupeds, however, the shoulder-blade is more often the fixed base and the neck the part acted upon.

In the horse, this muscle is visible between the posterior border of the mastoido-humeralis and the anterior border of the trapezius muscles *(see Plate 132).*

In the ox and in the Carnivora, these muscles meet on the side of the

neck and cover the levator anguli scapulæ, so that none of it can be seen *(see Plates 129, 134 & 135)*.

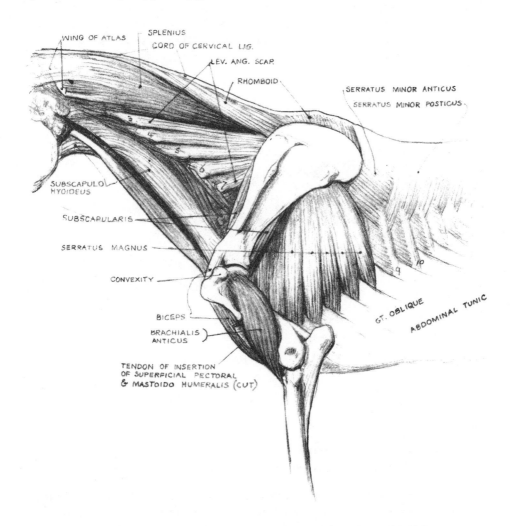

121. HORSE. MUSCLES ATTACHING THE SHOULDER-BLADE
Serratus Magnus. Levator Anguli Scapulæ. Rhomboideus.

Rhomboid. (See Plate 121.) This is a long narrow triangular muscle reaching from the upper extremity of the neck to the withers. It arises from the cord of the ligament of the neck and the summits of the succeeding dorsal vertebræ as far back as the sixth, and is inserted on the inner surface of the scapular cartilage. It draws the shoulder-blade upwards and forwards.

In Carnivora there are two rhomboid muscles, a deep and a super-

ficial. The deep muscle (Rhomboideus major), although much the larger, is unimportant as, except where it connects the backbone with the top of the shoulder-blade, it is too deeply buried to have any influence on the shape. It arises from the spinous processes of the last six cervical and the first four dorsal vertebræ and is inserted on the posterior half of the upper border of the scapula.

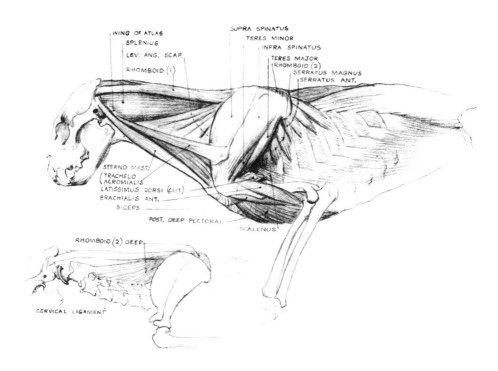

122. *CARNIVORA (FELINE)*
This shows the deep muscles of neck, shoulders, &c.

The superficial muscle (Rhomboideus capitis), on the other hand, although covered by the trapezius, makes a definite contribution to the form, and gives firmness and solidity to the neck in front of the shoulder-blade. It arises on the mastoid crest, and after uniting in the middle line with its fellow of the opposite side, is inserted on the cervical angle and the anterior half of the upper border of the scapula.

Latissimus Dorsi. This is a broad triangular muscle, partly fleshy, partly aponeurotic, spreading over the back, loins and a considerable part of the lateral surface of the thorax *(see Plate 123)*.

The aponeurotic portion arises from the summits of the spinous processes of the last fourteen dorsal and all the lumbar vertebræ—that is to say, it extends from the withers to the croup. It is continuous behind

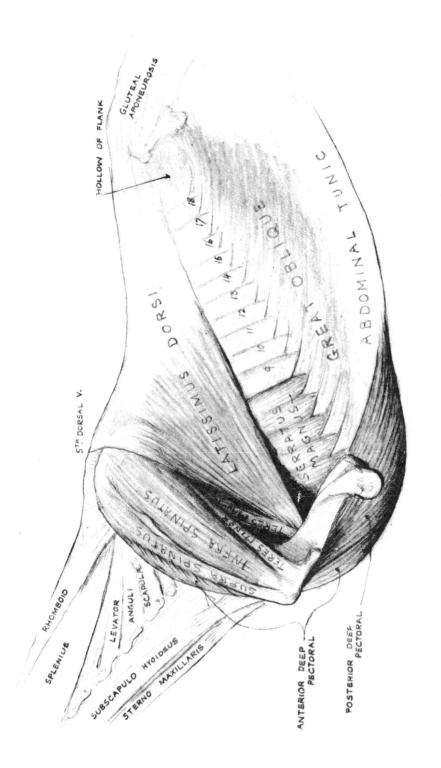

HOLLOW OF FLANK

GLUTEAL APONEUROSIS

5TH DORSAL V.

RHOMBOID

SPLENIUS

LEVATOR ANGULI SCAPULÆ

SUBSCAPULO HYOIDEUS

STERNO MAXILLARIS

LATISSIMUS DORSI

GREAT OBLIQUE

ABDOMINAL TUNIC

SERRATUS MAGNUS

INFRA SPINATUS

SUPRA SPINATUS

TERES MINOR

ANTERIOR DEEP PECTORAL

POSTERIOR DEEP PECTORAL

123. *MUSCLES ATTACHING FORE LIMB*

with the gluteal aponeurosis and blends in the hollow of the flank with
the fascia of the internal oblique muscle.

The muscular portion commences at the thirteenth or fourteenth rib,
its fibres being directed downwards and forwards to converge upon a

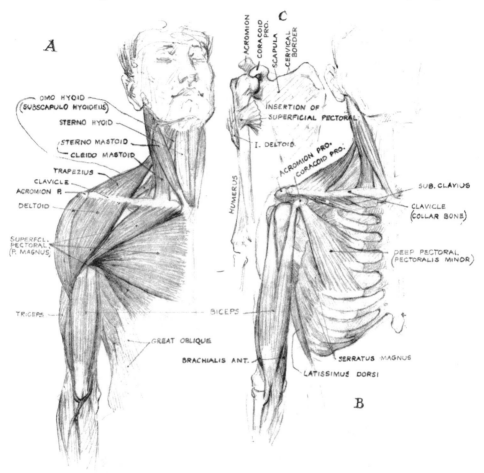

124. *SUPERFICIAL & DEEP MUSCLES*

A. *Front view of a man's chest (Superficial muscles).*
B. *Front view of a man's chest to show attachments of deep pectoral, &c.*
C. *Showing insertions of Superficial pectoral and deltoid muscles.*

flat tendon, which joins the tendon of the teres major, and is inserted
with it on the inner face of the shaft of the humerus (the internal
tubercle). The anterior border of the muscle overlaps the posterior part
of the prolonging cartilage and the dorsal angle of the scapula, and then
passes under the long head of the triceps and the scapulo-ulnaris
muscles to its insertion.

This muscle may be likened to a thick blanket spread over the surface of the body which, without appreciably affecting the shape, conceals the details of the underlying structure. The lower outline of the aponeurosis is seldom visible, but that of the thicker muscular portion, although not

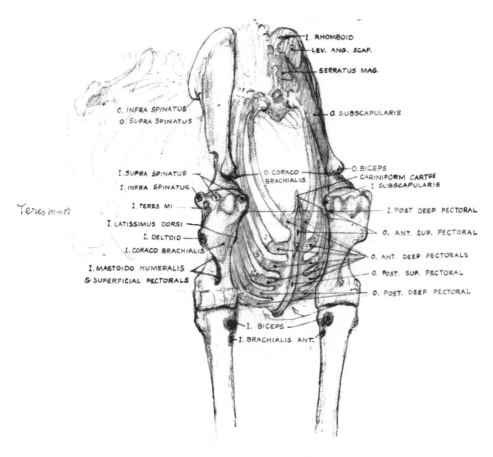

Teres minor

125. *FRONT VIEW OF HORSE*
 Origins and insertions of muscles.

strongly defined, can generally be seen as it crosses the posterior digitations of the serratus magnus. Action—to draw the fore limb backwards and upwards.

Subscapulo-hyoidens. *(See Plate 121.)* This is a thin wide muscle, deeply situated in the neck and only showing at the throat, where it emerges from between the two branches of the sterno-maxillaris and covers the upper end of the windpipe. It arises in the region of the scapulo-humeral angle from the fascia that covers the subscapularis muscle and is inserted on the hyoid bone. It is a depressor of the hyoid

bone and comes into action when swallowing. Absent in Carnivora, it corresponds to the omo hyoid of man.

Pectoral Muscles. As in man, the pectoral muscles of an animal are disposed in two layers.

In man, the superficial muscle is the largest, and is therefore called pectoralis magnus and the deep and smaller one pectoralis parvus or minor.

In quadrupeds, however, the deep muscle is much the larger of the two, and as the human names are inappropriate (although often employed), we prefer to distinguish them simply as the deep and superficial pectoral muscles.

Deep Pectoral Muscle. (See Plates 123, 126 & 127.) The Deep Pectoral of the horse is an enormous muscle occupying the front and under surface of the chest and consists of two distinct parts: —

(1) Anterior Portion. (Sterno-Prescapularis) *(see Plates 123, 125, 126 & 127).* The Anterior Deep Pectoral arises from the first four costal cartilages and the adjoining part of the sternum and, passing upwards and forwards, terminates on the aponeurosis that covers the supraspinatus muscle. The prescapular part of the muscle is distinctly visible on the living animal and constitutes the anterior limit of the shoulder muscles. It pulls the shoulder-blade backwards and downwards and also acts as a tensor of the scapular aponeurosis.

(2) Posterior Portion. (Sterno-trochineus.) The Posterior Deep Pectoral arises from the abdominal tunic as far back as the tenth rib, from the posterior two-thirds of the sternum, and from the fifth, sixth, seventh and 8th costal cartilages. It is inserted on the internal trochanter (trochin) of the humerus and the bicipital aponeurosis. In contracting, it pulls back the fore limb.

The *Superficial Pectoral* muscle is similarly divided into two portions, although in this case the distinction is less evident than in the preceding muscle: —

(1) The Anterior Portion. (Sterno-humeralis) (Pectoralis Anticus.) The Anterior Superficial Pectoral is a thick bulging muscle, tapering at both ends, situated on the front of the chest. It arises from the cariniform cartilage and the upper end of the sternum, and with some of the adjoining fibres of the posterior part, joins the tendon of the mastoidohumeralis, and is inserted with it on the front of the humerus below the deltoid tubercle *(see Plates 125 & 126).*

(2) Posterior Portion. (Sterno-aponeuroticus) (Pectoralis Transversus.) The Posterior Superficial Pectoral is a wide and thin muscle situated behind the foregoing, with which it is confounded, and extending between the breast-bone and the fore limb. It arises from the whole of the lower edge of the sternum. The anterior fibres are inserted along with the above muscle on the humerus, the remainder and larger part ending in a thin fascia which spreads over the antibrachial aponeurosis on the inside of the upper end of the forearm *(see Plate 126).*

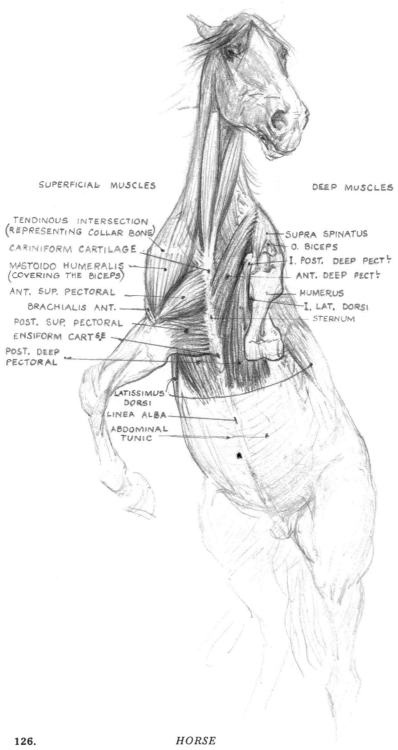

SUPERFICIAL MUSCLES

DEEP MUSCLES

TENDINOUS INTERSECTION
(REPRESENTING COLLAR BONE)
CARINIFORM CARTILAGE
MASTOIDO HUMERALIS
(COVERING THE BICEPS)
ANT. SUP. PECTORAL
BRACHIALIS ANT.
POST. SUP. PECTORAL
ENSIFORM CART.ᴳᴱ
POST. DEEP
PECTORAL

SUPRA SPINATUS
O. BICEPS
I. POST. DEEP PECTᴸ
ANT. DEEP PECTᴸ
HUMERUS
I. LAT. DORSI
STERNUM

LATISSIMUS
DORSI
LINEA ALBA
ABDOMINAL
TUNIC

126. *HORSE*
Superficial and deep muscles.

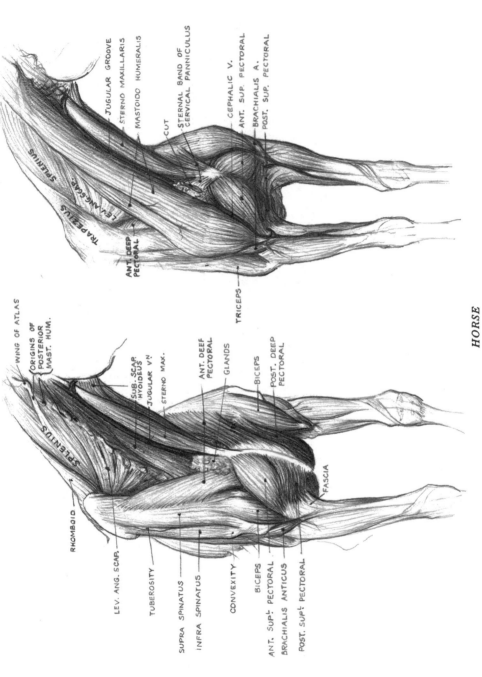

JUGULAR GROOVE
STERNO MAXILLARIS
MASTOIDO HUMERALIS
CUT
STERNAL BAND OF
CERVICAL PANNICULUS
CEPHALIC V.
ANT. SUP. PECTORAL
BRACHIALIS A.
POST. SUP. PECTORAL

SPLENIUS
TRAPEZIUS
LEV. ANG. SCAP.
ANT. DEEP
PECTORAL
TRICEPS

WING OF ATLAS
ORIGINS OF
POSTERIOR
MAST. HUM.
SUB. SCAP.
HYOIDEUS
JUGULAR V?
STERNO MAX.
ANT. DEEP
PECTORAL
GLANDS
BICEPS
POST. DEEP
PECTORAL

SPLENIUS
RHOMBOID
FASCIA

LEV. ANG. SCAP.
TUBEROSITY
SUPRA SPINATUS
INFRA SPINATUS
CONVEXITY
BICEPS
ANT. SUP. PECTORAL
BRACHIALIS ANTICUS
POST. SUP. PECTORAL

HORSE

127. *Showing on the right the deep Pectoral muscles and on the left the Superficial covering them.*

128. *Superficial muscles—front view.*

The superficial pectoral is an adductor of the fore limb and a tensor of the antibrachial aponeurosis. These two muscles together represent the Pectoralis Magnus of man.

Pectoral Muscles (Comparative). The chief difference to note in the Pectorals of the ox is that the anterior deep portion is not prolonged over the supraspinatus muscle, but terminates at the scapulo-humeral angle and is nowhere visible. The superficial pectoral is strongly developed and prominent, with the dewlap hanging from it.

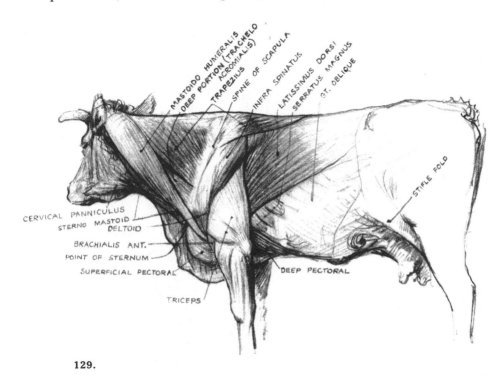

129.

In the dog, cat, &c. the anterior part of the superficial muscle is well developed, whereas the posterior part is narrow and thin *(see Plate 130).*

The anterior deep portion is very rudimentary and does not extend above the shoulder joint, but is confounded with the posterior part, and inserted with it on the tuberosity of the humerus.

It will be seen, therefore, that it is only in the horse that the anterior deep pectoral reaches the front of the shoulder or has any effect on the surface form.

The anterior portion of the superficial pectoral of an animal represents that part of the large pectoral of man *(see Plate 124)* that arises on the collar-bone, but owing to the absence of that bone in the animals with which we are dealing, its attachment has been transferred to the nearest available bone surface, namely, the sternum.

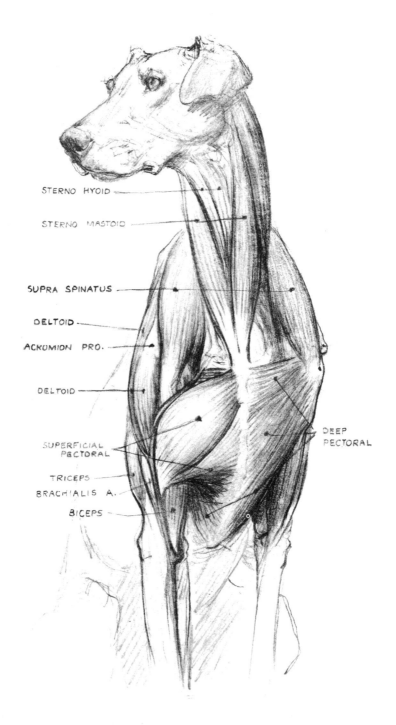

STERNO HYOID

STERNO MASTOID

SUPRA SPINATUS

DELTOID

ACROMION PRO.

DELTOID

SUPERFICIAL PECTORAL

TRICEPS

BRACHIALIS A.

BICEPS

DEEP PECTORAL

130. *FRONT VIEW OF DOG SHOWING PECTORAL MUSCLES CONNECTING LIMB WITH THORAX*

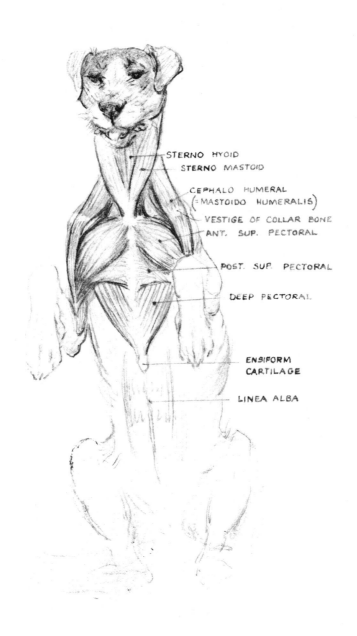

STERNO HYOID
STERNO MASTOID

CEPHALO HUMERAL
(=MASTOIDO HUMERALIS)

VESTIGE OF COLLAR BONE
ANT. SUP. PECTORAL

POST. SUP. PECTORAL

DEEP PECTORAL

ENSIFORM
CARTILAGE

LINEA ALBA

131. *FRONT VIEW OF DOG, SITTING UP TO SHOW DISPOSITION
OF SUPERFICIAL MUSCLES OF CHEST, NECK AND SHOULDERS*

Mastoido-humeralis. (Cephalo-humeral) (Brachio-cephalicus) (Levator Humeri) *(see Plates 126, 128, 132 & 133).* This is a large muscle reaching from the top of the head to the lower extremity of the arm-bone and filling the space between the sterno-maxillaris muscle and the cervical vertebræ. Throughout its course down the neck it is divided

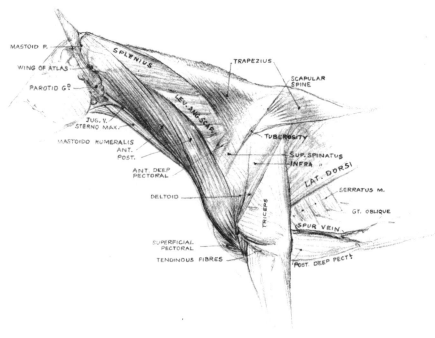

132. *FOREHAND OF HORSE*
Superficial muscles of neck and shoulder.

into two parts, which unite in front of the shoulder, and have a single termination on the arm-bone.

The anterior, or superficial portion, has its origin in a wide aponeurosis that is attached to the mastoid process and crest and whose anterior border passes under the parotid gland and joins the tendon of the sterno-maxillaris muscle.

The posterior, or deep portion, arises beneath it from the wing of the atlas by a tendon common to it, the splenius and the trachelo-mastoid, and from the transverse processes of the three succeeding vertebræ. After uniting with the superficial portion and enveloping the scapulo-humeral angle and the front of the arm, it terminates in a short tendon which is joined by that of the superficial pectoral and passes between the biceps and brachialis anticus muscles to be inserted on the front of the humerus below the deltoid tubercle. The lower end completely covers the biceps *(see Plate 126).*

The anterior border of the mastoido-humeralis runs parallel with the sterno-maxillaris muscle and with it forms the jugular groove. A few inches above the breast-bone it bends outwards and continues along the upper border of the superficial pectoral *(see Plate 128)* to its insertion, the cephalic vein occupying the groove between them.

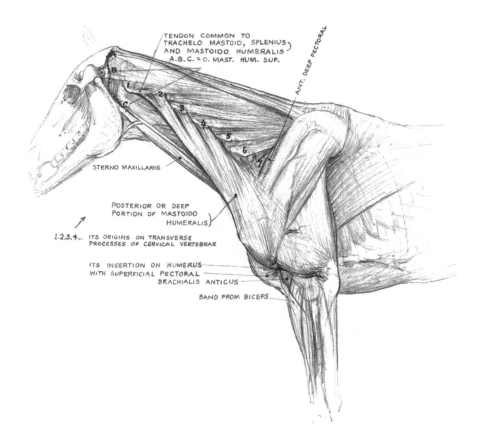

133. *MASTOIDO-HUMERALIS M. OF HORSE (posterior portion)*

Dotted line ABC indicates approximately the attachments of the Anterior portion of the Mastoido-humeralis M. Numerals indicate the positions of the transverse processes of the Cervical Vertebræ.

The posterior or deep division is thick and fleshy on the neck, but as it crosses the outer surface of the shoulder it becomes thin and aponeurotic, and after blending with the aponeurosis of the trapezius and sending down a septum between the two branches of the deltoid muscle, it fades away over the arm.

Acting from its upper extremity the mastoido-humeralis brings the shoulder and leg forward, or if from below it inclines the head and neck to one side.

The mastoido-humeralis of the horse has no exact counterpart in human anatomy, but results from modifications of the cleido-mastoid muscle and the clavicular portions of the trapezius and deltoid which, owing to the disappearance of the clavicle and acromion process, have joined up and formed a continuous muscle.

A vestige of the clavicle or collar-bone still remains in the form of a tendinous intersection at the level of the shoulder joint, but apart from this there is nothing to interrupt the continuity of the muscle.

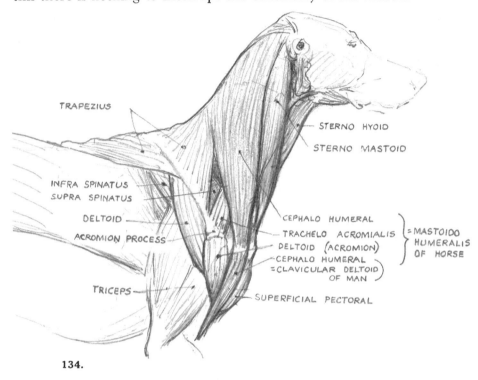

TRAPEZIUS

STERNO HYOID

STERNO MASTOID

INFRA SPINATUS
SUPRA SPINATUS

DELTOID

ACROMION PROCESS

CEPHALO HUMERAL

TRACHELO ACROMIALIS

DELTOID (ACROMION)

CEPHALO HUMERAL

=CLAVICULAR DELTOID)
OF MAN

= MASTOIDO
HUMERALIS
OF HORSE

TRICEPS

SUPERFICIAL PECTORAL

134.

Mastoido-humeralis (Comparative). In the ox, &c. this is a much wider muscle than it is in the horse and it covers more of the upper part of the neck. The two portions are more definitely separated and more obliquely placed with regard to each other *(see Plate 129)*.

The superficial portion divides and sends off a slip representing the cleido-mastoid of man, which joins the sterno-mastoid muscle and is inserted with it on the basilar process of the occipital bone, while the part that corresponds to man's clavicular trapezius spreads upwards over the nape of the neck and is attached to the mastoid process, the occipital bone, and the upper end of the cord of the cervical ligament.

The atloid tendon of the deep portion does not join the common tendon of the splenius and the trachelo-mastoid as it does in the horse, but has a separate attachment, and the inferior extremity terminates on

the lower end of the spine of the scapula, so that, whereas in the horse these two portions are joined and pass together to their insertion on the humerus, in the ox (as in the Carnivora) the two are quite separate, and only the superficial part is continued over the front of the arm. For this reason they are generally described as separate muscles, the anterior muscle only being called the mastoido-humeralis, and the posterior or deep muscle, which is almost entirely covered by it, the trachelo-acromialis or levator scapulæ ventralis *(see Plates 129, 134 & 135)*.

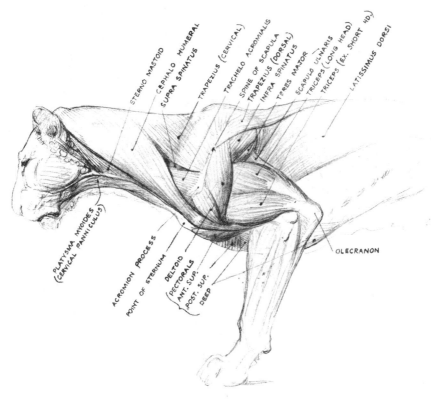

135. *CARNIVORA (FELINE)*
Superficial muscles.

Carnivora. The Mastoido-humeralis, or the Cephalo-humeral, as it is more commonly called when speaking of the dog, cat, &c. comports itself much in the same way as does the superficial muscle in the ox, &c. It is, however, wider above and narrower below, so that it covers a still larger area of the neck and crosses the trachelo-acromialis more obliquely.

The trachelo-acromialis, which is quite distinct from the cephalo-humeral, extends from the atlas bone to the acromion process and lower end of the spine of the scapula.

Trapezius. (See Plate 132.) The Trapezius of the horse is a thin muscle, partly fleshy, partly aponeurotic, and although covering a large area of the neck and back, is hardly distinguishable on the surface. It has an aponeurotic origin from the posterior two-thirds, or thereabouts, of the cord of the cervical ligament, and from the spinous processes of the succeeding seven or eight dorsal vertebræ. It may therefore be

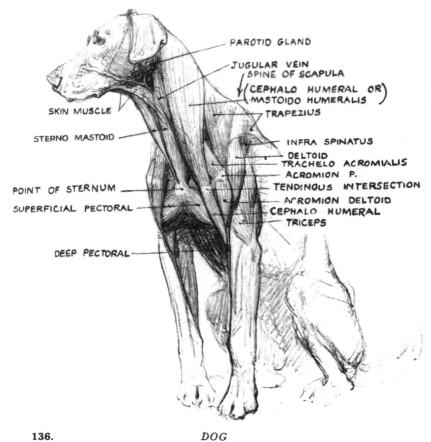

136. *DOG*
General view of the Superficial muscles of neck, chest and shoulder.

divided into two parts, a cervical and a dorsal, whose fleshy fibres converge upon a wide aponeurosis that is attached to the spine of the scapula. The edge of the cervical portion blends with the fascia on the neck and is very indistinct. That of the dorsal portion, however, is sharper, and though thin, may be occasionally seen as it goes to its insertion on the tuberosity of the spine of the scapula. It raises the shoulder-blade or draws it backwards or forwards, according to which part of the muscle is in action.

In the ox, &c. the trapezius is thick and wide *(see Plate 129).* It com-

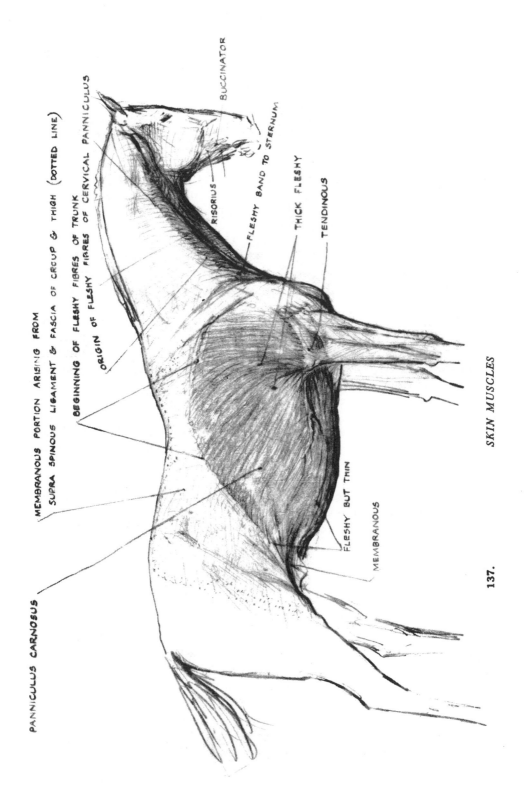

PANNICULUS CARNOSUS

MEMBRANOUS PORTION ARISING FROM
SUPRA SPINOUS LIGAMENT & FASCIA OF CROUP & THIGH (DOTTED LINE)

BEGINNING OF FLESHY FIBRES OF TRUNK

ORIGIN OF FLESHY FIBRES OF CERVICAL PANNICULUS

BUCCINATOR

RISORIUS

FLESHY BAND TO STERNUM

THICK FLESHY

TENDINOUS

FLESHY BUT THIN

MEMBRANOUS

SKIN MUSCLES

137.

mences a few inches behind the horn ridge. Its anterior border is in contact with the mastoido-humeralis throughout its length, so that the deeper muscles that are exposed in the horse are practically indistinguishable.

In the dog, cat, &c. the trapezius is well developed. The cervical portion occupies a relatively small area, extending about a third of the way up the neck. It unites above with the mastoido-humeralis (cephalo-humeral), and a triangular depression in front of the shoulder indicates where these muscles part company to go to their respective insertions *(see Plate 134)*. The dorsal portion is very thick, and accounts in great measure for the swell of the outline behind the shoulders which is characteristic of most of the Carnivora.

Panniculus Carnosus. (Cutaneous Muscle of the Neck and Trunk) (Skin Muscle, or " Fly Shaker "). This is the most superficial muscle in the body, and yet in the horse it is perhaps one of the least important, being little more than a duplication of the skin of the regions it occupies. It has no fixed shape or outline, and except at the stifle and elbow is hardly perceptible. Its chief function is to twitch and shake the skin to which it is closely adherent. It also serves in some regions as a support for the underlying muscles, much in the same way as does the containing aponeurosis. It covers the sides of the thorax, stomach and shoulder, and, as the Cervical Panniculus, is continued over the neck and part of the face.

The thoracic portion arises in a wide aponeurosis from the ligament that connects the summits of the vertebræ of the withers, back and loins, from the fascia of the croup and thigh, and from the abdominal tunic. On an imaginary line drawn between the withers and the stifle, the aponeurosis gives place to muscle, whose fibres are directed towards the elbow. On reaching the outer side of the chest wall the muscle divides so as to form two superposed layers. The upper layer then passes to the outer surface of the shoulder and arm—and incidentally forms the basis of the elbow flap—while the deeper portion clings to the posterior deep pectoral muscle, enters the armpit, and is finally attached to the tubercle on the inner face of the humerus with the latissimus dorsi and teres major muscles. Posteriorly, in a similar way, it bridges the gap between the thigh and the abdomen, and with the skin forms the triangular flap which is called the stifle fold.

Owing to the muscular portion being slightly thicker than the aponeurosis, the play of light is arrested where they meet, and although quite noticeable on a well-groomed horse, its effect on the actual modelling is very slight. It is mainly owing to this muscle carrying the skin with it from the body to the outer surface of the limbs, that outlines of the arm and thigh are obscured and which leads to their being so often misrepresented in pictures.

Cervical Panniculus. (Platysma Myoides) *(see Plate 137)*. Although

generally treated as a separate muscle in equine anatomy, the Cervical Panniculus is really a continuation of the skin muscle of the trunk. It adheres more closely to the underlying structures and is less intimately connected with the skin, consequently in this region it acts rather as a bandage than as a " fly shaker." It is very thin and membranous on the sides of the neck, but becomes muscular over the mastoido-humeralis,

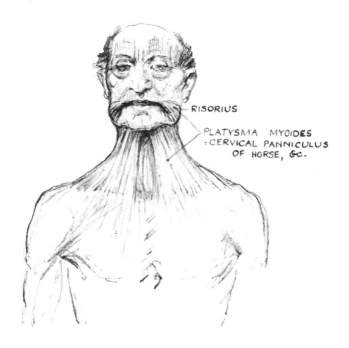

RISORIUS

PLATYSMA MYOIDES
: CERVICAL PANNICULUS
OF HORSE, &c.

138. *PLATYSMA MYOIDES*

A thin sheet of muscle originating in the fascia that covers the chest and shoulder muscles and attached above to the lower jaw-bone and the angle of the mouth. It represents the Cervical portion of the skin muscle of animals, and the direction of its fibres can be easily seen on one's own neck by throwing back the head and forcibly drawing down the corners of the mouth.

and sends off a thick fleshy band that crosses the lower end of the jugular groove and is attached to the cariniform cartilage of the sternum *(see Plate 128)*.

Continuing up the front of the neck it covers the intermaxillary space and, after gaining some attachment on the edge of the jaw-bone, sends off a slip which joins the buccinator muscle near the corner of the mouth (sometimes separately described as the Risorius muscle) *(see Plate 137),* and finally terminates indefinitely by becoming attached to the zygomatic ridge and blending with the superficial muscles of the face. The cervical panniculus corresponds to the Platysma Myoides in human anatomy, and is the only part of the skin muscle of an animal that is represented in man.

Panniculus Carnosus (Comparative). The skin muscle of the ox, &c.
is more strongly developed and more evenly distributed on the side of
the neck and face than is the case in the horse, and there is no obvious
separation between the cervical and the thoracic portions, neither is
there any visible line across the trunk dividing the fleshy from the
aponeurotic parts.

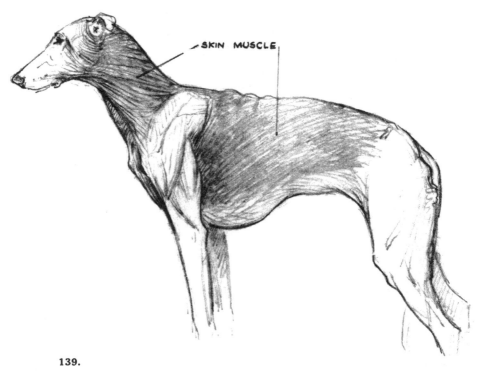

SKIN MUSCLE

139.

The stifle fold is deeper and reaches much lower down the hind leg,
which rather disguises the true outline of the limb *(see Plate 129).*

The fleshy band of the cervical panniculus, which in the horse crosses
from the mastoido-humeralis to the sternum, is absent in the ox. A
curious development, however, takes place on the front of the neck *(see
Plate 129),* and consists of a long, thick, muscular strip attached by its
inferior extremity to the point of the sternum which, after covering the
lower part of the sterno-mastoid, branches off to the lower jaw, and
spreads over the masseter muscle and the lower part of the face. This
muscular strip from which the dewlap hangs, although recognized as a
development of the skin muscle, clearly represents the sterno-maxillaris
of the horse, which, as such it may be remembered, is absent in the ox.

In the dog, cat, &c. the panniculus muscle is much more developed and
forms a loose cover over the body and neck. It is, however, very thin, if
not altogether absent on the shoulder and arm.

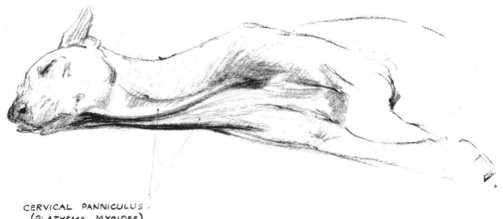

CERVICAL PANNICULUS.
(PLATYSMA MYOIDES)

140. *DOG*

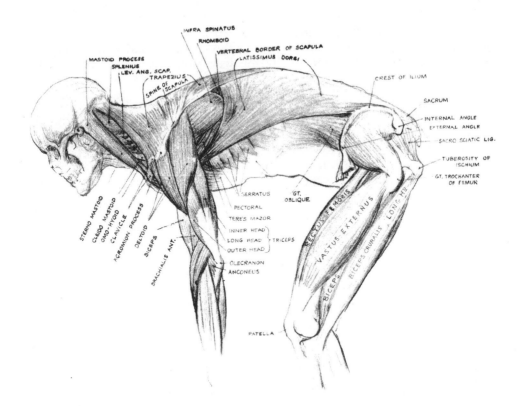

INFRA SPINATUS
RHOMBOID
VERTEBRAL BORDER OF SCAPULA
MASTOID PROCESS
LATISSIMUS DORSI
SPLENIUS
LEV. ANG. SCAP.
TRAPEZIUS
SPINE OF
SCAPULA
CREST OF ILIUM
SACRUM
INTERNAL ANGLE
EXTERNAL ANGLE
SACRO SCIATIC LIG.
TUBEROSITY OF
ISCHIUM
GT. TROCHANTER
OF FEMUR
STERNO MASTOID
CLEIDO MASTOID
OMO-HYOID
CLAVICLE
ACROMION PROCESS
DELTOID
BICEPS
BRACHIALIS ANT.
SERRATUS
GT. OBLIQUE
PECTORAL
TERES MAJOR
INNER HEAD
LONG HEAD TRICEPS
OUTER HEAD
OLECRANON
ANCONEUS
RECTUS FEMORIS
VASTUS EXTERNUS
BICEPS CRURALIS · LONG HD
BICEPS
PATELLA

141. *MAN STOOPING (Superficial muscles)*
To illustrate some anatomical features common to man and animals.

Unlike that of the horse, ox, &c. this muscle is continuous above with the muscle of the opposite side and has no fixed attachment on the supraspinous ligament, which explains why a dog can shake its coat when it comes out of the water, and why it can be carried by the scruff of its neck and the skin of its back.

The contraction of this muscle on the neck and back is the cause of the bristles standing on end when a dog scents danger and is preparing to defend itself. In the same way it erects the mane of the lion and the quills of the porcupine.

Two prominent veins, lying immediately under the skin and having numerous ramifications, call for notice because of the effect they have on the surface modelling of the inferior and lateral regions of the trunk. These are the so-called Spur Vein and the Subcutaneous Abdominal Vein.

The *Spur Vein (see Plate 132)*, as its name might suggest, is chiefly associated with the horse, in which animal it is the most conspicuous. It commences in a network of small vessels on the external surface of the belly and flank, which gradually converge towards the side of the chest and form two branches, a superior and an inferior. These continue to increase in volume, and finally unite in the main branch which, passing along the upper border of the posterior deep pectoral muscle, disappears from view within the armpit.

The *Subcutaneous Abdominal Vein,* which most concerns us when painting a milch cow, commences in a similar way on the posterior surface of the abdomen, and after receiving strong reinforcements from the surrounding parts, crosses the abdominal wall to enter the thorax near the posterior extremity of the sternum. This vein is also very noticeable in the brood mare.

CHAPTER VIII

THE hind limb of every quadruped contains three movable regions corresponding with the thigh, the leg and the foot of man, and the bones which form the framework bear the same names. Thus the thigh bone is called the femur; the skeleton of the leg, or, as it is more often termed when speaking of the horse, the " second thigh " or " gaskin," consists of the Tibia, the Fibula and the Patella, and the foot comprises the Tarsus, the Metatarsus and the Phalanges, and therefore, although we are accustomed to consider the foot of the horse as consisting only of the hoof and its contents, technically it embraces the pasterns, the cannon and hock bones as well.

The stifle of the horse corresponds to a man's knee, the point of the hock to his heel, and the hock joint represents his ankle joint.

SKELETON OF THE HIND LIMB (HORSE). The *Femur* is the largest and heaviest bone in the body. It articulates with the haunch bone by means of a ball and socket joint and offers for consideration a shaft and two extremities *(see Plates 145 & 146)*.

The Upper Extremity consists of the Articular Head and the Great External Trochanter. The head is smooth and semi-spherical and fits into the cotyloid cavity (Acetabulum) to form the hip joint, an articulation that permits of very free backward and forward movements, as well as a considerable amount of abduction, adduction and rotation.

The neck is very short and thick, and the head does not stand away from the body of the bone as it does in man, cat, dog, &c.

The Great Trochanter forms the outer prominence of the upper extremity and, like the great tuberosity of the humerus, comprises a summit, a convexity and a crest. The summit, inclined a little inwards and forwards, stands up from two to three inches above the level of the head. The convexity is an egg-shaped prominence, directed downwards and forwards and situated in front of and below the summit, from which it is separated by a deep notch. It is encrusted with smooth cartilage and bordered posteriorly by a rugged lip called the Crest, on which one of the tendons of the middle gluteal muscle is inserted.

The great external trochanter, although covered by muscle, is an important bone prominence that can always be recognized on the surface,

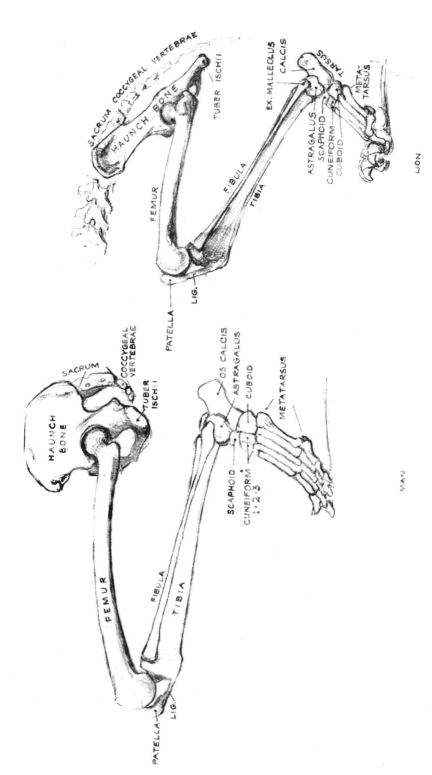

SACRUM COCCYGEAL VERTEBRAE

HAUNCH BONE

TUBER ISCHII

FEMUR

FIBULA

TIBIA

LIG.

PATELLA

EX. MALLEOLUS

CALCIS

TARSUS

META-
TARSUS

ASTRAGALUS

SCAPHOID

CUNEIFORM

CUBOID

LION

SACRUM

COCCYGEAL
VERTEBRAE

TUBER
ISCHII

HAUNCH
BONE

FEMUR

FIBULA

TIBIA

LIG.

PATELLA

OS CALCIS

ASTRAGALUS

CUBOID

METATARSUS

SCAPHOID

CUNEIFORM
1·2·3

MAN

142 & 143.

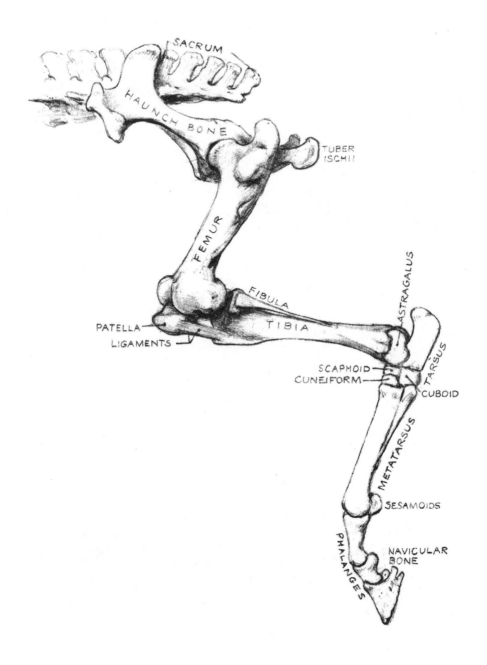

144. *SKELETON OF LEFT HIND LIMB OF HORSE (Outside view)*

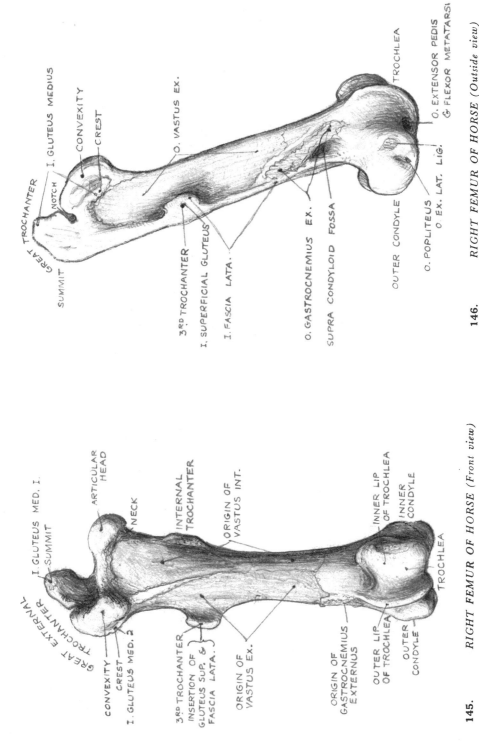

I. GLUTEUS MEDIUS

CONVEXITY

CREST

GREAT TROCHANTER

NOTCH

SUMMIT

O. VASTUS EX.

3RD TROCHANTER

I. SUPERFICIAL GLUTEUS

I. FASCIA LATA.

O. GASTROCNEMIUS EX.

SUPRA CONDYLOID FOSSA

TROCHLEA

O. EXTENSOR PEDIS & FLEXOR METATARSI

O. EX. LAT. LIG.

OUTER CONDYLE

O. POPLITEUS

146. *RIGHT FEMUR OF HORSE (Outside view)*

(*Giving origins and insertions of muscles*)

I. GLUTEUS MED. I.

SUMMIT

ARTICULAR HEAD

NECK

INTERNAL TROCHANTER

ORIGIN OF VASTUS INT.

GREAT EXTERNAL TROCHANTER

CONVEXITY

CREST

I. GLUTEUS MED. 2

3RD TROCHANTER
INSERTION OF
GLUTEUS SUP. &
FASCIA LATA.

ORIGIN OF
VASTUS EX.

ORIGIN OF
GASTROCNEMIUS
EXTERNUS

OUTER LIP
OF TROCHLEA

OUTER
CONDYLE

INNER LIP
OF TROCHLEA

INNER
CONDYLE

TROCHLEA

145. *RIGHT FEMUR OF HORSE (Front view)*

and is an indication of the position of the hip joint, of which the convexity is the outward and visible sign.

The Lower Extremity is formed by the Trochlea in front—a pulley-like structure over which the patella glides—and the two large Condyles behind, which project backwards and articulate with the tibia. The outer lip of the trochlea is narrow, sharp and inclined slightly inwards, The inner is wide, round and more elevated.

The Condyles, which may be regarded as backward continuations of

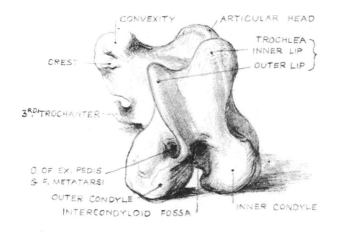

147. *END ON VIEW OF FEMUR FROM BELOW*
This shows the direction of the gliding surfaces of Trochlea and relative positions of Condyles & Intercondyloid fossa.

the lips of the trochlea, articulate with the upper end of the tibia to form the movable joint. They are separated from each other by a deep fissure called the Intercondyloid Fossa, in which the tibial spine is received.

The Outer Condyle is the largest and most prominent and gives attachment to the external lateral ligament of the stifle joint and to the popliteus muscle. Between the base of the condyle and the outer lip of the trochlea is a deep pit, in which the extensor pedis muscle and the tendinous portion of the flexor metatarsi arise *(see Plates 146 & 147)*.

The Inner Condyle is less conspicuous. It gives attachment to the internal lateral ligament connecting the femur with the tibia *(see Plate 148)*. The oblique direction of the articulating surfaces, and the manner in which they are bevelled, gives the inward inclination to the tibia that brings the hocks nearer together than they would be if the joint had a vertical action, and a reversal of this arrangement at the hock brings the lower leg back again so that, whether standing or moving, the femur and the cannon bone are always in approximately parallel planes.

The Shaft is thick and straight, round in front and flat behind. The flat posterior surface is separated from the rounded lateral surfaces by two ridges on which are various prominences and asperities for muscular attachment *(see Plates 148, AAA & BBB).*

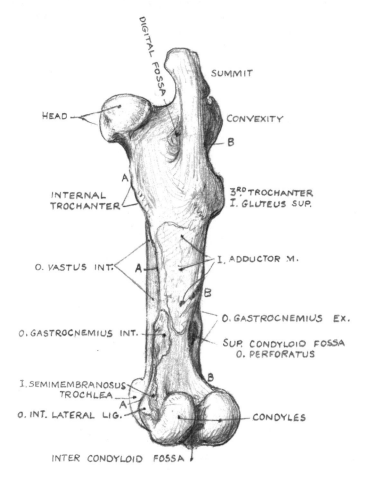

148. *RIGHT FEMUR OF HORSE (Back view)*
(Compare with Plates 150 & 151.)

AAA & BBB Ridges forming internal and external boundaries of the Posterior surface and corresponding with the linea aspera of the human femur.

On the outer ridge, a few inches below the convexity, is a large hook-shaped process which juts out and curves forwards, called the Small External or Third Trochanter *(see Plates 146, 147 & 148).* This process is peculiar to the horse family, and gives attachment to the tendon of the superficial gluteal muscle and to some of the upper fibres of the fascia lata.

At the lower end, a short distance above the outer condyle, the ridge is interrupted by a deep cavity called the Supracondyloid Fossa *(see Plates 146 & 148)*, in which the perforatus muscle arises, and around whose upper and anterior borders the outer head of the Gastrocnemius has its origin.

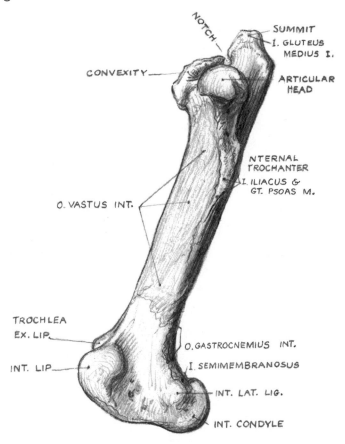

NOTCH

CONVEXITY

SUMMIT
I. GLUTEUS MEDIUS I.

ARTICULAR HEAD

NTERNAL TROCHANTER
I. ILIACUS & GT. PSOAS M.

O. VASTUS INT.

TROCHLEA
EX. LIP.

INT. LIP

O. GASTROCNEMIUS INT.
I. SEMIMEMBRANOSUS

INT. LAT. LIG.

INT. CONDYLE

149. *RIGHT FEMUR OF HORSE (Inside view)*

On the inner ridge and springing from the root of the neck is a rough elongated protuberance called the Internal or Lesser Trochanter. It gives attachment to the Iliacus and Great Psoas muscles which, although too deeply buried to be seen, exercise a considerable influence on the movements of the thigh and loins. The Semimembranosus is inserted on the lower part of this ridge, which at the same time forms the outer boundary of the surface on which the Inner Head of the Gastrocnemius muscle arises.

These edges or ridges represent the inner and outer rims of the linea aspera of a man's thigh bone and give attachment to the same muscles,

but whereas in the horse they are widely separated, in the human femur

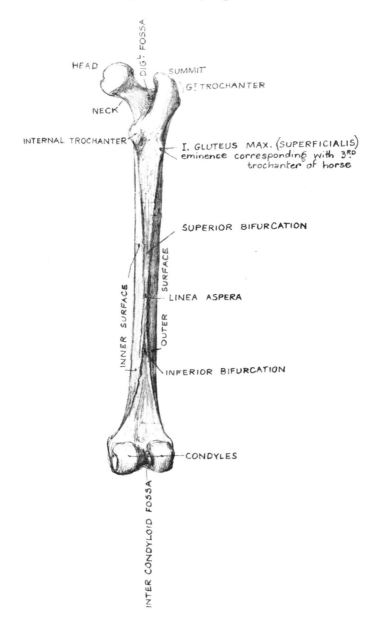

150. *HUMAN THIGH BONE (Back view)*

they meet in the middle of the shaft and form a salient crest which bifurcates above and below, being continued upwards to end on the great external and the internal trochanters and below to terminate on the

respective condyles. So that a continuous ridge extends from the external trochanter to the external condyle, and another from the small internal trochanter to the internal condyle, and the fact that in man they

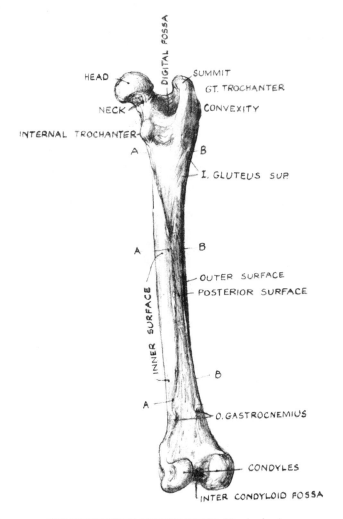

151. *WOLFHOUND'S THIGH BONE (Back view)*

AAA. Line corresponding with inner margin of linea aspera of man.
BBB. Line corresponding with outer margin of linea aspera of man.

are united for a short distance in the middle line of the back of the bone in no way affects the analogy.

The femur of the dog, cat, &c. more nearly resembles that of man than that of an Ungulate. It is long, slender and arched, and the edges of the posterior surface, although not actually in contact, are as a rule brought very close together in the middle of the shaft. The articular

head, too, is more detached, and the neck more constricted than in the horse.

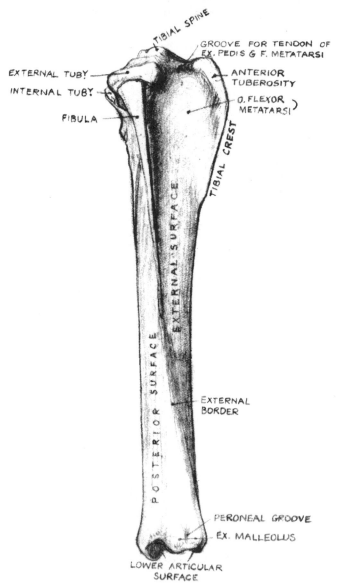

152. *TIBIA & FIBULA OF HORSE, RIGHT LEG (Outside view)*

The Skeleton of the " leg " or " second thigh " of the horse consists of the Tibia, the Fibula and the Patella.

The *Tibia* is the fundamental bone to which the other two are firmly fixed. It articulates by its superior extremity with the femur and in-

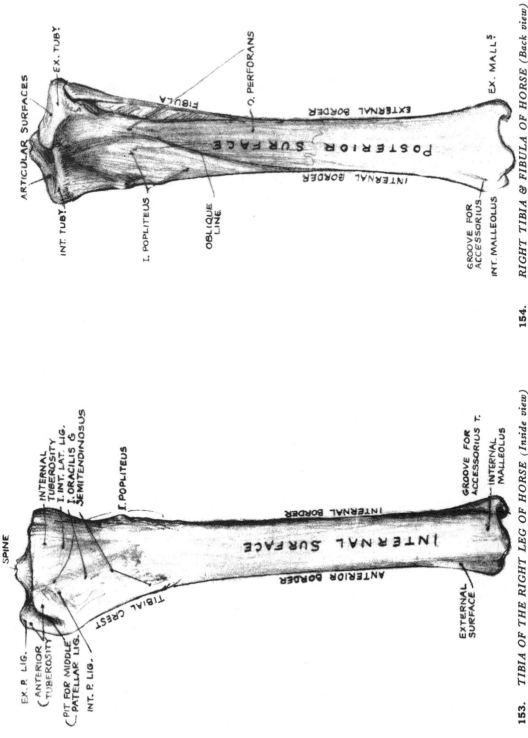

SPINE

EX. P. LIG.
Anterior
Tuberosity
Pit for Middle
Patellar Lig.
INT. P. LIG.

INTERNAL
TUBEROSITY
I. INT. LAT. LIG.
I. ORACILIS &
I. SEMITENDINOSUS

I. POPLITEUS

TIBIAL CREST

ANTERIOR BORDER

INTERNAL BORDER

INTERNAL SURFACE

EXTERNAL
SURFACE

GROOVE FOR
ACCESSORIUS T.

INTERNAL
MALLEOLUS

153. TIBIA OF THE RIGHT LEG OF HORSE (Inside view)

EX. TUBY.

ARTICULAR SURFACES

INT. TUBY.

I. POPLITEUS

OBLIQUE
LINE

FIBULA

O. PERFORANS

POSTERIOR SURFACE

EXTERNAL BORDER

INTERNAL BORDER

EX. MALLS.

GROOVE FOR
ACCESSORIUS

INT. MALLEOLUS

154. RIGHT TIBIA & FIBULA OF HORSE (Back view)

feriorly with the Astragalus. It may be divided into a body or shaft and two extremities. The body is triangular in section. It therefore has three surfaces—external, internal and posterior, and three borders, an anterior and two lateral. Both the external and posterior surfaces support large muscular masses which are separated from each other by the fibula and the external border, while the inner surface is mostly subcutaneous.

The external surface is twisted, and whereas the upper end is concave and faces outwards, the lower is flattened and faces forwards. The fleshy portion of the flexor metatarsi muscle arises in the superior concavity *(see Plates 152 & 155)*.

The internal surface is exposed in its lower two-thirds and covered above by the terminal aponeuroses of the gracilis and semi-tendinosus muscles.

The posterior surface is flat and ridged for muscular attachment. It is divided into two unequal triangular areas by an oblique line extending from behind the external tuberosity to the middle of the internal border. The internal and upper triangle affords attachment for the popliteus muscle, and the perforans arises on the external and larger one, so that the whole of the back of the bone is occupied by these two muscles. The borders are well marked and serve to separate the main groups of muscles from each other.

The anterior border, which corresponds to the sensitive part of a man's shin, forms superiorly a salient ridge called the Tibial Crest that crosses the upper third of the front of the bone in an oblique direction from without inwards, and which gives attachment to the anterior portion of the biceps muscle. It then becomes vertical and fades away on the front of the internal malleolus, i.e the inner prominence of the hock. The external and internal borders are relatively straight and upright.

The upper extremity is the most voluminous, and consists of three tuberosities, an anterior, an external and an internal, which form, as it were, the capitals of the three borders.

The anterior tuberosity is a triangular expansion of the upper end of the tibial crest and gives attachment to the three ligaments which unite the patella with the tibia. A vertical notch in front lodges the lower end of the middle ligament, the external ligament being attached to the eminence on the outer side of it and the internal to the flattened inner surface *(see Plate 155)*. The anterior tuberosity does not articulate with the femur.

The external tuberosity overhangs the external border. It forms the posterior limit of the groove in which the extensor pedis and flexor metatarsi muscles are lodged, and carries on the outside a facet for articulation with the head of the fibula. Above is a slightly concave horizontal surface for articulation with the outer condyle of the femur.

The internal tuberosity is the most extensive but the least conspicuous.

It is flattened on the inner side and gives attachment to the internal lateral ligament of the stifle *(see Plate 153)*. Posteriorly it projects to form the inner boundary of the concavity occupied by the fleshy part of the popliteus muscle. The upper surface, like that of the external

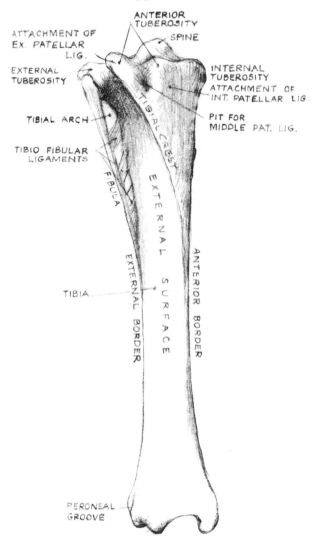

155. *RIGHT TIBIA & FIBULA OF HORSE (Front view)*

tuberosity, is horizontal and slightly concave, for articulation with the inner condyle of the femur *(see Plate 154)*.

In the centre of the top of the bone, where the three tuberosities meet, is a conical eminence called the Tibial Spine, which responds to the intercondyloid fossa of the femur.

Semi-lunar Cartilages of the Stifle Joint. (Interarticular Meniscii.) Interposed between the tuberosities of the tibia and the condyles of the femur are two crescent-shaped cartilaginous pads, which partly surround the tibial spine, and are moulded upon the opposing articular surfaces of the two bones, but have no outward effect *(see Plates 159 & 160).*

The femoro-tibial articulation forms an imperfect hinge joint—other movements being restricted by the powerful lateral ligaments.

156. *RIGHT TIBIA OF HORSE, FROM IN FRONT & BELOW*
(Foreshortened view.)

This shows primarily the way in which the articular surface of the lower end is moulded to fit the pulley of the astragalus.
1. Anterior tuberosity. 2. External tuberosity. 3. Internal tuberosity. 4. Notch for middle patellar ligament. 5. Upper concave part of external surface facing outwards. 6. Lower flat part facing forwards. 7. Anterior border. 8. Tibial crest. 9. External malleolus. 10. Internal malleolus. 11. Lower articular grooves. 12. Median ridge (N.B. Oblique direction).

The lower extremity of the tibia consists of an articular surface enclosed between two lateral tuberosities. The articular surface responds to the pulley of the astragalus and with it forms the true hock joint. It consists of two deep grooves separated by a median ridge and deflected from behind outwards to accord with the oblique direction of the pulley.

The external tuberosity or external malleolus, which represents the outer prominence of a man's ankle, is really the lower end of the fibula, which in the horse has become fused with the tibia. It overhangs and articulates with the astragalus. A vertical fissure on the outside affords passage for the tendon of the peroneus muscle *(see Plate 152)*, on either side of which the external lateral ligament of the hock is attached.

The internal malleolus is the more prominent of the two and is approximately level with the outer one. It provides attachment for the internal lateral ligament.

The *Patella (see also Plate 144)* is a small solid bone corresponding with the human knee-cap, linking the triceps tendon with the straight patellar ligaments, through which the action of the muscle is transmitted to the bones of the leg. It glides on the femoral trochlea in sympathy with the movements of the tibia, moving downwards whenever the stifle is flexed, and up again during extension. It may be described as having three surfaces, anterior, posterior and superior.

The anterior surface is convex *(see Plate 157)* with the lateral angles bent back, and the lower internal border incurved to allow it to glide over the protruding lip of the trochlea when the leg is extended.

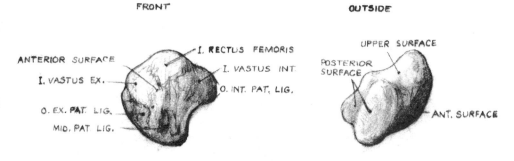

FRONT OUTSIDE

ANTERIOR SURFACE — I. RECTUS FEMORIS — UPPER SURFACE
I. VASTUS EX. — I. VASTUS INT — POSTERIOR SURFACE
O. EX. PAT. LIG. — O. INT. PAT. LIG. — ANT. SURFACE
MID. PAT. LIG.

157 & 158. *PATELLA OF HORSE, RIGHT LEG*

The posterior articular surface consists of two unequal concave facets imperfectly moulded upon the corresponding lips of the trochlea, and divided by a median ridge that runs in the groove *(see Plate 147)*. The inner border is extended by a fibrocartilage, which increases the area for articulation with the inner lip, and gives attachment to the internal patellar ligament.

The upper surface is saddle shaped. It is, however, so buried in fat and covered by tendons that it has very little influence on the shape.

Straight Patellar Ligaments. The patella is united to the anterior tuberosity of the tibia by three strong ligaments. The external and internal are flat bands and the middle one a round cord.

The external ligament, which is the largest and most powerful, extends from the outer angle and adjoining surface of the patella to the summit of the tuberosity, and receives insertions of the " fascia lata " and the long vastus and biceps muscles.

The middle ligament arises in close proximity to the external from the anterior face and inferior angle of the patella and is inserted in the median notch in front of the tuberosity. It runs parallel with the external ligament, but owing to its being more deeply placed and embedded in fat, as well as covered by a tendinous expansion that connects the outer and inner ligaments, it is hardly visible.

The internal ligament is the longest of the three. It commences behind the internal angle of the patella, where it is confounded with the cartilaginous extension of that bone, and after passing down the inner

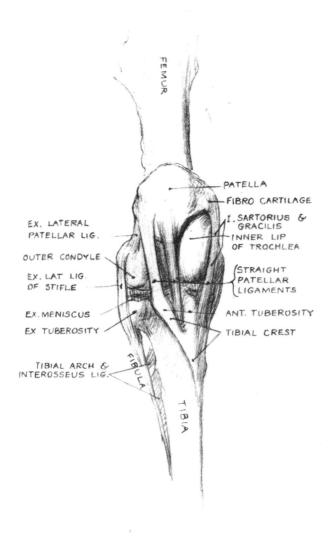

EX. LATERAL
PATELLAR LIG.

OUTER CONDYLE

EX. LAT. LIG.
OF STIFLE

EX. MENISCUS

EX. TUBEROSITY

TIBIAL ARCH &
INTEROSSEUS LIG.

FEMUR

PATELLA

FIBRO CARTILAGE

I. SARTORIUS &
GRACILIS

INNER LIP
OF TROCHLEA

STRAIGHT
PATELLAR
LIGAMENTS

ANT. TUBEROSITY

TIBIAL CREST

FIBULA

TIBIA

159. *LIGAMENTS*
Front view of right Stifle joint, extended.

side of the femoral trochlea, is attached to the inner receding face of the tuberosity. It is therefore separated from the middle ligament by a considerable interval in which, during extension of the joint, the inner lip of the trochlea protrudes. It gives insertion to the joint tendon of the gracilis and sartorius muscles.

In addition to these, there are two thin ligaments connecting the lateral angles of the patella with the corresponding condyles of the femur. These are called the lateral patellar ligaments, and prevent the

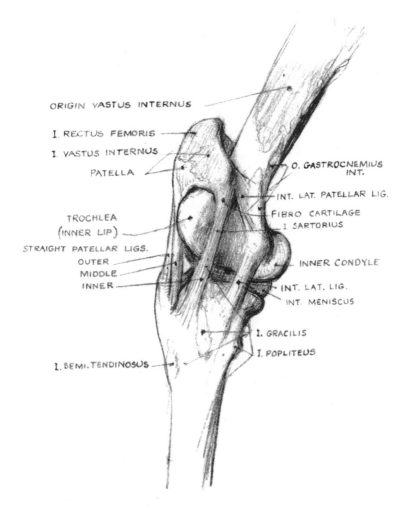

ORIGIN VASTUS INTERNUS

I. RECTUS FEMORIS

I. VASTUS INTERNUS

PATELLA

O. GASTROCNEMIUS INT.

INT. LAT. PATELLAR LIG.

FIBRO CARTILAGE

I. SARTORIUS

TROCHLEA (INNER LIP)

STRAIGHT PATELLAR LIGS.
OUTER
MIDDLE
INNER

INNER CONDYLE

INT. LAT. LIG.

INT. MENISCUS

I. GRACILIS

I. POPLITEUS

I. SEMI. TENDINOSUS

160. *INSIDE VIEW OF RIGHT STIFLE, EXTENDED*
This shows the position of Patella, Ligaments and origins and insertions of muscles. The Adductor muscle is entirely covered by the Gracilis.

patella slipping out of the trochlea.

In the profile view of a horse standing at attention, the patella is generally masked by overhanging muscles and fat, and forms the base of a depression, but when the leg is bent, it projects forwards and forms a conspicuous angle.

The *patella,* the *straight patellar ligaments,* the *anterior tuberosity*

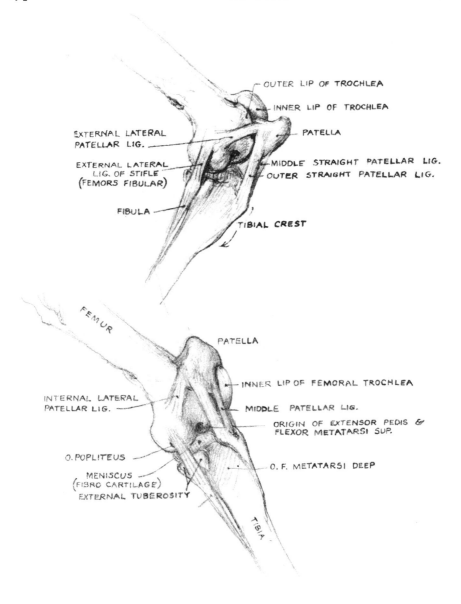

OUTER LIP OF TROCHLEA

INNER LIP OF TROCHLEA

EXTERNAL LATERAL PATELLAR LIG.

PATELLA

EXTERNAL LATERAL LIG. OF STIFLE (FEMORS FIBULAR)

MIDDLE STRAIGHT PATELLAR LIG.

OUTER STRAIGHT PATELLAR LIG.

FIBULA

TIBIAL CREST

FEMUR

PATELLA

INNER LIP OF FEMORAL TROCHLEA

INTERNAL LATERAL PATELLAR LIG.

MIDDLE PATELLAR LIG.

ORIGIN OF EXTENSOR PEDIS & FLEXOR METATARSI SUP.

O. POPLITEUS

O. F. METATARSI DEEP

MENISCUS (FIBRO CARTILAGE)

EXTERNAL TUBEROSITY

TIBIA

161 & 162. *FLEXION & EXTENSION*
(Outside view of right stifle)
162 shows how the patella rides over the femoral trochlea when the leg is extended.

and the *crest of the tibia* are superficial parts of the framework of the leg, whose relative positions do not vary. They move together as a single piece, so that whether the stifle is flexed or extended the distance between the patella and the tibia remains the same.

In the dog and cat the patella is narrow and does not overhang the lips of the trochlea. It is connected to the tibia by a single ligament.

The *Fibula* of the horse is a rudimentary bone immovably attached to the outer side of the tibia *(see Plates 152, 154 & 155)*. It has no special function and does not share in the formation of any movable joint. It closely resembles one of the splint bones both in size and shape, as well as in the way in which the upper extremity has continued in its development, and the lower end has wasted away.

The head is flat and wide and articulates with the external tuberosity of the tibia. The shaft is straight and tapering. It joins the outer border of the tibia some four or five inches above the hock joint, being continued thereafter as a fibrous cord that is sometimes, though very rarely, ossified, and terminates in the external malleolus.

Owing to the prominence of the external tuberosity of the tibia and the curvature of the upper end of the corresponding border, the fibula is only in contact with the tibia at its extremities and, the intervening space being bridged by an interosseus ligament, a partition is formed between the muscles arising on the external surface and those on the back of the tibia.

The lower end of the external lateral ligament of the stifle is attached to the head of the fibula, and the peroneus muscle arises on the upper end of the shaft.

In the ox, the fibula is replaced by a fibrous cord which is sometimes ossified, extending between the external tuberosity of the tibia and the hock, while the lower extremity is represented by a small floating bone that constitutes the external malleolus, and articulates with the tibia, the astragalus and the os calcis. By some authorities this is regarded as an extra tarsal bone and has received the name of the " Coronoid bone " *(see Plate 172)*. It reaches below the tibia, so that in the ox the external malleolus is lower than the internal as is the case in a man's foot, whereas in the horse and Carnivora they are level.

In the dog, cat, &c. the fibula is a long slender bone, approximately the same length as the tibia. The inferior extremity constitutes the external malleolus and articulates with the astragalus and the tibia, the lower half of the shaft being in close contact with the outer border of the latter and immovable, although not fused with it *(see Plate 143)*.

The *Tarsus*, like the carpus in the foreleg, is a group of irregularly-shaped bones arranged in two tiers, but whereas in the knee the two tiers are separable and form a working joint that is capable of flexion and extension, in the hock they are so closely united by ligaments as to render such action impossible. So that while the knee is operated by two joints, the Radio-carpal and the Inter-carpal, in the hock there is only the one in which the astragalus articulates with the tibia (the tibio-tarsal or true hock joint).

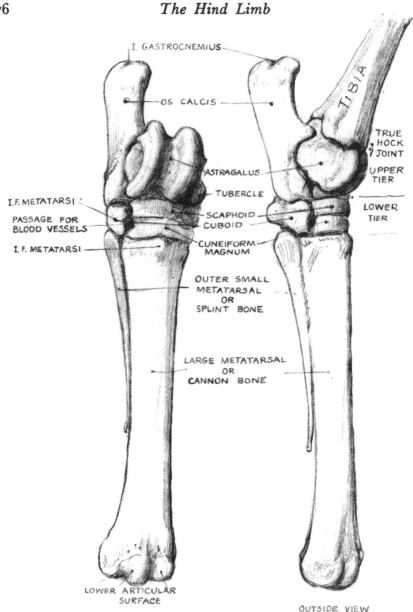

I. GASTROCNEMIUS

OS CALCIS

ASTRAGALUS

TUBERCLE

I.F. METATARSI

PASSAGE FOR
BLOOD VESSELS

I. F. METATARSI

SCAPHOID
CUBOID

CUNEIFORM
MAGNUM

OUTER SMALL
METATARSAL
OR
SPLINT BONE

LARGE METATARSAL
OR
CANNON BONE

TIBIA

TRUE
HOCK
JOINT

UPPER
TIER

LOWER
TIER

LOWER ARTICULAR
SURFACE

OUTSIDE VIEW

163 & 164. *TARSUS & METATARSUS OF RIGHT LEG*
OF HORSE (¾ Front view)

Every intertarsal articulation is technically a movable one, but the movements are very restricted and only consist of slight gliding between the opposing bone surfaces; they hardly affect the external form, and therefore have little artistic interest, although they are undoubtedly of considerable importance from a veterinary point of view, because of

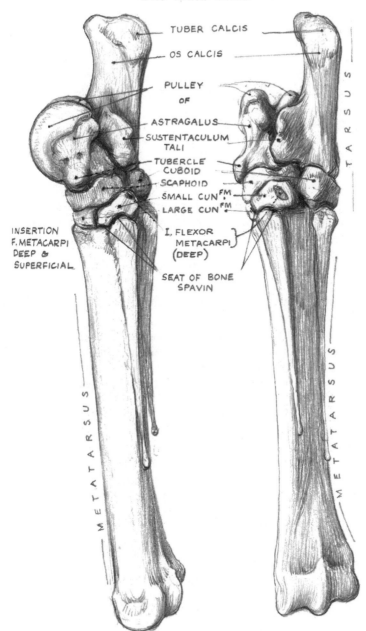

TUBER CALCIS

OS CALCIS

PULLEY

OF

ASTRAGALUS

SUSTENTACULUM
TALI

TUBERCLE
CUBOID

SCAPHOID

SMALL CUNFM

LARGE CUNFM

I. FLEXOR
METACARPI
(DEEP)

SEAT OF BONE
SPAVIN

INSERTION
F. METACARPI
DEEP &
SUPERFICIAL

TARSUS

METATARSUS

TARSUS

METATARSUS

165 & 166. *TARSUS & METATARSUS OF RIGHT LEG OF HORSE*
Inside view. *Back view.*

their liability to injury and disease. It is the shape of the mass that
matters in this case and not the details of its component parts.

The tarsus is united with the metatarsus in the same immovable way
as the carpus and metacarpus of the foreleg, and so far as the action of
the limb is concerned, the hock with the cannon and splint bones may

be regarded as a single structure articulating by its superior extremity with the tibia, and inferiorly with the first phalanx of the digit.

The tarsus comprises six bones, of which there are two above and four below. The two upper bones are the Astragalus and the Os Calcis, the lower tier consisting of the Cuboid, Scaphoid, and the large and small Cuneiform bones.

The Astragalus and Os Calcis are the largest and most important of the group, and are both of them larger and more massive than any in the carpal region. The former provides the surface that articulates with the tibia, and the latter the lever by means of which the foot is extended.

The *Astragalus,* situated in front, extends right across the hock and articulates above with the tibia, behind with the os calcis, and with the scaphoid below.

The surface that articulates with the tibia, to form the true hock joint, is in the form of a large pulley placed in an oblique direction forwards and outwards and overhanging the scaphoid in front. A large tubercle projects inwards from the base and gives attachment to some important ligaments.

The *Os Calcis* is by far the largest of the tarsal bones. It has a thick solid body articulating in front with the astragalus and below with the cuboid; the outer half is projected upwards and forms the tuber calcis, the large process whose apex constitutes the point of the hock.

In the middle of the upper surface is a depression in which the gastrocnemius tendon is inserted; in front of it a slight declivity on which the tendon rests when the muscle is relaxed, and behind, a smooth rounded area on which the perforatus tendon glides. Posteriorly, a wide groove is excavated in the body of the bone; it forms the floor of the tarsal sheath through which the perforans tendon runs, and is bounded outwardly by the ascending tuber calcis and inwardly by a process called the sustentaculum tali (talus being another name for the astragalus with which it articulates in front).

The *Cuboid (see Plate 164)* is the outermost of the lower tier of tarsal bones. It supports the outer half of the Os Calcis, and rests upon the head of the outer splint bone and the adjacent part of the cannon. It gives attachment to the external branch of the superficial (tendinous) portion of the flexor metatarsi muscle.

The *Scaphoid* is a flat bone, sandwiched between the astragalus and the two cuneiforms, with its external extremity in contact with the upper half of the cuboid.

The *Large Cuneiform* is very similar in appearance to the scaphoid, under which it is situated. It rests upon the cannon bone and is in contact by its outer end with the lower half of the cuboid, and by its posterior surface with the small cuneiform bone.

The *Small Cuneiform* is the smallest of the tarsal group. It is an odd-shaped bone wedged in between the scaphoid, the large cuneiform, the inner splint and the cannon bone, and occupies on the inner side of the hock a place similar to that occupied by the cuboid on the outside. It

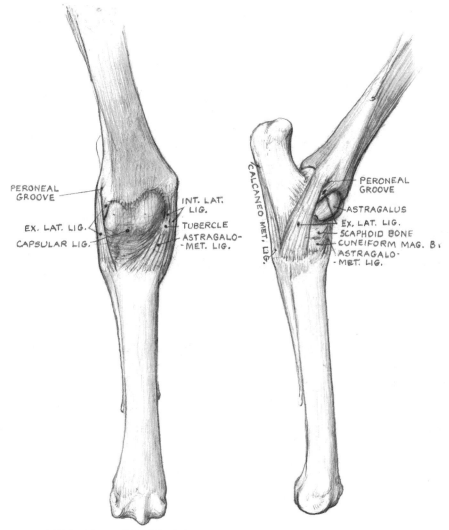

PERONEAL GROOVE

EX. LAT. LIG.

CAPSULAR LIG.

INT. LAT. LIG.

TUBERCLE

ASTRAGALO-MET. LIG.

CALCANEO MET. LIG.

PERONEAL GROOVE

ASTRAGALUS

EX. LAT. LIG.

SCAPHOID BONE

CUNEIFORM MAG. B.

ASTRAGALO-MET. LIG.

167 & 168. *LIGAMENTS OF THE HOCK OF HORSE*
Left. Right leg (Front view).
Right. Right leg (Outside view) Capsular Ligament omitted.

gives attachment to the inner terminal tendon of the deep (muscular) portion of the Flexor Metatarsi (*see Plate 166*). This little bone has a peculiar interest for horse owners as it is the seat of a very common arthritic disease which leads to the formation of a " bone spavin." The disease, which is generally the result of concussion, first of all attacks the

gliding joints between the two cuneiform bones, or/and between the small cuneiform and the metatarsal bones, i.e. on the inside of the lower part of the hock *(see Plates 165 & 166)*. In the early stages it does not affect the shape, and except for the lameness and evident pain it causes, and a predisposition to rest the leg, there are no visible signs of the disease; but eventually, a bony growth appears around the affected part, and the hock is definitely out of drawing. A horse suffering from a bone spavin avoids putting its heel on the ground when moving, and when standing it advances the foot and rests on its toe, and although this attitude is often adopted by animals with sound hocks, as it suggests a diseased condition, it is best to avoid it when painting horses of " quality."

The weight of the animal falls on the astragalus and is transmitted through the scaphoid and cuneiform bones to the cannon and inner splint bone, whereas the outer bones, os calcis, and cuboid, are not called upon to sustain any direct pressure from above, and are therefore seldom affected in this way.

Ligaments of the Hock. (See Plates 167, 168, 169 & 170.) The general arrangement of the ligaments of the hock is much the same as in the knee. First, there are those which bind the adjoining tarsal bones together, which are quite invisible, and need not therefore be described. Then, three ligaments, which are common to the tarsus and the metatarsus, viz. : —

(1) The *Astragalo-metatarsal Ligament (see Plate 167)*, a triangular ligament situated on the front of the hock, and connecting the tubercle of the astragalus with the scaphoid, the large cuneiform, and the cannon bone.

(2) The *Tarso-metatarsal Ligament (see Plate 169)* situated on the back of the hock, and uniting the bones of the tarsus with the cannon and splint bones. This ligament is continued below as the subtarsal ligament, which joins the perforans tendon in the same way as the " check " ligament of the foreleg.

(3) The *Calcaneo-metatarsal Ligament* connecting the os calcis and the cuboid with the outer splint bone *(see Plate 169)*.

These three ligaments by uniting the bones in front and behind prevent flexion and extension at the intertarsal and tarso-metatarsal articulations.

Finally, there are three ligaments which unite the tibia with the tarsometatarso combination to form the true hock joint (the Tibio-tarsal or Tibio-astragaloid articulation) viz. two Lateral ligaments and a Capsular ligament.

The *External Lateral Ligament* consists of a deep and a superficial layer which cross each other *(see Plate 168)*. The superficial portion, which is much the larger of the two, is attached by its superior extremity

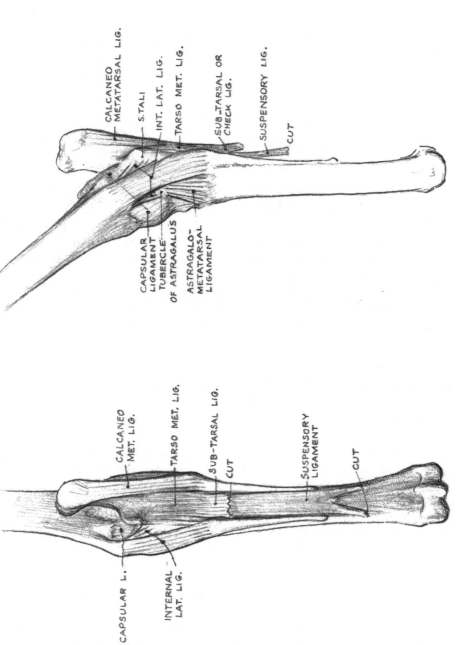

CALCANEO METATARSAL LIG.

S. TALI

INT. LAT. LIG.

TARSO MET. LIG.

SUB-TARSAL OR CHECK LIG.

SUSPENSORY LIG.

CUT

CAPSULAR LIGAMENT TUBERCLE OF ASTRAGALUS

ASTRAGALO-METATARSAL LIGAMENT

CALCANEO MET. LIG.

TARSO MET. LIG.

SUB-TARSAL LIG.

CUT

SUSPENSORY LIGAMENT

CUT

CAPSULAR L.

INTERNAL LAT. LIG.

169 & 170. *LIGAMENTS OF THE HOCK OF HORSE*
Left. Right leg (Back view).
Right. Right leg (Inside view).

to the posterior tubercle of the external malleolus—i.e. behind the peroneal groove—and after connecting with the astragalus, os calcis and cuboid bones, it terminates on the outer splint bone and the cannon bone. The deep portion commences on the anterior tubercle of the malleolus, and passing downwards and backwards is inserted on the astragalus and the os calcis.

The *Internal Lateral Ligament (see Plate 170)* may similarly be divided into two layers, of which the superficial is again the largest. It is fixed above to the internal malleolus, and ends on the head of the inner splint bone and the adjoining part of the cannon bone, with deep attachments on the underlying parts of the astragalus, scaphoid and cuneiform bones. The deep portion arises beneath the preceding and splits into two parts, the anterior terminating on the tubercle of the astragalus, and the posterior on the sustentaculum tali of the os calcis. Both of these are very powerful ligaments and have a marked influence on the shape of the hock.

The *Capsular Ligament* completely encloses the joint *(see Plate 167)*. The anterior part is loose and thin. It is attached above to the articular rim of the tibia and extends below to the astragalus, the scaphoid and the large cuneiform, blending with the astragalo-metatarsal ligament in front and with the lateral ligaments on either side of the hock.

The powerful tendons of the flexor metatarsi and extensor pedis muscles give it support in front, but on the inner side of these tendons the ligament is exposed, and consequently when there is an over secretion of fluid in the joint it bulges out and forms a " bog spavin." Care should therefore be taken in the delineation of this part of the hock and any enlargement or puffiness regarded with suspicion.

Hock (Comparative). In the ox, the cuboid and scaphoid are fused together, reducing the number of tarsal bones to five *(see Plate 172)*. The pulley of the astragalus is vertical, the os calcis longer and thinner, and the external malleolus, as represented by the detached end of the fibula, is situated lower down.

In the dog and cat there are three cuneiform bones, as in man, otherwise the general arrangement of the tarsal bones is the same as in the horse, but owing to modifications in some of their articular surfaces, movement is less restricted.

The skeleton of the leg of a horse below the hock consists of the large and rudimentary metatarsal bones and the three phalanges, with the sesamoids and navicular bone, and is such an exact repetition of the corresponding part of the skeleton of the fore limb that no further description is needed, and it is only necessary to mention one or two slight variations in the proportions of some of the bones: —

(1) The hind cannon bone is longer than the cannon of the foreleg by

from two to two and a half inches, say by one quarter the length of the latter. In a pony therefore, whose fore cannon measures eight inches, the hind cannon would be approximately ten inches, and the relative difference would be the same in larger animals.

(2) As a rule the outer splint bone is longer than the inner, the reverse being the case in the fore limb.

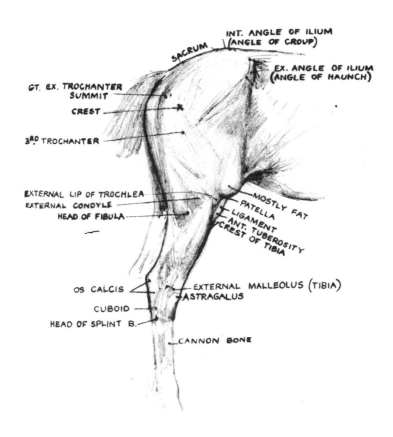

INT. ANGLE OF ILIUM
(ANGLE OF CROUP)

SACRUM

EX. ANGLE OF ILIUM
(ANGLE OF HAUNCH)

GT. EX. TROCHANTER
SUMMIT

CREST

3RD TROCHANTER

EXTERNAL LIP OF TROCHLEA
EXTERNAL CONDYLE
HEAD OF FIBULA

MOSTLY FAT
PATELLA
LIGAMENT
ANT. TUBEROSITY
CREST OF TIBIA

OS CALCIS
CUBOID
HEAD OF SPLINT B.

EXTERNAL MALLEOLUS (TIBIA)
ASTRAGALUS

CANNON BONE

171. *RIGHT HIND LIMB OF HORSE*
This shows the situation of some of the chief bone points mentioned in Chapter VIII.

(3) The first phalanx of the digit is a trifle shorter and the sesamoid bones a little smaller.

(4) Finally, the coffin bone is narrower and more pointed, a feature that is reflected in the shape of the hoof, which is a little more upright than that of the fore limb.

The suspensory ligament is precisely the same in both legs as are the terminal attachments of the extensor pedis and back tendons.

The chief point of difference to be noted in the Carnivora is in the development of the dew-claw. This, in the cat is absent altogether, except for a very fragmentary first metatarsal bone.

In the dog, however, although generally absent, it is sometimes de-

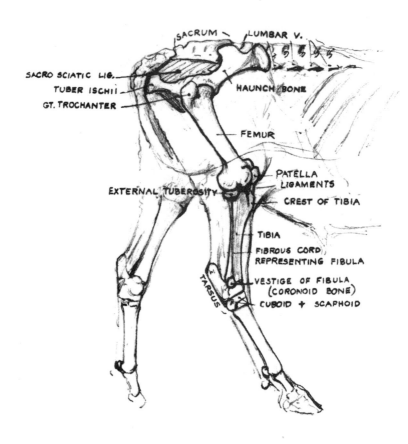

172. *BONES OF HIND LIMB OF OX*

veloped, in which case it consists of two distinct, although very small, phalanges, which are loosely attached to the rudimentary metatarsal by ligament. Its development is most frequent in the larger breed of dog, but as it is quite a useless appendage and very apt to get damaged, it is generally removed soon after birth.

MUSCLES OF THE HIND LIMB

Extensor Pedis. (Anterior Extensor of the Phalanges) (Extensor longus digitorum pedis of man). This is a superficial muscle reaching from the outer side of the stifle to the coffin bone. It arises, along with the tendinous portion of the flexor metatarsi, in the fossa between the trochlea and the external condyle of the femur. It consists of a muscular body and a long tendon. The muscular portion is thick in the middle and pointed at both ends. It covers the flexor metatarsi muscle, and with it forms the fleshy mass that occupies the external surface of the tibia. Before reaching the hock it is succeeded by a round tendon that flattens out as it passes over the front of the joint, and is kept in place by three annular bands, one of which retains it on the lower end of the tibia, another just below the pulley of the astragalus, and a third binds it down to the upper end of the cannon bone. About half-way down the cannon bone it is joined by the tendon of the peroneus muscle, and continuing over the fetlock and pastern, receives the phalangeal branches of the suspensory ligament, and terminates on the pyramidal process of the os pedis (coffin bone) in exactly the same way as the corresponding tendon of the fore limb. It is an extensor of the digit and a flexor of the hock.

In the ox, this muscle divides into two parts and is continued down the leg by two tendons terminating on the two digits in the same way as the extensor pedis of the foreleg *(see Plate 176)*.

In the dog and cat it consists of a single fleshy belly, whose tendon after passing over the front of the hock divides into four slips which are inserted on the two last phalanges of the four toes. The upper half of the muscle is covered by the flexor metatarsi *(see Plate 177)*.

Peroneus. (Lateral Extensor of the Phalanges) (Peroneus brevis of man). This muscle is situated on the outer side of the leg between the extensor pedis and the perforans. Like the preceding, it consists of a fleshy portion and a long tendon. It arises from the external lateral ligament of the stifle and from the whole length of the fibula, and the tendon, after passing through the groove on the external malleolus of the tibia (where it is retained by a fibrous band), penetrates the external lateral ligament of the hock and then inclines forwards and joins the extensor pedis tendon, whose action it shares. This muscle, like the suffraginis in the fore limb, is enclosed in a special aponeurotic sheath

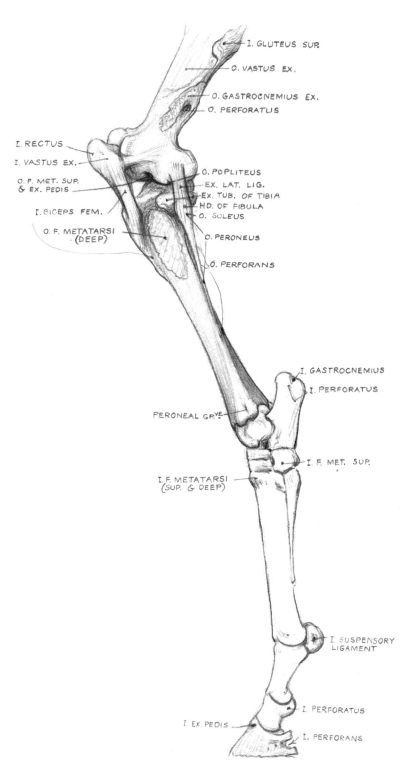

I. GLUTEUS SUP.

O. VASTUS EX.

O. GASTROCNEMIUS EX.
O. PERFORATUS

I. RECTUS

I. VASTUS EX.

O. F. MET. SUP.
& EX. PEDIS

I. BICEPS FEM.

O. F. METATARSI
·(DEEP)

O. POPLITEUS
EX. LAT. LIG.
EX. TUB. OF TIBIA
HD. OF FIBULA
O. SOLEUS

O. PERONEUS

O. PERFORANS

I. GASTROCNEMIUS

I. PERFORATUS

PERONEAL GR.VE

I. F. MET. SUP.

I. F. METATARSI
(SUP. & DEEP)

I. SUSPENSORY
LIGAMENT

I. PERFORATUS

I. EX. PEDIS

I. PERFORANS

173. *SKELETON OF LEFT HIND LEG OF HORSE*
Showing origins and insertions of muscles.

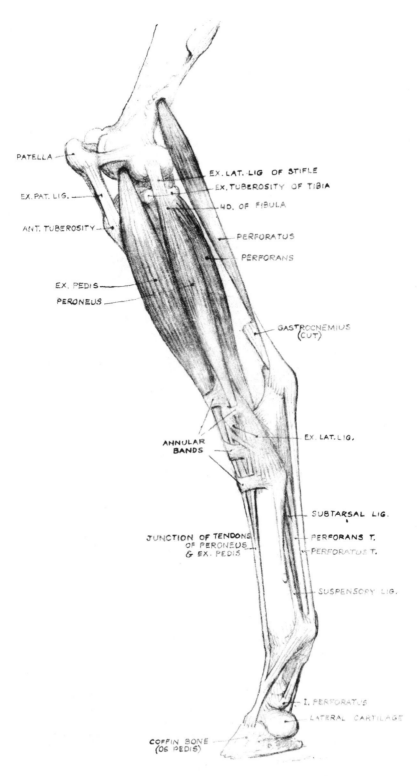

PATELLA

EX. PAT. LIG.

ANT. TUBEROSITY

EX. PEDIS

PERONEUS

EX. LAT. LIG. OF STIFLE

EX. TUBEROSITY OF TIBIA

HD. OF FIBULA

PERFORATUS

PERFORANS

GASTROCNEMIUS (CUT)

ANNULAR BANDS

EX. LAT. LIG.

SUBTARSAL LIG.

JUNCTION OF TENDONS OF PERONEUS & EX. PEDIS

PERFORANS T.

PERFORATUS T.

SUSPENSORY LIG.

I. PERFORATUS

LATERAL CARTILAGE

COFFIN BONE (OS PEDIS)

174. *MUSCLES ACTING ON FOOT (Outside view)*

that separates it from the adjoining muscles, and the tendon after passing through the annular band below the hock is often crisply defined.

In the ox there are two peroneal muscles, both visible on the outside of the leg: —

(1) The *Peroneus brevis,* analogous to that just described, and

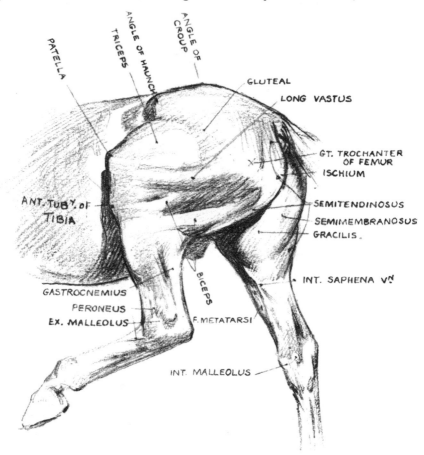

175. *ANALYSIS OF A DRAWING OF THE HIND QUARTERS OF A HORSE, WITH THE FOOT HELD UP, SEEN A LITTLE FROM BELOW*

(2) The *Peroneus longus,* situated between it and the extensor pedis muscle.

The Peroneus brevis (extensor of the outer toe) (lateral extensor of the foot) arises from the external tuberosity of the tibia and from the fibrous band that takes the place of the fibula. Its tendon does not, however, join that of the extensor pedis on the front of the cannon bone as in the horse, but continues single to the foot, and after receiving the external

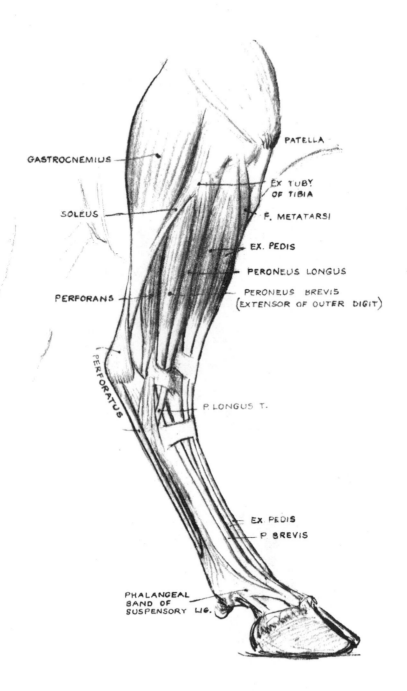

GASTROCNEMIUS

PATELLA

EX TUBY. OF TIBIA

SOLEUS

F. METATARSI

EX. PEDIS

PERONEUS LONGUS

PERONEUS BREVIS
(EXTENSOR OF OUTER DIGIT)

PERFORANS

PERFORATUS

P. LONGUS T.

EX. PEDIS

P BREVIS

PHALANGEAL
BAND OF
SUSPENSORY LIG.

176. *RIGHT HIND LEG OF OX*
Superficial muscles.

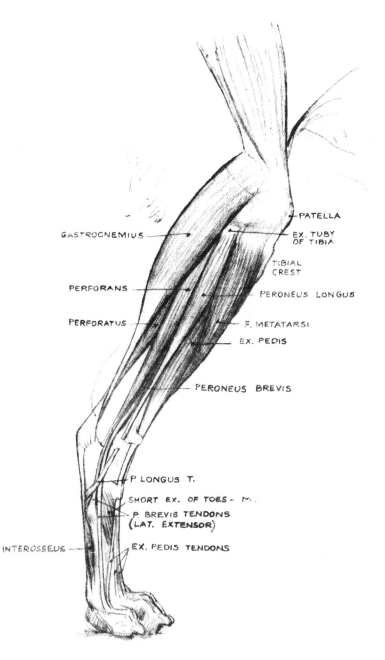

GASTROCNEMIUS

PERFORANS

PERFORATUS

PATELLA

EX. TUBY
OF TIBIA

TIBIAL
CREST

PERONEUS LONGUS

F. METATARSI

EX. PEDIS

PERONEUS BREVIS

P LONGUS T.

SHORT EX. OF TOES - M.

P. BREVIS TENDONS
(LAT. EXTENSOR)

INTEROSSEUS

EX. PEDIS TENDONS

177. *HIND LEG OF DOG (Outside view)*
Superficial muscles.

phalangeal branch of the suspensory ligament, is inserted on the outer digit.

The other muscle, Peroneus longus, of which there is no trace in the horse, arises in front of the external tuberosity of the tibia. About half-way down the leg it is succeeded by a tendon that passes, with that of the preceding muscle, through a fibrous ring on the external malleolus; it then crosses over that tendon, disappears beneath the ligaments, and winds round the back of the hock to its insertion on the upper end of the inner metatarsal bone.

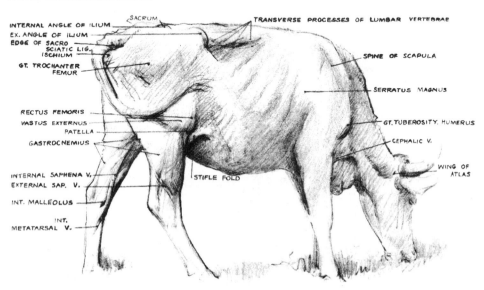

178. *SKETCH FROM NATURE ANALYSED*

Again, in Carnivora there are two peroneal muscles. In them the Peroneus longus is the more conspicuous, and fills the space in the upper half of the leg that is bounded in front by the extensor pedis and flexor metatarsi muscles, and behind by the perforans. It follows very much the same course as the corresponding muscle in the ox, arising in front of the external tuberosity of the tibia and terminating on the innermost metatarsal bone.

The Peroneus brevis arises on the fibula and divides into two portions, whose slender tendons pass together over the back of the external malleolus, then under the tendon of Peroneus longus to terminate in the following manner: The anterior tendon, representing the lateral extensor, passes down the front of the external metatarsal bone, joins the outer tendon of the extensor pedis muscle, and is inserted with it on the outer toe. The posterior tendon terminates on the upper extremity of the external metatarsal bone.

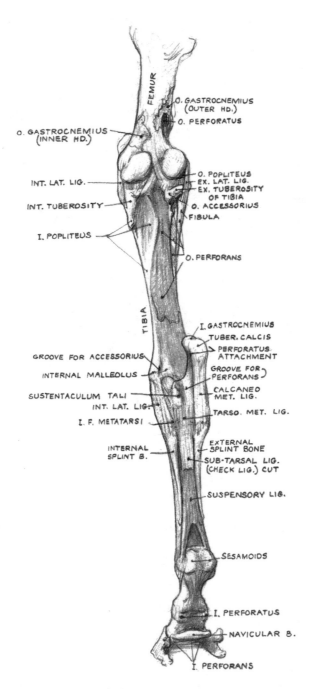

FEMUR

O. GASTROCNEMIUS
(OUTER HD.)

O. PERFORATUS

O. GASTROCNEMIUS
(INNER HD.)

INT. LAT. LIG.

INT. TUBEROSITY

O. POPLITEUS
EX. LAT. LIG.
EX. TUBEROSITY
OF TIBIA
O. ACCESSORIUS
FIBULA

I. POPLITEUS

O. PERFORANS

TIBIA

I. GASTROCNEMIUS
TUBER. CALCIS
PERFORATUS
ATTACHMENT

GROOVE FOR ACCESSORIUS

GROOVE FOR
PERFORANS

INTERNAL MALLEOLUS

CALCANEO
MET. LIG.

SUSTENTACULUM TALI

INT. LAT. LIG.

TARSO. MET. LIG.

I. F. METATARSI

EXTERNAL
SPLINT BONE

INTERNAL
SPLINT B.

SUB-TARSAL LIG.
(CHECK LIG.) CUT

SUSPENSORY LIG.

SESAMOIDS

I. PERFORATUS

NAVICULAR B.

I. PERFORANS

179. *BONES OF RIGHT HIND LEG OF HORSE*
This drawing shows origins and insertions of muscles, back view.

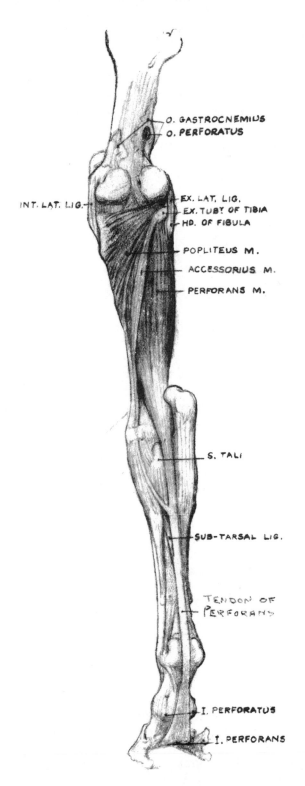

O. GASTROCNEMIUS
O. PERFORATUS

INT. LAT. LIG.

EX. LAT. LIG.
EX. TUBY OF TIBIA
HD. OF FIBULA

POPLITEUS M.

ACCESSORIUS M.

PERFORANS M.

S. TALI

SUB-TARSAL LIG.

TENDON OF
PERFORANS

I. PERFORATUS

I. PERFORANS

**180. *DEEP MUSCLES OF RIGHT HIND LEG OF HORSE,
FROM BEHIND***
Perforans, Popliteus and Accessorius.

Flexor Pedis Perforans. (Deep Flexor of the Phalanges) *(see Plates 179 & 180)*. This is a thick powerful muscle, imperfectly divided into two parts. It arises from the posterior surface of the tibia below the oblique line, its external tuberosity, from the fibula, and from the ligaments which unite the two bones. On nearing the hock joint, the two portions unite in a single strong tendon that passes through the tarsal sheath. Behind the upper end of the metatarsus it is joined by the tendon of the accessorius muscle, and a little below this by the subtarsal or " check " ligament, and afterwards comports itself and terminates in precisely the same way as the corresponding tendon in the fore limb. It is a flexor of the foot and fetlock, and through the subtarsal ligament serves as a mechanical stay in support of those joints when the animal is standing.

Flexor Accessorius. (Oblique Flexor of the Phalanges) *(see Plate 180)*. This is a thin, flat muscle crossing the preceding muscle obliquely from without inwards. It arises behind the external tuberosity of the tibia, and about the middle of the leg is succeeded by a slender tendon, which passes through the groove at the back of the internal malleolus of the tibia and joins the tendon of the perforans a little below the hock. It supplements the action of the perforans muscle. It is covered at its origin by the gastrocnemius and perforatus muscles, but for the remainder of its length is superficial.

Flexor Perforatus. (Superficial Flexor of the Phalanges) (Gastrocnemius Internus) (= Plantaris, plus the short flexor of the toes of man). The Perforatus of the horse consists almost entirely of tendinous tissue, with which at the upper end are incorporated some short muscular fibres, so that while it has some power of contraction it is practically inextensible. It reaches from the lower end of the femur to the small pastern bone, with intermediate attachments on each side of the os calcis. It arises in the supracondyloid fossa of the femur *(see Plate 179)*. At first covered by the gastrocnemius muscle, it comes to the surface on the inside of the leg, and after winding round and over the tendon of that muscle, it forms a cap over the point of the hock; it then passes down the back of the leg behind the perforans tendon, and is finally inserted on the posterior prominences of the second phalanx in exactly the same way as the perforatus tendon of the fore limb.

By its muscular action it flexes the second phalanx upon the first, and in so doing helps in the flexion of the fetlock and extension of the hock joint. Its chief function, however, is to give mechanical support to the hock and fetlock joints in the standing position.

Owing to its attachment on the os calcis, the hock joint automatically conforms to the extension movements of the stifle. *Flexion at the hock joint cannot take place when the stifle is extended.*

In the same way, as we shall presently show, a somewhat similar

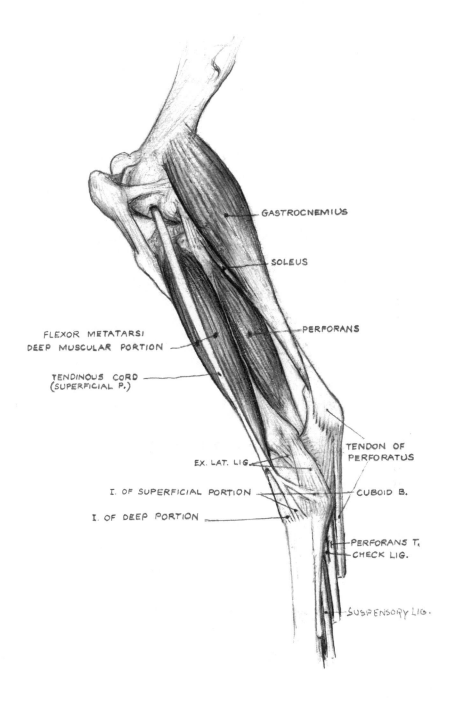

GASTROCNEMIUS

SOLEUS

PERFORANS

FLEXOR METATARSI
DEEP MUSCULAR PORTION

TENDINOUS CORD
(SUPERFICIAL P.)

TENDON OF
PERFORATUS

EX. LAT. LIG.

I. OF SUPERFICIAL PORTION

CUBOID B.

I. OF DEEP PORTION

PERFORANS T.
CHECK LIG.

SUSPENSORY LIG.

181. *LEFT HIND LEG OF HORSE (Outside view)*
The muscles acting on the tarsus and metatarsus.

mechanical contrivance on the front of the leg makes it impossible for the hock to be extended when the stifle is flexed.

The upper portion, as far as the hock, corresponds with the plantaris of man and the lower part with the flexor brevis digitorum.

In the dog and cat, the perforatus is more voluminous and shows on the outside as well as the inside of the leg *(see Plate 177)*.

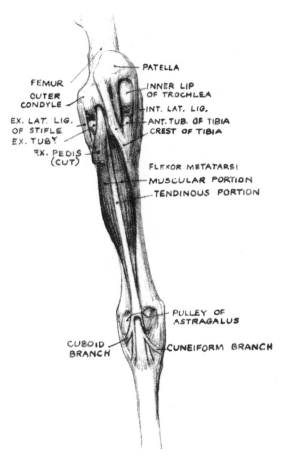

182. *RIGHT LEG OF HORSE (Front view)*
This shows structure of Flexor Metatarsi.

MUSCLES ACTING ON THE TARSUS AND METATARSUS. *Flexor Meta-tarsi.* This muscle consists of two distinct portions, one deep and muscular, occupying the external surface of the tibia, the other super-imposed and entirely tendinous.

The muscular portion corresponds to the tibialis anticus of man and arises in the concavity at the upper end of the external surface of the tibia. Thick and fleshy at first, it gradually tapers downwards, and is suc-

ceeded by a tendon which, after passing through a ring formed in the lower end of the tendinous portion, divides into two branches, one of which is inserted on the front of the upper end of the cannon bone, along with the tendinous portion, which it now covers, and the other (the

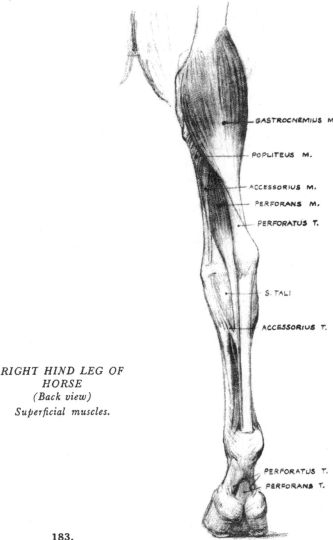

GASTROCNEMIUS M

POPLITEUS M.

ACCESSORIUS M.

PERFORANS M.

PERFORATUS T.

S. TALI

ACCESSORIUS T.

*RIGHT HIND LEG OF
HORSE
(Back view)
Superficial muscles.*

PERFORATUS T.

PERFORANS T.

183.

internal and narrower branch), after crossing over the inner surface of the hock, is inserted on the small cuneiform bone. It is a powerful flexor of the hock joint, and although in the horse invisible on the outside of the leg, it comes to the surface on the inner side between the edge of the bone and the extensor pedis muscle. The cuneiform tendon is always sharply defined when the hock is flexed by the action of the muscle.

The tendinous portion, or as it is sometimes called the cord of the flexor metatarsi, constitutes a powerful brace between the lower end of the femur and the metatarsus. It arises in conjunction with the extensor pedis muscle in the notch that is situated between the trochlea and the external condyle of the femur. It lies on the surface of the muscular portion and is covered by the extensor pedis. On reaching the groove formed by the pulley of the astragalus it is perforated to give passage to the tendon of the muscular portion and, after sending off a slip to be attached to the cuboid bone on the outside of the hock, it terminates on the front of the upper end of the cannon bone. Its action is entirely mechanical. It automatically bends the hock whenever the stifle joint is flexed, making the cannon bone move in the same direction as the thigh.

In the ox, &c. although the attachments of the two portions are similar, there is this great difference, that the part which corresponds to the tendinous portion is muscular and closely adherent to the extensor pedis.

In the dog, cat, &c. it forms a single voluminous muscle, arising from the external tuberosity and the crest of the tibia. The upper extremity is very thick and covers the upper end of the extensor pedis *(see Plate 177)*, while inferiorly it terminates in a single tendon that passes to the inner side of the tarsus and is inserted on the base of the rudimentary dew-claw.

Gastrocnemius. (Gemelli of the Tibia) (Bifemoro-calcaneus) *(see also Plate 181)*. This powerful muscle connects the lower end of the femur with the point of the hock. It arises by two large heads: the outer one from the anterior margin of the supracondyloid fossa of the femur (in which the perforatus originates) and the inner from some tubercles situated above the internal condyle (the supracondyloid crest).

These two portions soon become united and are succeeded by a single strong tendon which, after being joined by the tendon of the soleus muscle and enfolded by the perforatus tendon, is inserted beneath the latter in a depression on the summit of the os calcis. These combined tendons constitute what is known as the Tendo Achilles.

The Gastrocnemius is a powerful extensor of the hock joint, and therefore an active agent in the propulsion of the body.

Soleus. This muscle, which is rather a conspicuous feature on the calf of a man's leg, is very under-developed in quadrupeds, and in the dog, if not altogether absent, is so confused with the outer head of the gastrocnemius as to be unidentifiable.

In the horse *(see Plate 181)* it appears as a thin flattened band on the outer side of the leg between the gastrocnemius and the perforans muscles. It arises on the external tuberosity of the tibia, and its inferior tendon joins that of the gastrocnemius muscle, whose action it feebly assists.

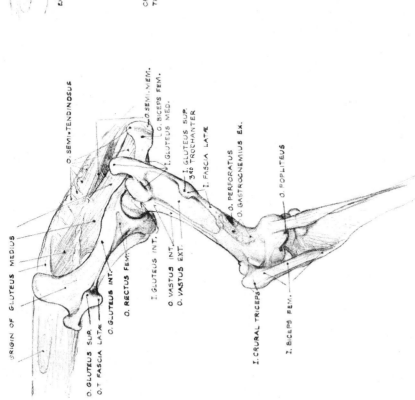

184. SKELETON OF CROUP & THIGH OF HORSE
This shows origins and insertions of muscles.

185. THIGH OF HORSE, DEEP MUSCLES

MUSCLES ACTING ON THE STIFLE JOINT. *Popliteus (see Plates 180 & 183)*. This is a wide, triangular muscle crossing the back of the stifle joint from without inwards. It arises from the outer condyle of the femur, passes beneath the external lateral ligament of the stifle, and spreading out like a fan, is inserted on the superior triangular surface and the inner border of the tibia. It bends the stifle joint, and at the same time gives it a slight twist, which causes the hock to be turned out and the foot to be turned in.

Crural Triceps, the enormous fleshy mass that envelops the front and sides of the thigh bone, consists of three separate muscles—two lateral and a central—which unite inferiorly in a common tendon that is inserted on the anterior face of the patella.

The two lateral portions are called the " vasti " muscles (external and internal) and arise from the sides and front of the upper half of the shaft of the femur. Joined together in the middle line, they there form a wide, deep groove in which the central portion is lodged.

These two muscles acting directly between the femur and the patella, straighten the tibia on the femur, i.e. they extend the stifle joint.

Rectus femoris. (Anterior Straight Muscle of the Thigh) *(see Plate 186)*. This, the central portion, arises on the haunch bone from two depressions situated in front of the cotyloid cavity. It lies embedded in the groove between the vasti muscles and is inserted as stated above with its fellows on the front of the patella. It is an extensor of the stifle and also, by reason of its pelvic origin, a flexor of the hip joint.

MUSCLES ACTING UPON THE FEMUR FROM THE PELVIS. *Iliacus.* (Iliac Psoas) *(see Plate 185)*. This is a powerful muscle arising from the whole of the inferior Iliac surface and the external angle of the Ilium (angle of the haunch) and inserted on the small internal trochanter of the femur. It is covered externally by the muscle of the fascia lata and has little or no effect on the surface. It is a powerful flexor of the hip joint and at the same time rotates the thigh outwards.

Gluteal Muscles. There are three gluteal muscles, superficial, middle and deep. In man, the superficial muscle is the largest and is called the Gluteus Maximus *(see Plate 188)*. In the horse, however, the middle one is the largest, and for the same reason is also sometimes called the Maximus. As this is apt to lead to confusion, we prefer to adopt the names that indicate their relative positions.

The *Deep Gluteal (see Plate 185)* or Internal Gluteal muscle, although of considerable volume, is of little interest, being entirely concealed beneath the middle muscle. It extends from the shaft of the ilium above the hip joint to the inner surface of the convexity of the great trochanter. It is a powerful abductor of the thigh and helps to rotate it inwards.

The *Gluteus Medius (see Plate 186)* is one of the thickest and strongest muscles in the body and is primarily responsible for the convexity of the

horse's croup. It arises on the loins from the depression in the apon-
eurosis that covers the longissimus dorsi muscle, from the whole of the
upper surface of the ilium, and from the ilio-sacral and sacro-sciatic
ligaments, and is inserted by means of three tendons on the summit, the
crest, and the posterior border of the great trochanter of the femur.

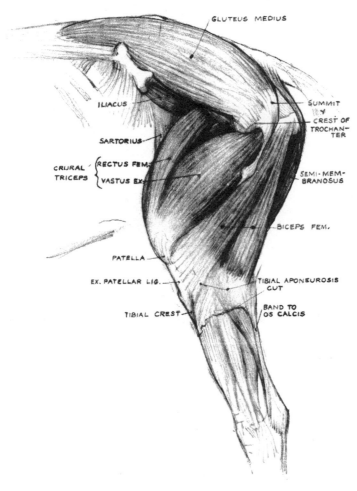

186. *HIND QUARTERS OF HORSE (Outside view)*

Acting from above, it extends and abducts the thigh, or if from below,
the femur being fixed, it assists in the action of rearing.

Gluteus superficialis (see Plates 184 & 187). The superficial gluteus of
the horse represents part of the gluteus maximus of man, the combined
upper portions of the long vastus, semitendinosus and semimembranosus
muscles representing the remainder. This muscle covers the posterior

part of the middle gluteus. It arises from the external angle of the haunch, and from the deep surface of the aponeurosis that covers this region. From these points of origin the fibres converge on a short tendon which, after uniting with the upper border of the deep layer of the fascia lata, is inserted on the small external (third) trochanter of the

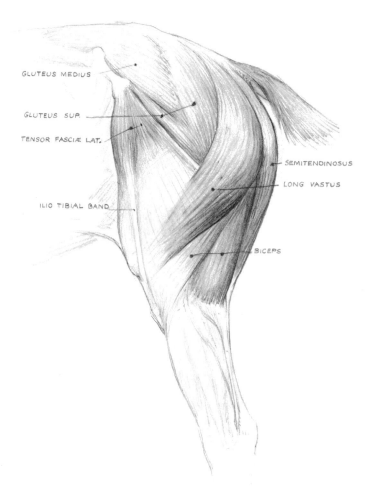

GLUTEUS MEDIUS

GLUTEUS SUP.

TENSOR FASCIÆ LAT.

SEMITENDINOSUS

LONG VASTUS

ILIO TIBIAL BAND

BICEPS

187. SUPERFICIAL MUSCLES OF THE HIND QUARTERS OF HORSE (Outside view)

femur *(see Plate 184)*. The anterior and visible portion of this muscle is fleshy and shaped like the letter V., whose branches are directed towards the external and internal angles of the ilium (angles of the haunch and croup). The posterior portion is covered by the long vastus, semitendinosus and semimembranosus muscles. This muscle is both an abductor and a flexor of the thigh.

Comparative. In the ox, &c. the gluteal muscles are much less developed than in the horse, which accounts for the relative concavity of the croup, the rounded form which is seen in " beef " animals being rather due to an accumulation of fat than to muscular development. In the ox, &c. the gluteus medius is, as a rule, thin and poorly developed,

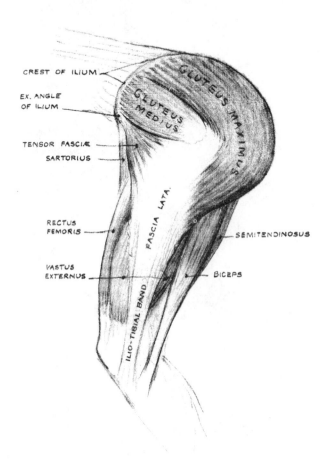

CREST OF ILIUM

EX. ANGLE OF ILIUM

TENSOR FASCIÆ

SARTORIUS

GLUTEUS MEDIUS

GLUTEUS MAXIMUS

RECTUS FEMORIS

FASCIA LATA.

SEMITENDINOSUS

VASTUS EXTERNUS

ILIO-TIBIAL BAND

BICEPS

188. *GLUTEAL & THIGH MUSCLES OF MAN*

and its origin on the loins is narrower and does not extend as far forward as on the horse; otherwise its attachments are much the same.

In Carnivora, the middle gluteus is thick and fleshy, and in a hound in good condition should be well developed and firm. It does not arise on the loins as in the Ungulates, but on the crest of the ilium *(see Plate 191)*.

Superficial Gluteus (Comparative). As was pointed out in the chapter

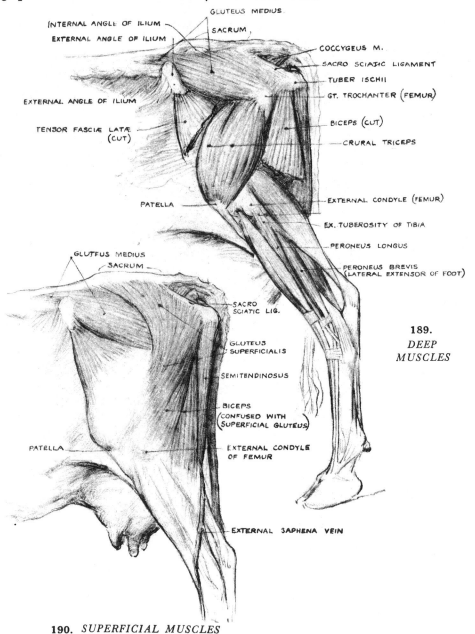

GLUTEUS MEDIUS.

INTERNAL ANGLE OF ILIUM

EXTERNAL ANGLE OF ILIUM

SACRUM

COCCYGEUS M.

SACRO SCIATIC LIGAMENT

TUBER ISCHII

GT. TROCHANTER (FEMUR)

EXTERNAL ANGLE OF ILIUM

TENSOR FASCIÆ LATÆ
(CUT)

BICEPS (CUT)

CRURAL TRICEPS

PATELLA

EXTERNAL CONDYLE (FEMUR)

EX. TUBEROSITY OF TIBIA

PERONEUS LONGUS

PERONEUS BREVIS
(LATERAL EXTENSOR OF FOOT)

189.
*DEEP
MUSCLES*

GLUTEUS MEDIUS
SACRUM

SACRO
SCIATIC LIG.

GLUTEUS
SUPERFICIALIS

SEMITENDINOSUS

BICEPS
(CONFUSED WITH
SUPERFICIAL GLUTEUS)

PATELLA

EXTERNAL CONDYLE
OF FEMUR

EXTERNAL SAPHENA VEIN

190. *SUPERFICIAL MUSCLES*

dealing with the bones of the hind limb, the small external or third trochanter of the femur on which, in the horse, this muscle is inserted, is absent in the cloven-footed Ungulates and Carnivora, and therefore in them this muscle finds different attachments.

In the ox *(see Plate 190)* it has no connection with the external angle

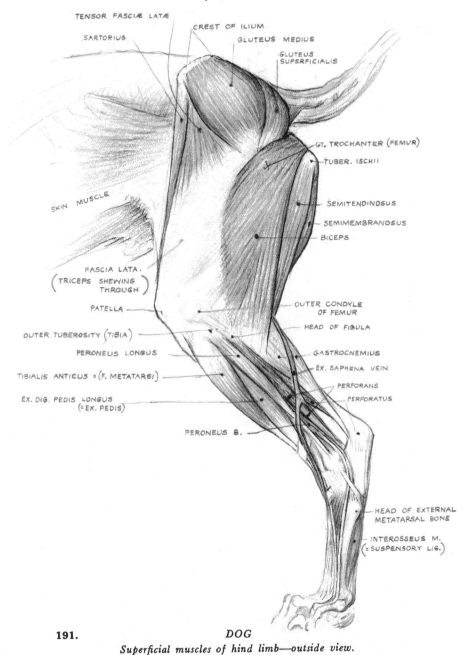

TENSOR FASCIÆ LATÆ

CREST OF ILIUM

SARTORIUS

GLUTEUS MEDIUS

GLUTEUS SUPERFICIALIS

GT. TROCHANTER (FEMUR)

TUBER. ISCHII

SKIN MUSCLE

SEMITENDINOSUS

SEMIMEMBRANOSUS

BICEPS

FASCIA LATA.
(TRICEPS SHEWING THROUGH)

PATELLA

OUTER CONDYLE OF FEMUR

OUTER TUBEROSITY (TIBIA)

HEAD OF FIBULA

PERONEUS LONGUS

GASTROCNEMIUS

TIBIALIS ANTICUS = (F. METATARSI)

EX. SAPHENA VEIN

EX. DIG. PEDIS LONGUS (=EX. PEDIS)

PERFORANS

PERFORATUS

PERONEUS B.

HEAD OF EXTERNAL METATARSAL BONE

INTEROSSEUS M. (=SUSPENSORY LIG.)

191. *DOG*

Superficial muscles of hind limb—outside view.

of the ilium, but arises from the surface of the gluteus medius, from the sacrum, the sacro-sciatic ligament and from the ischium, and gliding over the back of the great trochanter of the femur it blends with the anterior portion of the biceps muscle, the two uniting to form a single

muscular mass analogous to the long vastus of the horse, whose anterior border terminates on the fascia lata. It has no attachment on the femur.

In Carnivora, this muscle consists of two portions, an anterior arising

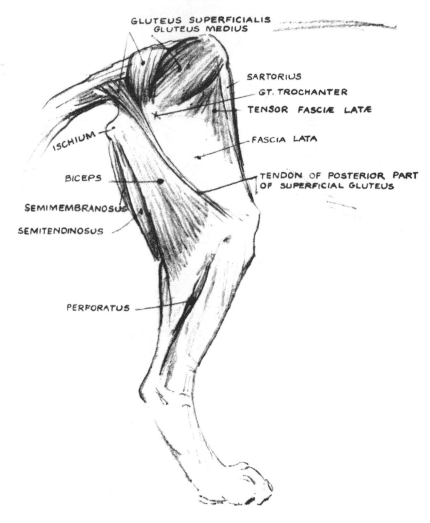

GLUTEUS SUPERFICIALIS
GLUTEUS MEDIUS

SARTORIUS

GT. TROCHANTER

TENSOR FASCIÆ LATÆ

FASCIA LATA

ISCHIUM

BICEPS

TENDON OF POSTERIOR PART
OF SUPERFICIAL GLUTEUS

SEMIMEMBRANOSUS

SEMITENDINOSUS

PERFORATUS

192. *HIND LIMB OF LION*

from the sacrum and the surface of the gluteus medius which is inserted on the great trochanter, and a posterior, confused with the Coccygeus, arising on the two first vertebræ of the tail and inserted on the outer border of the femur.

In the cat this portion is prolonged by a slender tendon, which passes over the outer surface of the thigh, and terminates on the patella.

Long Vastus (see Plate 187). This is a very large superficial muscle, which in its development is peculiar to solipeds. It is situated on the outside of the thigh and extends from the top of the croup to the stifle. By some authorities it is described as the posterior part of the superficial gluteus, by others as the anterior portion of the biceps cruris, but in the horse it has been so transformed that it is generally recognized as a distinct muscle with the above designation. It arises from the spinous processes of the sacrum, the sacro-sciatic ligament, the tuberosity of the ischium, and from the aponeurosis that envelops the gluteal and tail muscles, and is inserted first on the back of the third trochanter of the femur (deep), and by its inferior tendon on the outer part of the anterior face of the patella. It is an extensor of the thigh (i.e. draws it back) and an abductor of the whole limb, and to a certain extent also it assists the crural triceps to extend the stifle joint. The fleshy and visible part of this muscle may be described as crescent-shaped owing to the way in which it curves round the great trochanter of the femur, with its upper horn pointing in the direction of the angle of the croup, and the lower one to the stifle. On the croup it is confounded with the underlying parts of the superficial gluteus and is partly covered by the upper end of the semitendinosus muscle. It covers the great trochanter of the femur.

The posterior border is, as a rule, well defined, especially when the leg is flexed. The anterior border is less distinct as it is thinner and covered by the external layer of the fascia lata.

Biceps femoris (see Plates 186 & 187). This is a large triangular muscle situated on the outside of the quarters, immediately behind the long vastus, and extending from the angle of the buttock to the upper end of the leg. It consists of two well-marked fleshy heads, which arise in front of the ischial tuberosity *(see Plate 184)* and terminate on the aponeurosis that envelops the tibial region and is attached in front to the tibial crest. This part of the aponeurosis may be regarded as the terminal tendon of the anterior head with which it is continuous. The lower extremity of the anterior head is flattened and curves forward. The posterior, thicker and rounder, is more vertical and ends rather abruptly over the outer head of the gastrocnemius; from here a strong band of the fascia passes down the back of the leg, and is attached in front of the upper end of the os calcis. At its origin the biceps muscle is intimately connected with the long vastus and slightly overlapped by the upper extremity of the semitendinosus muscle.

The biceps is a very conspicuous muscle especially when the leg is in action. The posterior border is well marked, and with the semi-tendinosus muscle forms a deep groove dividing the external muscles from those which are inserted on the inside of the limb. This groove has been named the "line of poverty" as it is most noticeable on lean animals. When this muscle contracts it tightens the fascia and flexes the

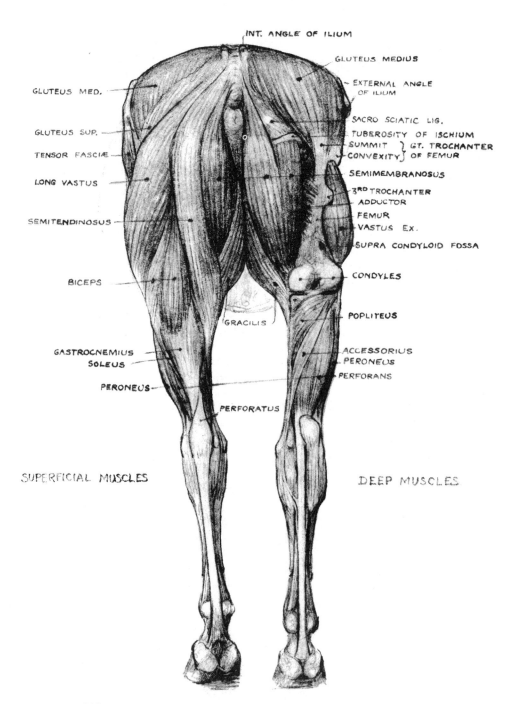

INT. ANGLE OF ILIUM

GLUTEUS MEDIUS

GLUTEUS MED.

EXTERNAL ANGLE
OF ILIUM

GLUTEUS SUP.

SACRO SCIATIC LIG.

TUBEROSITY OF ISCHIUM

TENSOR FASCIÆ

SUMMIT } GT. TROCHANTER
CONVEXITY } OF FEMUR

LONG VASTUS

SEMIMEMBRANOSUS

3RD TROCHANTER
ADDUCTOR

FEMUR

SEMITENDINOSUS

VASTUS EX.

SUPRA CONDYLOID FOSSA

BICEPS

CONDYLES

POPLITEUS

GRACILIS

GASTROCNEMIUS
SOLEUS

ACCESSORIUS
PERONEUS

PERFORANS

PERONEUS

PERFORATUS

SUPERFICIAL MUSCLES

DEEP MUSCLES

193.

leg. If the leg is firmly planted on the ground, acting in the reverse direction, it extends the hip joint and so helps to raise the forehand.

Comparative. In the ox *(see Plate 190)* this muscle is relatively thin and the dividing line between the two heads less defined than in the horse. The anterior head blends with the posterior part of the superficial gluteus muscle from which it is hardly distinguishable, and is inserted on the fascia lata. The posterior head, rather narrow, and flat, lies in a vertical direction and terminates on the tibial aponeurosis as in the horse.

In the dog, cat, &c. *(see Plate 191)* the biceps is large and fan shaped. It arises on the sacro-sciatic ligament and the tuberosity of the ischium and terminates on the fascia lata and the tibial aponeurosis.

In a greyhound in hard condition the junction of the muscle with the fascia is generally well marked and forms a sharp ridge on the outside of the thigh. It is quite distinct from the superficial gluteus.

Tensor fasciæ latæ. (Tensor vaginæ femoris) *(see Plates 184 & 187)*. This is a thick, triangular muscle situated in front of and below the superficial gluteus. It arises from the external angle of the ilium (angle of haunch) and terminates in a wide aponeurosis that spreads over the outside of the thigh (the fascia lata), and has fixed attachments on the patella and femur. When the muscle contracts it flexes the thigh and raises the entire limb.

The fascia lata also acts as a mechanical brace in the standing position. When one foot is planted on the ground and the other raised it steadies the pelvis and resists the action of the muscles of the opposite side, so that during the alternate movements of the limbs when a horse is trotting, the croup remains practically level. When, however, the animal is standing on one leg and resting the other, the pelvis is tilted over, but the displacement of weight is counteracted by the tension of the fascia of the supporting limb, and the muscles are relieved of a considerable amount of strain. In this attitude a strong band of the fascia that is attached to the external patellar ligament comes into view and, compressing the muscles over which it passes, forms a definite groove that may be traced upwards in a straight line to the angle of the haunch. This represents the ilio-tibial band in man *(see Plate 188)*.

The fascia lata forms a kind of apron which does more than anything else to disguise the true shape of the thigh, though a practised eye will always be able to recognize the underlying structure through it.

Semitendinosus. (Adductor Tibialis.) A long fleshy muscle pointed above and expanded below, situated on the back of the hind quarters and reaches from the top of the croup to the inside of the leg. It arises by two heads, one superficial from the two last spinous processes of the sacrum, the two first vertebræ of the tail and from the sacro-sciatic ligament, and the other, beneath it, from the inferior surface of the

tuberosity of the ischium. From this point they form a single muscle which continues vertically down the back of the thigh and turning inwards terminates in a wide tendinous expansion that blends with the fascia of the leg, and is continued forwards to be finally inserted on the inner edge of the crest of the tibia.

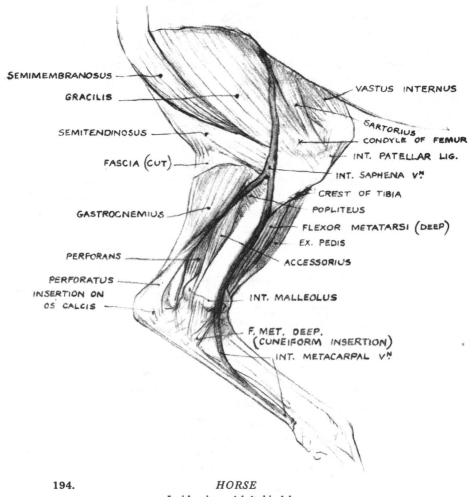

SEMIMEMBRANOSUS

GRACILIS

SEMITENDINOSUS

FASCIA (CUT)

GASTROCNEMIUS

PERFORANS

PERFORATUS
INSERTION ON
OS CALCIS

VASTUS INTERNUS

SARTORIUS
CONDYLE OF FEMUR
INT. PATELLAR LIG.
INT. SAPHENA V.
CREST OF TIBIA
POPLITEUS
FLEXOR METATARSI (DEEP)
EX. PEDIS
ACCESSORIUS
INT. MALLEOLUS
F. MET. DEEP.
(CUNEIFORM INSERTION)
INT. METACARPAL V.

194. *HORSE*
 Inside view of left hind leg.

This is a very conspicuous muscle and constitutes the greater part of the profile outline of the hind quarters. The upper portion corresponds to the posterior part of the gluteus maximus of man *(see Plate 188);* it is not represented in Ruminants or Carnivora, only that portion which arises on the ischium being present. Acting from above, it is a flexor of the leg and a tensor of the tibial aponeurosis; from below, it elevates the fore-part of the pelvis and so assists in rearing, &c.

Semimembranosus. (See Plates 193 & 194.) This is a very large thick muscle situated on the back and inside of the thigh. It arises from the fascia surrounding the root of the tail and from the tuberosity and the inferior surface of the ischium (i.e. under the ischiatic arch), and is inserted by a short tendon joined to that of the large adductor muscle on

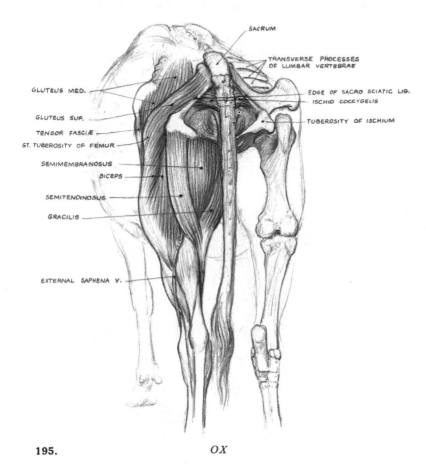

SACRUM

TRANSVERSE PROCESSES
OF LUMBAR VERTEBRAE

GLUTEUS MED.

EDGE OF SACRO SCIATIC LIG.

ISCHIO COCCYGEUS

GLUTEUS SUP.

TENSOR FASCIÆ

TUBEROSITY OF ISCHIUM

GT. TUBEROSITY OF FEMUR

SEMIMEMBRANOSUS

BICEPS

SEMITENDINOSUS

GRACILIS

EXTERNAL SAPHENA V.

195. *OX*

the inner condyle of the femur. It is an adductor of the thigh and, like the semitendinosus, when acting from below assists in such movements as rearing.

This is the muscle that is mainly responsible for the shape of the inner half of the quarters as seen from behind. With the adductors it forms the basis of the broad fleshy mass that on the inside of the thigh is covered by the gracilis and tapers towards the stifle.

In both Ruminants and Carnivora, the semitendinosus and semimembranosus muscles have their origins on the ischium. In neither case do they extend above it, or form any part of the croup.

Great Adductor. (See Plates 185 & 193.) This is a large fleshy muscle situated on the inside of the thigh in front of the semi-membranosus, and with the small Adductor occupies the greater part of the interval between that muscle and the inner border of the femur. It is entirely covered by the gracilis muscle, and it is only because of its volume and its close association with the semimembranosus that it claims

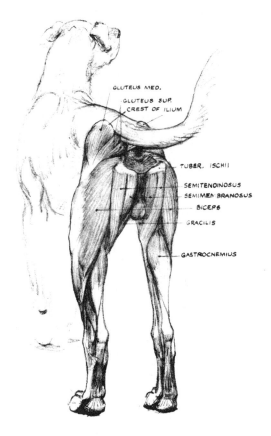

GLUTEUS MED.

GLUTEUS SUP.
CREST OF ILIUM

TUBER. ISCHII

SEMITENDINOSUS
SEMIMEMBRANOSUS
BICEPS
GRACILIS

GASTROCNEMIUS

196. *DOG*

our attention. It arises from the under surface of the ischium and is inserted (1) on the middle of the back of the femur, and (2) on the inner condyle, with the semimembranosus.

Gracilis. (See Plates 193 & 194.) This is a wide thin muscle covering the greater part of the flat of the thigh. It arises from the ischio-pubic symphysis by a tendon common to it and its fellow of the opposite side and is inserted with the sartorius on the internal patellar ligament. It is entirely superficial. It is an adductor of the limb.

Sartorius. (Long Adductor of the Leg.) This is a long, narrow muscle lying in front of the preceding. It arises within the abdominal cavity from the fascia that covers the sublumbar muscles, and is inserted with the gracilis on the internal patellar ligament. A small triangular space, through which the saphena vessels pass, separates the two muscles above. It is an adductor and a flexor of the thigh.

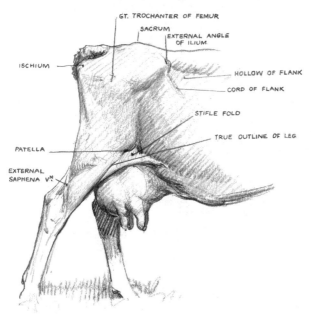

GT. TROCHANTER OF FEMUR
SACRUM
EXTERNAL ANGLE OF ILIUM
ISCHIUM
HOLLOW OF FLANK
CORD OF FLANK
STIFLE FOLD
TRUE OUTLINE OF LEG
PATELLA
EXTERNAL SAPHENA Vᴺ

197.

In the dog, cat, &c. the sartorius arises from the anterior iliac spine and the inferior border of the ilium, and is inserted on the patella and the inner surface of the tibia, and its anterior border is visible in front of the tensor fasciæ latæ *(see Plates 191 & 192)*.

The only veins of the hind limb that need be mentioned are the *Internal* and *External Saphena* and the *Internal Metatarsal Vein (see Plate 194)*.

From the foot upwards as far as the upper third of the metatarsus, the veins are disposed in exactly the same way as in the fore limb and need no further description.

At this point, however, the Internal Metatarsal vein comes prominently into view, crosses to the inner side of the front of the hock and, after receiving a contribution from the middle metatarsal vein, which has penetrated the tarsus, gives rise to the anterior branch of the large superficial vein of the leg and thigh (Internal Saphena Vein).

Meanwhile, the external metatarsal vein continues its course in front

of the outer edge of the perforans tendon, and with it passes through the tarsal sheath to reach the inside of the hollow of the hock, where it forms the root of the posterior branch of the Internal Saphena vein.

The two branches of the saphena vein, following the direction respectively of the anterior and internal borders of the tibia, unite over the inner surface of the upper end of that bone and form a single large vessel that, after passing over the flat of the thigh, eventually disappears in the region of the groin, either by penetrating the upper end of the gracilis muscle, or between it and the Sartorius.

The anterior branch, which is much the larger and more conspicuous of the two, ascends in front of the internal malleolus and along the inner edge of the flexor metatarsi muscle until it reaches the lower end of the tibial crest, at which point it parts company with the muscle to meet the posterior branch as stated above.

The posterior branch, at first hidden between the perforans and the gastrocnemius muscles, becomes visible some four or five inches before joining its fellow, and forms with it a fork that is rather a noticeable feature.

The external saphena vein arises on the outside of the hock and follows a somewhat similar course on the outer surface of the limb and, after passing over the external head of the gastrocnemius muscle, disappears between the biceps and the semitendinosus and enters the popliteal vein. In the horse it is small and hardly recognizable on the surface. In the ox and dog, however, it is more voluminous than the internal, and is a characteristic feature in those animals *(see Plates 190 & 191)*.

CHAPTER X

No two horses are exactly alike. Each one differs from its stable companion in some way or another, although at first sight they may look very much the same.

If, however, we have a fixed standard to go by, the distinguishing features may be discovered by their resemblance to that standard or their deviation from it.

The formula given herewith does not pretend to be scientifically exact, but it will be found to give a fair general idea of the relative proportions of an average horse when standing at attention, and will at any rate show the student *what* to measure and where to expect equalities in the profile view, and although, of course, he must expect different results, the same method may be applied, and corresponding parts compared when gauging the proportions of other animals *(see Plate 198)*.

When sizing up our model one of the first things we have to decide is the correct inclination of the shoulder-blade.

The proper way to judge the slope of a horse's shoulder is from the side when the animal is standing at attention with the forelegs upright and parallel with each other. In an average horse, such as we imagine our " standard " to represent, a perpendicular line *(see A.B. Plate 198)* dropped from the apex of the withers would pass through the dorsal angle of the scapula, the elbow, and down the back of the leg, and the spine of the shoulder-blade would then be at an angle of approximately thirty degrees with it, or if tested with a watch (which is a convenient way of estimating it) at five minutes past the hour.

In a horse with an oblique shoulder the leg may be slightly in front of the vertical line, with an upright shoulder, a little behind it, but with the expectation of finding the line cutting the points indicated it should be an easy matter for the student to find out the variation, and so determine one of the fundamental characteristics of his model *(see Plate 199)*.

Similarly with the hind limb: if a perpendicular line be dropped from the tuberosity of the ischium, it would, according to our formula, when the horse is standing evenly on both legs, coincide with the back tendons, and if standing with one leg forward and the other back *(see Plate 200)*, a straight line, although no longer vertical, could still be drawn from the tuberosity of the ischium to the point of the hock that if

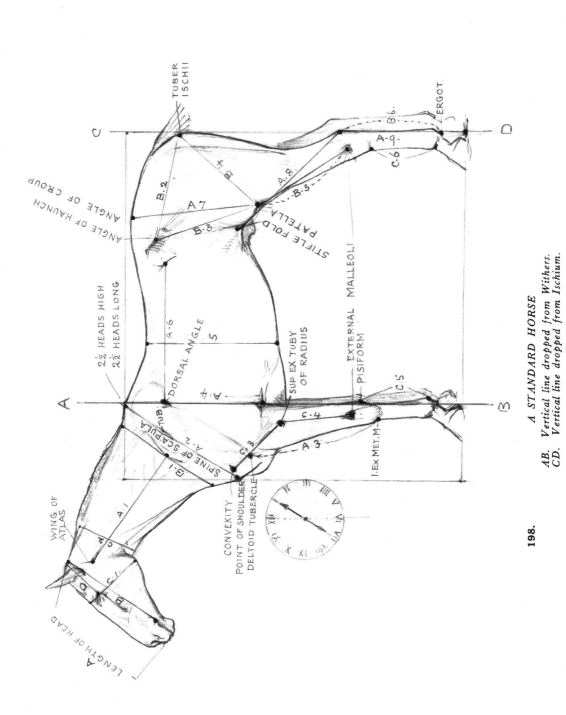

A STANDARD HORSE

AB. Vertical line dropped from Withers.
CD. Vertical line dropped from Ischium.

198.

A STANDARD OF MEASUREMENTS AND A FORMULA FOR ASCERTAINING THE PROPORTIONS AND INDIVIDUAL CHARACTERISTICS OF DIFFERENT HORSES.

A. Represents the length of the head; used as a unit of measurement, it equals approximately:—

A.1. The length of the neck from the wing of the atlas to the front of the shoulder muscles.

A.2. The length of the shoulder from the apex of the withers to the point of the shoulder.

A.3. The distance from the deltoid tubercle of the humerus to the insertion of the extensor metacarpi magnus (below knee).

A.4. From the apex of the withers to the elbow.

A.5. Depth of body at girth.

A.6. Length of body between the dorsal angle of the scapula and the last rib.

A.7. From the angle of the croup to the patella.

A.8. From the stifle fold to the point of the hock.

A.9. From the point of the hock to the ground.

B. A short head, as measured from the top of the head to the corner of the mouth, equals approximately:—

B.1. Width of neck in front of shoulders, i.e. collar place.

B.2. Length of croup, from external angle of ilium (angle of haunch) to tuberosity of ischium.

B.3. Angle of haunch to patella ⎫ when
B.4. Tuberosity of ischium to patella ⎭ standing

B.5. Patella to external malleolus of tibia.

B.6. Point of hock to bottom of fetlock at ergot.

C. Half the length of the head equals approximately:—

C.1. The width of the head at the level of the eye.

C.2. Width of upper end of neck at throat.

C.3. From convexity of external tuberosity of the humerus to supero-external tuberosity of radius.

C.4. Distance between supero-external tuberosity of the radius and external malleolus of same bone.

C.5. Distance between pisiform bone and fetlock.

C.6. Length of cannon bone of hind leg.

D. Distance from top of skull to outer corner of eye equals one-third the length of the head.

D.1. Length of ear from root to tip.

D.2. Width of cheek.

It also equals approximately the greatest width of head as seen from the front, just above the eyes.

produced would pass down the back tendons and so give the approximate slope of the lower part of the leg.

In a horse, however, whose normal attitude differs from this rule, and in which the vertical line passes in front of *(see Plate 201A)* or behind *(see Plate 201C)* the hock, or whose cannon bone is not vertical when

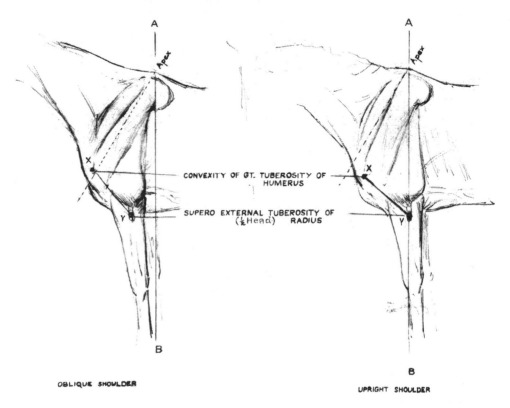

CONVEXITY OF GT. TUBEROSITY OF HUMERUS

SUPERO EXTERNAL TUBEROSITY OF (½ Head) RADIUS

OBLIQUE SHOULDER

UPRIGHT SHOULDER

199. *VARIATIONS FROM STANDARD*

The dotted line indicates the direction of the spine of the scapula of the standard horse. X—Y The length of the arm must always be maintained whatever the attitude.

standing evenly, a corresponding allowance must be made when the leg is advanced or retired. Although not infallible, this will be found a useful guide when drawing a horse standing or walking, and should prevent the student making the common mistake of so placing the legs as to make them appear as if they worked on a pivot that passed through both stifles instead of moving freely and independently from the hip joints. The leg can neither move backward nor forward unless the thigh moves.

When drawing the back view of a horse the student would do well to compare the distance from the hock to the ground with the height

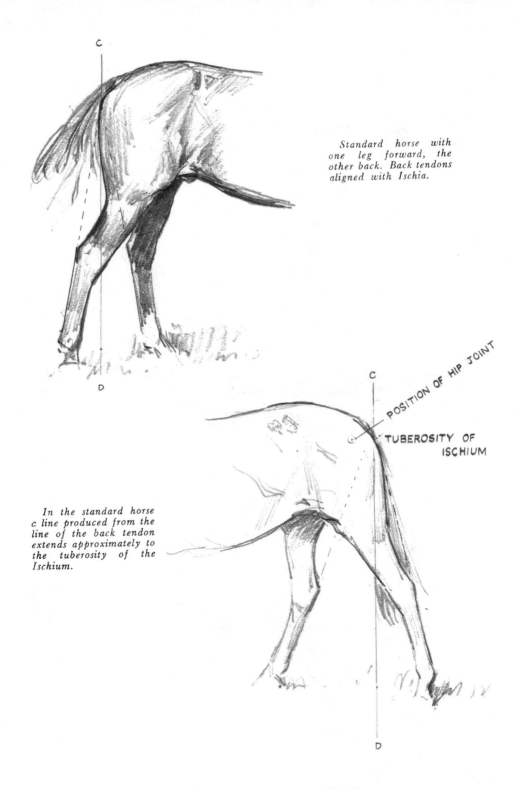

C

Standard horse with
one leg forward, the
other back. Back tendons
aligned with Ischia.

D

POSITION OF HIP JOINT

C

TUBEROSITY OF
ISCHIUM

In the standard horse
c line produced from the
line of the back tendon
extends approximately to
the tuberosity of the
Ischium.

D

ALIGNMENT OF BACK TENDON

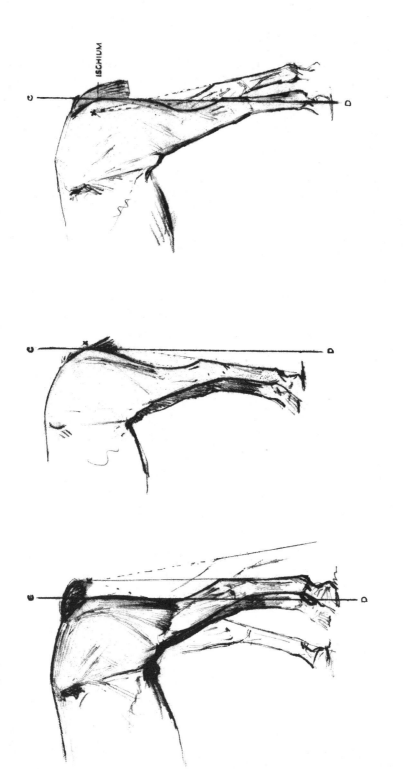

ISCHIUM

Not conforming ⎰ **201a.** *Back tendons pointing to X, i.e. behind the Ischium.*
to standard. ⎱ **201b.** *Back tendons aligned with a point behind the Ischium.*
 201c. *Back tendons pointing to X in front of Ischium.*

at the croup and with the width across the haunches and the lower part of the thighs. He should also drop an imaginary vertical line from the root of the tail and see what relation it bears to the positions of the hocks and feet. From the exact back view he may expect to find that the length from hocks to ground approximately equals the width of the haunches. It is also approximately equal to the width across the lower part of the thighs, and also to the vertical measurement from the top of the croup to the parting of the thighs in the middle line.

202. *A COMMON FAULT IN DRAWING*
The thighs fixed; the legs moving as though turning on a pivot at the stifle.

No formula can be given for front view measurements because of the perspective distortion.

The only reliable comparisons that a painter can make are of things that are equidistant from his eye, and although we may tell him that the width across the chest equals approximately two-thirds the length of the head *as measured on the animal itself,* he must realize that the foreshortening causes the head to appear proportionately very much larger. He can, however, compare the length of the forearm with the width of the chest, or the distance from the hock to the ground with that

between the stifle and the top of the quarters; but on no account should he use the head or any part of it as a basis of comparison with more distant parts unless he places himself at such a distance from his model

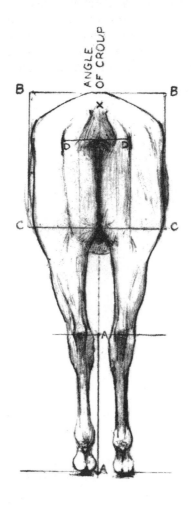

203. *POINTS WORTH COMPARING WHEN DRAWING THE BACK VIEW*

Compare the distance from hock to ground AA with the width at haunches BB. Compare the distance across the lower part of the thighs CC with the depth from the angle of the croup to the parting of the thighs CC. The width across the Ischia DD will be about half the above.

as will nullify the inequalities, and this will generally be much further away than he would choose to stand when at work. It is better to stand a long way off and note the horizontal and vertical relationships of the various parts instead of trying to measure them.

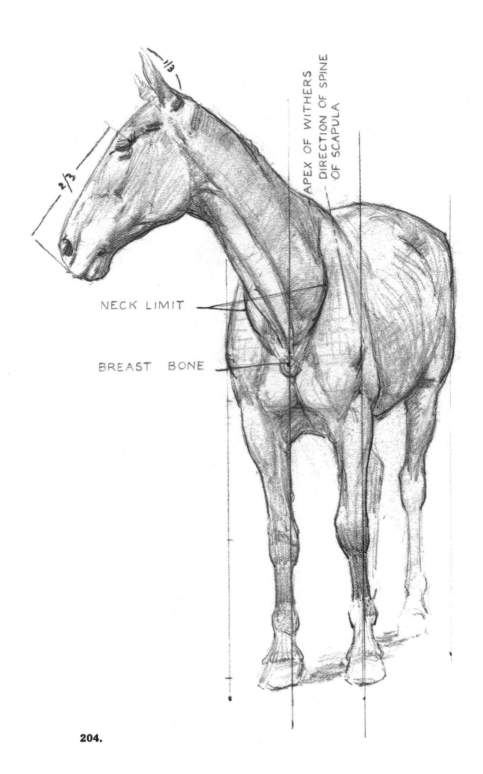

1/3

2/3

APEX OF WITHERS

DIRECTION OF SPINE
OF SCAPULA

NECK LIMIT

BREAST BONE

204.

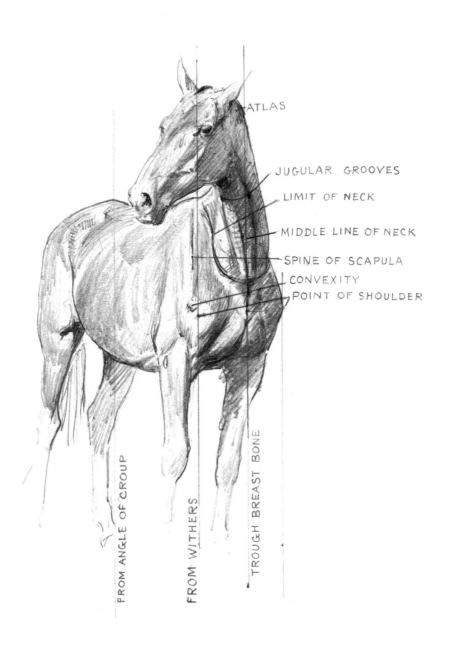

ATLAS

JUGULAR GROOVES

LIMIT OF NECK

MIDDLE LINE OF NECK

SPINE OF SCAPULA

CONVEXITY

POINT OF SHOULDER

FROM ANGLE OF CROUP

FROM WITHERS

TROUGH BREAST BONE

205. *DIAGRAM TO SHOW COLLAR PLACE*
Note direction of Scapular spine in relation to vertical line.

It is always a great help to take vertical lines from some fixed points of the trunk and see what they cut through. Such a line dropped from the point of the breast-bone will serve as a guide in determining the placing of the legs and feet and the balance of the body, and, although sometimes it may be hidden by the head and neck, the student should always try to imagine where the apex of the withers would come in reference to that vertical line.

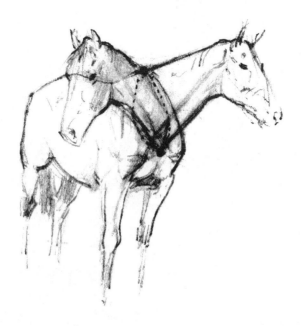

206. *COLLAR POSITION WITH NECK TURNED*

Most beginners have some difficulty in fitting the neck on to the body when representing a horse in the three-quarter front view. They are inclined to think too much of the slope of the shoulder as they know it in profile, and to forget that they are looking at it from in front and not from the side. If, however, the student can visualize the positions of the top of the withers and the breast-bone, he will have two fixed points of attachment for the neck, one above and the other below, and if he can then imagine a collar resting against the front of the shoulders *(see Plate 205)* (and even indicate it roughly) and takes care that, wherever the head may be, the neck passes through the collar, he will find that he can vary the position of the head and neck if he wishes to without jeopardising the rest of his drawing.

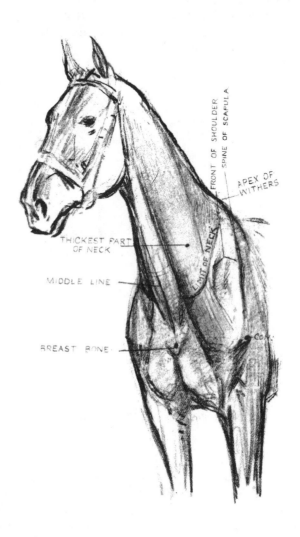

FRONT OF SHOULDER

SPINE OF SCAPULA

APEX OF WITHERS

THICKEST PART OF NECK

LIMIT OF NECK

MIDDLE LINE

BREAST BONE

COR.

207. *THE LIMIT OF THE NECK*

In drawing the foreshortened view, the student must always try to imagine what the section of each succeeding part would be like, how a wider part hides a narrower that is beyond it, &c. He should try to carry in his mind what is the section of the neck at its base, what is the section of the shoulders, of the barrel and of the quarters, and should learn the

208.　*TO SHOW HOW HARNESS MAY HELP TO EXPLAIN FORM*

shapes of his animals from above, in front and behind, as well as from the side view, and there is no better way of learning these things than by modelling them.

Drawing horses in harness is a very good way of learning the sections, and if the student examines and draws each piece in turn, bridle, collar, pad, breeching, &c.. &c. he will more readily appreciate the shapes of the parts over which they fit. He should make studies in sunlight and note how the shadows of the various straps help to emphasize the form.

INDEX

Abdomen, Internal muscle of the, 166
Abdominal tunic, 169
— vein, subcutaneous, 256
Abductor, 220, 230
Accessorius, Flexor, 294
Accessory carpal bone, 183
Acetabulum, 257
Acromion process, 170, 174
Action, 54, 57—61
Adductor, Great, muscle, 312
Alveolo labialis, 150
Anatomy of the Domesticated Animals,
 180
Anconeus, 225
Angle of the haunch, 169
Angular vein of the eye, 157, 158
Annular cartilage, 139
— ligament, 219
Antea spinatus, 230
Anterior auricular, 155
— common ligament, 185, 219
— extensor of the phalanges, 208
— ligaments, 184
— serratus muscle, 168
— straight muscle, Great, 161
Antibrachial aponeurosis, 223, 227, 228
— fascia, 219
Aponeurosis muscle, 144, 239, 307
Arm, 172
— bone, 206
— muscles, 224, 231
Articular head of the humerus, 225
— rim of the radius, 186
Asternal ribs, 100
Astragalo-metatarsal ligament, 280
Astragalus, 268, 278, 282, 298
Atlas, 97, 159
Atloido-occipitalis muscle, 160
Auditory process, 139
Axillary border, 170
Axis, 98, 99
Axoido-occipitalis muscle, 160

Balance in composition, 80
Basilar process, 120, 163, 192
Basilic vein, 233
" Bellows " muscles, 166

Biceps, 170, 227, 229, 233
— brachii, 227
— cruris muscle, 307
— femoris muscle, 305, 307, 309
Bicipital aponeurosis, 231
— grooves, 227
— prominence, 180
— tuberosity, 225
Bog spavin, 282
Bone spavin, 279
Brachialis anticus muscle, 219, 221, 225
Buccalis, 150
Buccinator, 150, 151, 155
— deep, 145
— superficial, 149

Calcaneo-metatarsal ligament, 280
Calcis, Os, 278, 294
" Calf kneed," 182
Cannon bone, 186, 189, 202, 213, 220,
 282, 288
Capsular ligament, 186, 219, 228, 282
Card, Measuring with a, 19
Cariniform cartilage, 100
Carpus, 170, 183, 186, 196
Carpal, inter-, joint, 275
— ligaments, 184, 185, 186
— sheath, 206
Carpi ulnaris, Extensor, 217
Caruncula lachrymalis, 145, 153
Cephalic vein, 158, 233
Cervical angle, 170, 175
— border, 170
— ligament, 115, 167
— panniculus muscle, 252, 254
— vertebræ, 165, 167
Cervico-auricularis, 149, 156
Charcoal, 23, 25
Chauveau, 180
" Check ligament," 184, 206, 294
Chest, 169
Coccygeal vertebræ, 166
Coccygeus, 306
Coffin bone, 283, 285
— joint, 190, 192, 208
Cole, Rex Vicat., 26
Colour, 54, 85, 87, 89, 90

Comma cartilages, 152
Common mass, 165
Complexus muscle, 162, 167
Composition, 67—86
Conception of a picture, The, 62—66
Concha, 155, 157
Conchal cartilage, 138, 139
Condyles, 120, 124, 133, 177, 261, 265
Constable, 78
Convexity, 177
Copying, 25, 38
Coraco-brachialis, 229
— -humeralis, 229
— -radialis, 227
Coracoid process, 170, 227, 229
Coronæ, 190
Coronary band, 194
Coronoid process, 124, 149
Corrugator supercilii, 145, 153
Costal border, 170
— cartilages, 100
Cotyloid cavity, 113, 257
Cranium, Bones of the, 118, 120, 125, 130
Croup, 96, 108
Crural arch, 167, 169
— triceps muscle, 300
Crust, 194
Cuboid, 278
Cuneiform bones, 196, 278, 279, 280, 282, 297
Cut-out, The use of the, 83, 84
Cuyp, 78

da Vinci, Leonardo, 18, 39
Deltoid muscle, 175, 229, 230
— tubercle, 177, 225
Depressor labii inferioris, 152
— labii sup. inf., 145
Derby of 1821, The, by Gericault, 58, 59
Dew claw, 196, 221, 284
Digits, 190, 198, 199, 200, 201, 202
— Common extensor of the, 212
— Extensor of the two inner, 212
Digital veins, 232
Dilatator naris lateralis, 145, 152
Dorsal angle, 170, 174
— tuberous, 173
— vertebræ, 99
Drawing, 17, 19, 21, 23, 25, 31, 35, 40, 43, 46, 49

Ears, 120, 138—143, 149
Ensiform cartilage, 100, 101
Epicondyle of the humerus, Inner, 208
Ergot, 201
Evolution of animal forms, 52, 53
Exercises for students, 18, 19
Extensor carpi ulnaris, 217
— communis digitorum, 208
— of the digits, Common, 212
— longus digitorum pedis, 285
— metacarpi magnus, 219, 227
— metacarpi obliquus, 219
— of the metacarpus, 285
— pedis tendon, 192, 203, 208
— suffraginis, 212
— tendons, 182
External oblique muscle, 169
— orbital process, 131
— tuberosity, 177, 179
Eye, The training of, 17, 18
Eyelashes, 153
Eyelids, 145, 153

Face, Bones of, 121
Facial veins, 157, 158
False nostril, 122, 152, 157
— ribs, 100, 169
Fascia, 144
Femur, 257, 259, 261, 265, 298
— External condyle of, 285
Fetlock joint, 189, 197
Fibula, 275, 285
Flank, 166
— flat, Copying from the, 25
Flexor carpi radialis, 217, 219
— carpi ulnaris, 217
— of the forearm, Long, 227
— of the head, Long, 161
— metacarpi externus, 217
— metacarpi internus, 217, 219
— metacarpi medius, 217
— metatarsi muscle, 279
— muscles of arm, 224
— pedis perforans, 206
— pedis perforatus, 206
Flexors of the metacarpus, 208
Foot, 193, 207
— Lateral cartilages of the, 192
— muscles, 206
— Muscles acting on, 287
Forearm, 179, 180, 182
— Internal subcutaneous vein of the, 233

Forearm, Large extensor, 228
— Long extensor of the, 228
— Muscles acting between shoulder-blade and, 227
— Short extensor of the, 225
— Short flexor of the, 225
Forefoot, 191, 195, 197, 198
Foreleg, 181, 187, 190, 207, 209, 210, 211, 213, 216, 220
— Bones of, 188
— Muscles and veins of, 226
— Origins and Insertions of, 222
— Superficial muscles of, 214, 218
Fore limb, 170, 215
— Bones of, 171, 172, 173
— Muscles of the, 206—233
— Veins of the, 232
Forepaw, 200, 201
Freedom, 23, 25
Frog, Sensitive, 192, 194, 195, 196
Frontal bone, 120, 122, 125, 126, 128, 130, 154
— orbital process, 130
— portion, 149
— ridge, 125, 156

Gallop, The, 58
Galloping horse, 203
Gastrocnemius, 263, 294—298
— internus, 294
Gemelli of tibia, 298
Gericault's " The Derby of 1821," 58, 59
Glands, 124
Glazing, 85
Glenoid cavity, 120, 177
Glosso-facial vein, 155, 158
Gluteus muscle, 108, 165
— Deep, 300
— medius, 300, 303, 305, 306
— superficial muscle, 301, 303, 304, 307
Gracilis muscle, 312

Hand, Bones of, 186
Harness, assistance in showing form, 325, 327
Haunch bone, 108, 113
Head, Muscles of the, 144—158
Head of cow, 127
— dog, 148, 155
— foxhound, 148, 156

Head of greyhound, 157
— horse, 135, 146, 149
— man, 148
— ox, 125
Heels, 194
Hind leg, 285, 289, 290, 292, 293, 295, 297
Hock, 280, 282
— joint, 298
— Ligaments of, 280
Hoof, 193
Horizontal ramus, 124
Horns, 128
Horny frog, 195
Humeral angle, 170
— head, 208
Humeralis obliquus, 225
Humero-olecranius externus, 225
— internus, 225
— minor, 225
Humero-radialis, 225
Humerus, 170, 175, 176, 177, 178, 224, 227

Iliacus muscle, 263, 300
Ilio-sacral ligament, Superior, 115, 117
Ilium, 113, 165, 166, 309
Imagination, 64
Incisors, 123, 124
Inclination of back tendons, 315, 319
— shoulder-blade, 315
Inferior carpal stay, 184
Infraspinatus muscle, 170, 229, 230, 232
Infraspinous fossæ, 170, 174
Interarticular meniscii, 270
Inter-carpal articulation, 183
Intercondyloid fossa, 261
Intercostal muscles, 166
Interdental space, 124, 151
Intermaxillary space, 124
Internal orbital process, 130
— tuberosity, 177, 180
Interosseus ligaments, 184
— muscle, 202, 205
Intertransversales colli, 159
Intestines, 169
Ischio-coccygeal muscle, 165, 166
Ischium, 108

Jaw, Angle of the, 133
Jaw bone, 133, 158
— Lower, 118, 124, 152, 153
— Upper, 118, 121

Jugular vein, 155, 158

Knee bones, 184
— Lateral ligaments of the, 186
— Muscles which straighten the, 219
— of horse, 182, 183, 184

Labialis (see orbicularis oris)
Lachrymal bone, 120, 122, 123, 125, 126, 132
— fossa, 122, 126
— tubercle, 153
Lateral cartilage, 192
— ligaments, Internal and External, 225, 280, 282
Latissimus dorsi muscle, 165, 234, 236
Leg, 296
— Hind, 286, 289, 290, 292, 293, 295, 297
Levator anguli scapulæ muscle, 234
— labii superior alæque nasi, 149, 152, 154
— labii superioris proprius, 145, 152
Life, Drawing from, 41—49
Ligaments, 115
— Muscles of the hind, 285
— of hock, 280
Line direction of, 20, 21
— drawing, 37, 38
— good, 37
— " of poverty," 307
Lips, 134, 135, 136, 137
Loins, 96, 106
Longissimus dorsi, 159, 163, 165, 167
Longus colli, 159
Long vastus muscle, 145, 307
Lower maxilla, 133
Lumbar transverse processes, 167
— vertebræ, 106, 165

Magnum, Os, 197
Mahl stick, 24
Malar bone, 120, 121, 122, 125, 126, 131, 152
— orbital process, 131
Malleolus, 180
— External, 186, 213, 270, 291
— Internal, 182, 233, 268, 270, 294
— of the tibia, External, 285

Mandible, 118, 124
Masseter muscle, 127, 149, 151, 153, 154, 158
Masseteric ridge, 121, 123, 126, 131, 153, 154
— tubercle, 123, 127, 158
Mastoido-humeralis, 99, 145, 158, 163, 234, 246, 248, 249
Mastoid process, 120, 163
Maxilla, Lower, 124, 133, 149
Maxillary bones, 122
— fissure, 124, 158
Measuring, 19
Membrane, 144
Memory drawing, 17, 19, 54
Mesial ridge, 227
Metacarpal bones, 186, 219, 220
— veins, 232
Metacarpi magnus, Extensor, 227
Metacarpo-phalangeal joints, 197
Metacarpus, 170, 183, 186, 189, 197, 208
— Anterior extensor of the, 219
— Extensor of the, 233
Metatarsal bones, 280, 282
— vein, Internal and External, 313
Metatarsi, Flexor, 279, 285, 291
Metatarsus, 296, 298
Modelling, 32
Models, animal, The management of, 41, 45, 49
Molaris, 150
Molar teeth, 123, 124, 125, 132
Movement, 54, 57—61
Muffle of the ox, 137
Muscles of the head, 144—158
Musculo-spiral groove, 225
Muybridge Animals in Motion, 58

Nasal bone, 120, 122, 123, 127, 154
— cavity, 134
— peak, 122, 152
Navicular bone, 192, 206, 282
Neck, 96, 97, 99, 101, 159
Nerves, 149
Nictitans membrane, 145, 153
Nipper teeth, 124
Nose, 134, 135
Nostril, 134, 135
— False, 122, 152, 157
— Framework of, 132
Note books, 36

Oblique muscle, Large, 160, 169
— Internal, 167
— Small, 160, 166
Occipital bone, 120, 125
— crests, 120, 125
— tuberosity, 120, 125
Olecranon, 228
— fossa, 177, 227
— process, 177, 183, 208
Omo-brachialis, 229
Orbicularis oris, 137, 145, 151, 152
— palpebrarum, 145, 153
Orbicular muscle, 122, 126, 150, 152, 154
Orbit, 121, 122, 127
Orbital arch, 121, 125, 126, 130
— ligaments, 131
— portion, 149
— process, External, 131
— process, Internal, 130

Pads, 201
Painting, 87, 89, 90, 92
Panniculus carnosus, 252, 254, 256
Parietal bones, 120, 125, 130
— ridge, 156
Parotid gland, 124, 149, 154, 155, 157, 158, 163
Parotido-auricularis, 149, 157
Pastern bone, 190
— joint, 190, 208
Patella, 271
Patellar ligaments, 271, 272
— External, 309
Pectoral muscles, 240, 243
Pedis muscle, Extensor, 190, 213, 285, 288, 298
— Extensor longus digitorum, 285
Pedis perforans, Flexor, 294
Pelvis, 108, 113, 165, 169
Pens, for cattle, sheep, &c., 47
Perforans muscle, 208, 209, 285
Perforatus muscle, 205, 208, 294
— flexor, 294
— tendon, 206
Periople, 194
Perioplic ring, 194
Peroneus muscle, 270, 285
— brevis, 285, 288, 291
— longus, 288, 291
Perspective, 26—32, 83
Perspective, by Rex Vicat Cole, 26

Phalangeal pads, 195, 201
Phalanges, 170, 197, 282
— Anterior extensor of the, 285
— Deep flexor of, 294
— Lateral extensor of the, 285
— Oblique flexor of the, 294
— Superficial flexor of the, 294
Phases of action, 58
Photographs, Use of, 57, 61
Pisanello, 39
Pisiform, 183, 187, 196
— pad, 201
Planes, 32
Plantar pad, 201
Plantaris, 294
Plate vein, 158, 233
Platysma myoides muscle, 253
Point of the shoulder, 177
Popliteus muscle, 268
Postea spinatus, 230
Posterior common ligament, 184, 186
— serratus muscle, 168
Premaxillary bone, 120, 123, 127, 133, 134
Prick-ears, 140, 141
Prolonging cartilage, 174
Prominens, 99
Pronator radii teres, 221
— Square, 221
Psoas, Great, muscle, 263
— Iliac, 300
Pubis, 108, 167, 169
Pulley of the astragalus, 285, 298
Pyramidal process, 192

Quarters, 194, 288

Radial head, 208
— muscles, 219
— vein, Anterior, 233
Radio-carpal articulation, 183
— joint, 275
Radius, 170, 177, 179, 183, 186, 219
— Extremity of the, 188
— Lower tuberosity of, 213
Raphael, 39
Rectus abdominis muscle, 166, 167
— femoris muscle, 300
Retractor costæ muscle, 167
Rhomboid muscle, 235
Ribs, 99, 100, 165

Risorius muscle, 253
Rocking-horse motion, 58
Rudimentary structures, &c., 52
Rythm, 76

Sacro-coccygeus muscle, 165
Sacro-sciatic ligament, 115, 116, 166, 309
Sacrum, 108, 113, 165, 306
— Spinous process of, 307
Saphena, Internal and external veins, 313
Sartorius muscle, 313
Scalenus, 163
Scale, Relative, 82, 84
Scaphoid, 196, 278, 280, 282
Scapho-lunar, 196
Scapula, 170, 173, 174, 176, 224
Scapular aponeurosis, 230, 232
— cartilage, 230
Scapulo-humeral angle, 230
— -humeral articulation, 224, 228, 229
— -humeralis magnus, 230
— -humeralis, Middle, 229
— -humeralis minor, 229
— -olecranius magnum, 228
— -radialis, 227
— -ulnaris muscle, 228, 238
Sculpture, 29
Scutiform cartilage, 139, 154, 155
Semi-lunar, 196
— cartilage, 270
— crest, 192, 206
Semimembranosus muscle, 263, 311
Semispinales colli, 159
Semitendinosus muscle, 307, 309
Sensitive frog, 196
Septa, 223
Serratus muscle, Great, 176, 234
Sesamoid, 190, 197, 282
— bones, 203, 204
— of the third phalanx, 192
Sesamoidean arch, 232
Shading, 30
Shank, 189
— bone, 219, 221
Shoulder, 224
— muscles, 165, 231, 234—256
Shoulder-blade, 206
— Inclination of, 315, 317
— Muscles acting between forearm and, 227
Sketch books, 36

Sketches, 33, 35, 40, 68, 71, 73
Skull, Bones of the, 118
— bull's, 126
— dog's, 130
— goat's, 127
— horse's, 119
— Irish wolfhound's, 129
— lion's, 129
— man's, 131
— ox's, 121, 122, 123
— sheep's, 127, 128
Sole, 194, 195
Soleus, 298
Spavin, Bog, 282
— bone, 279
Sphincter muscle, 153
Spinal column, 97—100, 104, 113
Spine, 165, 170, 175
— Tuberosity of, 174
Splenius, 162, 167, 168
Splint bone, 184, 189, 219, 220, 283
— External, 186, 187
Spur vein, 256
Standard horse, A., 315—326
Sternal ribs, 100
" Steno's Duct," 155
Sterno-humeralis muscle, 163, 240
— -maxillaris muscle, 158, 163
— -trochineous muscle, 240
Sternum, 100, 101, 106, 167
Stifle, 270, 273, 285
— fold, The, 254
— joint, 298, 300
Stomach, 169
Straight muscle, Great, 166
— Posterior, 160
Stubbs, George, 58, 60
Studies, 28, 33, 35, 40
Styloid processes, 120
Subacromio trochiterius, 230
Subcarpal ligament, 206
Subcutaneous vein of the forearm, Internal, 233
Subdorso-atloideus, 159
Submaxillary vein, 157
Subscapular fossa, 229
Subscapularis muscle, 229, 230
Subscapulo-humeralis, 229
— -hyoideus muscle, 163, 239
— -trochineus, 229
Suffraginis, 190, 212
— Extensor, 212, 223
— Os, 212

Superficial muscles, 151
— plane, 151
— vein, Internal, 232
Superior carpal ligament, 206
Supermaxillary bone, 120, 121, 122, 123, 127, 132, 150, 151, 152
Supermaxillo-nasalis, Great, 152
Supinator Longus, 221
— Short, 221
Supra-acromio trochiterius, 230
Supracondyloid fossa, 263
— ridges, 177
Supracotyloid crest, 166
Supra-orbital canal, 125, 128
— foramina, 125
Supraspinatus, 170, 230, 232
Supraspinous fossa, 170, 174
— ligament, 115, 116
Suspensory ligament, 202, 203, 204, 205, 216, 232, 284, 285
Synovial sheath, 213

Tail, 96, 113
— muscles, 165
Tarsal sheath, 294
Tarso-metatarsal Ligament, 280
Tarsus, 275, 277, 278, 296
Teeth, 123, 124, 125
Temporal bone, 120, 121, 124, 126, 131
— fossa, 121, 124, 125, 128, 149, 150
— muscles, 124, 130, 150
Temporalis, 145, 149, 150, 153, 155
Temporo-auricularis, 149, 156
— -maxillary articulation, 133
— -maxillary Joint, 120, 158
Tendon, 144
— Back, 232
— of Insertion, 150
Tensor Fasciæ Antibrachii, 228
— Latæ, 309
Teres Externus, 230
— Internus, 229
— Major, 177, 229
— Minor, 229
Third dimension, The, 26—32, 83
Thorax, 99, 101, 104
Tibia, 266, 268, 270, 285
— External tuberosity of the, 291
Tibial Aponeurosis Muscle, 309
— Crest, 268
— Spine, 269
Tibialis Anticus, 296

Toe, 194
Tongue, 124
Trachea, 163
Trachelo-mastoid, 162, 165, 167
Transversalis Nasi, 145, 152
Transverse Carpal Ligament, 184, 188
— Muscle of Nose, 152
Trapezium, 196
Trapezius Muscle, 170, 234, 250, 251
Trapezoid, 197
Triceps, 183, 227, 238
— Brachialis, 225
— Crural, 300
— External, 225
— Internal, 225
— Long Head of, 228
— Short Head of the, 225
— Small Head of the, 225
Tendon, 271
Trochanter, Great, 305, 306
— Great External, 257, 265
— Small, 300
— The third, 262
Trochlea, 261, 285
True ribs, 100
Trunk, 176
Tubercle, Internal, 177
Tuberosity, External and internal, 177 179, 268, 269
— of the Radius, 182
— of the Spine, 174
Tusks, 124

Unciform, 197
Ulna, 170, 177, 180, 182
Ulnar Head, 208
— Posterior, 217

Vastus, Long, Muscle, 307
Vein, 149
— Abdominal (subcutaneous), 256
— Cephalic, 158
— Facial, 157
— Plate, 158
— Spur, 256
— Submaxillary, 157
Veins of the Face, Superficial, 157
— Fore Limb, 232
Vertebræ, 97—100
— Number of in various animals, 96

Vertebral Border, 170, 174, 175
— Skeleton, The, 95—117, 159—169
Vertical Ramus, 124, 149, 153
Visual Training, 17, 18

Wall, 194
" Watching Muscle," 156
Windpipe, 163
Withers, 167

Wrist, 183

Zygomatic Arches, 120, 121, 124, 126,
 130, 131, 153, 154, 155
— Bone, 121
— Portion, 149
— Process, 121, 124, 126
Zygomatico-auricularis, 149, 154, 155,
 157
Zygomaticus, 149, 154

A CATALOGUE OF SELECTED DOVER
BOOKS IN ALL FIELDS OF INTEREST

RACKHAM'S COLOR ILLUSTRATIONS FOR WAGNER'S RING. Rackham's finest mature work—all 64 full-color watercolors in a faithful and lush interpretation of the *Ring*. Full-sized plates on coated stock of the paintings used by opera companies for authentic staging of Wagner. Captions aid in following complete Ring cycle. Introduction. 64 illustrations plus vignettes. 72pp. 8⅝ x 11¼. 23779-6 Pa. $6.00

CONTEMPORARY POLISH POSTERS IN FULL COLOR, edited by Joseph Czestochowski. 46 full-color examples of brilliant school of Polish graphic design, selected from world's first museum (near Warsaw) dedicated to poster art. Posters on circuses, films, plays, concerts all show cosmopolitan influences, free imagination. Introduction. 48pp. 9⅜ x 12¼. 23780-X Pa. $6.00

GRAPHIC WORKS OF EDVARD MUNCH, Edvard Munch. 90 haunting, evocative prints by first major Expressionist artist and one of the greatest graphic artists of his time: *The Scream, Anxiety, Death Chamber, The Kiss, Madonna*, etc. Introduction by Alfred Werner. 90pp. 9 x 12. 23765-6 Pa. $5.00

THE GOLDEN AGE OF THE POSTER, Hayward and Blanche Cirker. 70 extraordinary posters in full colors, from Maitres de l'Affiche, Mucha, Lautrec, Bradley, Cheret, Beardsley, many others. Total of 78pp. 9⅜ x 12¼. 22753-7 Pa. $5.95

THE NOTEBOOKS OF LEONARDO DA VINCI, edited by J. P. Richter. Extracts from manuscripts reveal great genius; on painting, sculpture, anatomy, sciences, geography, etc. Both Italian and English. 186 ms. pages reproduced, plus 500 additional drawings, including studies for *Last Supper*, Sforza monument, etc. 860pp. 7⅞ x 10¾. (Available in U.S. only) 22572-0, 22573-9 Pa., Two-vol. set $15.90

THE CODEX NUTTALL, as first edited by Zelia Nuttall. Only inexpensive edition, in full color, of a pre-Columbian Mexican (Mixtec) book. 88 color plates show kings, gods, heroes, temples, sacrifices. New explanatory, historical introduction by Arthur G. Miller. 96pp. 11⅜ x 8½. (Available in U.S. only) 23168-2 Pa. $7.95

UNE SEMAINE DE BONTÉ, A SURREALISTIC NOVEL IN COLLAGE, Max Ernst. Masterpiece created out of 19th-century periodical illustrations, explores worlds of terror and surprise. Some consider this Ernst's greatest work. 208pp. 8⅛ x 11. 23252-2 Pa. $5.00

THE COMPLETE BOOK OF DOLL MAKING AND COLLECTING, Catherine Christopher. Instructions, patterns for dozens of dolls, from rag doll on up to elaborate, historically accurate figures. Mould faces, sew clothing, make doll houses, etc. Also collecting information. Many illustrations. 288pp. 6 x 9. 22066-4 Pa. $4.50

THE DAGUERREOTYPE IN AMERICA, Beaumont Newhall. Wonderful portraits, 1850's townscapes, landscapes; full text plus 104 photographs. The basic book. Enlarged 1976 edition. 272pp. 8¼ x 11¼. 23322-7 Pa. $7.95

CRAFTSMAN HOMES, Gustav Stickley. 296 architectural drawings, floor plans, and photographs illustrate 40 different kinds of "Mission-style" homes from *The Craftsman* (1901-16), voice of American style of simplicity and organic harmony. Thorough coverage of Craftsman idea in text and picture, now collector's item. 224pp. 8⅛ x 11. 23791-5 Pa. $6.00

PEWTER-WORKING: INSTRUCTIONS AND PROJECTS, Burl N. Osborn. & Gordon O. Wilber. Introduction to pewter-working for amateur craftsman. History and characteristics of pewter; tools, materials, step-by-step instructions. Photos, line drawings, diagrams. Total of 160pp. 7⅞ x 10¾. 23786-9 Pa. $3.50

THE GREAT CHICAGO FIRE, edited by David Lowe. 10 dramatic, eye-witness accounts of the 1871 disaster, including one of the aftermath and rebuilding, plus 70 contemporary photographs and illustrations of the ruins—courthouse, Palmer House, Great Central Depot, etc. Introduction by David Lowe. 87pp. 8¼ x 11. 23771-0 Pa. $4.00

SILHOUETTES: A PICTORIAL ARCHIVE OF VARIED ILLUSTRATIONS, edited by Carol Belanger Grafton. Over 600 silhouettes from the 18th to 20th centuries include profiles and full figures of men and women, children, birds and animals, groups and scenes, nature, ships, an alphabet. Dozens of uses for commercial artists and craftspeople. 144pp. 8⅜ x 11¼. 23781-8 Pa. $4.00

ANIMALS: 1,419 COPYRIGHT-FREE ILLUSTRATIONS OF MAMMALS, BIRDS, FISH, INSECTS, ETC., edited by Jim Harter. Clear wood engravings present, in extremely lifelike poses, over 1,000 species of animals. One of the most extensive copyright-free pictorial sourcebooks of its kind. Captions. Index. 284pp. 9 x 12. 23766-4 Pa. $7.95

INDIAN DESIGNS FROM ANCIENT ECUADOR, Frederick W. Shaffer. 282 original designs by pre-Columbian Indians of Ecuador (500-1500 A.D.). Designs include people, mammals, birds, reptiles, fish, plants, heads, geometric designs. Use as is or alter for advertising, textiles, leathercraft, etc. Introduction. 95pp. 8¾ x 11¼. 23764-8 Pa. $3.50

SZIGETI ON THE VIOLIN, Joseph Szigeti. Genial, loosely structured tour by premier violinist, featuring a pleasant mixture of reminiscenes, insights into great music and musicians, innumerable tips for practicing violinists. 385 musical passages. 256pp. 5⅝ x 8¼. 23763-X Pa. $3.50

THE AMERICAN SENATOR, Anthony Trollope. Little known, long un-available Trollope novel on a grand scale. Here are humorous comment on American vs. English culture, and stunning portrayal of a heroine/villainess. Superb evocation of Victorian village life. 561pp. 5⅜ x 8½.
23801-6 Pa. $6.00

WAS IT MURDER? James Hilton. The author of *Lost Horizon* and *Goodbye, Mr. Chips* wrote one detective novel (under a pen-name) which was quickly forgotten and virtually lost, even at the height of Hilton's fame. This edition brings it back—a finely crafted public school puzzle resplendent with Hilton's stylish atmosphere. A thoroughly English thriller by the creator of Shangri-la. 252pp. 5⅜ x 8. (Available in U.S. only)
23774-5 Pa. $3.00

CENTRAL PARK: A PHOTOGRAPHIC GUIDE, Victor Laredo and Henry Hope Reed. 121 superb photographs show dramatic views of Central Park: Bethesda Fountain, Cleopatra's Needle, Sheep Meadow, the Blockhouse, plus people engaged in many park activities: ice skating, bike riding, etc. Captions by former Curator of Central Park, Henry Hope Reed, provide historical view, changes, etc. Also photos of N.Y. landmarks on park's periphery. 96pp. 8½ x 11. 23750-8 Pa. $4.50

NANTUCKET IN THE NINETEENTH CENTURY, Clay Lancaster. 180 rare photographs, stereographs, maps, drawings and floor plans recreate unique American island society. Authentic scenes of shipwreck, light-houses, streets, homes are arranged in geographic sequence to provide walking-tour guide to old Nantucket existing today. Introduction, captions. 160pp. 8⅞ x 11¾. 23747-8 Pa. $6.95

STONE AND MAN: A PHOTOGRAPHIC EXPLORATION, Andreas Feininger. 106 photographs by *Life* photographer Feininger portray man's deep passion for stone through the ages. Stonehenge-like megaliths, forti-fied towns, sculpted marble and crumbling tenements show textures, beau-ties, fascination. 128pp. 9¼ x 10¾. 23756-7 Pa. $5.95

CIRCLES, A MATHEMATICAL VIEW, D. Pedoe. Fundamental aspects of college geometry, non-Euclidean geometry, and other branches of mathe-matics: representing circle by point. Poincare model, isoperimetric prop-erty, etc. Stimulating recreational reading. 66 figures. 96pp. 5⅜ x 8¼.
63698-4 Pa. $2.75

THE DISCOVERY OF NEPTUNE, Morton Grosser. Dramatic scientific history of the investigations leading up to the actual discovery of the eighth planet of our solar system. Lucid, well-researched book by well-known historian of science. 172pp. 5⅜ x 8½. 23726-5 Pa. $3.00

THE DEVIL'S DICTIONARY. Ambrose Bierce. Barbed, bitter, brilliant witticisms in the form of a dictionary. Best, most ferocious satire America has produced. 145pp. 5⅜ x 8½. 20487-1 Pa. $2.00

"OSCAR" OF THE WALDORF'S COOKBOOK, Oscar Tschirky. Famous American chef reveals 3455 recipes that made Waldorf great; cream of French, German, American cooking, in all categories. Full instructions, easy home use. 1896 edition. 907pp. 6⅝ x 9⅜. 20790-0 Clothbd. $15.00

COOKING WITH BEER, Carole Fahy. Beer has as superb an effect on food as wine, and at fraction of cost. Over 250 recipes for appetizers, soups, main dishes, desserts, breads, etc. Index. 144pp. 5⅜ x 8½. (Available in U.S. only) 23661-7 Pa. $2.50

STEWS AND RAGOUTS, Kay Shaw Nelson. This international cookbook offers wide range of 108 recipes perfect for everyday, special occasions, meals-in-themselves, main dishes. Economical, nutritious, easy-to-prepare: goulash, Irish stew, boeuf bourguignon, etc. Index. 134pp. 5⅜ x 8½.
23662-5 Pa. $2.50

DELICIOUS MAIN COURSE DISHES, Marian Tracy. Main courses are the most important part of any meal. These 200 nutritious, economical recipes from around the world make every meal a delight. "I . . . have found it so useful in my own household,"—N.Y. Times. Index. 219pp. 5⅜ x 8½. 23664-1 Pa. $3.00

FIVE ACRES AND INDEPENDENCE, Maurice G. Kains. Great back-to-the-land classic explains basics of self-sufficient farming: economics, plants, crops, animals, orchards, soils, land selection, host of other necessary things. Do not confuse with skimpy faddist literature; Kains was one of America's greatest agriculturalists. 95 illustrations. 397pp. 5⅜ x 8½.
20974-1 Pa. $3.95

A PRACTICAL GUIDE FOR THE BEGINNING FARMER, Herbert Jacobs. Basic, extremely useful first book for anyone thinking about moving to the country and starting a farm. Simpler than Kains, with greater emphasis on country living in general. 246pp. 5⅜ x 8½.
23675-7 Pa. $3.50

A GARDEN OF PLEASANT FLOWERS (PARADISI IN SOLE: PARADISUS TERRESTRIS), John Parkinson. Complete, unabridged reprint of first (1629) edition of earliest great English book on gardens and gardening. More than 1000 plants & flowers of Elizabethan, Jacobean garden fully described, most with woodcut illustrations. Botanically very reliable, a "speaking garden" of exceeding charm. 812 illustrations. 628pp. 8½ x 12¼. 23392-8 Clothbd. $25.00

ACKERMANN'S COSTUME PLATES, Rudolph Ackermann. Selection of 96 plates from the Repository of Arts, best published source of costume for English fashion during the early 19th century. 12 plates also in color. Captions, glossary and introduction by editor Stella Blum. Total of 120pp. 8⅜ x 11¼. 23690-0 Pa. $4.50

CATALOGUE OF DOVER BOOKS

THE DEPRESSION YEARS AS PHOTOGRAPHED BY ARTHUR ROTH-
STEIN, Arthur Rothstein. First collection devoted entirely to the work of
outstanding 1930s photographer: famous dust storm photo, ragged children,
unemployed, etc. 120 photographs. Captions. 119pp. 9¼ x 10¾.
23590-4 Pa. $5.00

CAMERA WORK: A PICTORIAL GUIDE, Alfred Stieglitz. All 559 illus-
trations and plates from the most important periodical in the history of
art photography, Camera Work (1903-17). Presented four to a page, re-
duced in size but still clear, in strict chronological order, with complete
captions. Three indexes. Glossary. Bibliography. 176pp. 8⅜ x 11¼.
23591-2 Pa. $6.95

ALVIN LANGDON COBURN, PHOTOGRAPHER, Alvin L. Coburn. Re-
vealing autobiography by one of greatest photographers of 20th century
gives insider's version of Photo-Secession, plus comments on his own work.
77 photographs by Coburn. Edited by Helmut and Alison Gernsheim.
160pp. 8⅛ x 11. 23685-4 Pa. $6.00

NEW YORK IN THE FORTIES, Andreas Feininger. 162 brilliant photo-
graphs by the well-known photographer, formerly with Life magazine, show
commuters, shoppers, Times Square at night, Harlem nightclub, Lower
East Side, etc. Introduction and full captions by John von Hartz. 181pp.
9¼ x 10¾. 23585-8 Pa. $6.00

GREAT NEWS PHOTOS AND THE STORIES BEHIND THEM, John
Faber. Dramatic volume of 140 great news photos, 1855 through 1976,
and revealing stories behind them, with both historical and technical in-
formation. Hindenburg disaster, shooting of Oswald, nomination of Jimmy
Carter, etc. 160pp. 8¼ x 11. 23667-6 Pa. $5.00

THE ART OF THE CINEMATOGRAPHER, Leonard Maltin. Survey of
American cinematography history and anecdotal interviews with 5 masters—
Arthur Miller, Hal Mohr, Hal Rosson, Lucien Ballard, and Conrad Hall.
Very large selection of behind-the-scenes production photos. 105 photo-
graphs. Filmographies. Index. Originally Behind the Camera. 144pp.
8¼ x 11. 23686-2 Pa. $5.00

DESIGNS FOR THE THREE-CORNERED HAT (LE TRICORNE),
Pablo Picasso. 32 fabulously rare drawings—including 31 color illustrations
of costumes and accessories—for 1919 production of famous ballet. Edited
by Parmenia Migel, who has written new introduction. 48pp. 9⅜ x 12¼.
(Available in U.S. only) 23709-5 Pa. $5.00

NOTES OF A FILM DIRECTOR, Sergei Eisenstein. Greatest Russian
filmmaker explains montage, making of Alexander Nevsky, aesthetics; com-
ments on self, associates, great rivals (Chaplin), similar material. 78 illus-
trations. 240pp. 5⅜ x 8½. 22392-2 Pa. $4.50

HISTORY OF BACTERIOLOGY, William Bulloch. The only comprehensive history of bacteriology from the beginnings through the 19th century. Special emphasis is given to biography-Leeuwenhoek, etc. Brief accounts of 350 bacteriologists form a separate section. No clearer, fuller study, suitable to scientists and general readers, has yet been written. 52 illustrations. 448pp. 5⅝ x 8¼. 23761-3 Pa. $6.50

THE COMPLETE NONSENSE OF EDWARD LEAR, Edward Lear. All nonsense limericks, zany alphabets, Owl and Pussycat, songs, nonsense botany, etc., illustrated by Lear. Total of 321pp. 5⅜ x 8½. (Available in U.S. only) 20167-8 Pa. $3.00

INGENIOUS MATHEMATICAL PROBLEMS AND METHODS, Louis A. Graham. Sophisticated material from Graham *Dial*, applied and pure; stresses solution methods. Logic, number theory, networks, inversions, etc. 237pp. 5⅜ x 8½. 20545-2 Pa. $3.50

BEST MATHEMATICAL PUZZLES OF SAM LOYD, edited by Martin Gardner. Bizarre, original, whimsical puzzles by America's greatest puzzler. From fabulously rare *Cyclopedia*, including famous 14-15 puzzles, the Horse of a Different Color, 115 more. Elementary math. 150 illustrations. 167pp. 5⅜ x 8½. 20498-7 Pa. $2.75

THE BASIS OF COMBINATION IN CHESS, J. du Mont. Easy-to-follow, instructive book on elements of combination play, with chapters on each piece and every powerful combination team—two knights, bishop and knight, rook and bishop, etc. 250 diagrams. 218pp. 5⅜ x 8½. (Available in U.S. only) 23644-7 Pa. $3.50

MODERN CHESS STRATEGY, Ludek Pachman. The use of the queen, the active king, exchanges, pawn play, the center, weak squares, etc. Section on rook alone worth price of the book. Stress on the moderns. Often considered the most important book on strategy. 314pp. 5⅜ x 8½.
20290-9 Pa. $4.50

LASKER'S MANUAL OF CHESS, Dr. Emanuel Lasker. Great world champion offers very thorough coverage of all aspects of chess. Combinations, position play, openings, end game, aesthetics of chess, philosophy of struggle, much more. Filled with analyzed games. 390pp. 5⅜ x 8½.
20640-8 Pa. $5.00

500 MASTER GAMES OF CHESS, S. Tartakower, J. du Mont. Vast collection of great chess games from 1798-1938, with much material nowhere else readily available. Fully annotated, arranged by opening for easier study. 664pp. 5⅜ x 8½. 23208-5 Pa. $7.50

A GUIDE TO CHESS ENDINGS, Dr. Max Euwe, David Hooper. One of the finest modern works on chess endings. Thorough analysis of the most frequently encountered endings by former world champion. 331 examples, each with diagram. 248pp. 5⅜ x 8½. 23332-4 Pa. $3.50

SECOND PIATIGORSKY CUP, edited by Isaac Kashdan. One of the greatest tournament books ever produced in the English language. All 90 games of the 1966 tournament, annotated by players, most annotated by both players. Features Petrosian, Spassky, Fischer, Larsen, six others. 228pp. 5⅜ x 8½. 23572-6 Pa. $3.50

ENCYCLOPEDIA OF CARD TRICKS, revised and edited by Jean Hugard. How to perform over 600 card tricks, devised by the world's greatest magicians: impromptus, spelling tricks, key cards, using special packs, much, much more. Additional chapter on card technique. 66 illustrations. 402pp. 5⅜ x 8½. (Available in U.S. only) 21252-1 Pa. $3.95

MAGIC: STAGE ILLUSIONS, SPECIAL EFFECTS AND TRICK PHO-TOGRAPHY, Albert A. Hopkins, Henry R. Evans. One of the great classics; fullest, most authorative explanation of vanishing lady, levitations, scores of other great stage effects. Also small magic, automata, stunts. 446 illus-trations. 556pp. 5⅜ x 8½. 23344-8 Pa. $6.95

THE SECRETS OF HOUDINI, J. C. Cannell. Classic study of Houdini's incredible magic, exposing closely-kept professional secrets and revealing, in general terms, the whole art of stage magic. 67 illustrations. 279pp. 5⅜ x 8½. 22913-0 Pa. $3.00

HOFFMANN'S MODERN MAGIC, Professor Hoffmann. One of the best, and best-known, magicians' manuals of the past century. Hundreds of tricks from card tricks and simple sleight of hand to elaborate illusions involving construction of complicated machinery. 332 illustrations. 563pp. 5⅜ x 8½. 23623-4 Pa. $6.00

MADAME PRUNIER'S FISH COOKERY BOOK, Mme. S. B. Prunier. More than 1000 recipes from world famous Prunier's of Paris and London, specially adapted here for American kitchen. Grilled tournedos with anchovy butter, Lobster a la Bordelaise, Prunier's prized desserts, more. Glossary. 340pp. 5⅜ x 8½. (Available in U.S. only) 22679-4 Pa. $3.00

FRENCH COUNTRY COOKING FOR AMERICANS, Louis Diat. 500 easy-to-make, authentic provincial recipes compiled by former head chef at New York's Fitz-Carlton Hotel: onion soup, lamb stew, potato pie, more. 309pp. 5⅜ x 8½. 23665-X Pa. $3.95

SAUCES, FRENCH AND FAMOUS, Louis Diat. Complete book gives over 200 specific recipes: bechamel, Bordelaise, hollandaise, Cumberland, apri-cot, etc. Author was one of this century's finest chefs, originator of vichyssoise and many other dishes. Index. 156pp. 5⅜ x 8. 23663-3 Pa. $2.50

TOLL HOUSE TRIED AND TRUE RECIPES, Ruth Graves Wakefield. Authentic recipes from the famous Mass. restaurant: popovers, veal and ham loaf, Toll House baked beans, chocolate cake crumb pudding, much more. Many helpful hints. Nearly 700 recipes. Index. 376pp. 5⅜ x 8½. 23560-2 Pa. $4.50

YUCATAN BEFORE AND AFTER THE CONQUEST, Diego de Landa. First English translation of basic book in Maya studies, the only significant account of Yucatan written in the early post-Conquest era. Translated by distinguished Maya scholar William Gates. Appendices, introduction, 4 maps and over 120 illustrations added by translator. 162pp. 5⅜ x 8½.
23622-6 Pa. $3.00

THE MALAY ARCHIPELAGO, Alfred R. Wallace. Spirited travel account by one of founders of modern biology. Touches on zoology, botany, ethnography, geography, and geology. 62 illustrations, maps. 515pp. 5⅜ x 8½.
20187-2 Pa. $6.95

THE DISCOVERY OF THE TOMB OF TUTANKHAMEN, Howard Carter, A. C. Mace. Accompany Carter in the thrill of discovery, as ruined passage suddenly reveals unique, untouched, fabulously rich tomb. Fascinating account, with 106 illustrations. New introduction by J. M. White. Total of 382pp. 5⅜ x 8½. (Available in U.S. only) 23500-9 Pa. $4.00

THE WORLD'S GREATEST SPEECHES, edited by Lewis Copeland and Lawrence W. Lamm. Vast collection of 278 speeches from Greeks up to present. Powerful and effective models; unique look at history. Revised to 1970. Indices. 842pp. 5⅜ x 8½. 20468-5 Pa. $8.95

THE 100 GREATEST ADVERTISEMENTS, Julian Watkins. The priceless ingredient; His master's voice; 99 44/100% pure; over 100 others. How they were written, their impact, etc. Remarkable record. 130 illustrations. 233pp. 7⅞ x 10 3/5. 20540-1 Pa. $5.00

CRUICKSHANK PRINTS FOR HAND COLORING, George Cruickshank. 18 illustrations, one side of a page, on fine-quality paper suitable for watercolors. Caricatures of people in society (c. 1820) full of trenchant wit. Very large format. 32pp. 11 x 16. 23684-6 Pa. $5.00

THIRTY-TWO COLOR POSTCARDS OF TWENTIETH-CENTURY AMERICAN ART, Whitney Museum of American Art. Reproduced in full color in postcard form are 31 art works and one shot of the museum. Calder, Hopper, Rauschenberg, others. Detachable. 16pp. 8¼ x 11.
23629-3 Pa. $2.50

MUSIC OF THE SPHERES: THE MATERIAL UNIVERSE FROM ATOM TO QUASAR SIMPLY EXPLAINED, Guy Murchie. Planets, stars, geology, atoms, radiation, relativity, quantum theory, light, antimatter, similar topics. 319 figures. 664pp. 5⅜ x 8½.
21809-0, 21810-4 Pa., Two-vol. set $10.00

EINSTEIN'S THEORY OF RELATIVITY, Max Born. Finest semi-technical account; covers Einstein, Lorentz, Minkowski, and others, with much detail, much explanation of ideas and math not readily available elsewhere on this level. For student, non-specialist. 376pp. 5⅜ x 8½.
60769-0 Pa. $4.50

DRAWINGS OF WILLIAM BLAKE, William Blake. 92 plates from Book of Job, *Divine Comedy, Paradise Lost,* visionary heads, mythological figures, Laocoon, etc. Selection, introduction, commentary by Sir Geoffrey Keynes. 178pp. 8⅛ x 11. 22303-5 Pa. $4.00

ENGRAVINGS OF HOGARTH, William Hogarth. 101 of Hogarth's greatest works: *Rake's Progress, Harlot's Progress, Illustrations for Hudibras, Before and After, Beer Street and Gin Lane,* many more. Full commentary. 256pp. 11 x 13¾. 22479-1 Pa. $7.95

DAUMIER: 120 GREAT LITHOGRAPHS, Honore Daumier. Wide-ranging collection of lithographs by the greatest caricaturist of the 19th century. Concentrates on eternally popular series on lawyers, on married life, on liberated women, etc. Selection, introduction, and notes on plates by Charles F. Ramus. Total of 158pp. 9⅜ x 12¼. 23512-2 Pa. $5.50

DRAWINGS OF MUCHA, Alphonse Maria Mucha. Work reveals drafts- man of highest caliber: studies for famous posters and paintings, render- ings for book illustrations and ads, etc. 70 works, 9 in color; including 6 items not drawings. Introduction. List of illustrations. 72pp. 9⅜ x 12¼. (Available in U.S. only) 23672-2 Pa. $4.00

GIOVANNI BATTISTA PIRANESI: DRAWINGS IN THE PIERPONT MORGAN LIBRARY, Giovanni Battista Piranesi. For first time ever all of Morgan Library's collection, world's largest. 167 illustrations of rare Piranesi drawings—archeological, architectural, decorative and visionary. Essay, detailed list of drawings, chronology, captions. Edited by Felice Stampfle. 144pp. 9⅜ x 12¼. 23714-1 Pa. $7.50

NEW YORK ETCHINGS (1905-1949), John Sloan. All of important American artist's N.Y. life etchings. 67 works include some of his best art; also lively historical record—Greenwich Village, tenement scenes. Edited by Sloan's widow. Introduction and captions. 79pp. 8⅜ x 11¼.
23651-X Pa. $4.00

CHINESE PAINTING AND CALLIGRAPHY: A PICTORIAL SURVEY, Wan-go Weng. 69 fine examples from John M. Crawford's matchless private collection: landscapes, birds, flowers, human figures, etc., plus calligraphy. Every basic form included: hanging scrolls, handscrolls, album leaves, fans, etc. 109 illustrations. Introduction. Captions. 192pp. 8⅞ x 11¾.
23707-9 Pa. $7.95

DRAWINGS OF REMBRANDT, edited by Seymour Slive. Updated Lipp- mann, Hofstede de Groot edition, with definitive scholarly apparatus. All portraits, biblical sketches, landscapes, nudes, Oriental figures, classical studies, together with selection of work by followers. 550 illustrations. Total of 630pp. 9⅛ x 12¼. 21485-0, 21486-9 Pa., Two-vol. set $15.00

THE DISASTERS OF WAR, Francisco Goya. 83 etchings record horrors of Napoleonic wars in Spain and war in general. Reprint of 1st edition, plus 3 additional plates. Introduction by Philip Hofer. 97pp. 9⅜ x 8¼.
21872-4 Pa. $3.75

ART FORMS IN NATURE, Ernst Haeckel. Multitude of strangely beautiful natural forms: Radiolaria, Foraminifera, jellyfishes, fungi, turtles, bats, etc. All 100 plates of the 19th-century evolutionist's *Kunstformen der Natur* (1904). 100pp. 9⅜ x 12¼. 22987-4 Pa. $4.50

CHILDREN: A PICTORIAL ARCHIVE FROM NINETEENTH-CENTURY SOURCES, edited by Carol Belanger Grafton. 242 rare, copyright-free wood engravings for artists and designers. Widest such selection available. All illustrations in line. 119pp. 8⅜ x 11¼. 23694-3 Pa. $3.50

WOMEN: A PICTORIAL ARCHIVE FROM NINETEENTH-CENTURY SOURCES, edited by Jim Harter. 391 copyright-free wood engravings for artists and designers selected from rare periodicals. Most extensive such collection available. All illustrations in line. 128pp. 9 x 12. 23703-6 Pa. $4.50

ARABIC ART IN COLOR, Prisse d'Avennes. From the greatest ornamentalists of all time—50 plates in color, rarely seen outside the Near East, rich in suggestion and stimulus. Includes 4 plates on covers. 46pp. 9⅜ x 12¼. 23658-7 Pa. $6.00

AUTHENTIC ALGERIAN CARPET DESIGNS AND MOTIFS, edited by June Beveridge. Algerian carpets are world famous. Dozens of geometrical motifs are charted on grids, color-coded, for weavers, needleworkers, craftsmen, designers. 53 illustrations plus 4 in color. 48pp. 8¼ x 11. (Available in U.S. only) 23650-1 Pa. $1.75

DICTIONARY OF AMERICAN PORTRAITS, edited by Hayward and Blanche Cirker. 4000 important Americans, earliest times to 1905, mostly in clear line. Politicians, writers, soldiers, scientists, inventors, industrialists, Indians, Blacks, women, outlaws, etc. Identificatory information. 756pp. 9¼ x 12¾. 21823-6 Clothbd. $40.00

HOW THE OTHER HALF LIVES, Jacob A. Riis. Journalistic record of filth, degradation, upward drive in New York immigrant slums, shops, around 1900. New edition includes 100 original Riis photos, monuments of early photography. 233pp. 10 x 7⅞. 22012-5 Pa. $6.00

NEW YORK IN THE THIRTIES, Berenice Abbott. Noted photographer's fascinating study of city shows new buildings that have become famous and old sights that have disappeared forever. Insightful commentary. 97 photographs. 97pp. 11⅜ x 10. 22967-X Pa. $5.00

MEN AT WORK, Lewis W. Hine. Famous photographic studies of construction workers, railroad men, factory workers and coal miners. New supplement of 18 photos on Empire State building construction. New introduction by Jonathan L. Doherty. Total of 69 photos. 63pp. 8 x 10¾. 23475-4 Pa. $3.00

HOLLYWOOD GLAMOUR PORTRAITS, edited by John Kobal. 145 photos capture the stars from 1926-49, the high point in portrait photography. Gable, Harlow, Bogart, Bacall, Hedy Lamarr, Marlene Dietrich, Robert Montgomery, Marlon Brando, Veronica Lake; 94 stars in all. Full background on photographers, technical aspects, much more. Total of 160pp. 8⅜ x 11¼. 23352-9 Pa. $6.00

THE NEW YORK STAGE: FAMOUS PRODUCTIONS IN PHOTO-GRAPHS, edited by Stanley Appelbaum. 148 photographs from Museum of City of New York show 142 plays, 1883-1939. *Peter Pan, The Front Page, Dead End, Our Town*, O'Neill, hundreds of actors and actresses, etc. Full indexes. 154pp. 9½ x 10. 23241-7 Pa. $6.00

MASTERS OF THE DRAMA, John Gassner. Most comprehensive history of the drama, every tradition from Greeks to modern Europe and America, including Orient. Covers 800 dramatists, 2000 plays; biography, plot summaries, criticism, theatre history, etc. 77 illustrations. 890pp. 5⅜ x 8½. 20100-7 Clothbd. $10.00

THE GREAT OPERA STARS IN HISTORIC PHOTOGRAPHS, edited by James Camner. 343 portraits from the 1850s to the 1940s: Tamburini, Mario, Caliapin, Jeritza, Melchior, Melba, Patti, Pinza, Schipa, Caruso, Farrar, Steber, Gobbi, and many more—270 performers in all. Index. 199pp. 8⅜ x 11¼. 23575-0 Pa. $6.50

J. S. BACH, Albert Schweitzer. Great full-length study of Bach, life, background to music, music, by foremost modern scholar. Ernest Newman translation. 650 musical examples. Total of 928pp. 5⅜ x 8½. (Available in U.S. only) 21631-4, 21632-2 Pa., Two-vol. set $10.00

COMPLETE PIANO SONATAS, Ludwig van Beethoven. All sonatas in the fine Schenker edition, with fingering, analytical material. One of best modern editions. Total of 615pp. 9 x 12. (Available in U.S. only) 23134-8, 23135-6 Pa., Two-vol. set $15.00

KEYBOARD MUSIC, J. S. Bach. Bach-Gesellschaft edition. For harpsichord, piano, other keyboard instruments. English Suites, French Suites, Six Partitas, Goldberg Variations, Two-Part Inventions, Three-Part Sinfonias. 312pp. 8⅛ x 11. (Available in U.S. only) 22360-4 Pa. $6.95

FOUR SYMPHONIES IN FULL SCORE, Franz Schubert. Schubert's four most popular symphonies: No. 4 in C Minor ("Tragic"); No. 5 in B-flat Major; No. 8 in B Minor ("Unfinished"); No. 9 in C Major ("Great"). Breitkopf & Hartel edition. Study score. 261pp. 9⅜ x 12¼. 23681-1 Pa. $6.50

THE AUTHENTIC GILBERT & SULLIVAN SONGBOOK, W. S. Gilbert, A. S. Sullivan. Largest selection available; 92 songs, uncut, original keys, in piano rendering approved by Sullivan. Favorites and lesser-known fine numbers. Edited with plot synopses by James Spero. 3 illustrations. 399pp. 9 x 12. 23482-7 Pa. $7.95

AMERICAN ANTIQUE FURNITURE, Edgar G. Miller, Jr. The basic coverage of all American furniture before 1840: chapters per item chronologically cover all types of furniture, with more than 2100 photos. Total of 1106pp. 7⅞ x 10¾. 21599-7, 21600-4 Pa., Two-vol. set $17.90

ILLUSTRATED GUIDE TO SHAKER FURNITURE, Robert Meader. Director, Shaker Museum, Old Chatham, presents up-to-date coverage of all furniture and appurtenances, with much on local styles not available elsewhere. 235 photos. 146pp. 9 x 12. 22819-3 Pa. $5.00

ORIENTAL RUGS, ANTIQUE AND MODERN, Walter A. Hawley. Persia, Turkey, Caucasus, Central Asia, China, other traditions. Best general survey of all aspects: styles and periods, manufacture, uses, symbols and their interpretation, and identification. 96 illustrations, 11 in color. 320pp. 6⅛ x 9¼. 22366-3 Pa. $6.95

CHINESE POTTERY AND PORCELAIN, R. L. Hobson. Detailed descriptions and analyses by former Keeper of the Department of Oriental Antiquities and Ethnography at the British Museum. Covers hundreds of pieces from primitive times to 1915. Still the standard text for most periods. 136 plates, 40 in full color. Total of 750pp. 5⅜ x 8½.
23253-0 Pa. $10.00

THE WARES OF THE MING DYNASTY, R. L. Hobson. Foremost scholar examines and illustrates many varieties of Ming (1368-1644). Famous blue and white, polychrome, lesser-known styles and shapes. 117 illustrations, 9 full color, of outstanding pieces. Total of 263pp. 6⅛ x 9¼. (Available in U.S. only) 23652-8 Pa. $6.00

Prices subject to change without notice.

Available at your book dealer or write for free catalogue to Dept. GI, Dover Publications, Inc., 180 Varick St., N.Y., N.Y. 10014. Dover publishes more than 175 books each year on science, elementary and advanced mathematics, biology, music, art, literary history, social sciences and other areas.